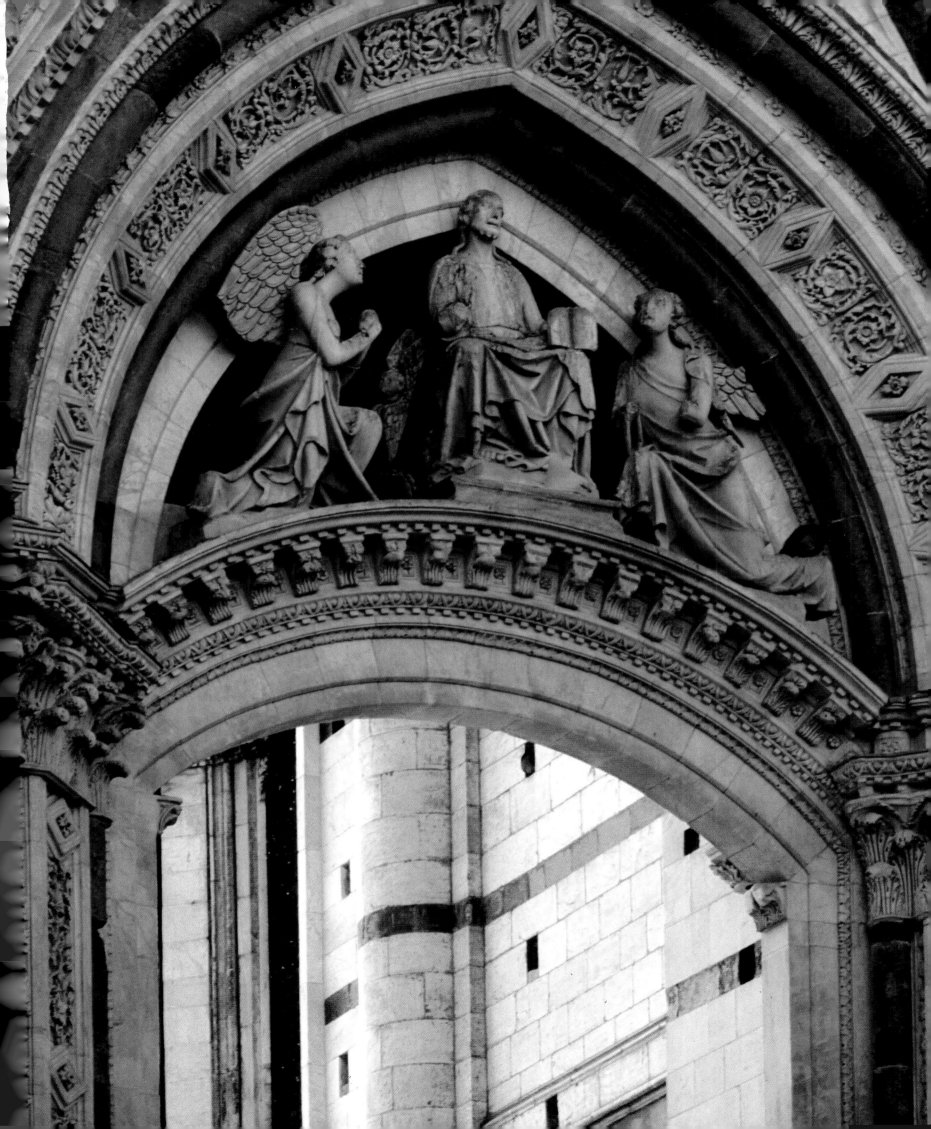

WONDERS
of the WORLD

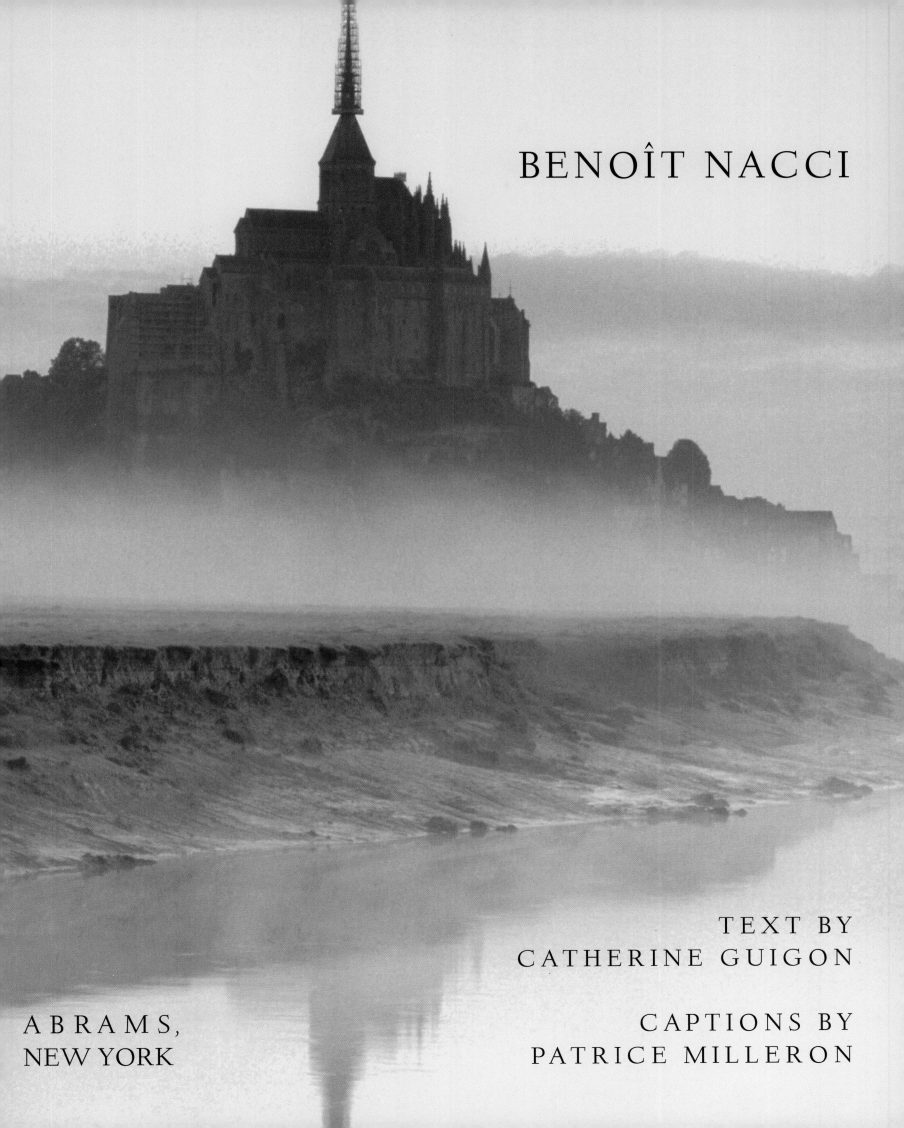

BENOÎT NACCI

TEXT BY
CATHERINE GUIGON

CAPTIONS BY
PATRICE MILLERON

ABRAMS,
NEW YORK

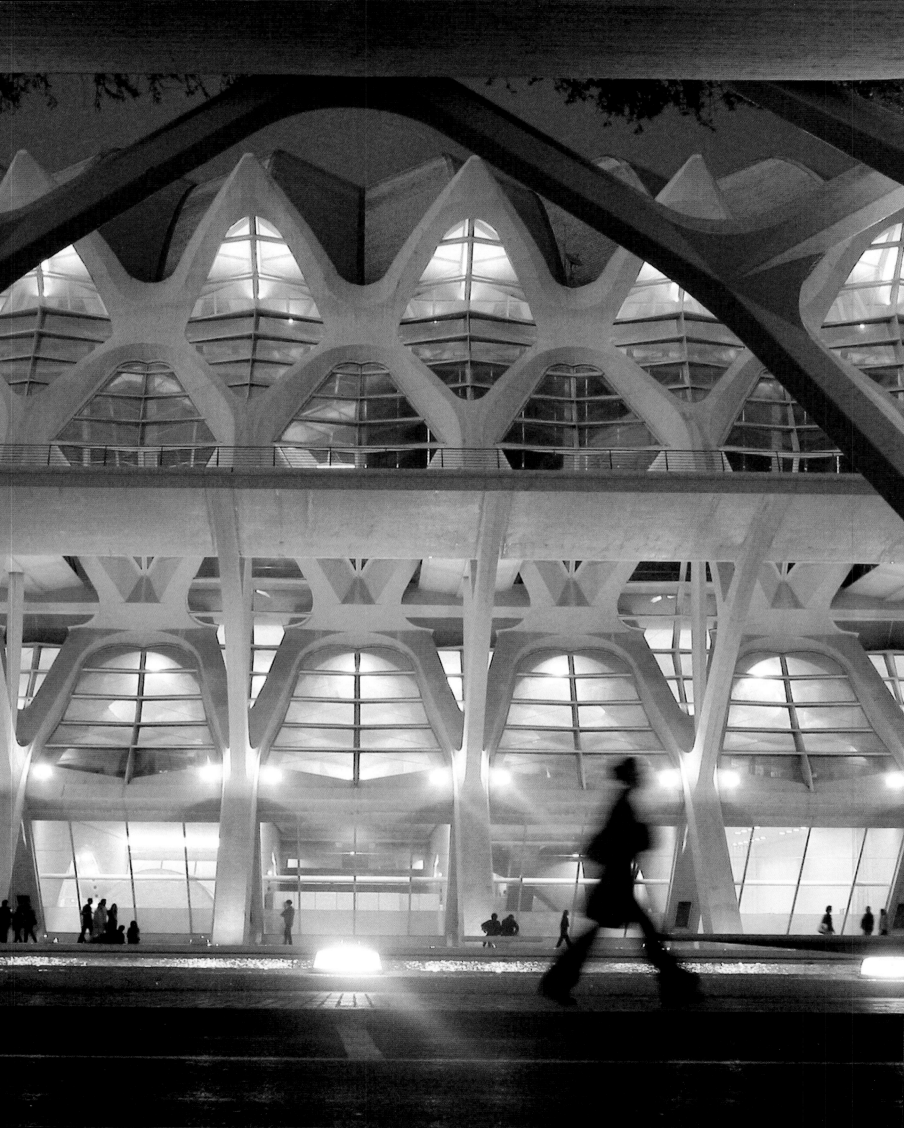

CONTENTS

Frontispiece: Siena Cathedral, Italy
Title pages: Mont-Saint-Michel, France
Opposite: Science Museum in Valencia, Spain

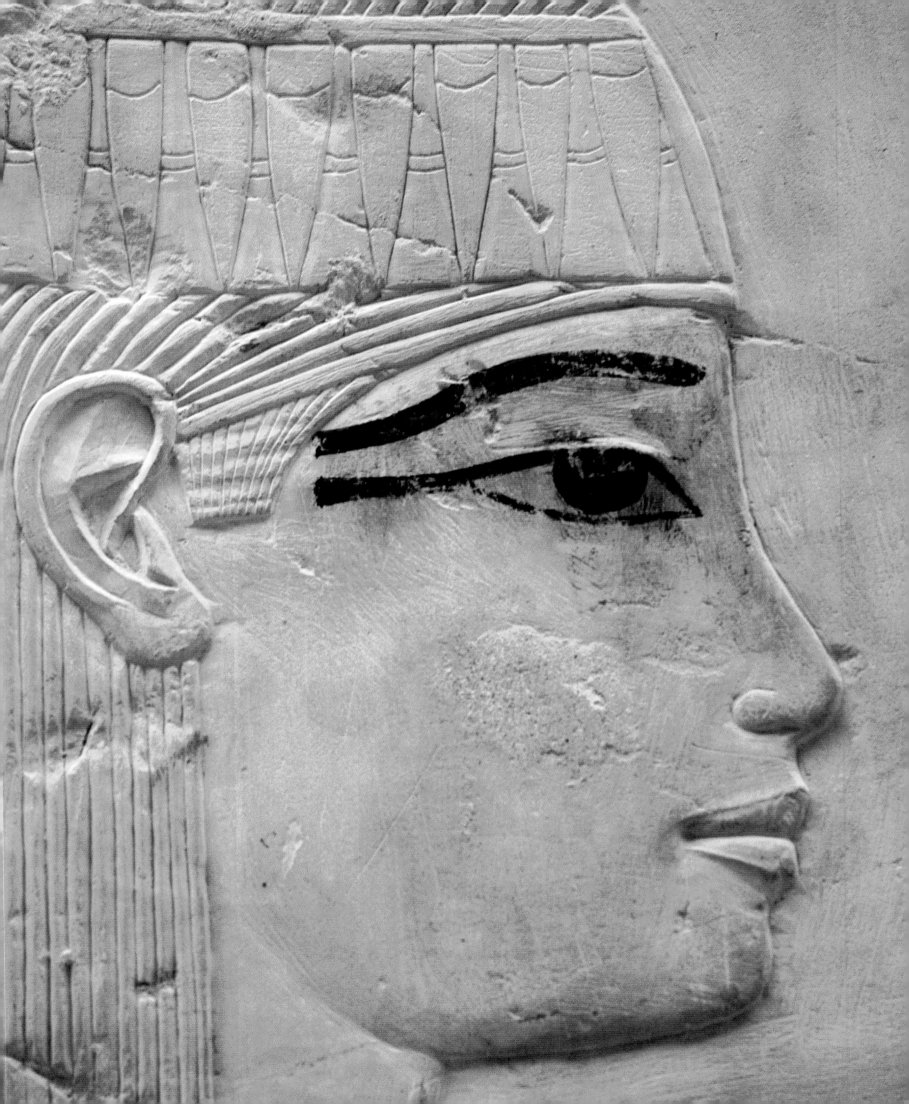

HUMANS AND GODS IN THE MEDITERRANEAN

Civilizations are perhaps not as "mortal" as the poet Paul Valéry once declared them to be. In reality, they often show flexibility, merging with one another, adapting to the changes imposed by history, making those trade-offs required by the rules of power politics, and surviving change through cross-fertilization, the exchange between different cultures. The theory certainly holds good in the Mediterranean Basin, crucible of the world of antiquity. In this region humans were dazzled by the light and worshiped the sun. Their gods were clever enough to change their names—Zeus or Jupiter, Dionysus or Bacchus, as the century or conqueror ordered—while losing nothing of their mythical attributes. The *Mare Nostrum*, "Our Sea," was the name given to the virtually landlocked sea whose waters lapped against some 12,400 miles (20,000 kilometers) of African and European coastline. The Mediterranean favored the fusion of cultures, especially given its blend of landscapes and climates and the relative ease of sea travel from place to place as the winds and currents allowed.

The story behind the textbook chronology speaks of the impressive momentum that drove the peoples of the Mediterranean to sail to different places, open trading posts, make war, enslave, build, and settle, until they, in turn, found themselves subject to a new wave of conquest. Such expeditions sometimes fed mythology. Theseus, son of King Aegius, landed in Crete in order to kill the Minotaur, the monster kept in the Labyrinth at Knossos, the palace of King Minos, which bears testimony to Minoan civilization at its height around 1700 BC. Then there was Odysseus, whose incredible "Odyssey" was chanted by Homer, probably around the eighth century BC. It is said that Odysseus sailed as far as the Pillars of Hercules—today's Gibraltar—the confines of the then known world, on his perilous journey back to Ithaca. History supported by archaeology reveals the audacity of the Phoenicians. They veered west in their heavy black ships to establish Carthage in Tunisia and Cadiz in Spain, on their way destroying Mycenae, the ancient city of the Greeks on the Peloponnese peninsula. And so the cycle of conquests continued. Greece triumphed under Alexander the Great in the fourth century BC, sending its armies eastward, colonizing Egypt, and reaching India to forge a fleeting political union between Orient and Occident. Yet once the Hellenic Empire succumbed to fratricidal struggles, it found itself quickly gobbled up by Rome. In a new phase, the ambitions of Caesar caused Rome to send its legions west to take on the Gauls in war. And we must not lose sight of the amorous conquest that united Rome with Cleopatra, queen of the Nile.

So much extraordinary cultural and human interchange has left behind a magnificent mineral heritage, ceramics, frescoes, sculpture, and the like. There is scarcely an island, headland, or inlet in the Mediterranean that did not have its own town, amphitheater, or temple. For many centuries, these relics remained silent and forgotten, and some disappeared beneath the sands. Only when

(Detail) Bas-relief from a tomb in the Valley of the Kings, Luxor, Egypt

Champollion had deciphered Egyptian hieroglyphics thanks to the Rosetta Stone, discovered in 1799, did the Egypt of the Pharaohs begin to give up its secrets. The sandstone walls of the temples at Abu Simbel (pages 12–13) and Karnak were able to tell again the epic tales that honored gods and kings. Amon Ra, with his sun disk, and Isis, the mother goddess feeding the young falcon-headed Horus, have become almost familiar images to us, although the great Sphinx at Giza is still an enigma. Nor should this surprise us. The wonders of antiquity seem destined to feed our fantasies. They take us into a world inhabited by gods—Egyptian, Greek, or Roman—whose lives are beset with very human struggles, the torments of love, war, power, and glory.

The magic of antiquity's great sites lies in their psychological power to evoke the past. For example, in the exquisite temple at Delphi, in its setting among the olive trees on Mount Parnassus, it becomes almost possible to hear Pythia muttering her oracles. Meanwhile, in Athens, we are able to follow in the footsteps of Pericles, the father of democracy five centuries before Christ. Here, for the first time, the temples of the gods were sited together for the common good on Athena's hill (pages 14–15), while the city developed down below, around the agora, the marketplace and center of political life. Revised and embellished by the Romans, this was an urban model that lasted a thousand years.

The Rome of antiquity, the capital of an empire that dispensed its *pax romana* throughout the entire Mediterranean Basin, still speaks through its monuments: a Pantheon that is a temple to all the gods, a Forum (pages 16–17) open to debates, a basilica law court, thermal baths, a theater, and a Colosseum (pages 16–17) for circus games. Its rival, Leptis Magna (page 20) in the province of Africa, tried vainly to outdo it. Yet building in stone also had to do with pride, and Rome's pride made her build always bigger and higher, like the arena at Arles (pages 24–25) for twenty thousand spectators, or the Pont du Gard (pages 22–23), the longest aqueduct in colonized Gaul. The relics bequeathed by the civilizations of Mediterranean antiquity are so spectacular that it is tempting to imagine that the humans who built them considered themselves hardly less immortal than the gods they honored.

Face of a Roman statue, Tripoli Museum, Libya

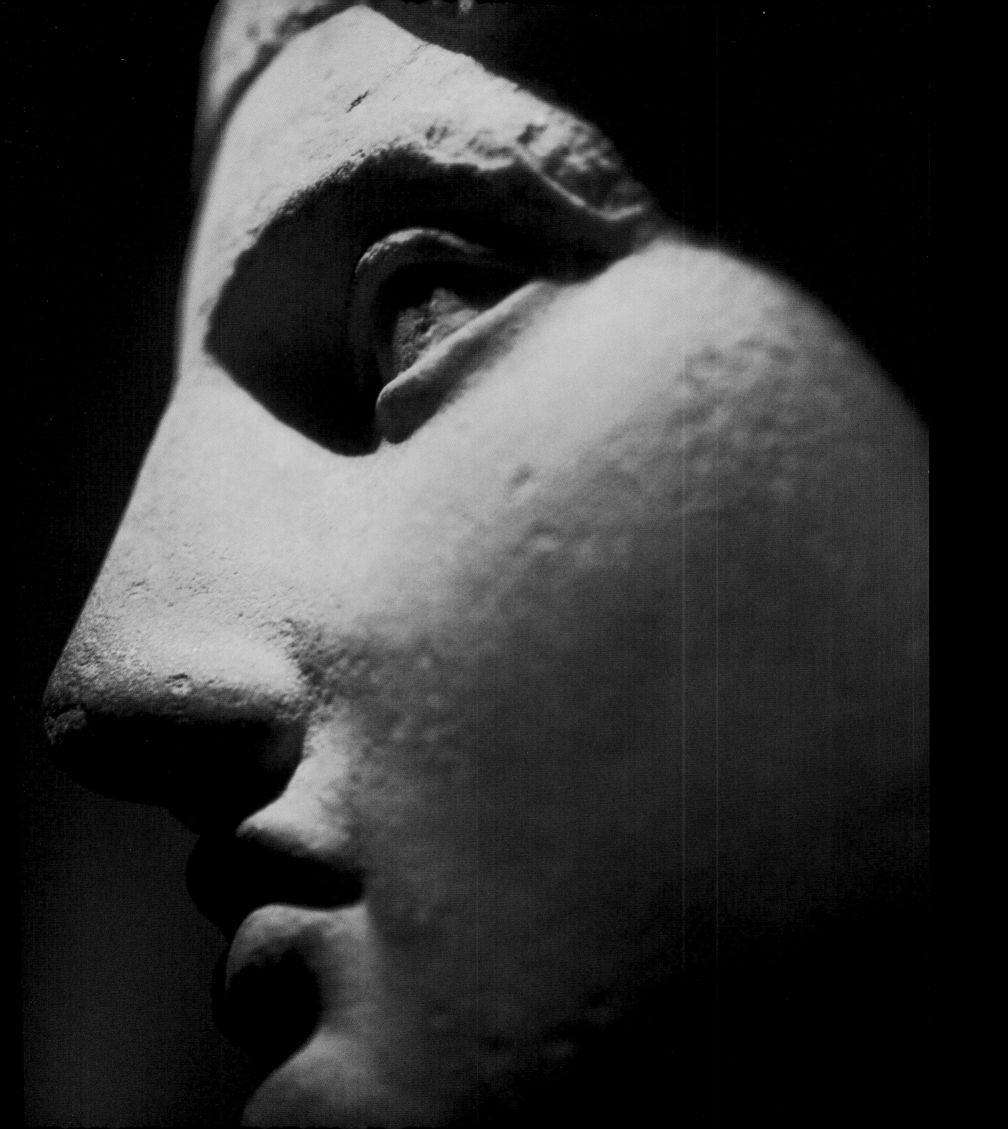

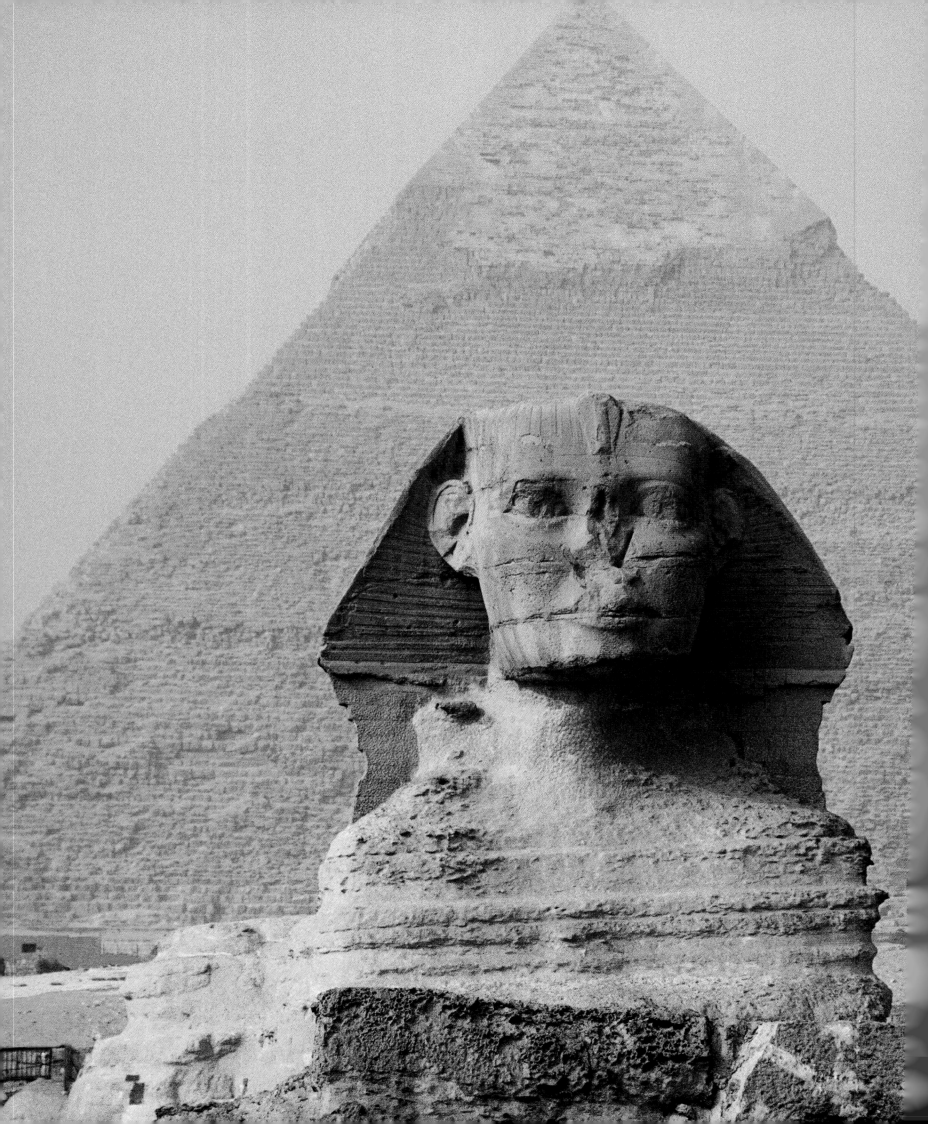

THE PYRAMIDS AND ABU SIMBEL, EGYPT

Left and following pages:

More than any other river, the Nile is a river of life. Within its valley lies all of ancient Egypt, its temples and tombs. We still do not know exactly how the Pyramids of the Pharaohs—like those, shown here, of Cheops (also known as Khufu), Khephren, and Mykerinos—were built. Yet the amazingly perfect forms of these royal mansions destined for life after death stand for all time on the edge of the desert. Their construction did not supplant the need for temples honoring the gods. Between 1294 and 1224 BC, Ramses II had two temples hollowed out in the sandstone cliffs where the nourishing floodwaters of the Nile entered Egypt. The larger of the two was dedicated to him, and the smaller belonged to his wife Nefertari. The couple were thus associated both with a number of gods and with the source of Egypt's prosperity, the floodwaters of the Nile. The monumental façades of the temples lead to chambers with piers carved out in the rock; the chamber walls are covered in bas-reliefs and hieroglyphs. The façades feature large statues of Ramses II and Nefertari. Abandoned for centuries to the desert sands, the temples were threatened by flooding in the rising waters of Lake Nasser, when the Aswan Dam project was undertaken in the 1960s and 1970s. At that time, they were cut out from their original location in the rock wall, raised up, and inserted into an artificial cliff, especially designed for the purpose, above the new lake.

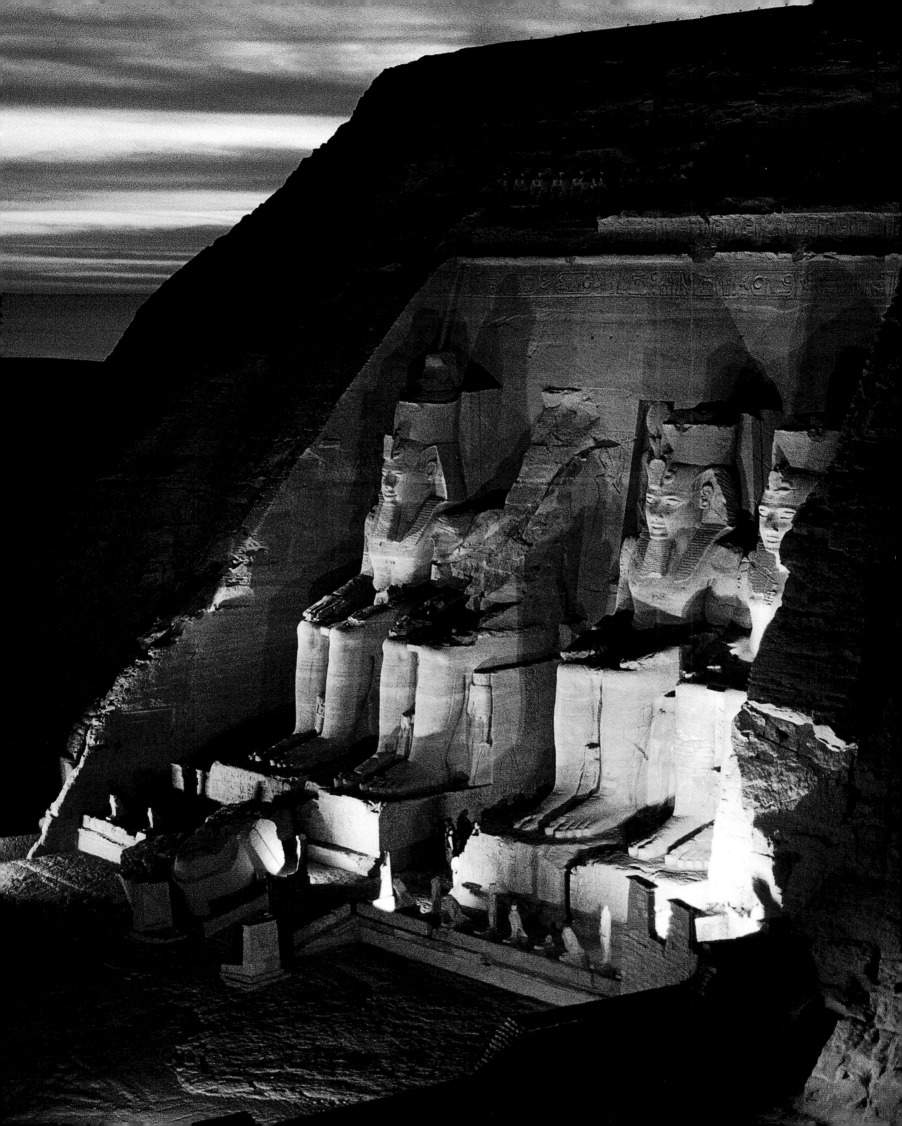

THE ACROPOLIS, ATHENS, GREECE

Right:

The Acropolis is a steep plateau 984 feet (300 meters) long. Originally a defensive citadel and then a temple site, it was devastated by the Persians in 480 BC, after which it was equipped with a statue and temple dedicated to Athena, the city's patron goddess. The site's prestige originated in the commission Pericles gave to Phidias for its redevelopment. Dominating the hill and the city of Athens, a new temple to Athena Parthenos—the Parthenon—was finished in 432 BC and remains the crowning glory of classical Greek architecture and sculpture. To the north, the smaller-scale Erechtheum celebrated a sacred olive tree that the goddess was supposed to have planted there. The Temple of Athena Nike glorified Athena as the bringer of victory. These essential buildings are complemented by the Propylaea, a monumental entranceway. Considered a jewel of Western culture, the Acropolis underwent restoration during the nineteenth and twentieth centuries.

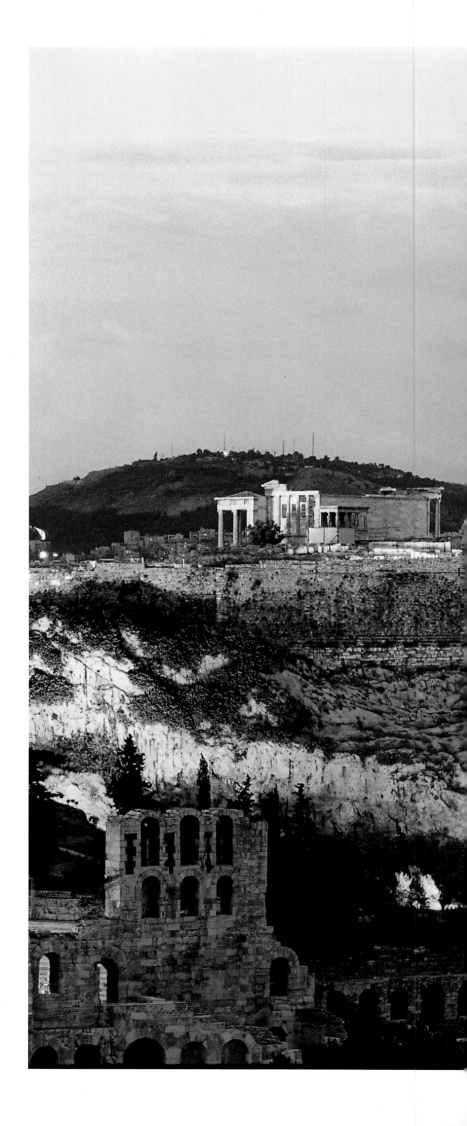

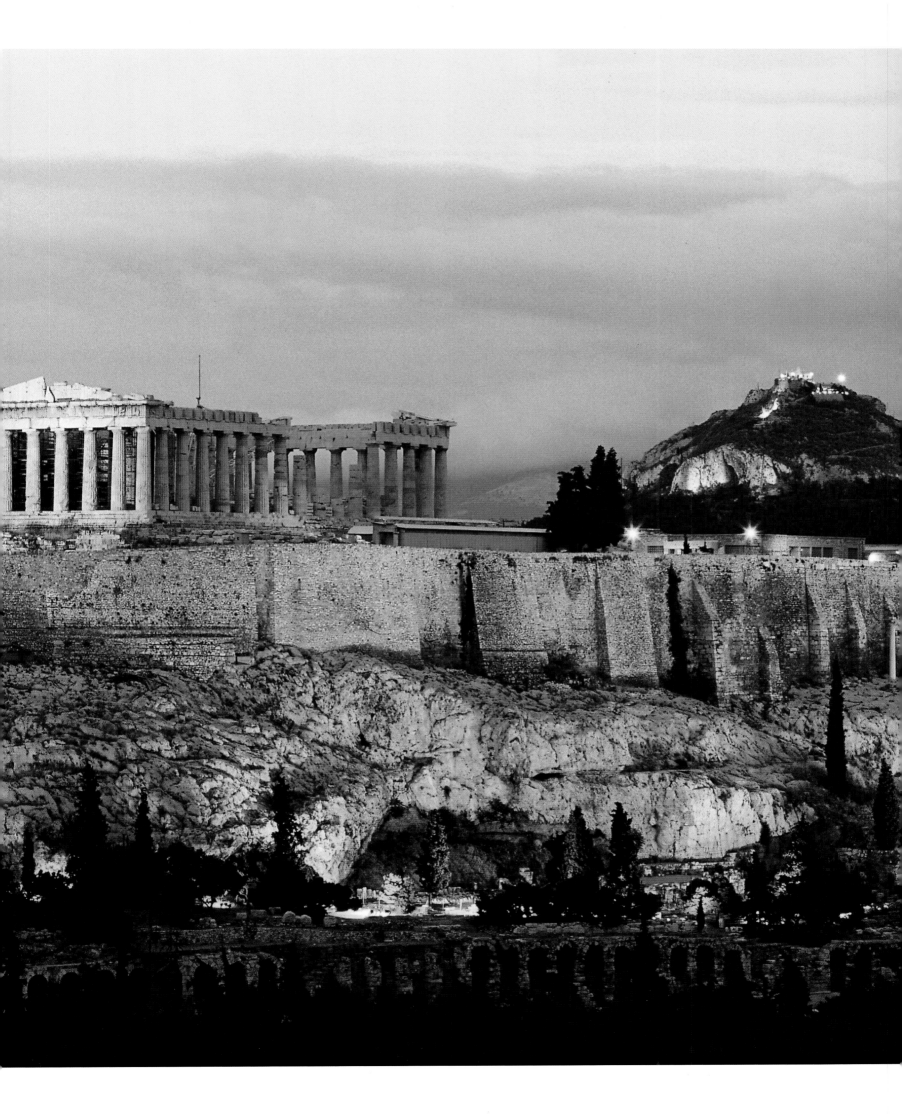

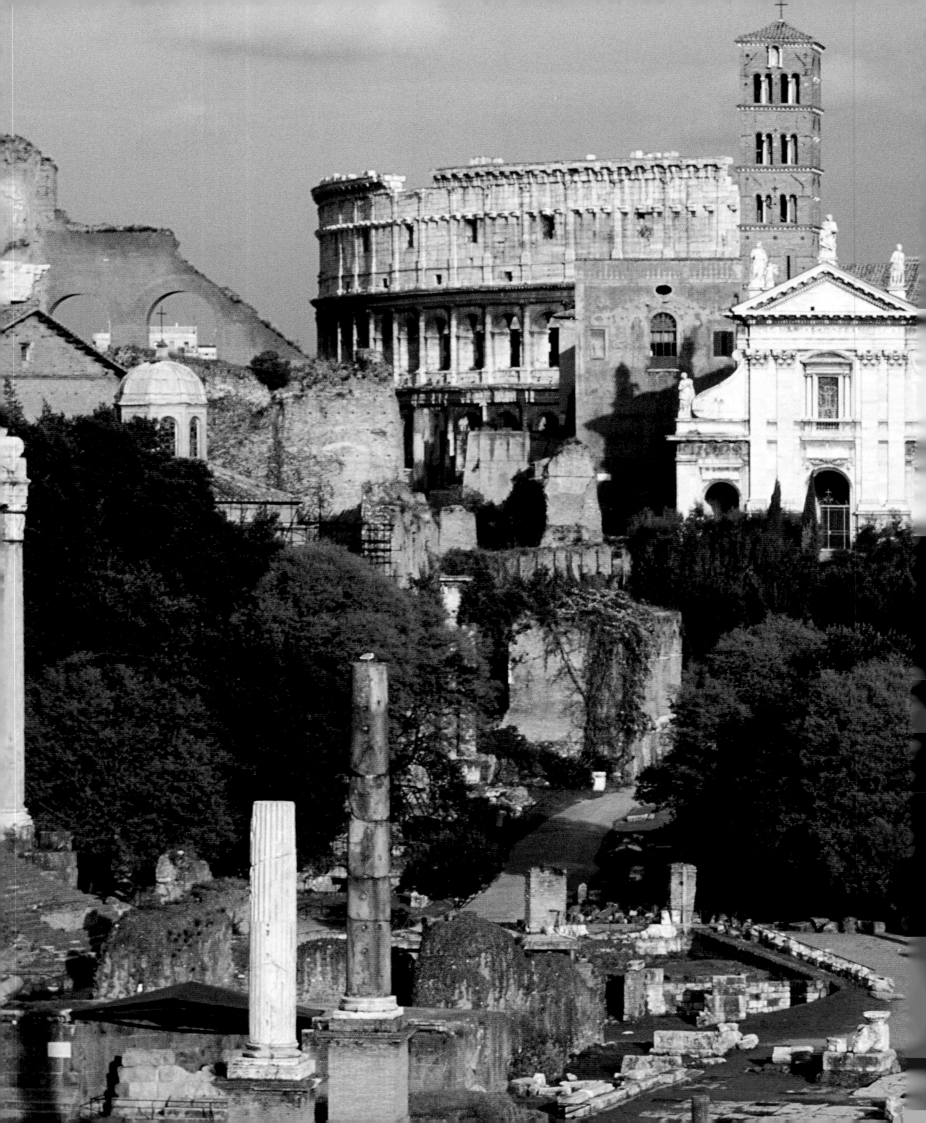

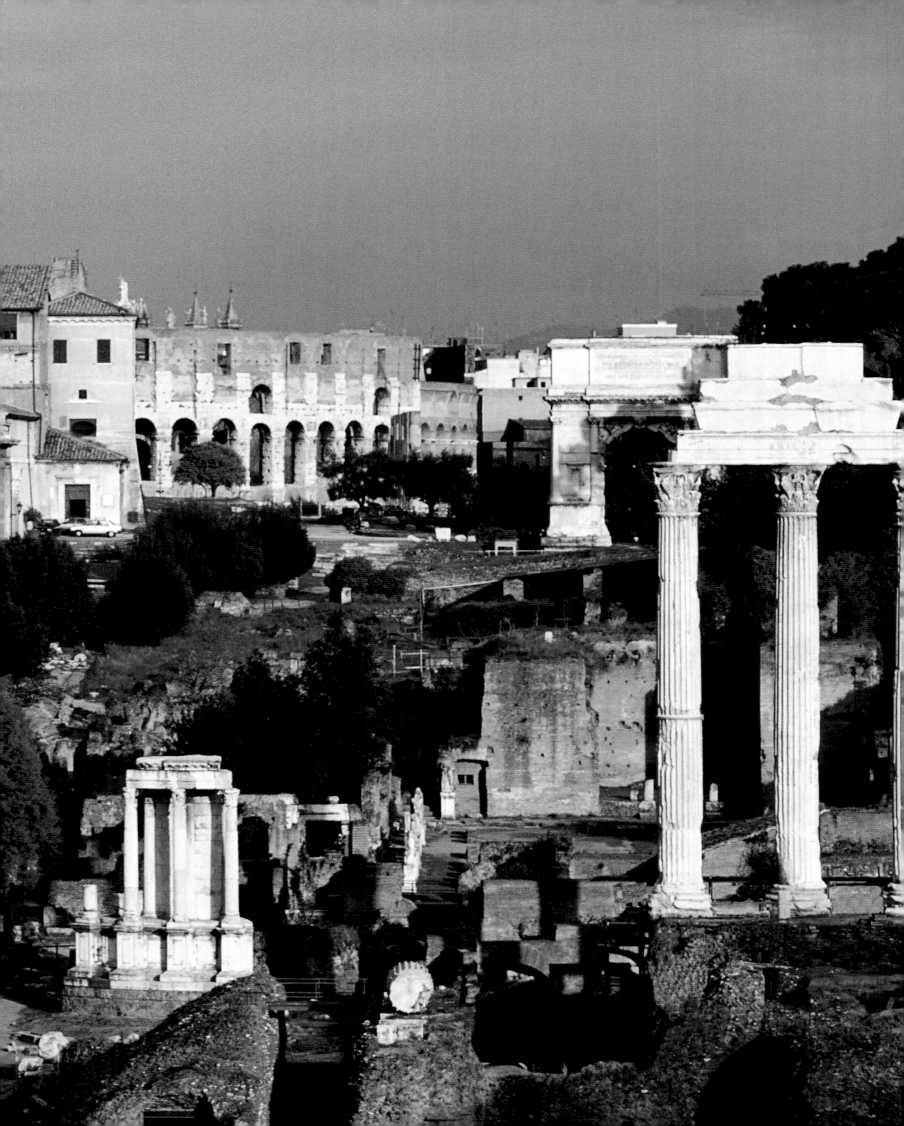

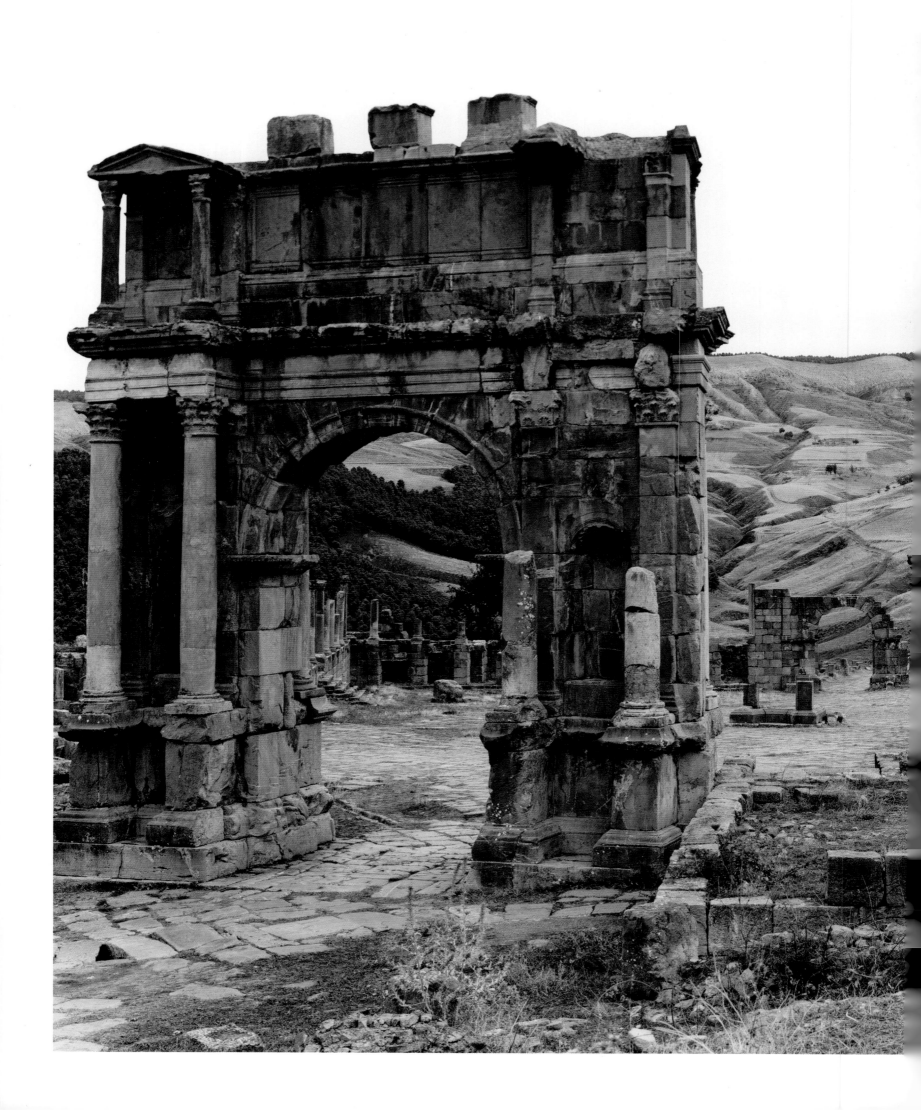

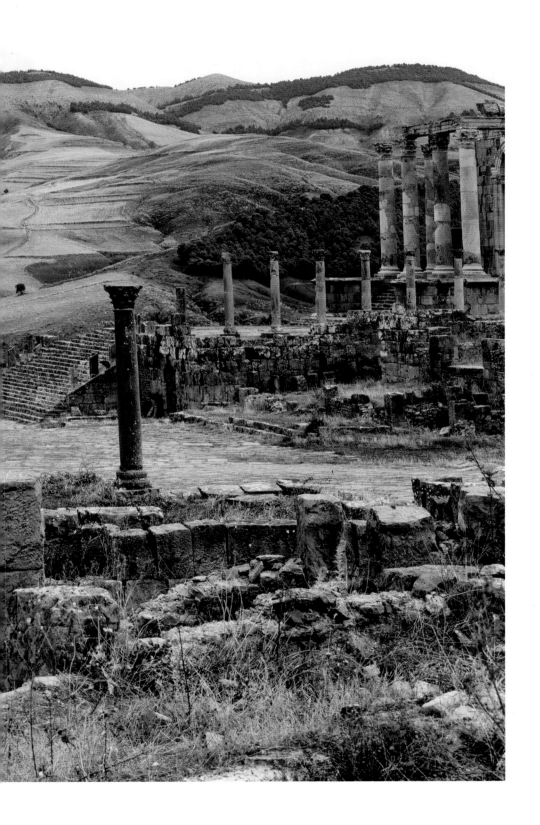

THE FORUM AND COLOSSEUM, ROME, ITALY

Preceding pages:

Like the agora, its Greek forerunner, the Forum at Rome was the focus of its citizens' collective life. The same site of several hectares between the Palatine and Capitoline hills saw a succession of Forums, beginning with the first Forum Romanum in the seventh century BC, followed by those of Caesar, Augustus, Vespasian, Nerva, and Trajan. These developments represented continuous expansion; and each included at least the temple containing the state treasury, places for public speaking such as the Rostra, the senate, basilicas, or meeting halls, commercial areas, prisons, and triumphal arches. Abandoned in the eighth century AD, the Roman Forum was destroyed in the sixteenth, when its stones were raided for the building works of the Renaissance. The Colosseum in the background dates from 70 AD; more than ten thousand gladiators died in its arena.

THE RUINS OF CUICUL, DJEMILA, ALGERIA

Left:

Caught in the crossfire between the Romans and Carthaginians, the Algeria of antiquity was a theater of warfare and unstable alliances, but it has nonetheless managed to preserve substantial traces of its bygone splendor. Now called Djemila—*the beautiful* in Arabic—the former Cuicul sits on a plateau between two gorges, at an altitude of 2,952 feet (900 meters) between the coastal Atlas and Aures mountains. Established in 98 AD, it prospered for several centuries. The Forum is entered by the Arch of Caracalla, built in 216 AD. Behind is the magnificent temple of Septimus Severus, constructed shortly afterward. The houses, some of them sumptuous, the numerous temples, triumphal arches, basilicas, spacious theater, and statues all testify to an important city of probably more than ten thousand inhabitants. In Christian times, Cuicul passed into obscurity, having fallen into Byzantine hands during the fifth century AD.

LEPTIS MAGNA, LIBYA

Right:

Leptis Magna was once described as a rival to Rome. This was mainly due to Emperor Septimus Severus, who was born here and who embellished the city throughout his reign, beginning in 193 AD. Originally established as a port and commercial center by the Phoenicians, Leptis Magna was for a time linked to Carthage, but it subsequently gained its independence. In Roman times, it became the equal of Carthage or Alexandria. By the late third century AD, decline had set in as a result of commercial pressures in the Mediterranean. The city was laid to waste by Vandals and Berbers alike. But its ruined amphitheater, theater, hippodrome, forum, baths, temples, and marketplaces still evoke the majestic Roman metropolis it once was, here in today's Libya, where the Mediterranean Basin meets the essential Africa.

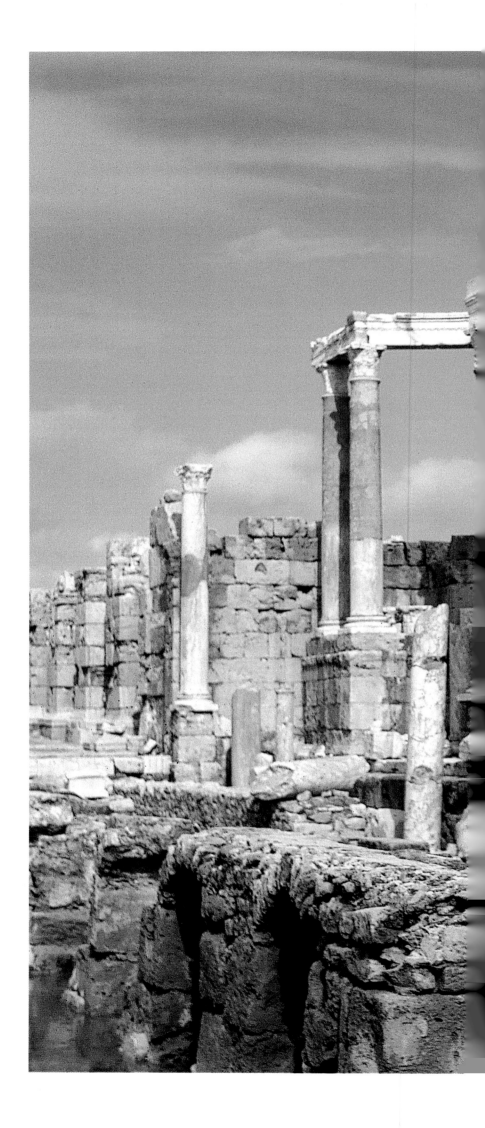

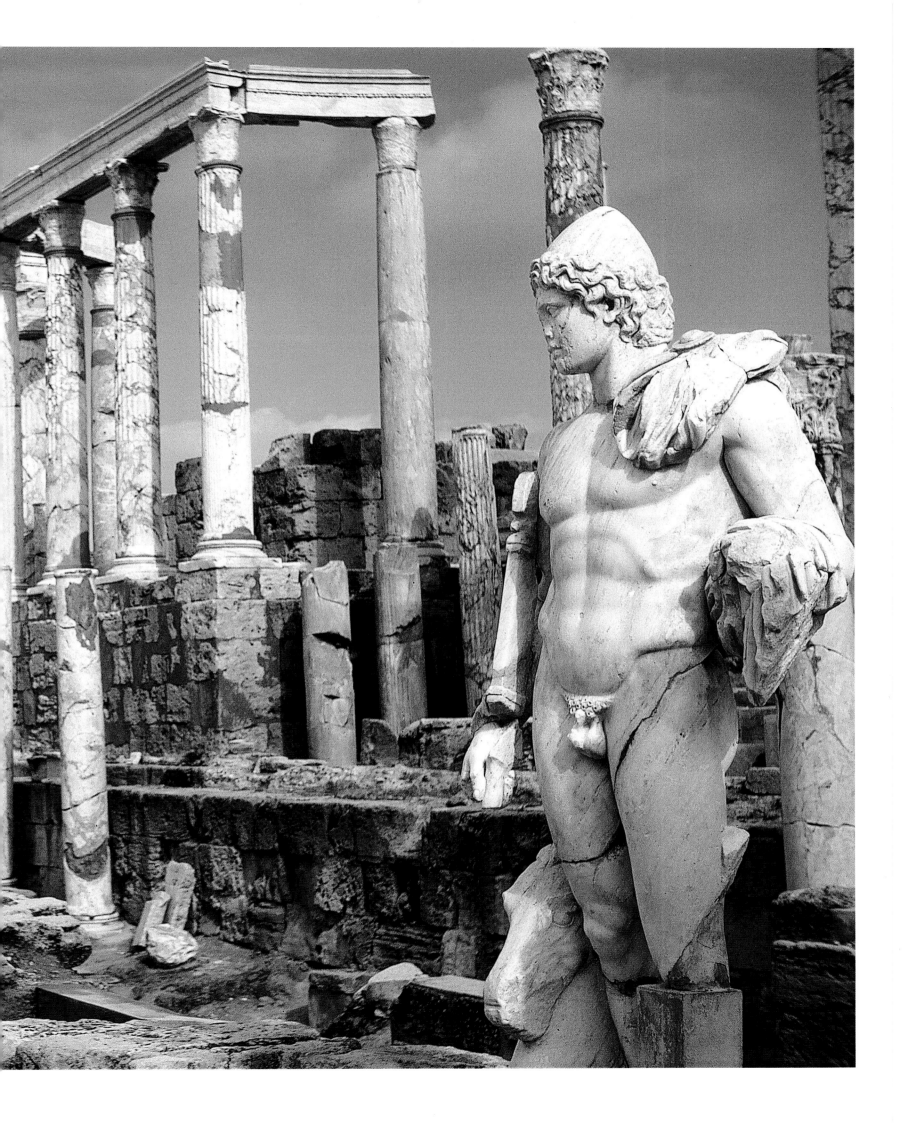

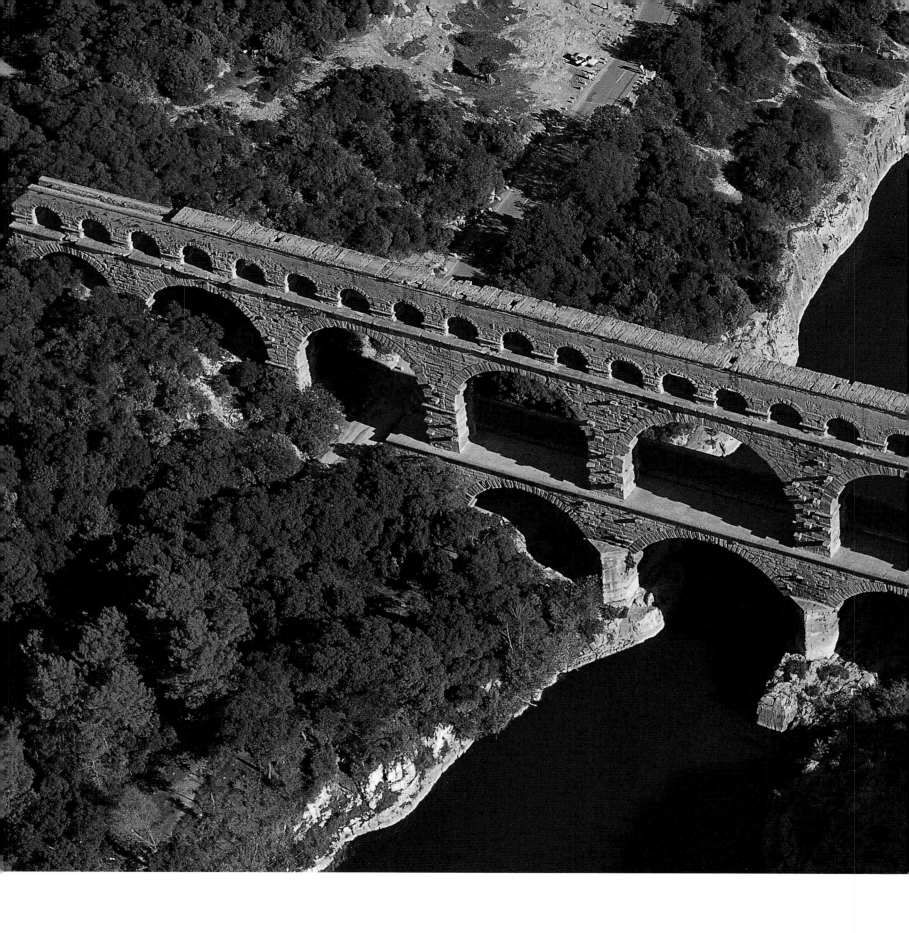

THE PONT DU GARD AND THE ROMAN ARENA AT ARLES, FRANCE

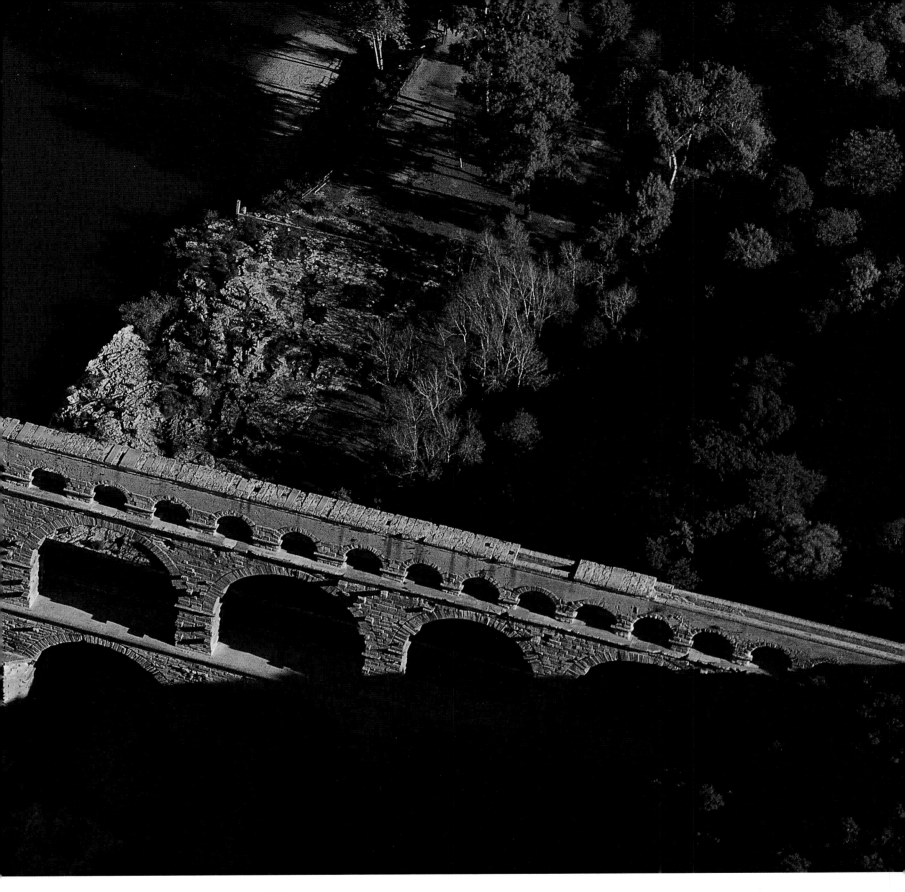

Above and following pages:

Bread and circuses? In addition to these two key ingredients of Roman civilization there is another, namely, water. The Roman capacity to regulate water was exceptional. Across the sunburned, arid landscape of the Gardon Valley in southern France, they threw a stone line of majestic elegance—the Pont du Gard aqueduct. At 902 feet (275 meters) in length and almost 164 feet (50 meters) high at its summit, it carried water to the city of Nîmes, a distance of 12 miles (20 kilometers) as the crow flies. Further away, at Arles, the Romans' remarkable skill as builders is also visible in the Arena. Inspired by the Colosseum in Rome, it could hold a crowd of twenty-five thousand spectators.

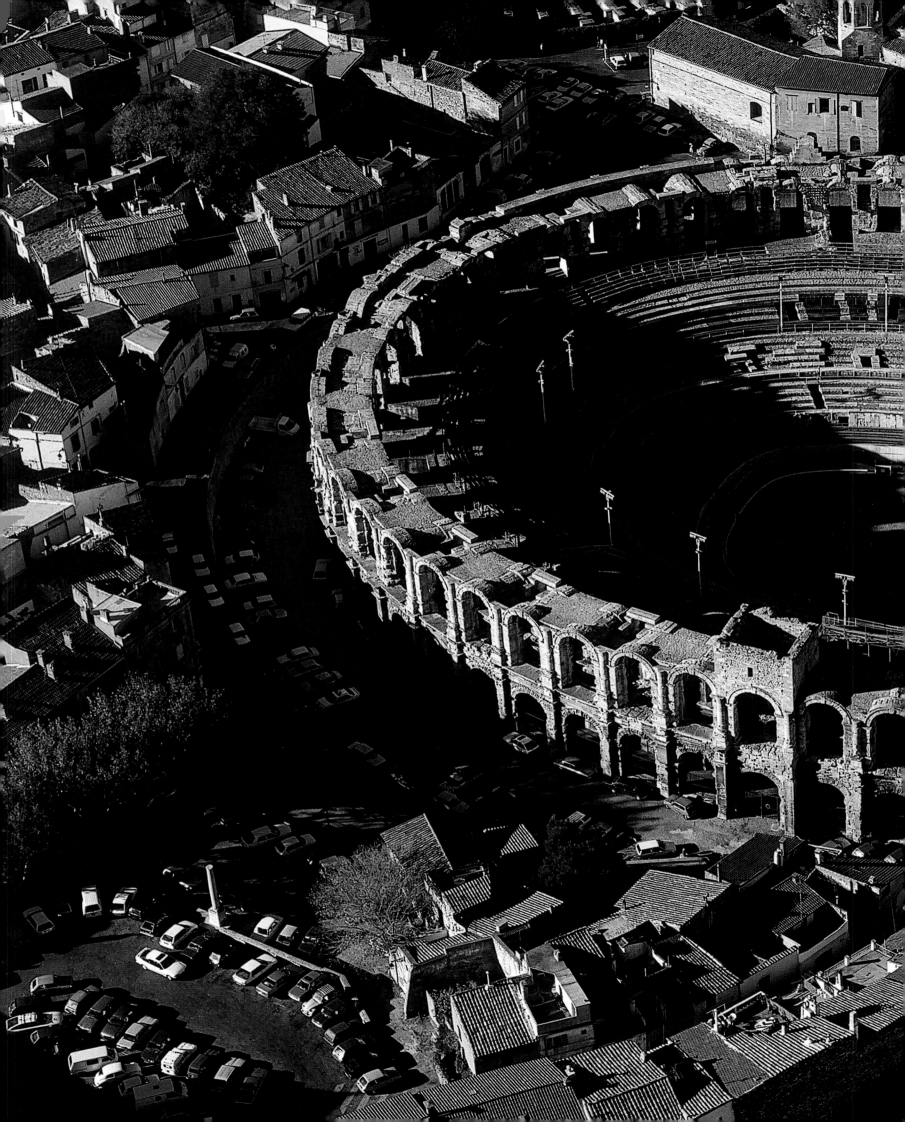

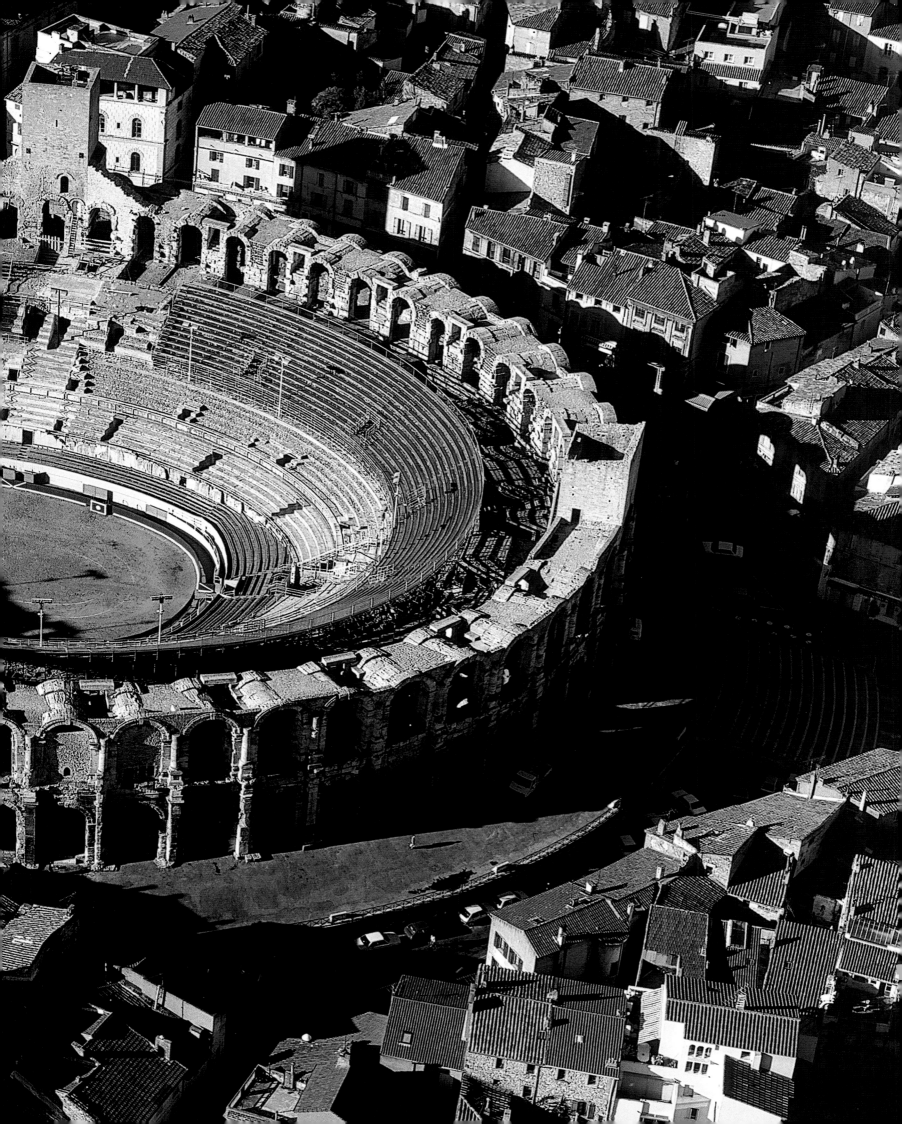

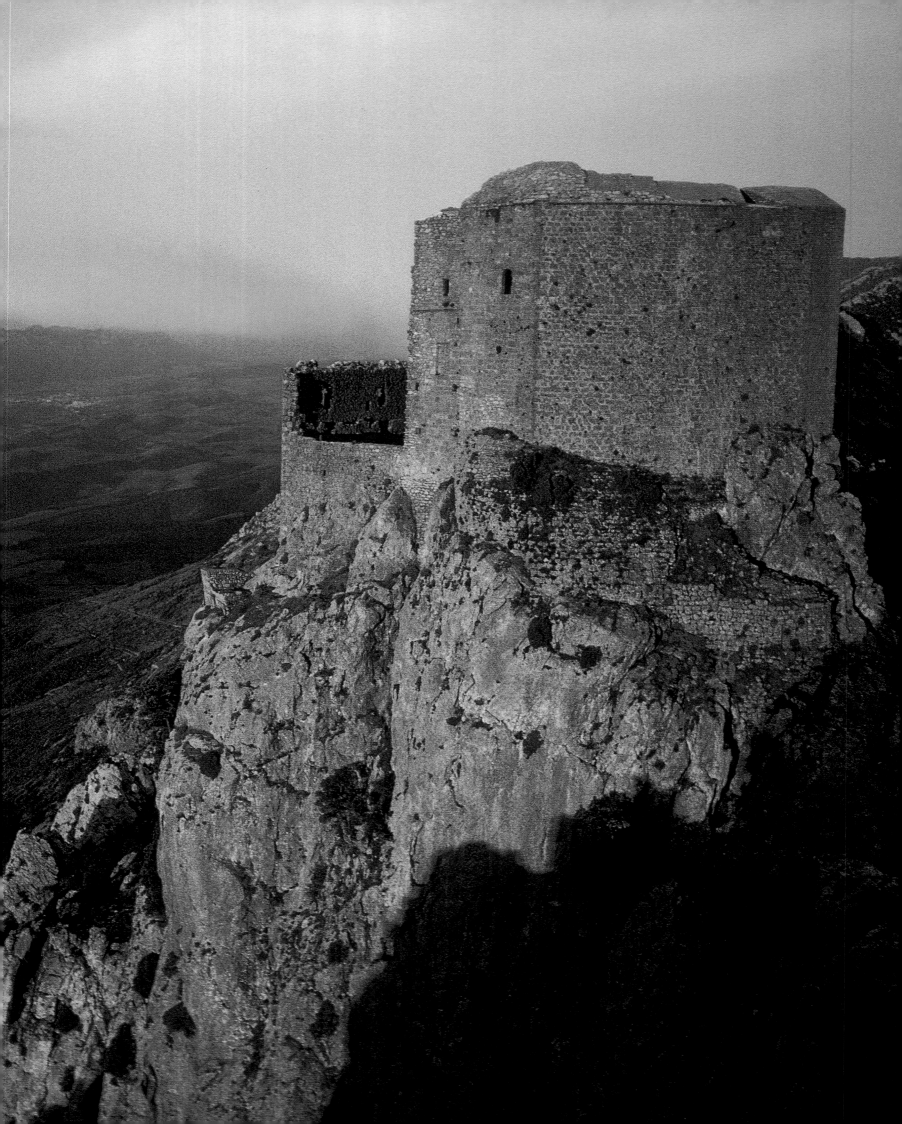

FORTRESSES RISING UP FROM THE EARTH

Epics in praise of war did not bring about the great invasions of the Dark Ages that shook the world and reshaped its heritage. Nonetheless, the hordes of barbarian horsemen who menaced the settled populations of the supposedly civilized world fed the collective medieval imagination with the stuff of legend and epic tales. And these fantasies soon found concrete expression in the building of fortifications, fortresses, and citadels that were both splendid and crude. Some of these structures survive and still seem to bristle with the heroic imagery linked to their stones. A thousand years of instability, from roughly the fourth to the fourteenth century AD, saw the advancing Huns, Crusaders in the Holy Land, and the internal quarrels of the feudal system bring disarray to both the West and the East as far as distant Asia.

The story began on the arid steppes of Mongolia. Why and how the powerful confederations of nomads inhabiting those regions suddenly decided to relocate is not clear. Some experts point to the climate, possibly a drought that decimated their flocks and encouraged them to find means of survival elsewhere. Some went east, and no doubt ran up against the Great Wall of China (pages 30–31), which by this time stretched some 3,968 miles (6,400 kilometers), from today's Korean border to the Gobi Desert. Others—the most numerous or at least the best known—went west; and those inhabiting the lands from the Danube in the south to the Baltic in the north had to endure bands of frenzied riders on spirited thoroughbreds who shot arrows with consummate skill, killing the last few infantrymen descended from the phalanxes of antiquity.

In Europe, neither the *pax romana* nor the monotheistic God who had displaced the Roman deities when the Emperor Constantine was converted to Christianity in 312 AD could halt their progress. Franks, Allemans, Burgundians, Visigoths, and Vandals came out of nowhere and turned the land into their fiefdoms. Legend had it that Paris was saved from devastation in 451 only when Saint Geneviève, thereby earning her halo, managed to deflect the wrath of Attila, the terrifying chief of the Huns. This was only the start. In the East, the Mongols made raids on Russia, Ukraine, and Hungary. In the West, the Scandinavian Vikings, in their dragon-prowed *drakkars*, threatened Charlemagne's empire. They landed in England and Ireland, sailed to Seville in Spain, then traveled up the rivers of what was formerly Gaul. In 864, King Charles the Bald's Edict of Pistres ordered the building of castles to resist them. This marked the birth of feudalism, the system of decentralized defense in which independent lords built up their own fortified castles and fiefdoms, protecting those weaker than themselves in return for an oath of loyalty. Several centuries later, these same feudal families sent their sons overseas as Crusaders to defend Jerusalem against the infidels. And who were these "infidels"? They were Moors, Turks, and Saracens who had converted to Islam and, in their turn, set out to conquer the world. This much belligerence greatly encouraged the development of the art of siege warfare and fortification.

Cathar Castle, Quéribus, France

However different they may seem from outward appearances, castles, fortified townships, ramparts, and "kremlins," as Russian citadels are called, do share common features. Their location tends to be strategic, ideally elevated, with a decent field of vision, and close to a water supply so as to withstand a siege. Even so, the Cathar castles at Quéribus (page 26) and Puylaurens (pages 42–43), perched high in the French Pyrenees, were unable to prevent their devastation and the massacre of their populations during the appalling Crusade against the Albigensian heretics in the early thirteenth century. Other fortresses, on less hilly terrain, defended themselves by means of thick walls, battlements, machicolations (parapets for dropping missiles), heavy doors, portcullises, and drawbridges. At Aigues-Mortes (pages 58–59) in southern France, a whole town and harbor was thus defended on the orders of Louis IX, Saint Louis. It was the port from which he was later to charter the vessels that bore him and his pregnant wife, Marguerite of Provence, to the Latin states in the east, then on the brink of collapse. It was also in the Holy Land that the Crusaders learned how to improve their own defenses by inspecting the fortresses built by the Arabs from Upper Mesopotamia to the Red Sea. The Crusader fortress of Krak des Chevaliers (pages 36–37) in Syria, built by the soldier-monks of the Order of Hospitalers of Saint John of Jerusalem, remains a powerful example of the Crusaders' work. In 1909, Lawrence of Arabia famously described it as "perhaps the most wholly admirable castle in the world."

But the way of life in these strongholds was not always warlike or even austere. The chivalric code of honor was perfected in the castle, and it was the setting in which the most poetic forms of courtly love were expressed. The fortified monastery of Mont-Saint-Michel (pages 48–49) was a place of religious fervor and a destination of medieval pilgrimage. Gothic art, long considered barbaric, found expression in such surroundings. However, little by little the clash of steel gave way to cannon fire. Gunpowder, which arrived in Europe via the Silk Road, spelled the end of medieval styles of fortification that were vulnerable to artillery. In France, around 1497, the fortress at Salses was the first to sink its walls into the earth in order to escape artillery fire. Vauban, Louis XIV's military engineer, brought in low-level construction and ramparts with bastions, as at Neuf-Brisach in Alsace (pages 70–71) on the eastern border, the direction from which invasion was considered likely. Even so, a page in warfare had been turned. Epics in praise of war were over, although, it should be acknowledged, they had provided the world with a glorious architectural heritage.

Belém Tower, Lisbon, Portugal

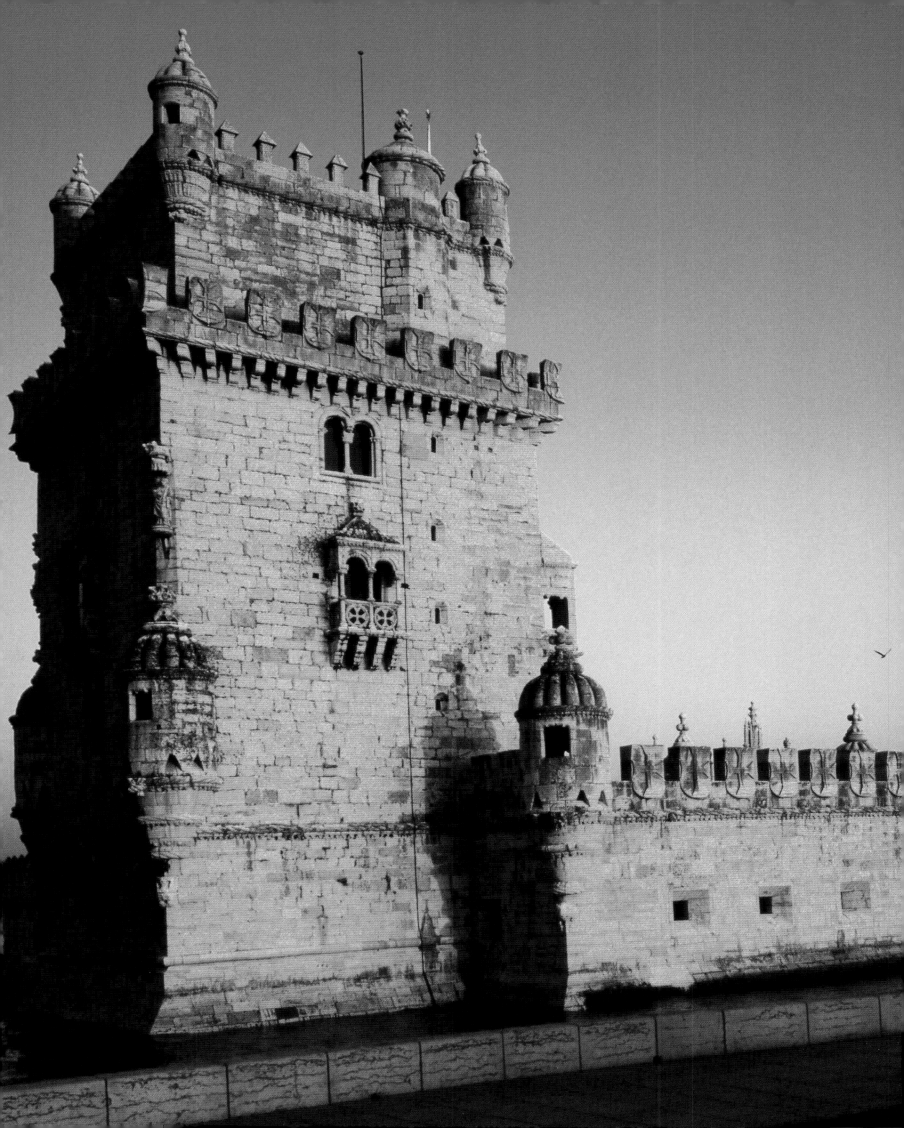

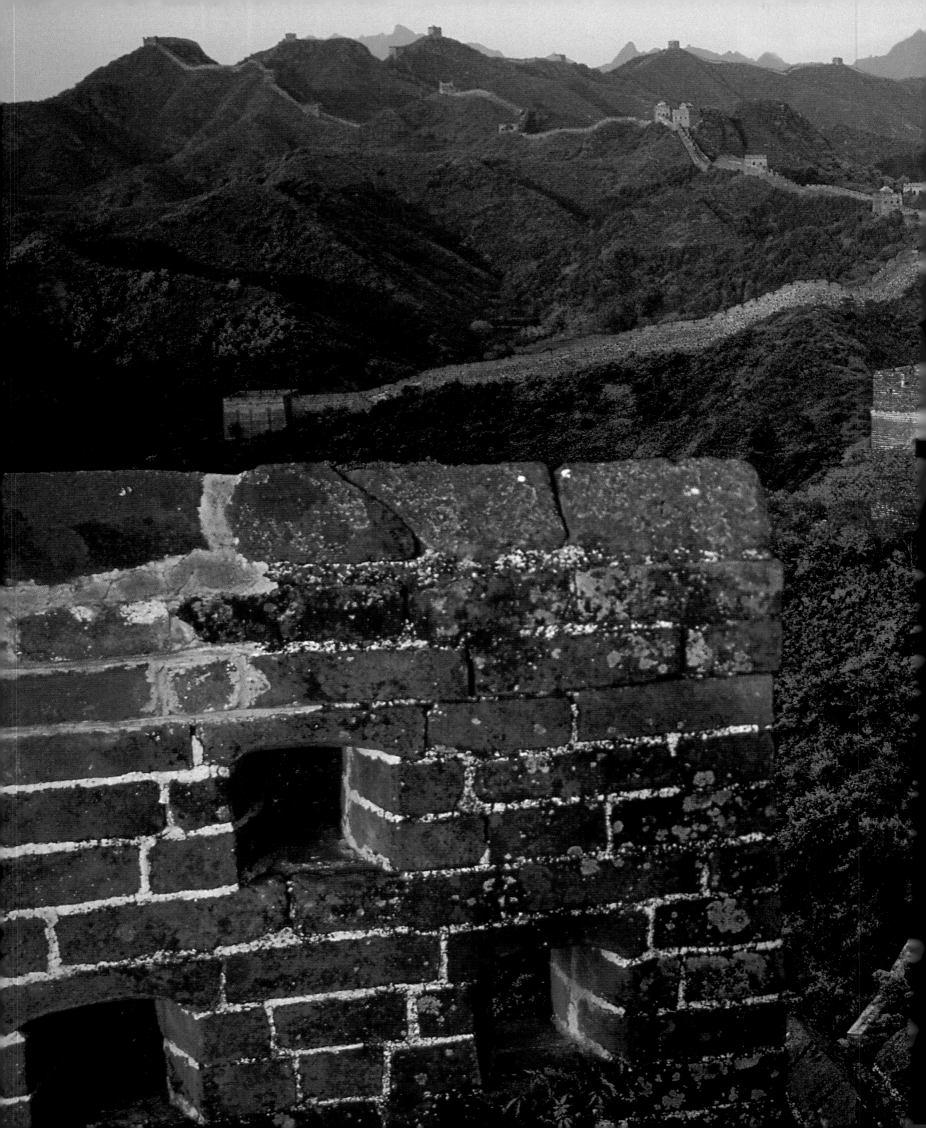

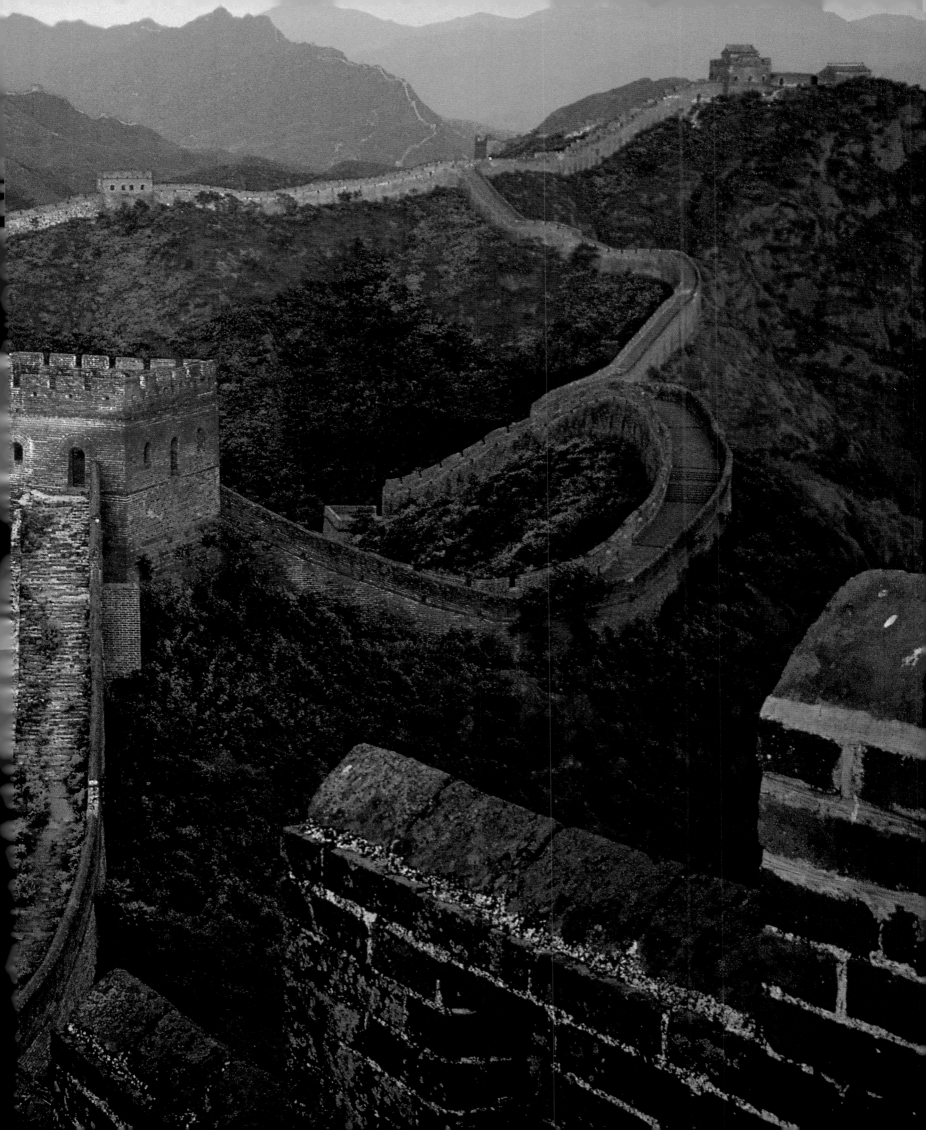

THE GREAT WALL OF CHINA

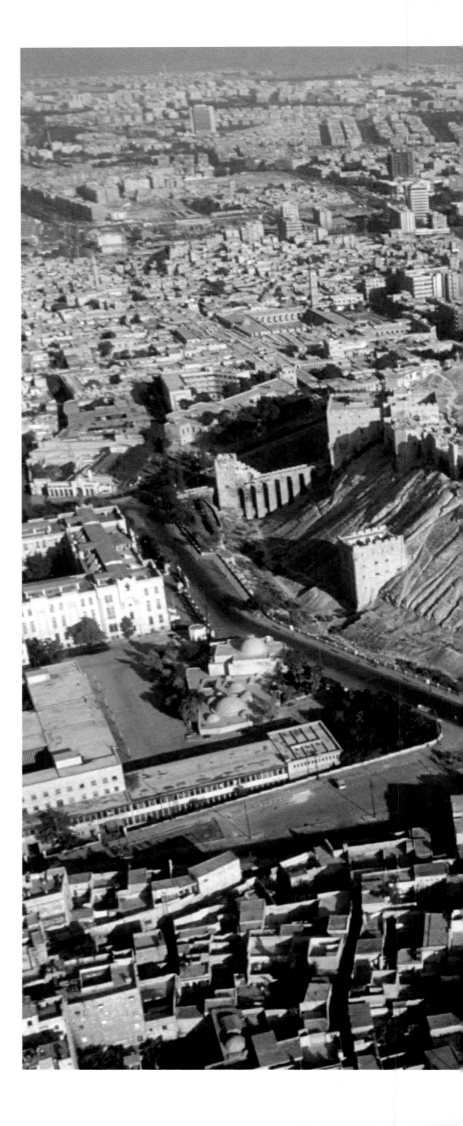

Preceding pages:

This section of the Wall is just one part of the gigantic construction put together over the centuries to defend the empire against possible invaders from the Central Asian steppes. Portions were constructed between 770 and 220 BC, and these were then linked by Emperor Qin Shi Huang to form one continuous rampart 3,100 miles (5,000 kilometers) long. The Wall continued to be extended. By the third century AD it had doubled in length. During the fourteenth and fifteenth centuries it was reinforced, the original earthwork replaced in some sections with masonry up to 20 feet (6 meters) thick and 26 feet (8 meters) high. At that time the Ming Dynasty feared the Mongol threat and equipped the Wall with a crenellated parapet walk punctuated by towers and strongholds. The titanic structure, however, had more to fear from earthquakes, sandstorms, and vandalism than from invaders. Today, only 30 percent of the original Wall survives.

ALEPPO CITADEL, SYRIA

Right:

Aleppo is said to be the oldest city in the world; it is known to have existed in the early Babylonian period around 2000 BC. The Crusaders battled to make it a Frankish city; and one could easily imagine how costly the battle was in light of the ferocious citadel that overlooks the old city crouching below. It was built as a defensive site in the tenth century AD and was also a royal palace. The citadel took on its definitive shape in 1230, and was partly destroyed by the Mongols. In Aleppo the Crusaders discovered soap, a product developed in the souk, at some unknown time, by blending olive oil, the oil of the bay-tree fruit, Salicornia ash (a natural soda), and water. Aleppo soap had already been known for many centuries, since the city was a stopover for caravans and a center of trade. Its vast marketplaces, or souks, were rebuilt during the sixteenth and seventeenth centuries, and are among the most important in the Middle East.

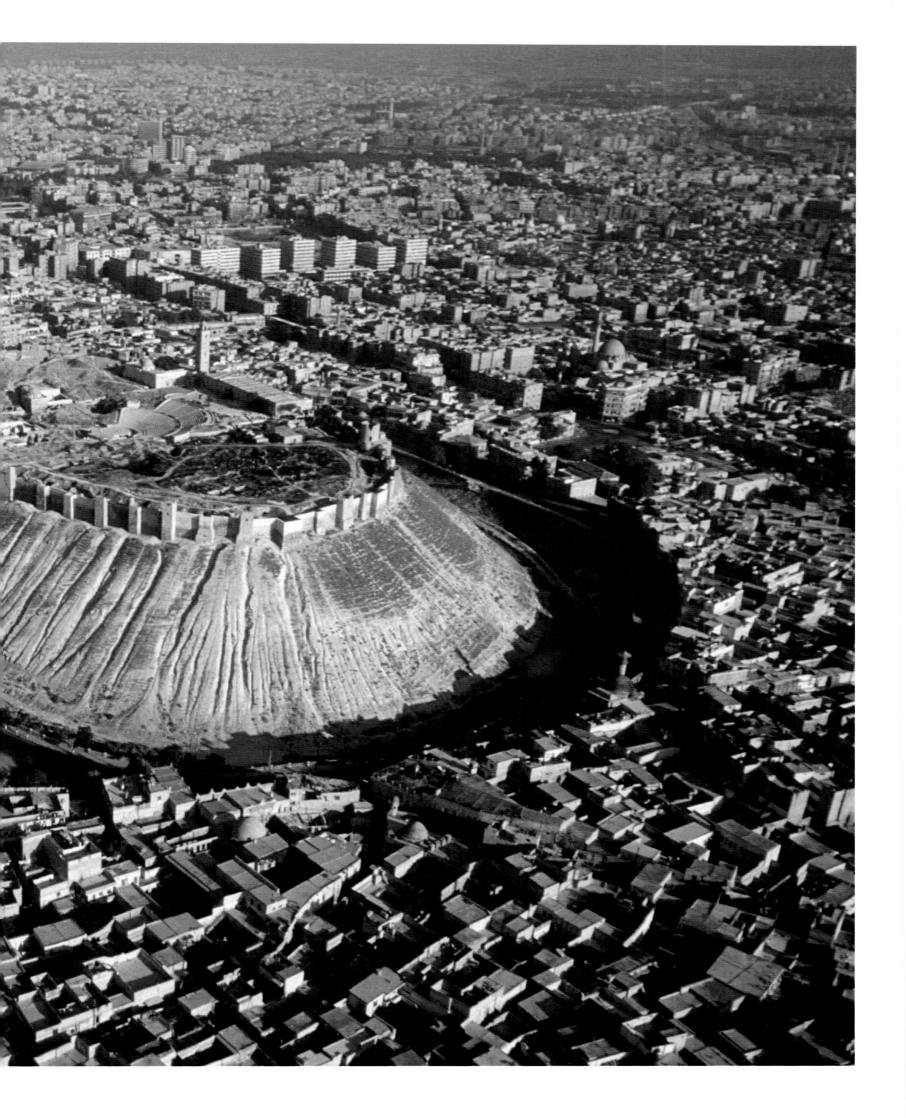

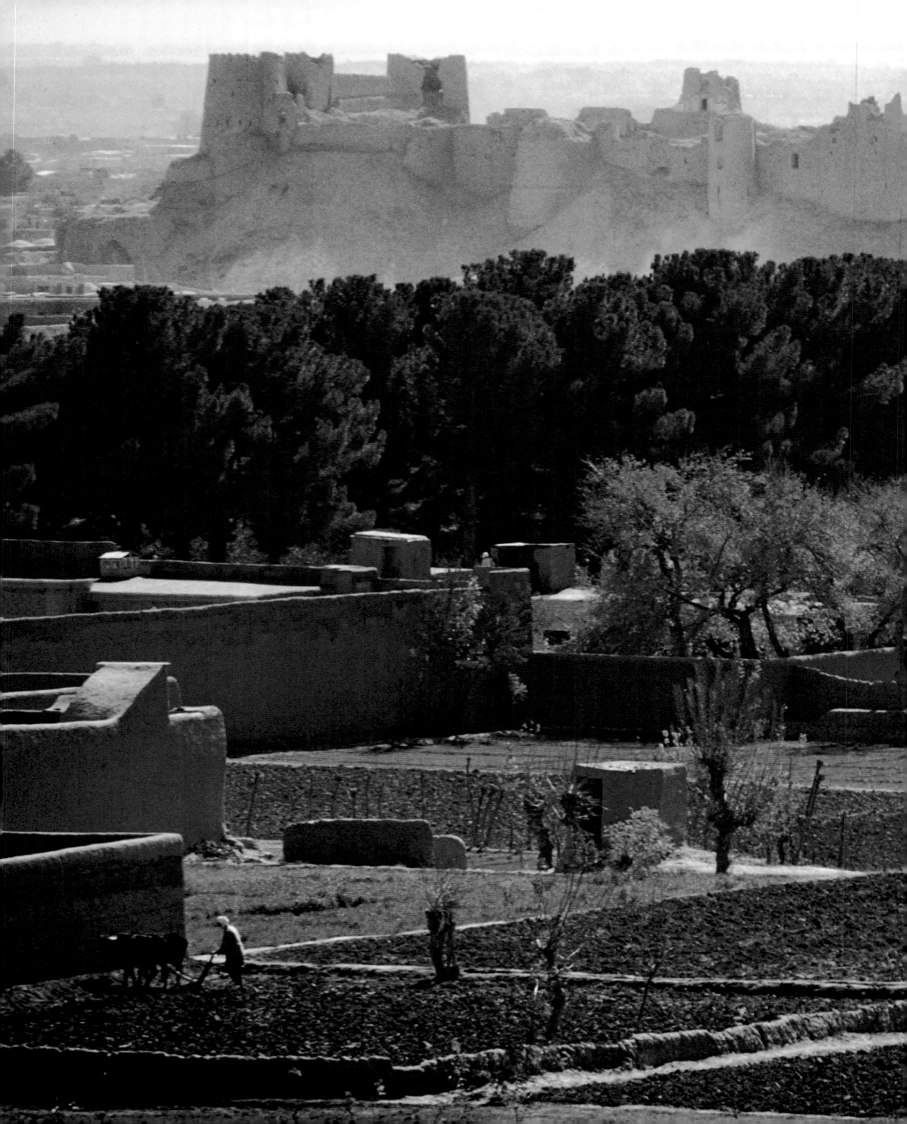

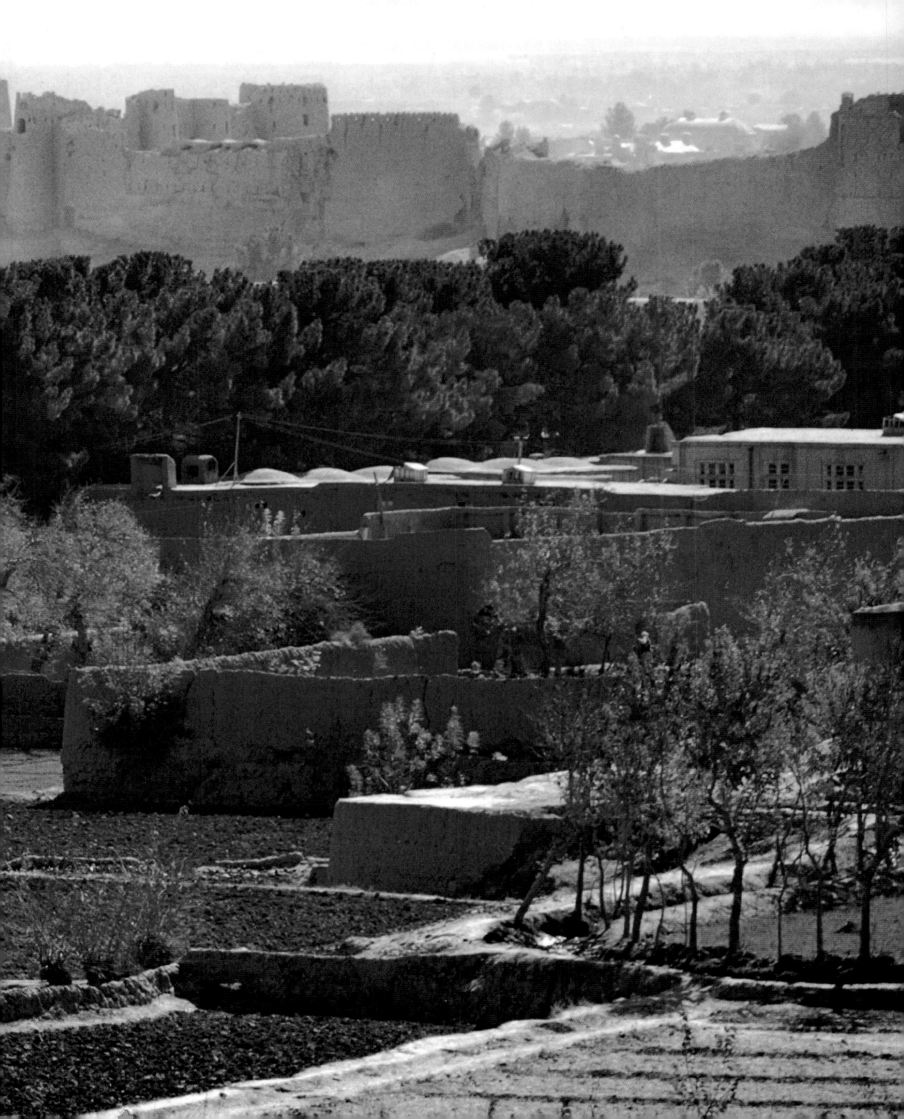

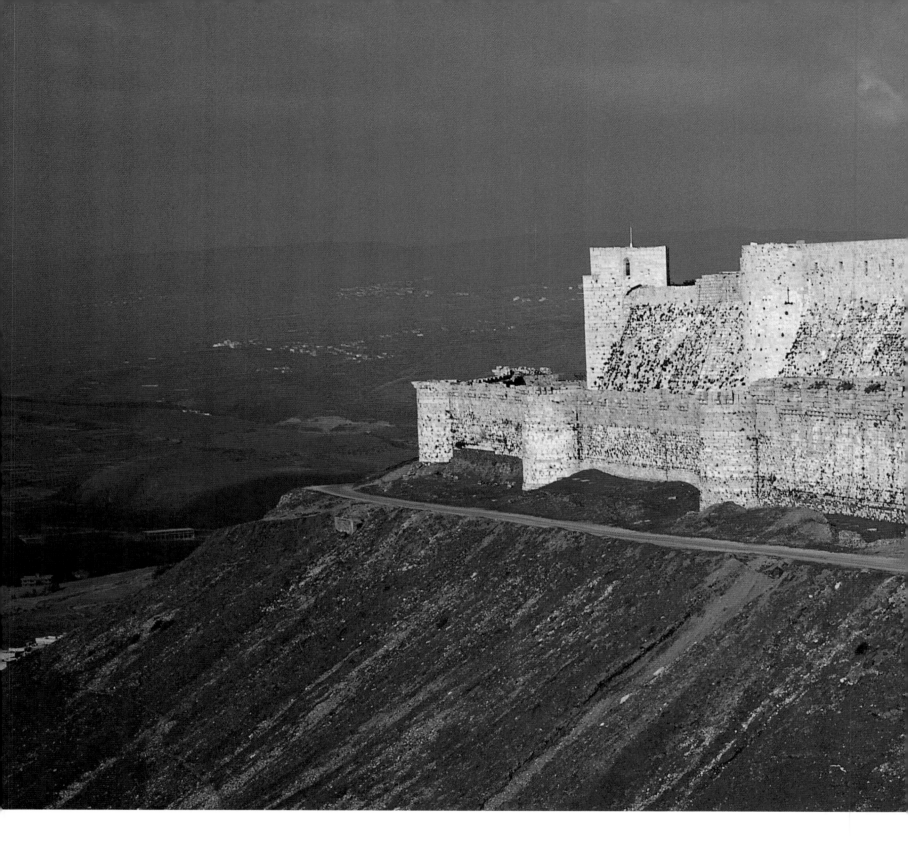

HERAT, AFGHANISTAN

Preceding pages:

An ancient city probably Assyrian in origin, Herat was already an important commercial center in the pre-Islamic period. Conquered by Cyrus and Darius, it was captured by Alexander the Great, rebuilt, and renamed Alexandria of Aria. The city was much later taken by Genghis Khan and Tamerlane, which says much about its wealth. In the heart of the gray-blue mountains of Afghanistan, Herat was an essential way station on the Silk Road; here western gold was handed over in exchange for the Orient's precious textiles, spices, and perfumes. During the fifteenth century, the city's role as a center of culture and art earned it the appellation "Florence of the East." At this time Herat governed the Timurid Empire, which extended from the Tigris River to the Chinese frontier.

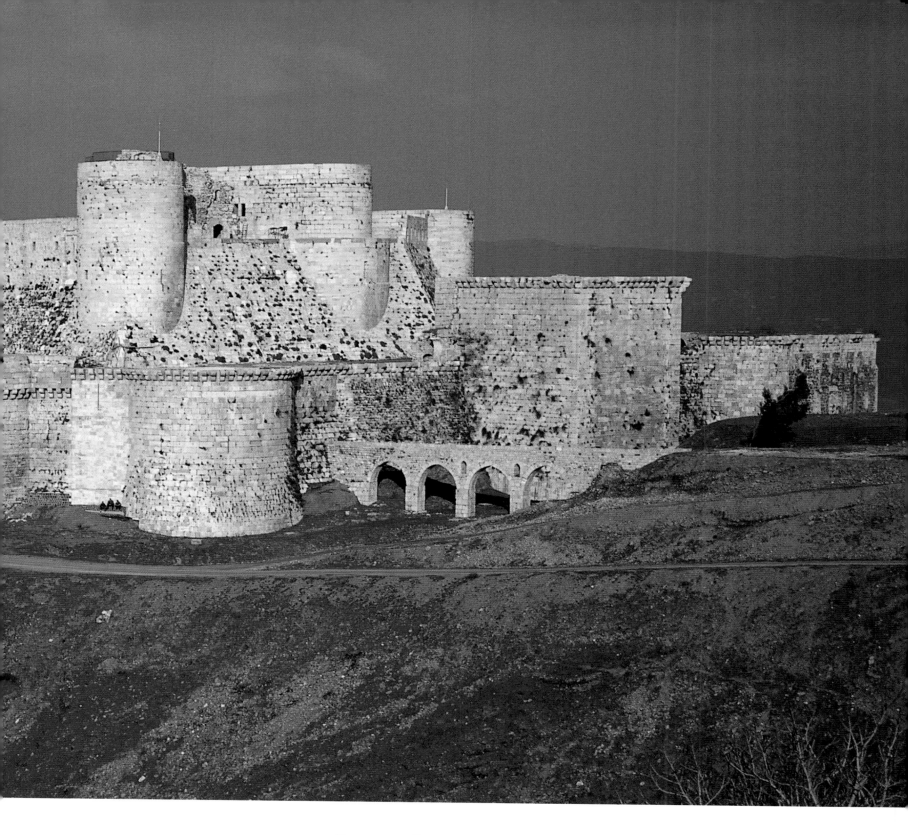

KRAK DES CHEVALIERS, SYRIA

Above:

Apearing to rise up from the rock on which it sits, this medieval fortress is still an imposing presence. Its power reflects the struggles of the Crusades: proud, arrogant, and ultimately in vain. The site had probably been fortified since antiquity. In the eleventh century, the fortress was rebuilt by the Abbasids. Raymond IV of Toulouse took it during the First Crusade, followed by Tancred, the regent of Antioch. Krak—Syrian for fortress—thereafter was an important base on the outlying frontier of the Frankish realms in Palestine. In 1142, it was entrusted to the military and religious Order of Knights Hospitalers of Saint John of Jerusalem (later the Order of Malta). Rebuilt after two earthquakes in 1170, the castle was the last word in military architecture. It was lost to a Mameluke sultan in 1271 only through subterfuge.

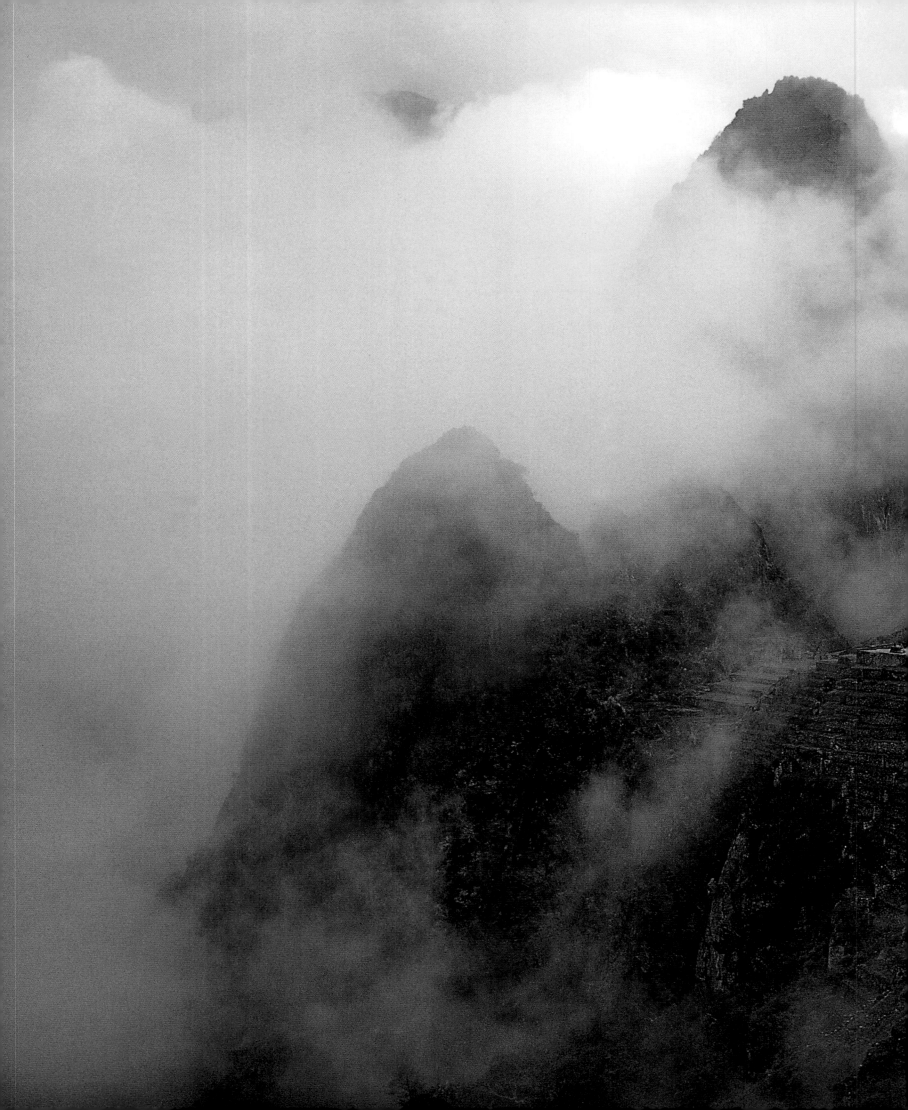

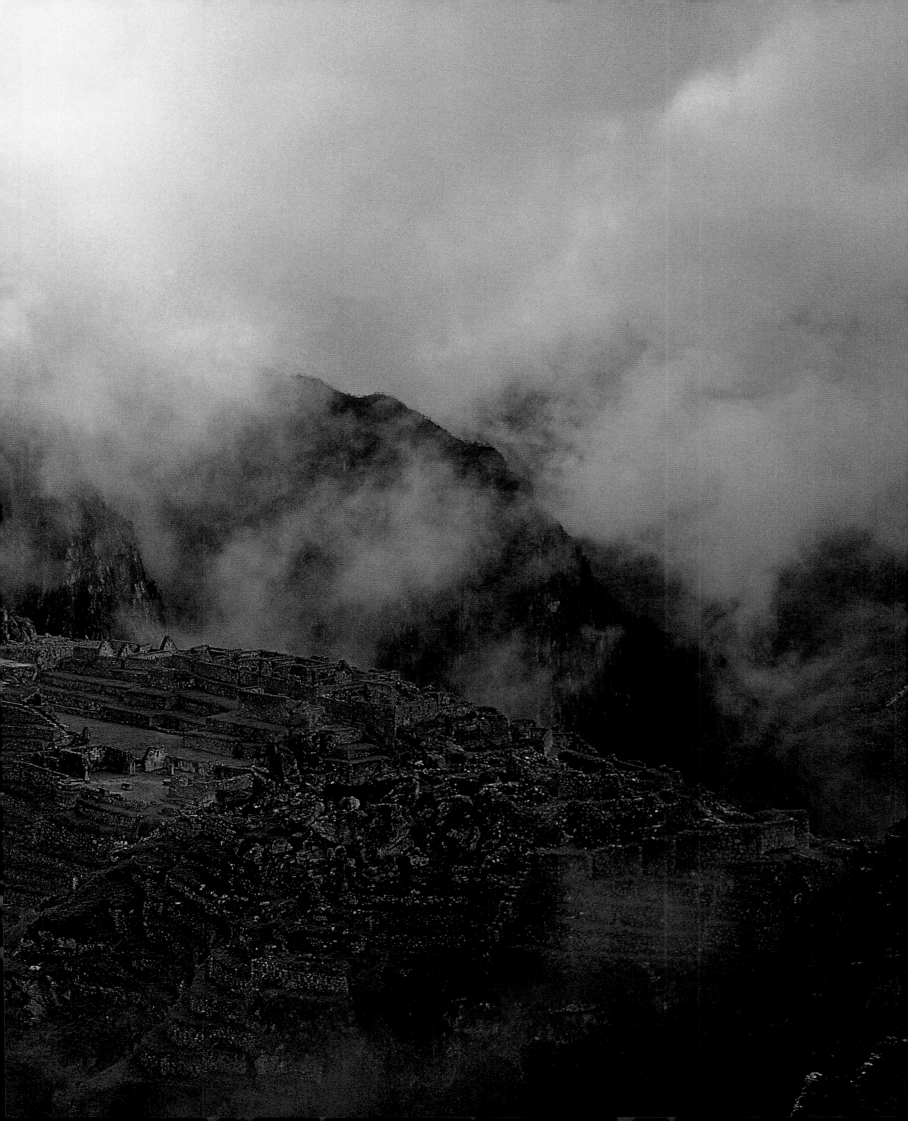

MACHU PICCHU, PERU

Preceding pages:

High in the Andean cordillera, at an altitude of 7,872 feet (2,400 meters), the sacred military city of the Incas, Machu Picchu, is perfectly defended by its mountainous surroundings. Its construction, around 1440, is attributed to Pachacutec. Perched on a sheer ridge in the midst of a tropical forest where wild orchids bloom, the city appears to have been deserted even before the Spanish invaders arrived about ninety years later; it was therefore inhabited for barely a century. More of a huge fortress and palace than a township, the site was rediscovered in 1911. Archaeological research shows it to have included a sacred area dedicated to the sun god, living quarters, and areas for priests and nobility. All the buildings are of high-quality dry-stone granite. The most remarkable are a solar clock and a temple to the Sun, the major god in the Inca pantheon.

THE CASBAH AT TAMDAGHT, MOROCCO

Right:

In the far south of Morocco, not far from Ouarzazate, earthen citadels raise their towers to the sky as a sign of human presence. These are *ksours*, or fortified villages, and casbahs, or fortresses. Constructed of soil, ageless and ancestral, yet fragile and in need of constant upkeep, these splendid buildings have in recent times aroused real enthusiasm and are now slowly being restored. Their beautiful forms match perfectly the ocher and green of the valleys and oases in which they are set. Tamdaght Casbah, a fortified palace surrounded by almond trees and figs, was one of many residences belonging to Glaoui (1878–1956), the pasha of Marrakech appointed by Hubert Lyautey to head the administration of all of southern Morocco.

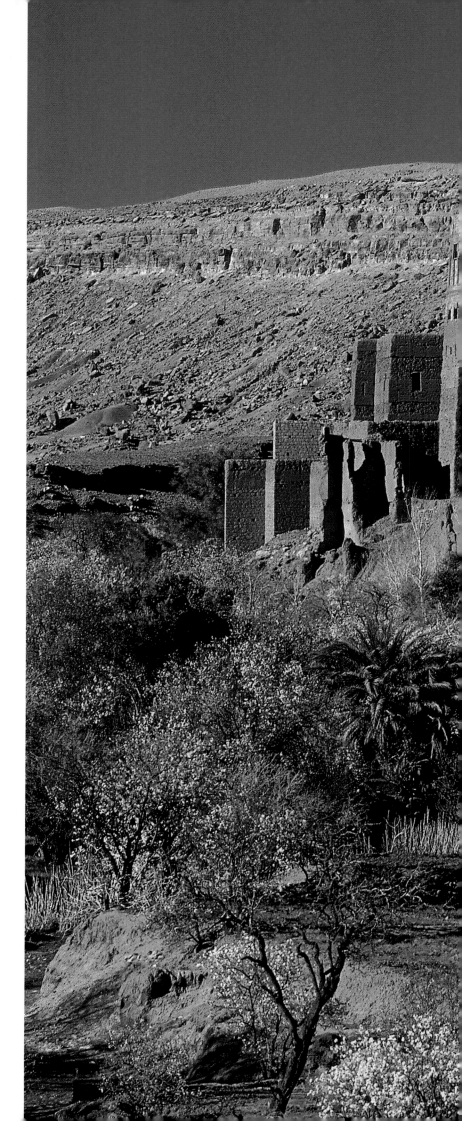

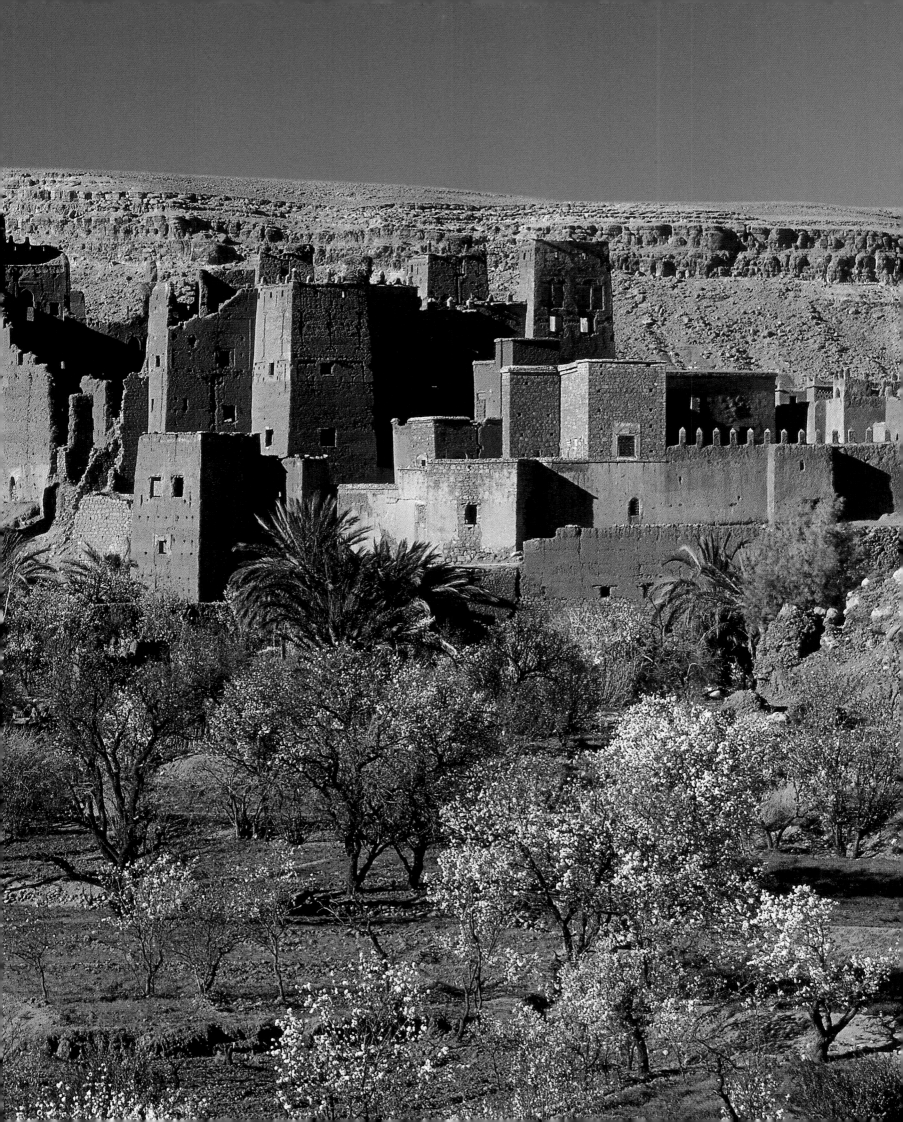

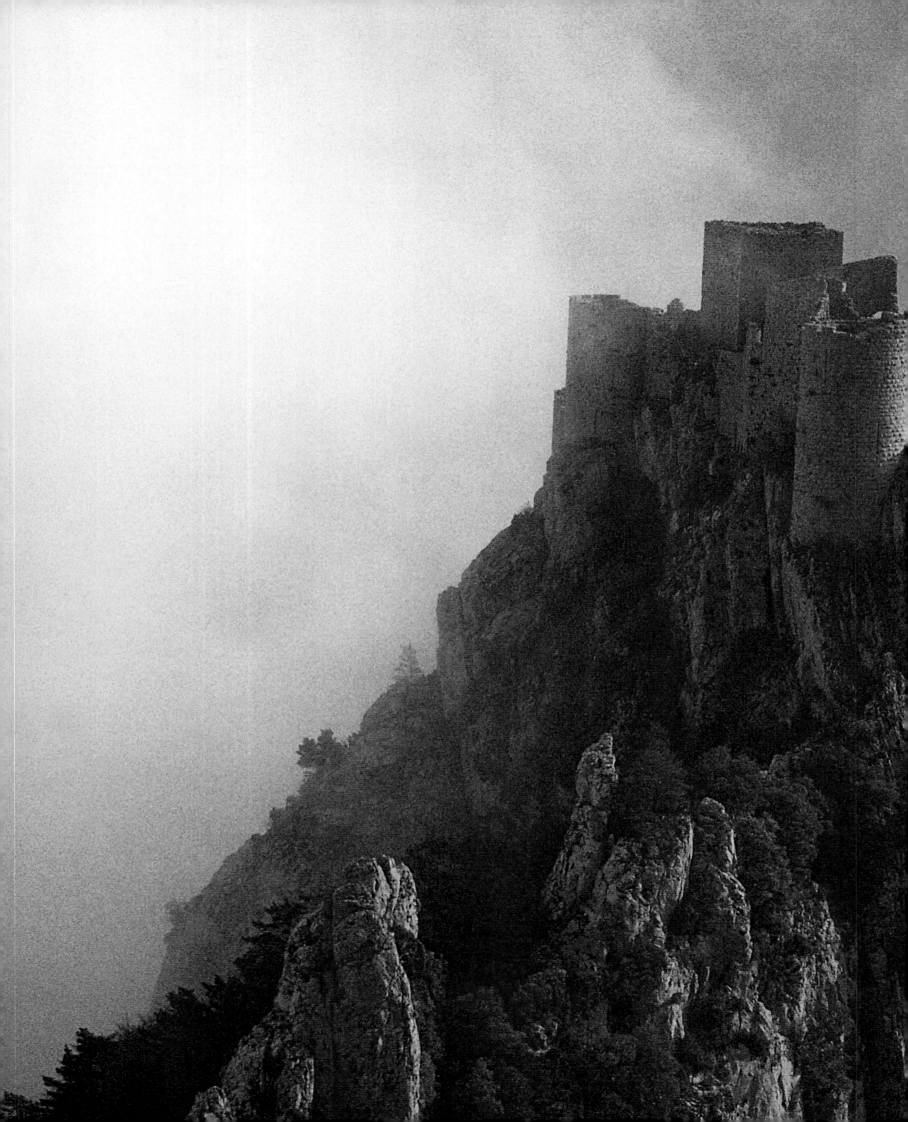

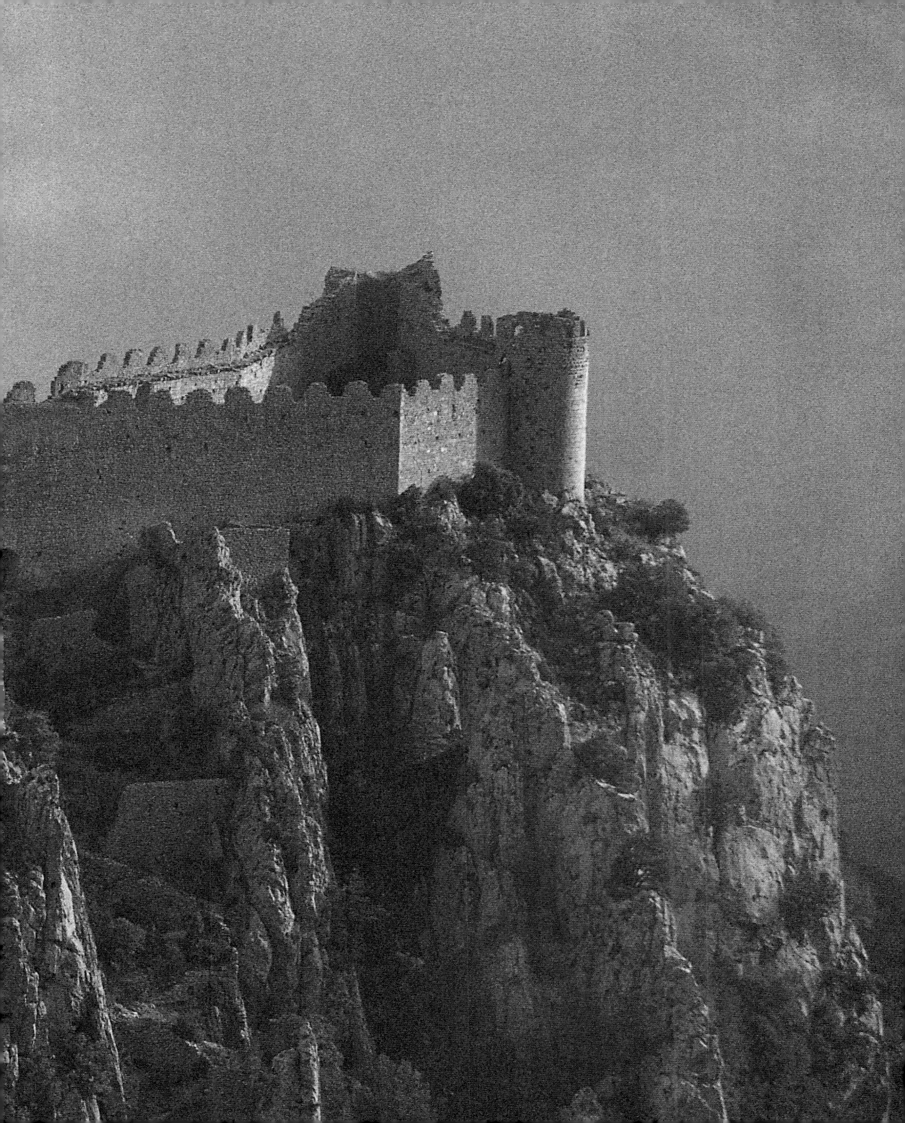

PUYLAURENS CASTLE, FRANCE

Preceding pages:

It took a lot of nerve to place a fortress on a rocky spur 2,286 feet (697 meters) high, in front of the glorious backdrop provided by the Pyrenees. The Cathars needed the protection it offered when they were persecuted during the tragic and bloody Albigensian Crusade of the thirteenth century. They found refuge here, and Simon de Montfort never managed to storm their stronghold. Constantly strengthened from the eleventh to the thirteenth century, the fortress became French in 1250. Taken by royal troops and refortified by Saint Louis, it became a point of frontier defense between Languedoc and Catalonia. It is worth visiting today in spite of the hard climb. Its towers, stores, and apartments are still impressive, and the panoramic view at the top well justifies the effort.

HOLY TRINITY MONASTERY, METEORA, GREECE

Right:

In the heart of Greece, tenth-century monks sought isolation at the foot of gigantic rocky pillars. During the fourteenth century, their successors took refuge on the summit to defend themselves against the Turks. With incredible daring, they braved enormous physical difficulties to rebuild their monasteries on the narrow rocky platforms above, some of which are 984 feet (300 meters) high. These are the *Meteora monasteria,* "monasteries suspended in the sky." In reality, the Meteora are not the meteors—rocks falling from the sky—that the ancients believed, but rather enormous blocks of sandstone formed by erosion and seismic movements hundreds of thousands of years ago. Out of perhaps sixty of them, twenty-four supported monasteries in the fifteenth century. Five are still occupied, including Holy Trinity Monastery (Hagia Triáda), founded in 1476. Access is via a corridor carved into the rock.

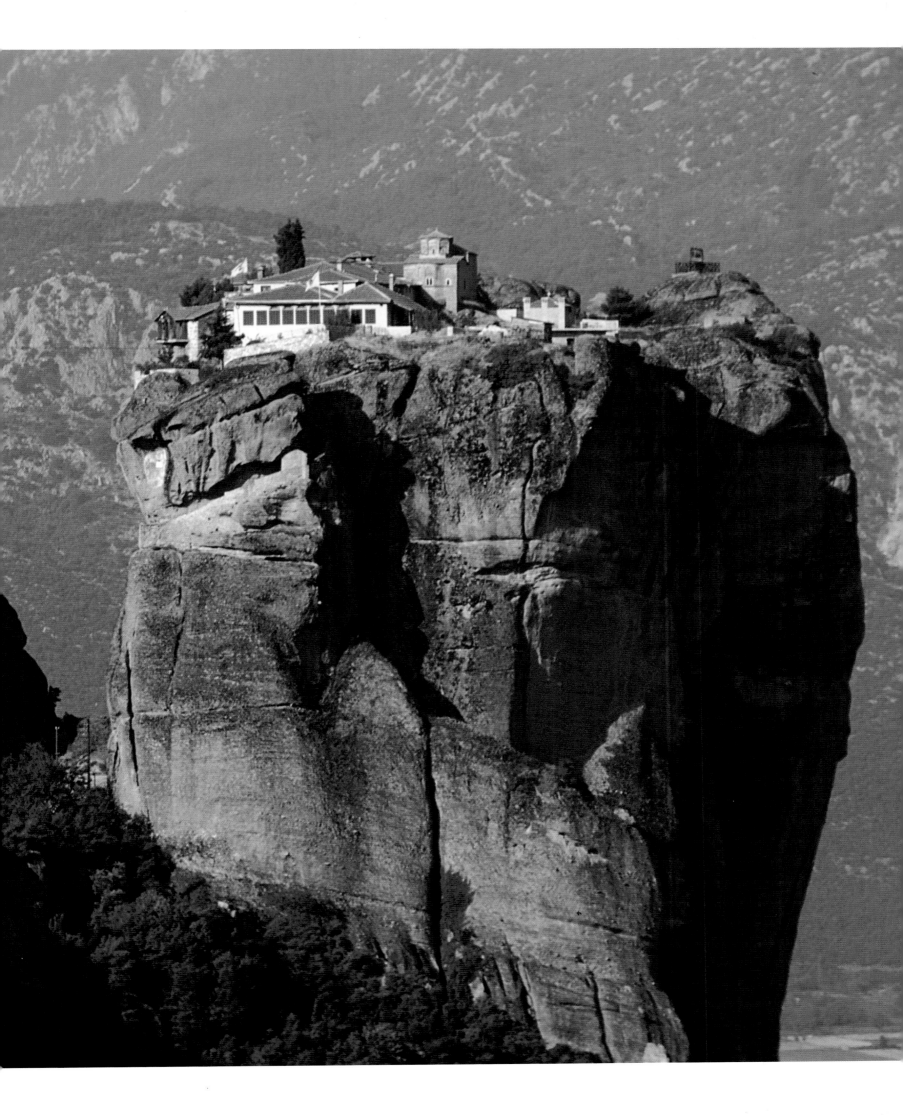

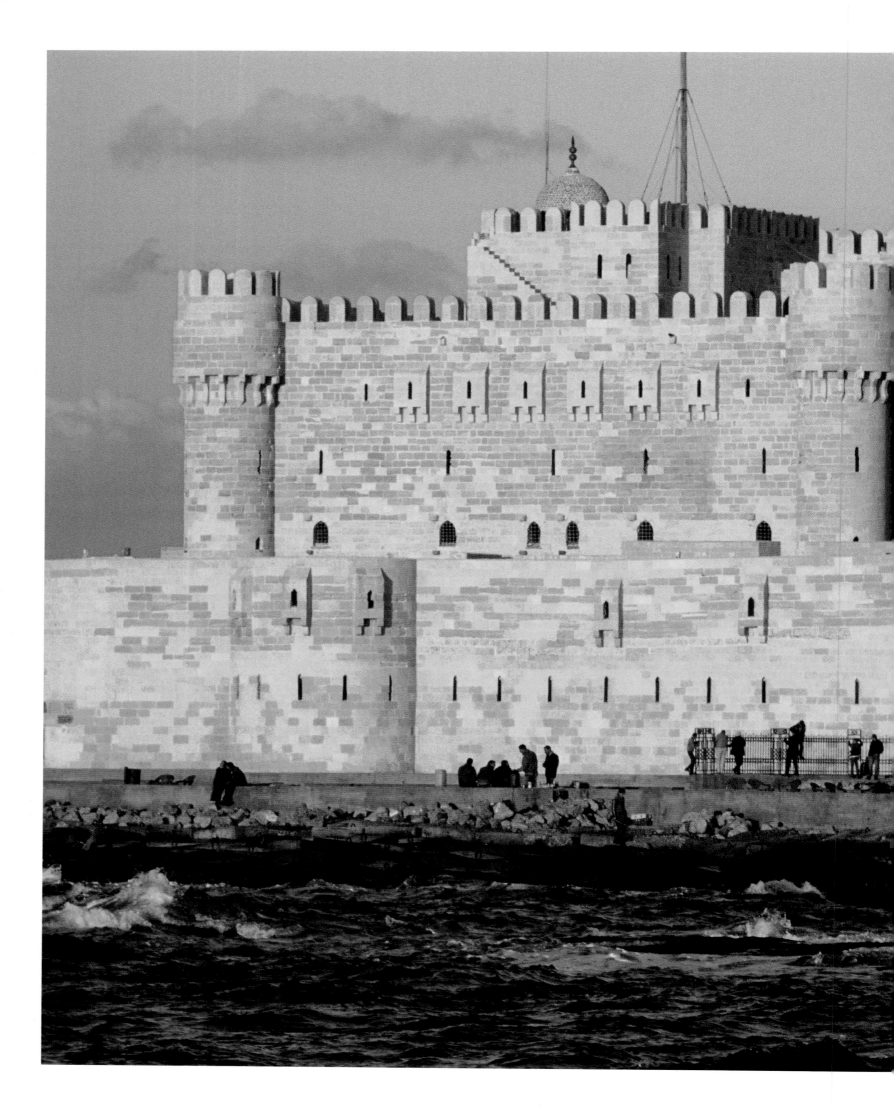

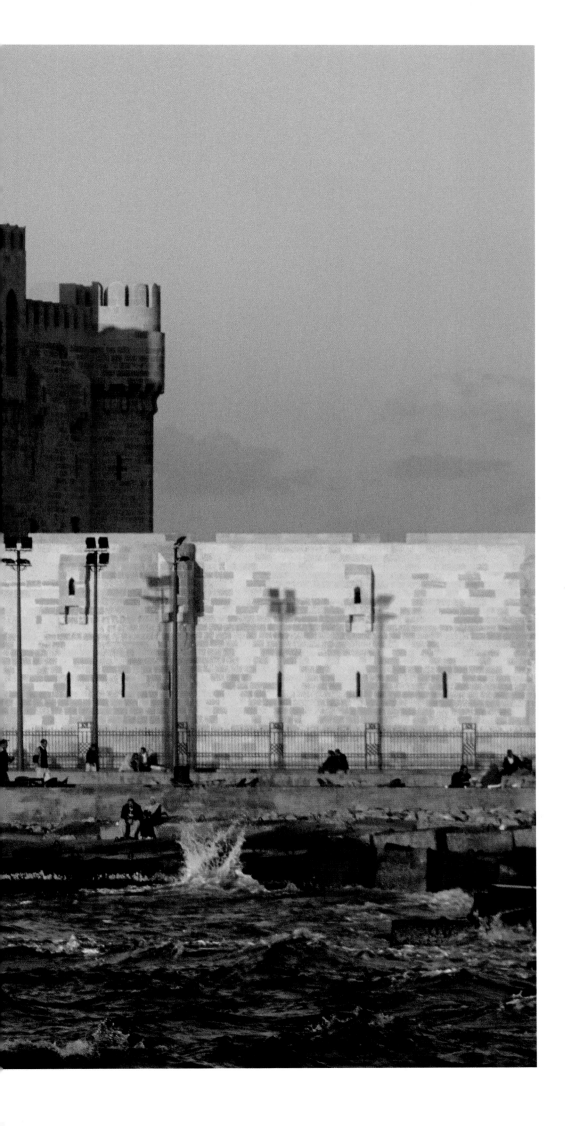

FORT QAITBEY, ALEXANDRIA, EGYPT

Left:

This city founded by Alexander the Great in Egypt continues to be the stuff of dreams. The crenellated walls and watchtowers shown here at the water's edge speak of a military past. But they represent far more. Qaitbey is not simply a fifteenth-century Mameluke fort, restored in the nineteenth century, with imposing military architecture and superbly laid stones—many of them reused from antiquity—radiant amid the blues of sea and sky. It probably occupies the very site of the monument that gave its name to the island on which the fort is built— *Pharos*, the lighthouse that was a key constituent of the cosmopolitan city of antiquity inhabited by an estimated one million people.

MONT-SAINT-MICHEL, FRANCE

Following pages:

Stormy souls, not just stormy winds and waves, have for centuries been calmed in this fortress monastery— since 966 in fact, when Aubert had the foolhardy idea to build an oratory on a rock in the middle of a bay with dangerous currents. Although the bay has gradually silted up, deep water is due to return once the gigantic project is completed that will enable the sea once again to send spray against the rock's medieval buildings. Completed in the thirteenth century, the edifice has the appearance of a stack of chapels, with a tall spire, and monastic buildings adjoining a cloister justly called "the Marvel"—227 fine colonnades that create a lacework between sea and sky.

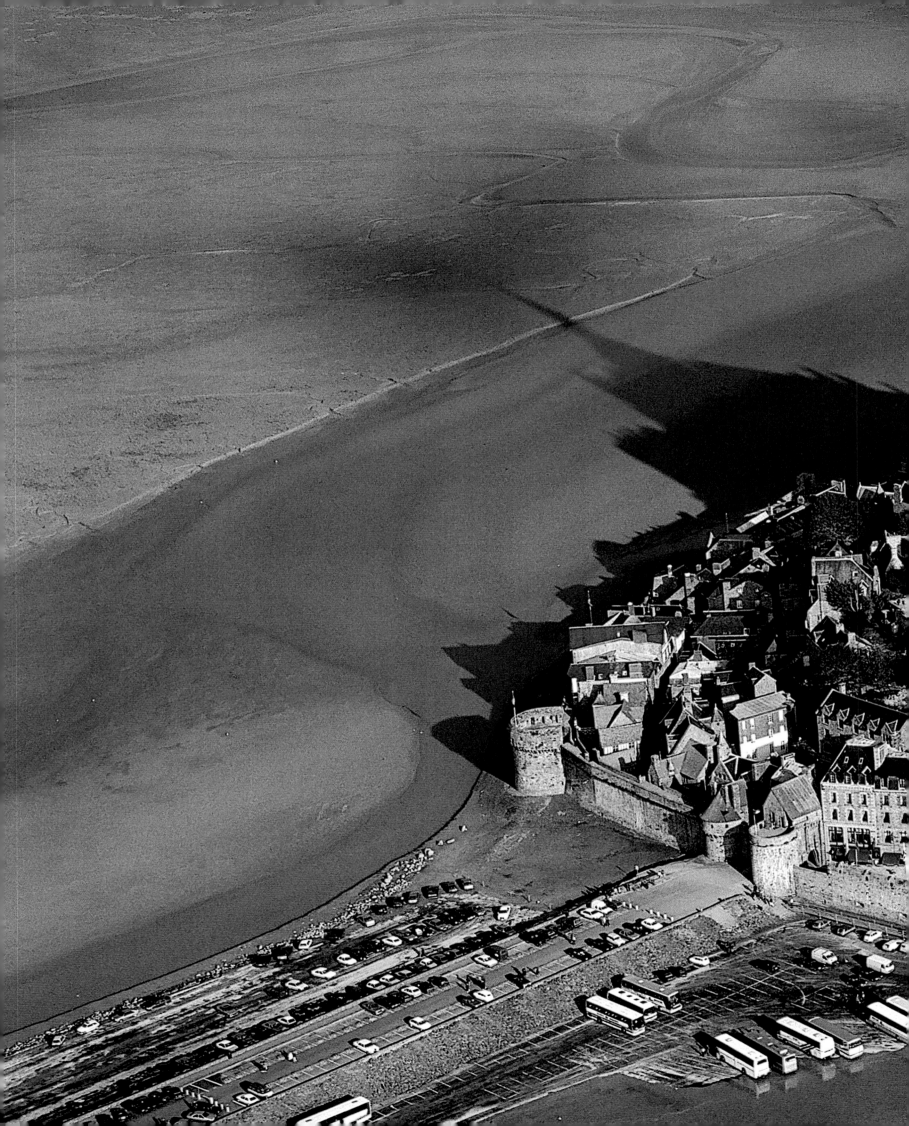

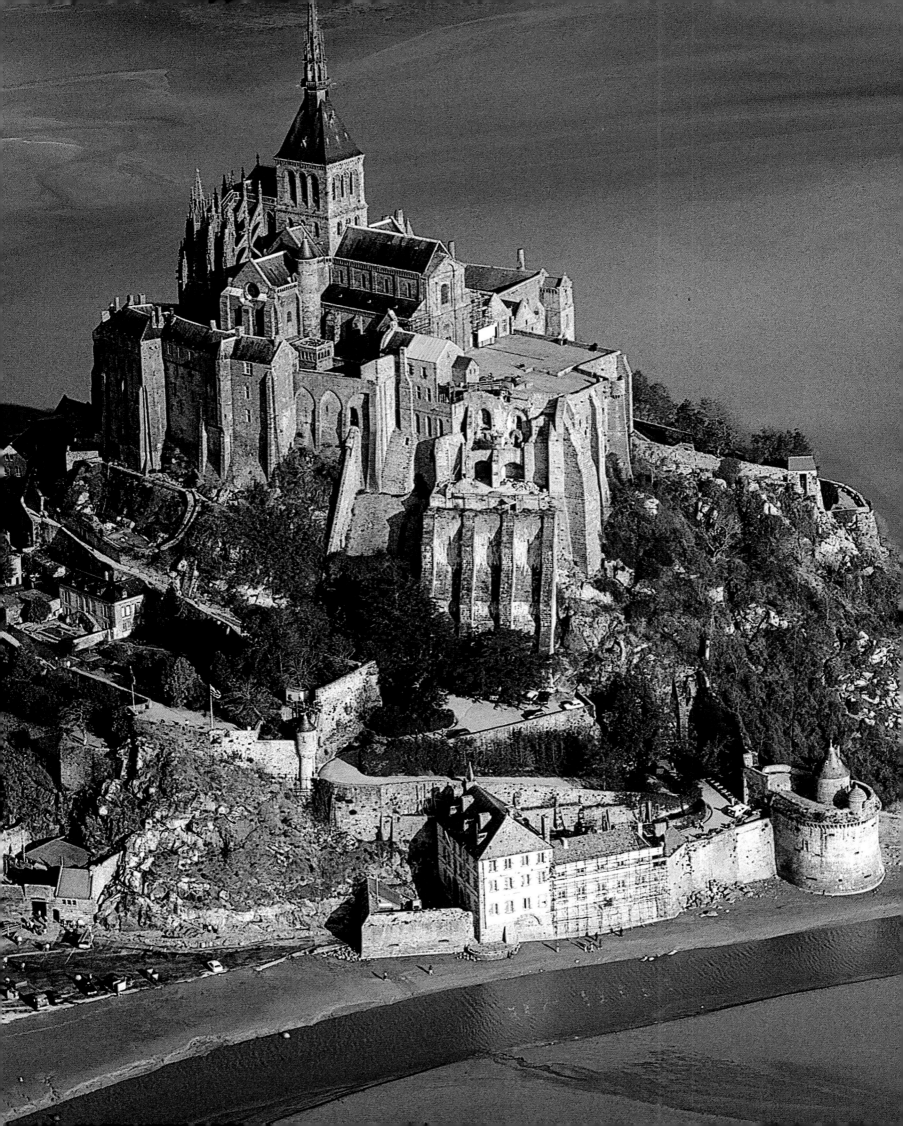

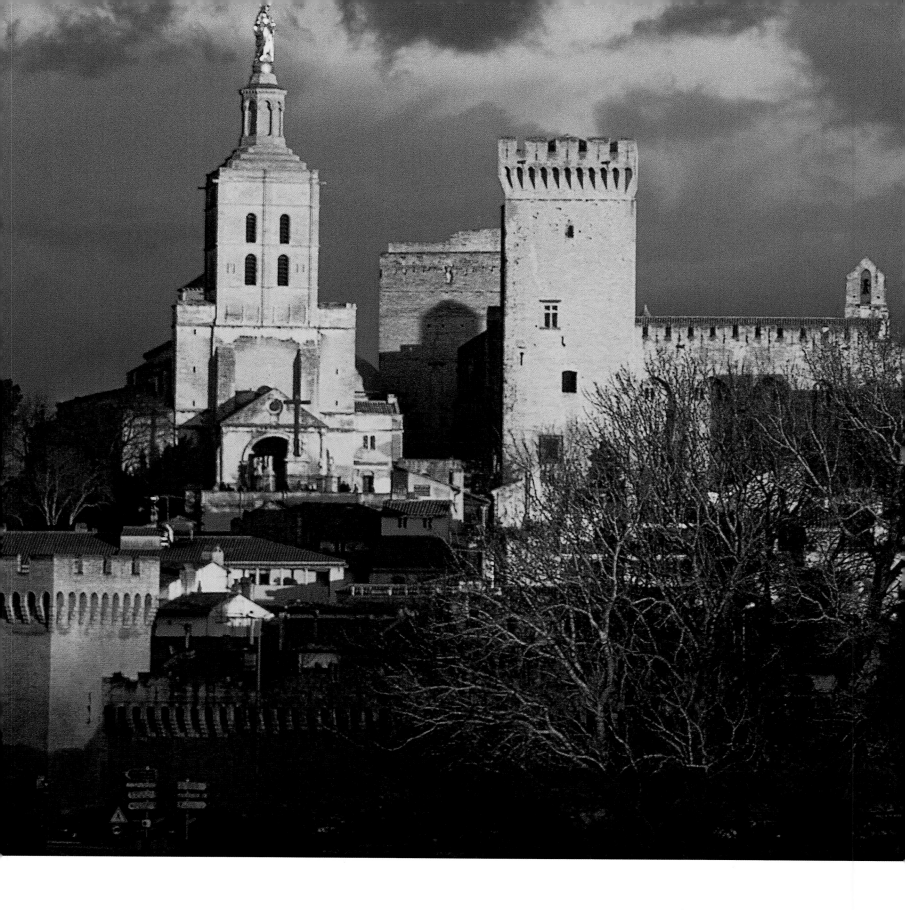

THE PAPAL PALACE, AVIGNON, FRANCE

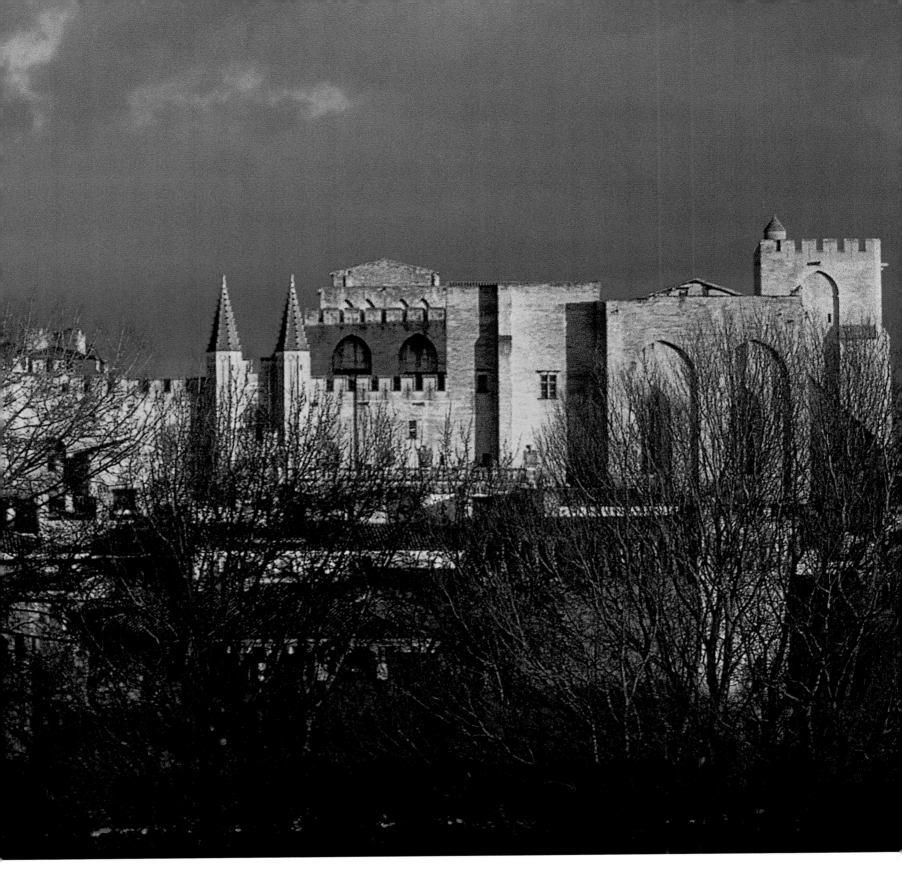

Above:

Is it a castle or a palace? The later Middle Ages apparently could not decide. Avignon became papal property in 1274. But it was not until 1307 that Clement V settled here, followed by his successor John XXII. Then, in 1336, Benedict XII started building a palace that today is known as the "Old Palace," an edifice of thoroughly Cistercian austerity. More spacious and lavish is the "New Palace," built by Clement VI in the 1340s. These days, this spacious architecture has a somewhat empty feel. It is organized around a courtyard of some 5,904 square feet (1,800 square meters) in a style that is half-civil, half-military.

HAUT-KOENIGSBOURG CASTLE, ALSACE, FRANCE

Right:

This very model of a medieval fortress with its stout red sandstone walls keeps watch over the Alsatian plain like an eagle in its aerie. In 1871 France lost Alsace when the region was absorbed into the German Empire inherited by Kaiser Wilhelm II. In an effort to emphasize the Germanic character of the region, the Kaiser decided to restore Haut-Koenigsbourg, which had dominated the plain and town of Sélestat since the twelfth century but now lay in ruins. Its architect, Bodo Ebhardt, began work in 1900, transforming the site into a textbook example of a medieval fortress refashioned in accordance with contemporary post-Romantic taste.

CANYON DE CHELLY NATIONAL MONUMENT, ARIZONA, USA

Following pages:

These cliffs more than 984 feet (300 meters) high have been cut by two streams, the Tsaile Creek and Whiskey Creek, which later join the Rio de Chelly for more than 25 miles (40 kilometers) in the Native American Canyon de Chelly, land sacred to the Navajo, near the town of Chinle in northeastern Arizona. Although they are still huge, the canyons thus created are perceived by some as scaled-down versions of Colorado's Grand Canyon. The watercourses slip between the brown and frequently reddish ocher walls of the canyons, leaving some room for splashes of green vegetation. Navajo guides take visitors to the archaeological remains left by their ancestors in the eighteenth century, when they replaced the Anasazis, whose cave dwellings survive in the region.

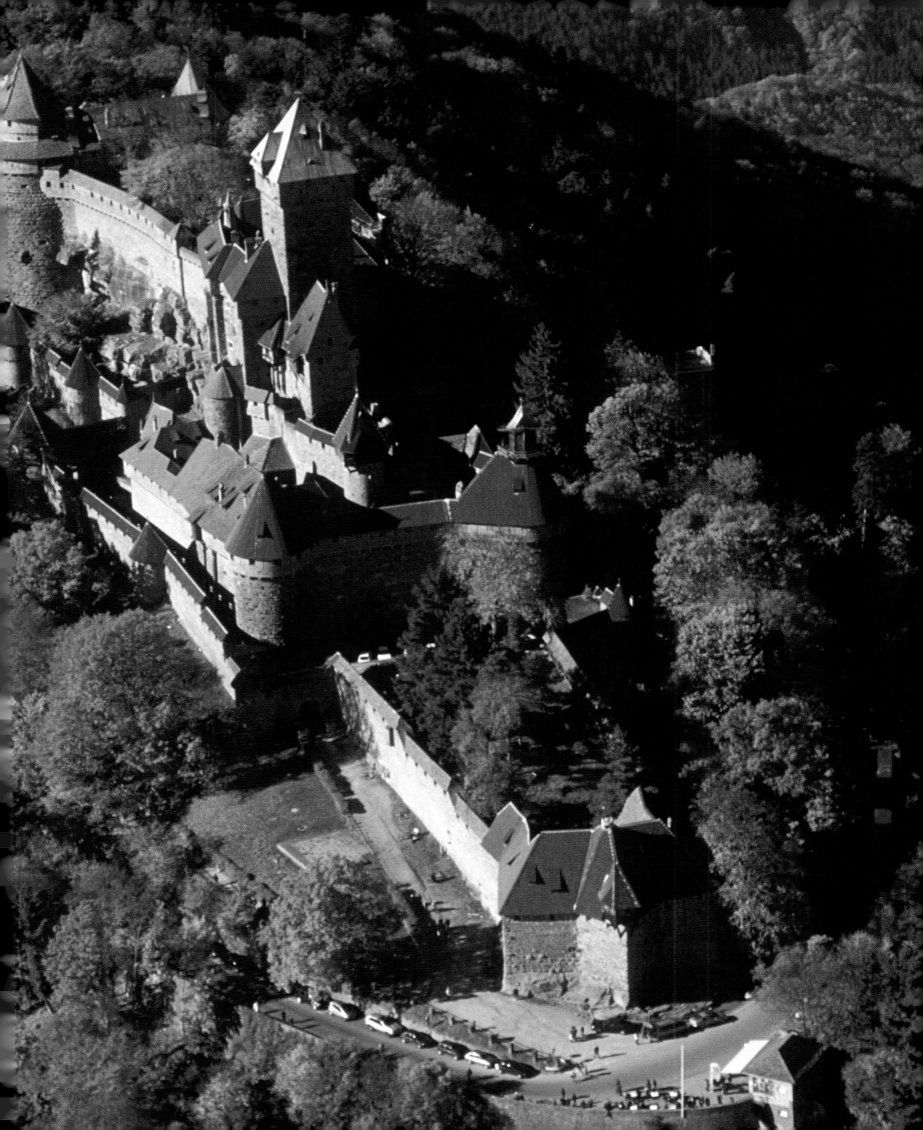

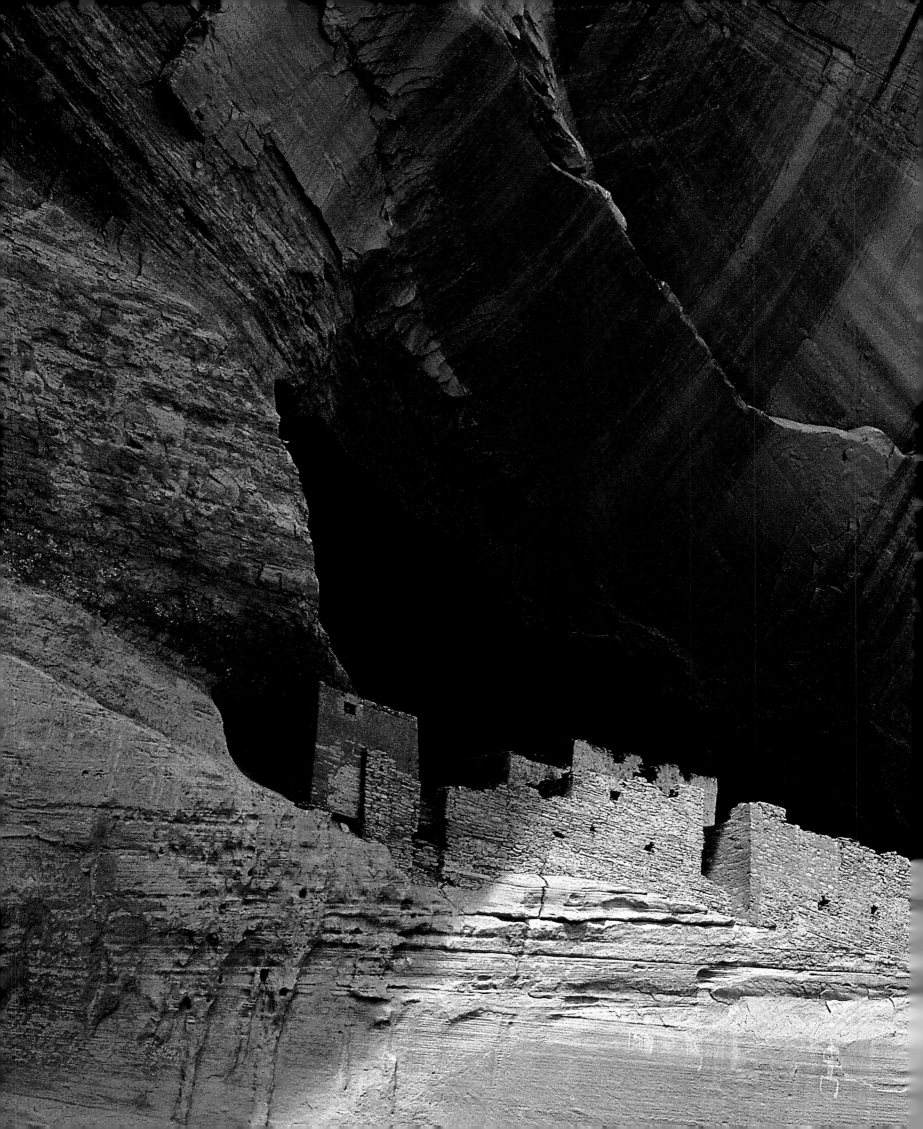

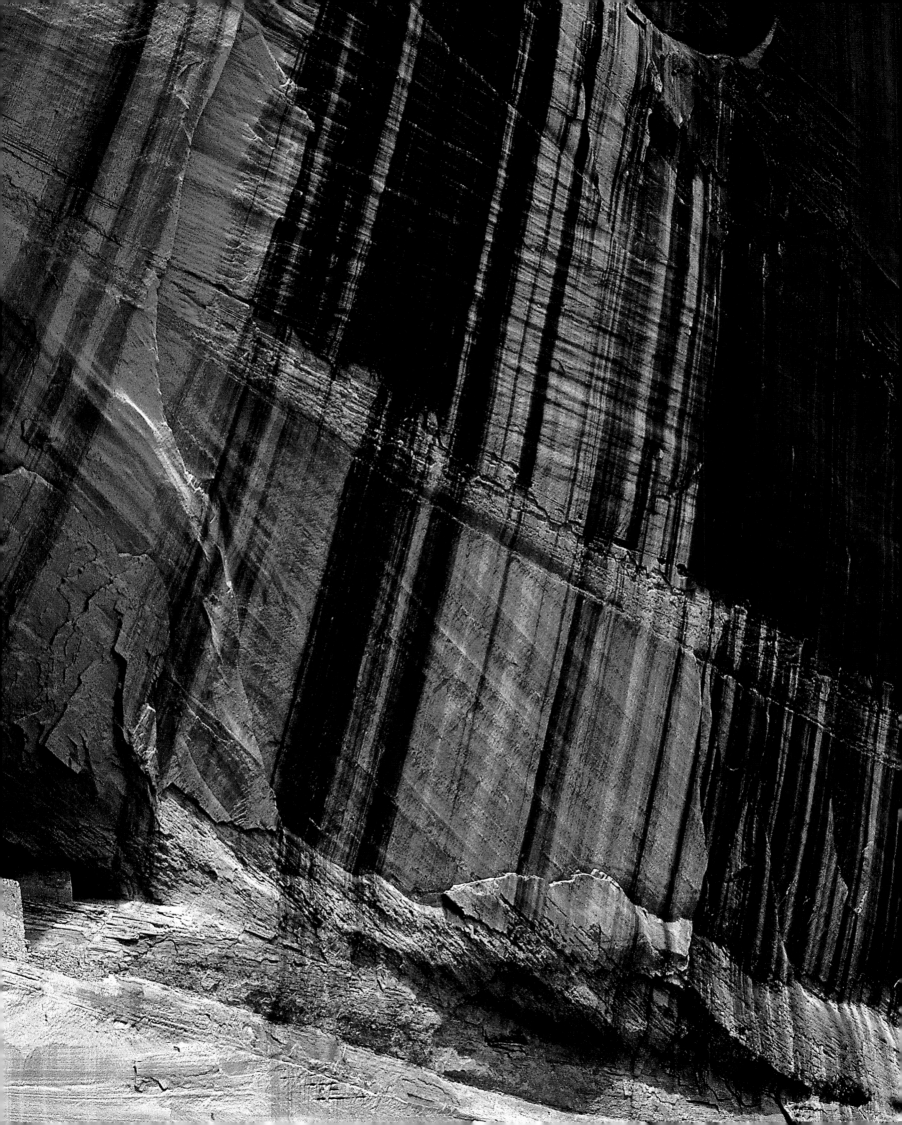

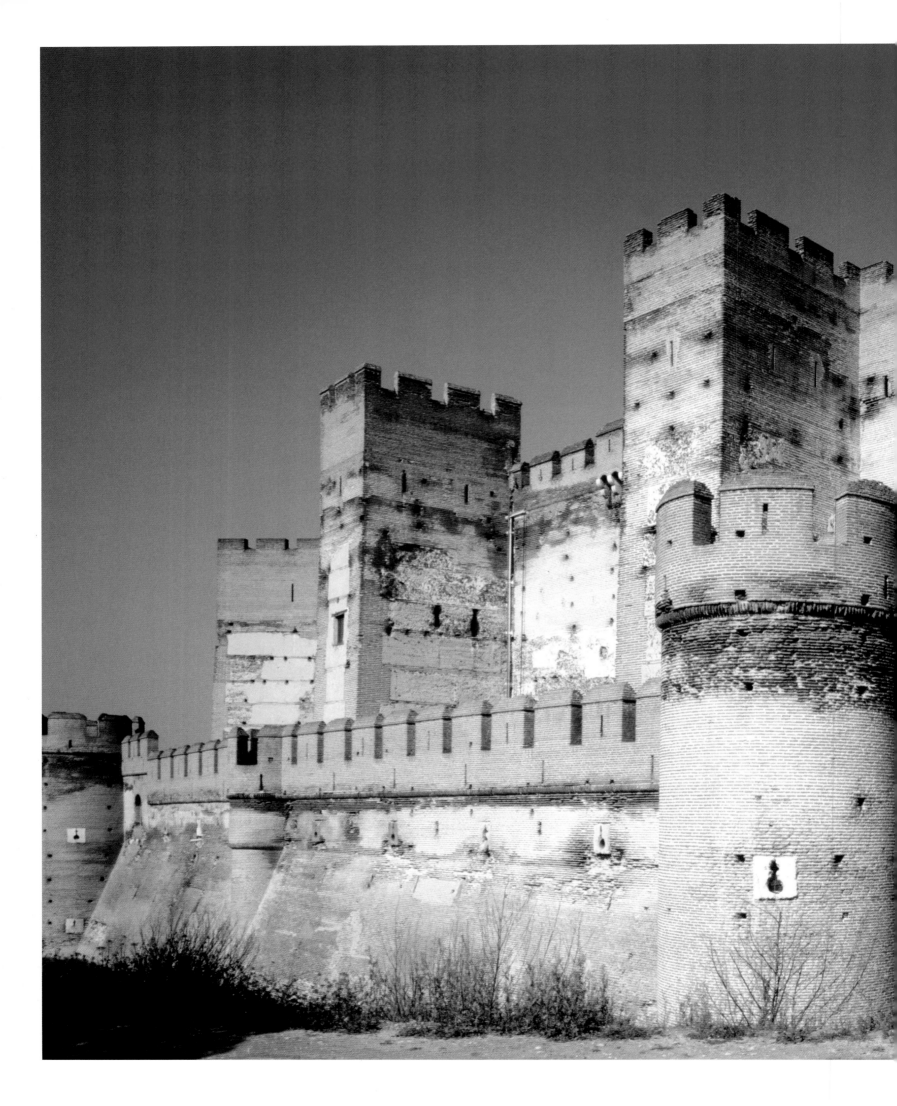

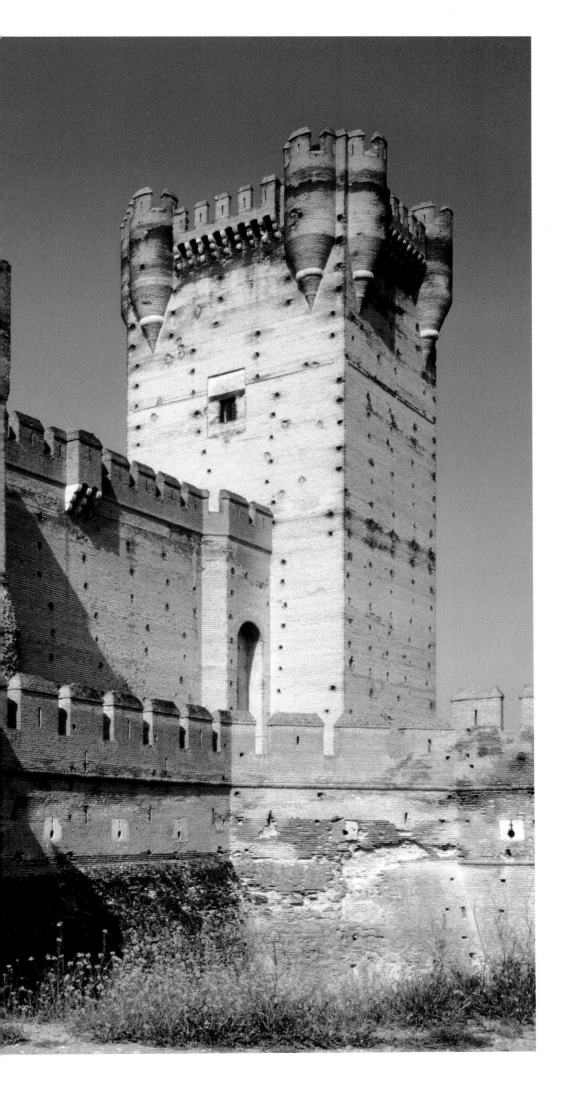

HUNYADI CASTLE, HUNEDOARA, TRANSYLVANIA, ROMANIA

Left:

The regional capital of Transylvania has as its guardian the largest medieval castle in the land, a magnificent collection of walls, battlements, and pointed roofs that are still impressive. From the castle's defensive construction it is easy to imagine the walls echoing with the shouts of combat and the clash of steel. But such are the ironies and incongruities of history that today's visitor passes through the ruins of a huge steel-making complex dating from the Communist era before reaching the castle. Built in the very early fourteenth century, it was modified sometime later in an ornate Gothic style of the period and then again during the Renaissance, when it became the seat of the Corvin family (*Corvinesti* in Romanian). Hence the castle's other name, Castelul Corvinestilor, or Corvins' Castle.

AIGUES-MORTES, FRANCE

Following pages:

Over the centuries, the sands have won their battle with the sea, and the port where Saint Louis boarded ship for the Crusades is now far inland. The Capetian kings intended a large Mediterranean port here, and that is what they had in the thirteenth century, when trade flourished, with links to the Orient, Genoa, and Barcelona, and expeditions across land to distant fairs held in the Champagne region. The town boasted deep-water mooring, a lagoon harbor, and more than a kilometer (less than a mile) of fortified walls. But dating from the sixteenth century, health risks associated with the marshlands, the silting up of the harbor, and sectarian strife between Catholics and Protestants, together with development of its rival port of Sète, quickly put an end to all that.

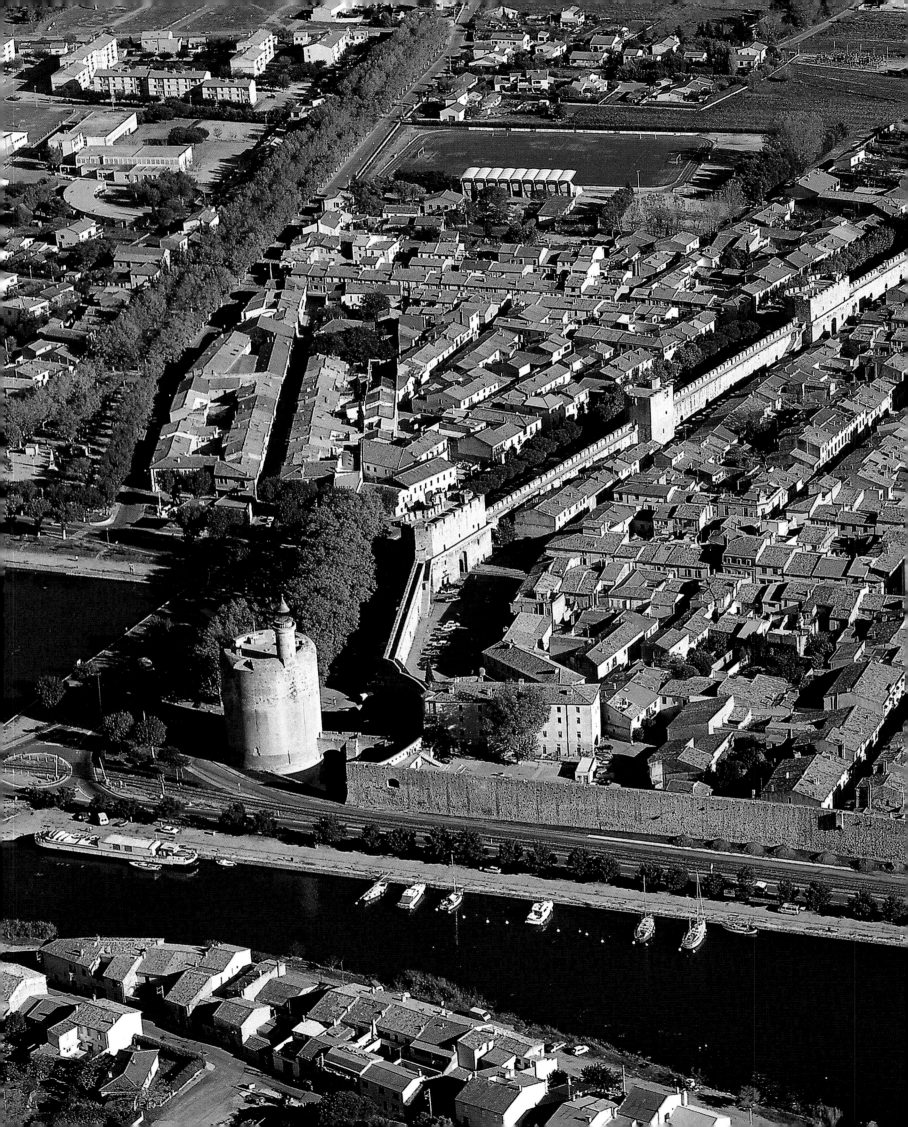

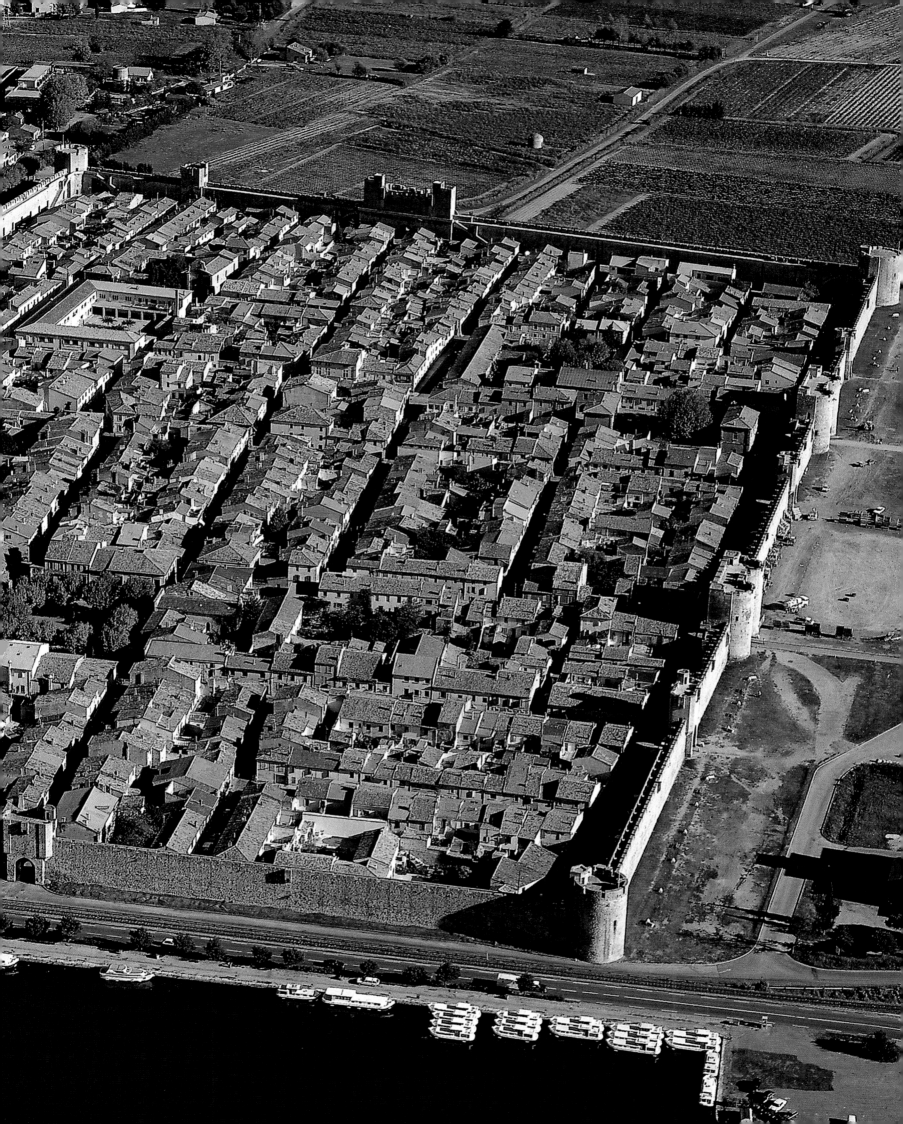

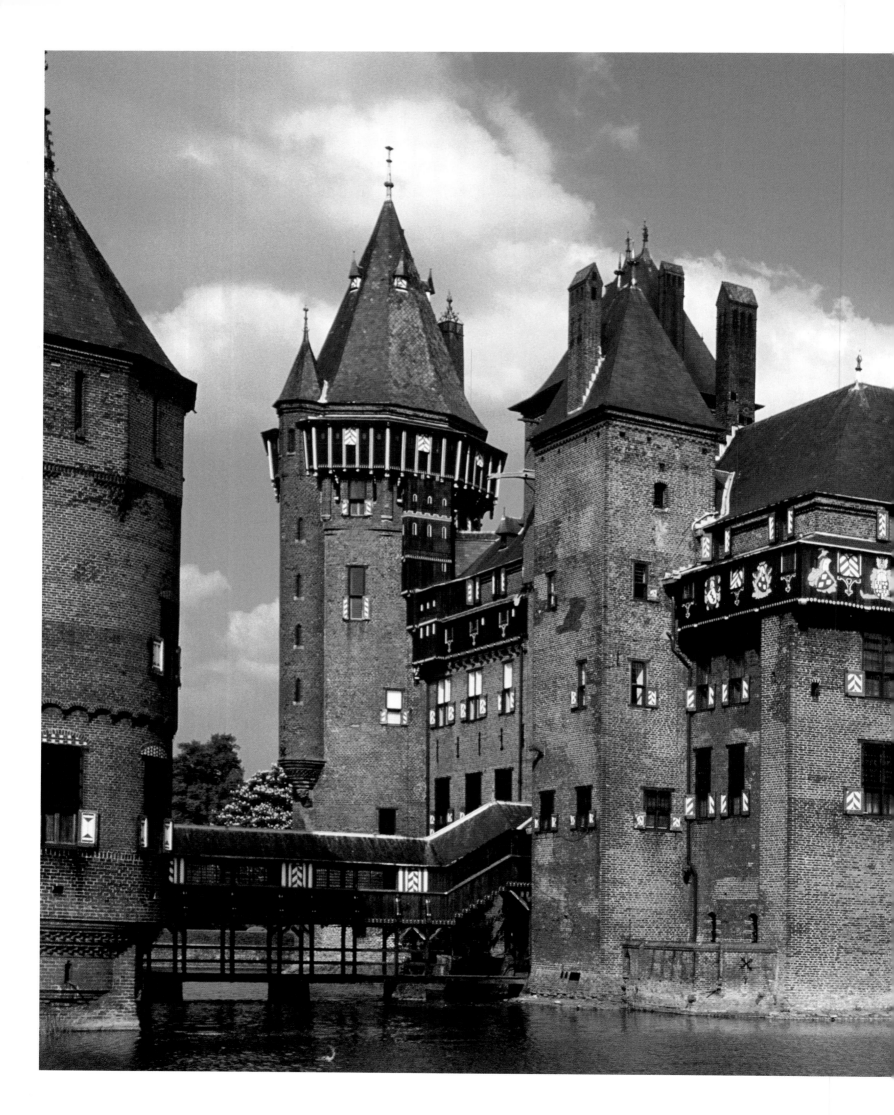

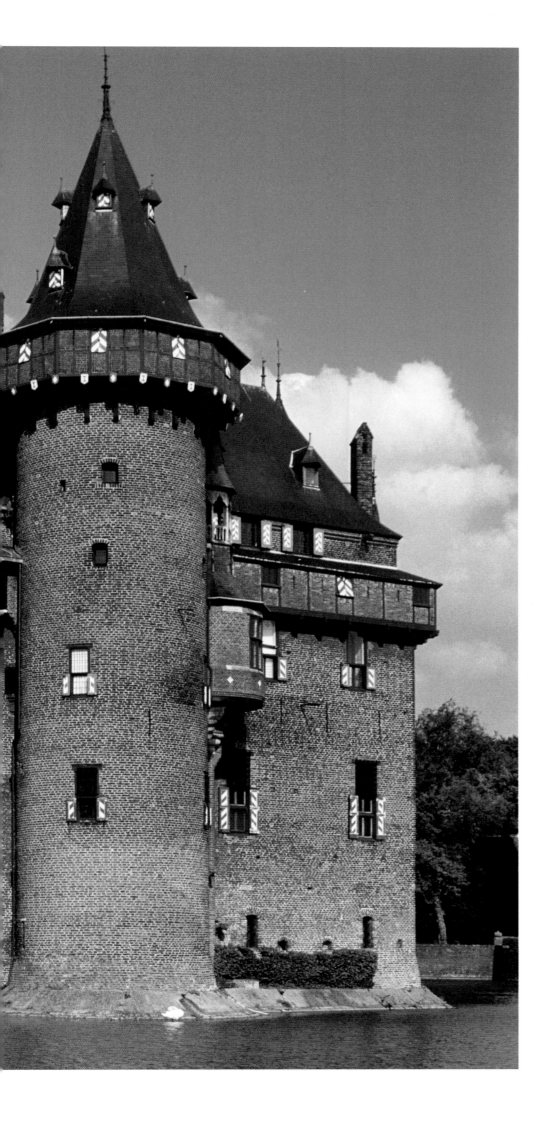

DE HAAR CASTLE,
THE NETHERLANDS

Left:

In the vicinity of Utrecht in the Netherlands, De Haar Castle looks like something straight out of a picture book or a film set. Abundant restoration work undertaken in the nineteenth century in fact replaced the oldest sections of the building, which date from the fourteenth century. Shortly after its original construction, the castle was turned into a ruin by violent confrontations with the Burgundians. But it was rebuilt during the first half of the sixteenth century, retaining the appearance of a defensive castle. Apart from the moat, it owes much of its attraction to the brick walls and slate roofs, not to mention the authenticity of its restoration, which is rich in late Gothic-style embellishments.

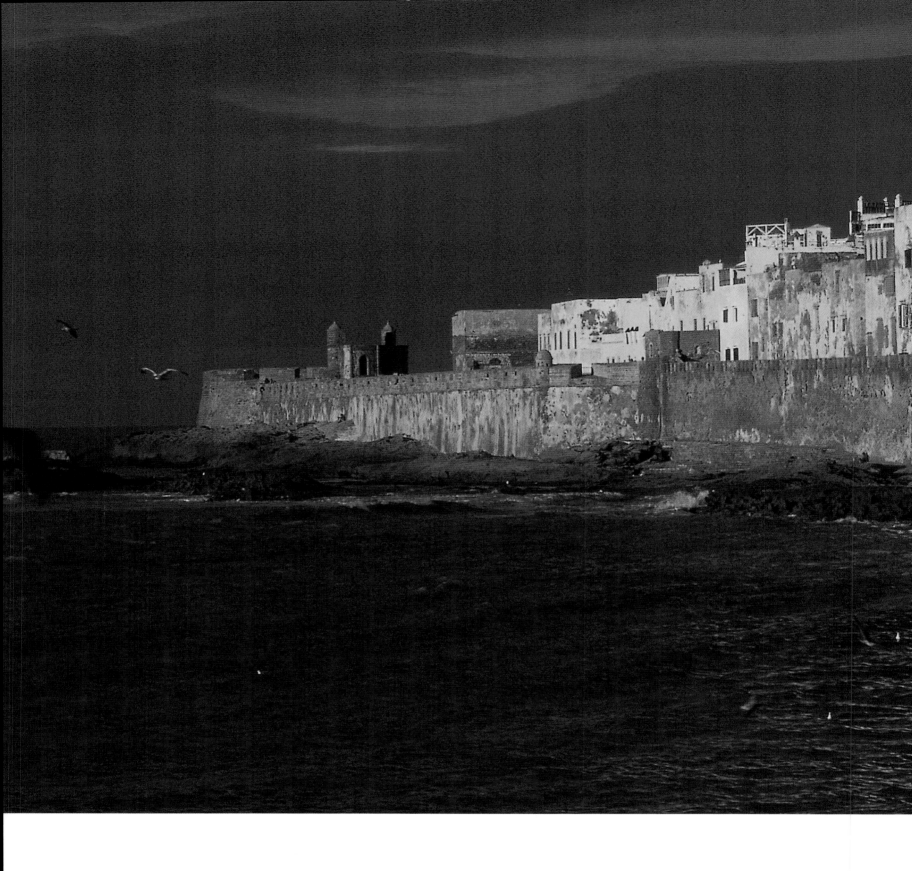

ESSAOUIRA, MOROCCO

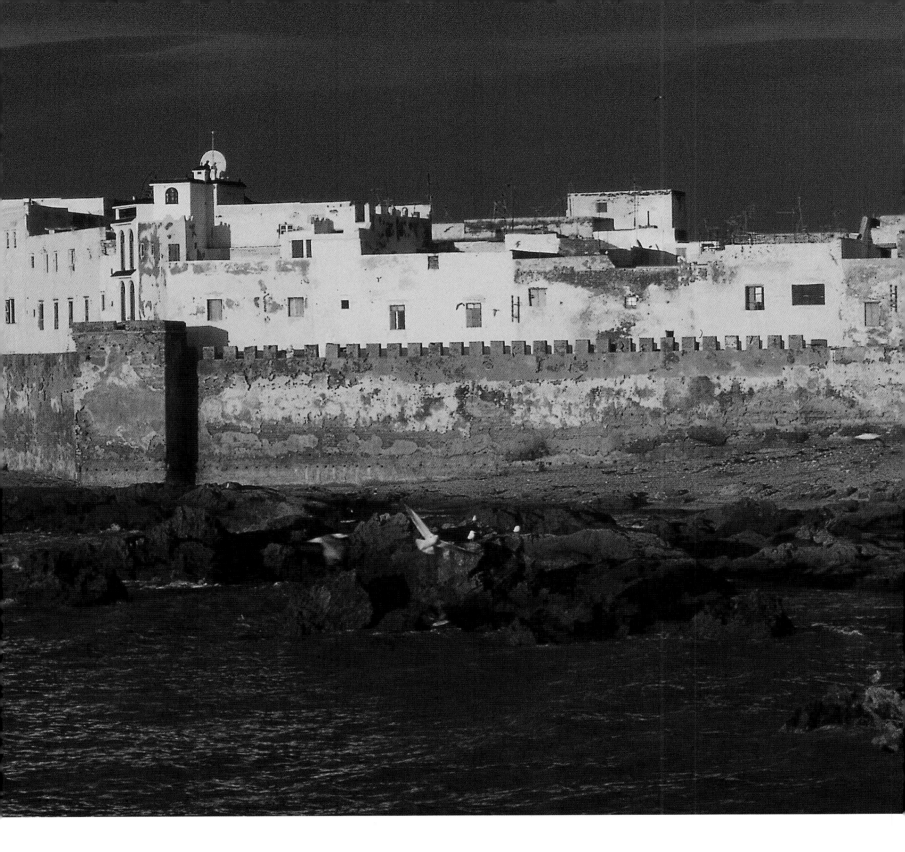

Above:

The sea is only a stone's throw from the souk. Between the sea and the market stand medieval walls guarding the white houses with their blue shutters. The breezes that sweep through Essaouira come from the sea, not the sands; but this is still the Maghreb, even if the quays suggest a harbor in Brittany. The town is a busy, colorful place, where coolness and calm can be found in the gardens of the riads, traditional houses with hidden courtyards. The Carthaginians probably founded the port called Amogdul ("the well kept") in Berber and Mogador by the sailors and traders who visited from Portugal, Spain, and France. These are the names of legend. But today's Essaouira is a "new town." In 1764, Sultan Mohammed ben Abdallah hired a French architect working for the English to build a harbor and Casbah. Essaouira "the well designed" quickly became a leading center of trade, with a large and active Jewish community. It became less important commercially as other ports were established in Morocco under the French protectorate.

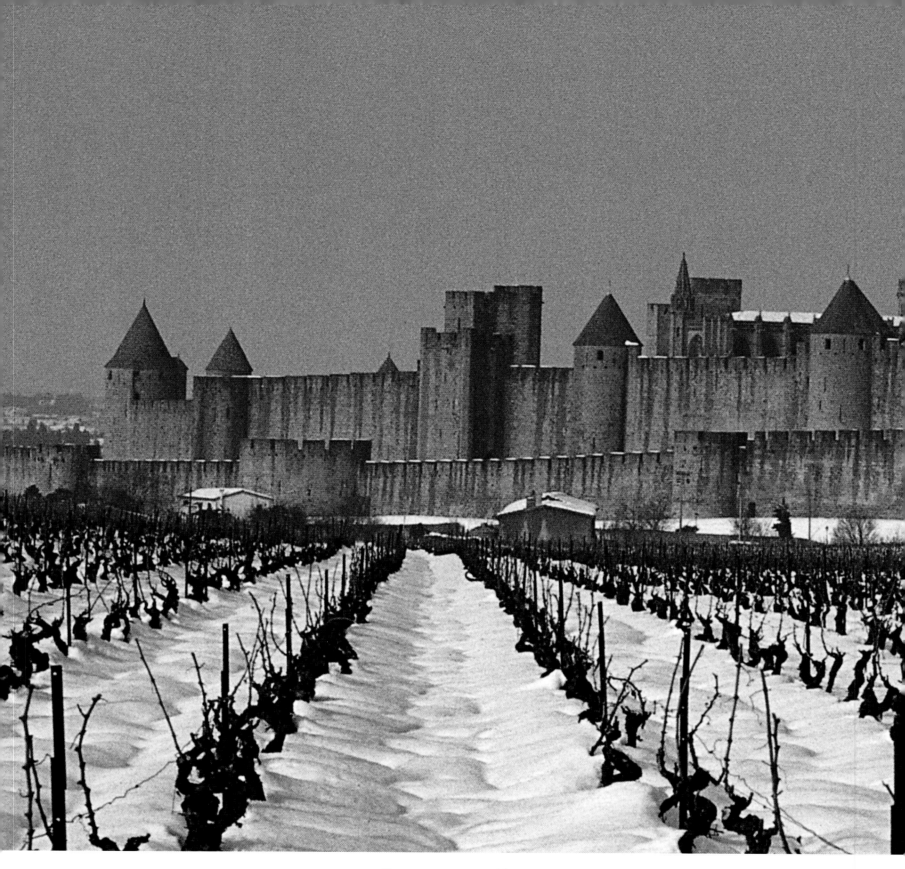

CARCASSONNE, FRANCE

Above:

Above the "new town" built on the banks of the Aude River beginning in the thirteenth century, the city of Carcassonne still has the aspect of a fortified medieval town. This is the work of Eugène Viollet-le-Duc, the famous architect who restored it in the nineteenth century and is responsible for its stylistic unity. Two enclosures with fifty-two towers, a count's castle superbly erected on Gallo-Roman ruins, a Romanesque and Gothic cathedral, all dating mainly from the thirteenth and fourteenth centuries, make up a thoroughly medieval entity, with an unusual homogeneity that attracts hordes of visitors every year.

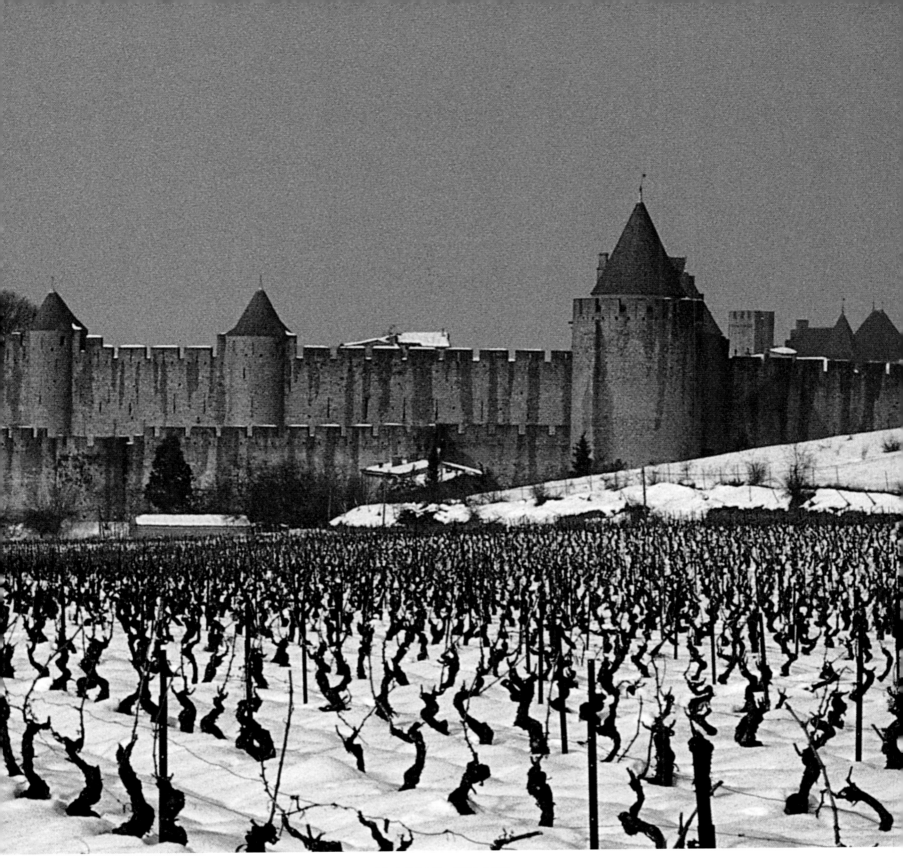

MALBORK, POLAND

Following pages:

In the far north of Poland, on the right bank of a branch of the Vistula River, the high walls of this vast Gothic fortress still echo with the footsteps of the Teutonic Knights, the soldier-monks and hospitalers who had their seat here in the thirteenth century. Building went on for more than two centuries to create a fortified site of some 20 hectares that was both strategic and commercially advantageous. There are two castles here, a Grand Masters' palace, chapels, habitations, and large outbuildings. The layout reflects the site's dual function as both stronghold and monastery. Stone foundations sustain brick walls that, in turn, bear sloping roofs covered in tiles, giving the whole a dominant red aspect. The knights abandoned Malbork in 1457; the stronghold and town became Polish and subsequently Prussian.

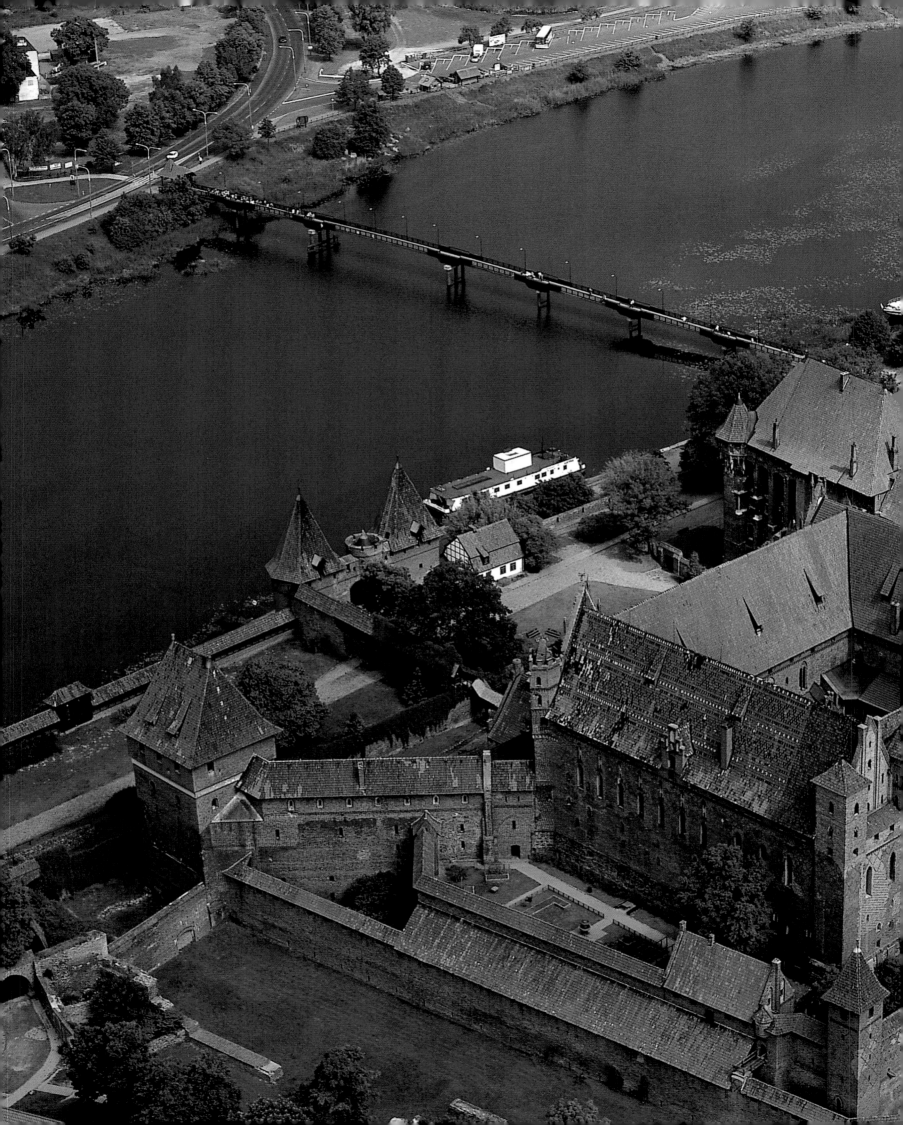

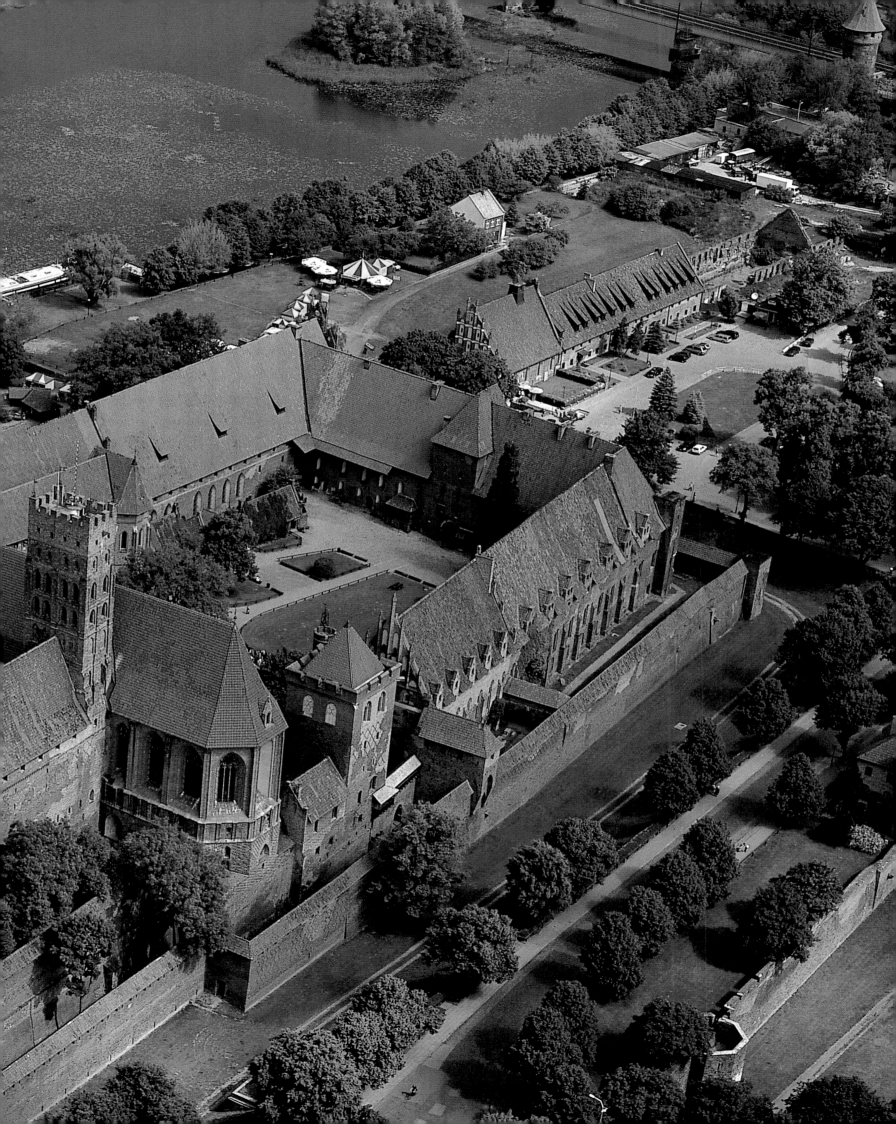

AMBOISE CASTLE, FRANCE

Right:

Here, at this royal castle, a medieval stronghold has lost itself in the elegance of the Italian Renaissance. Both Charles VIII (1470–1498), who was born here, and Louis XII (1462–1515) enhanced its beauty. Both understood and appreciated the new cultural and artistic currents arriving from Italy. Charles was responsible for the architecture of late Gothic elegance, and Louis ensured that the castle became a comfortable dwelling place more than a military installation. Its antique and medieval defensive foundations then acquired a stately home, terraces, and gardens that bore the early signs of a new art de vivre, a new style brought from Italy with artists summoned by Louis's successor, Francis I (1494–1547). Among them was the protean genius Leonardo da Vinci, who died in 1519 in the mansion of Clos-Lucé only a stone's throw from the castle.

NEUF-BRISACH, ALSACE, FRANCE

Following pages:

Neuf-Brisach is a masterpiece of military architecture built by Vauban between 1699 and 1709, replacing the old, medieval town of Brisach with a garrison town intended to defend France against the Germans. Its eight-sided layout organized around the Place d'Armes and its system of fortification belong to the great military engineer's most intricate conceptions. Thick rampart walls (14.8 feet, or 4.5 meters, at the base) protect a second enclosure of blockhouses; four gates give access to blocks of ten houses and barracks arranged in a regular layout dictated by defensive geometry.

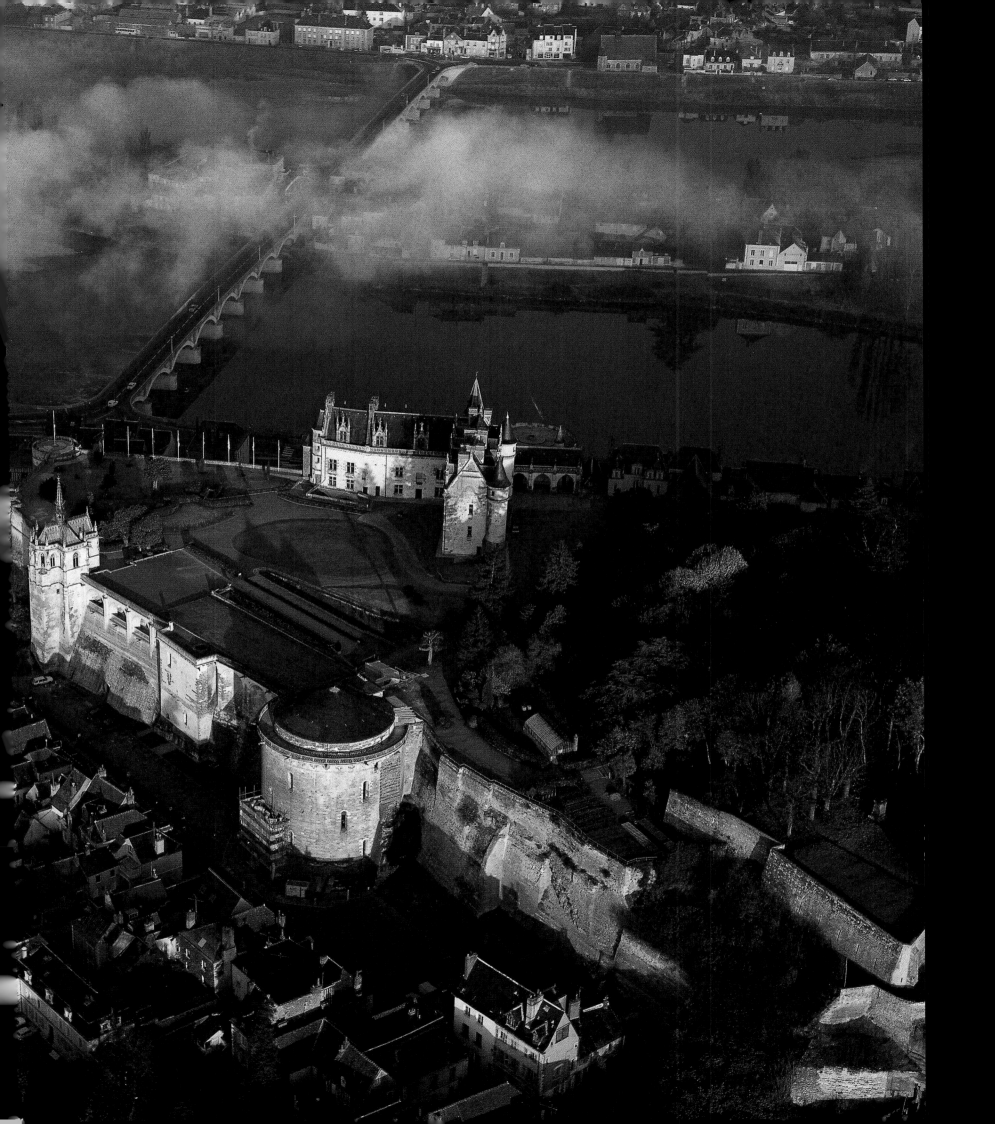

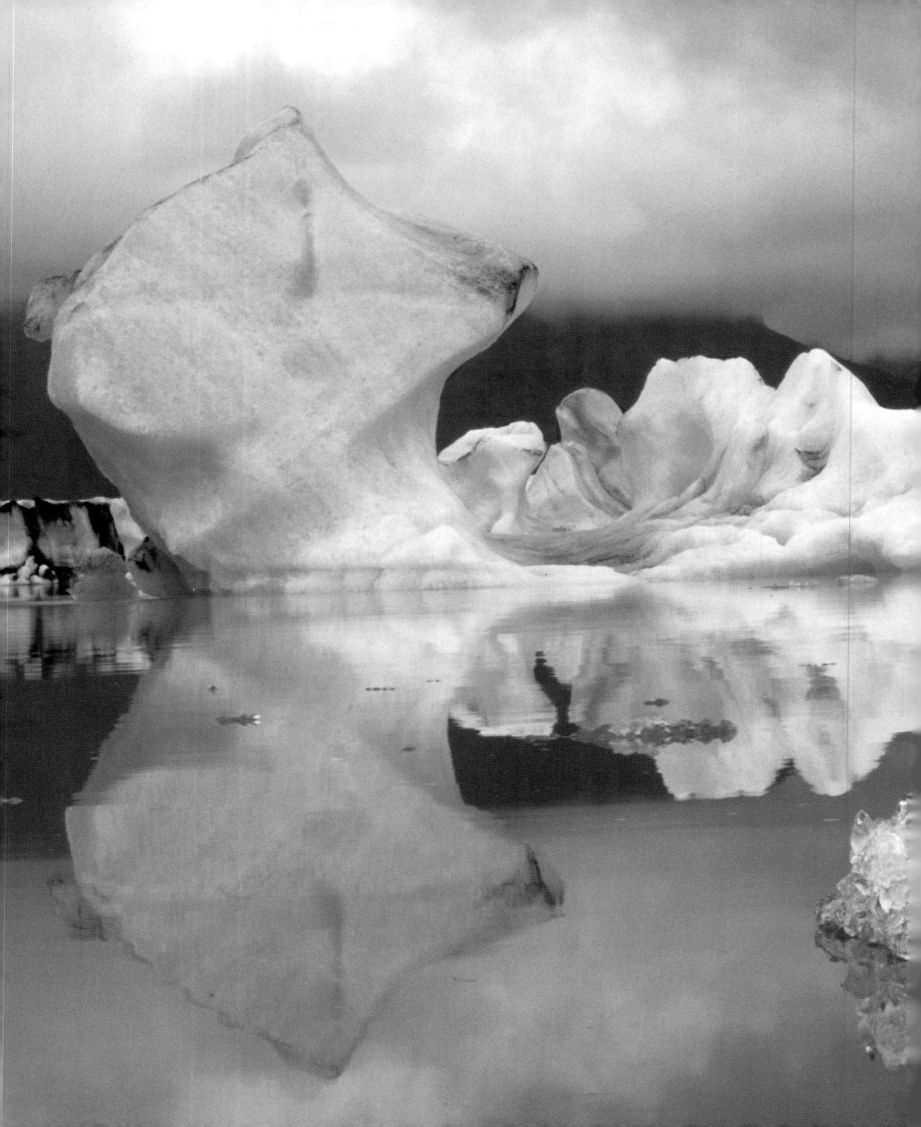

WATER, THE SOURCE OF LIFE

The management of water resources was second only to the discovery of fire in the development of early civilizations. In the region between the Tigris and Euphrates rivers, the need to irrigate encouraged the construction of canals and norias, water wheels of the sort still used today by tribes tied to ancestral ways of life. As early as the annual sacred flooding of the Nile, water was conveyed as far as possible into the desert sands. In Asia, Africa, and throughout the world, management of water conferred fundamental rights that enabled societies to organize and function. The Romans, absolute masters in channeling water to bathhouses and fountains, left some imposing relics of their hydraulic engineering, such as the magnificent Pont du Gard aqueduct (pages 22–23) in the former Gaul. Under Roman rule, the supply of water to towns became highly sophisticated. Moreover, theirs was a riverine culture. It is impossible to think of Rome without the Tiber, or of the Roman Paris (Lutetia) without the Seine; and plenty of other towns and cities developed where previously there had been a harbor, ford, or bridge.

Water can be a frontier. It can also be used for transportation, as in networks of canals. Water has also proved itself as a source of electrical or mechanical power, driving the wheels of mills, workshops, and factories. Although it is a vital resource, however, not all water is subject to human control. The earth still possesses wild waters in their primitive state. They may be threatened or coveted, but they continue to be powerful and impressive, like the vast glacial expanses of the polar regions; the huge roaring waterfalls (pages 76–77) that interrupt the course of mighty rivers; the geysers of the American West (page 75), where water rises up as steam; or the turbulent, refreshing streams of the wilderness. And what of the oceans and seas, the wide expanses of water that are both alluring and frightening? To love freedom is to love the sea, sings the poet. But the sea sometimes exacts a terrible price for that love, as sailors know only too well.

Whether by its presence or absence, including the extremes of torrential rain and drought, water is ultimately an uncontrollable, inhuman force before which humans must bow. Neptune and his nymphs (pages 108–9), the local divinities of streams and rivers, plead the sacredness of water. Some primordial forms of water are themselves perceived as gods; and even when they are not seen as divine, they intervene in humanity's relationship with the transcendent through rituals of purification and rebirth. We need only think of holy ablutions, bathing in the Ganges, miraculous springs, and the like. To submerge oneself in water in order to be reborn to a new life is to ascribe to water an exceptional vital force. How could humankind, with its irrepressible urge to subdue and conquer, not seek to lay hold of this vital liquid that is both dangerous and kind, sliding over the body and slipping through the fingers, yet soothing the throat and cleansing wounds?

A glacial lake, Jokulsarlon, Iceland

Water is life. But it is equally, today, a luxury for billions of human beings. A third of the world's population does not have access to water of drinking quality. There is a pressing need to realize how precious water is, to find ways to protect it and to better share it with the world. Whenever astrophysicists speculate about the existence of planets similar to ours, the leading question is always: "Is there water?" Water is everywhere the indispensable condition for life; and when faced with drought, human beings have no option but exile. The water that is so intimately linked to human history is the planet's gift. Since the Earth is neither too near nor too far from the Sun, the world's water readily takes liquid form. And thanks to the cycle that the Earth's water ceaselessly pursues—large bodies of water forming clouds, rain, underground reservoirs, and then springs, rivers, and, once again, large bodies of water—it may seem inexhaustible. In a manner of speaking it is: the hydrosphere's seas and oceans, surface and subterranean water sources, rivers and lakes contain 181,280,753,000 cubic yards (1,385,990,800 cubic meters) of water. But it does not circulate fast enough to satisfy human consumption. Nor is this situation likely to be improved by global warming, which increases desertification and provokes a rise in sea level in certain regions. Forty percent of the earth's land is arid, that is, continuously deficient in water, and that surface area is increasing. Intensive and irrational exploitation of water together with the growing pollution of existing resources are also major concerns. At the beginning of 2007, the Secretary General of the United Nations declared that it was time to regard water as a common human heritage and to reapportion it democratically.

A geyser in Yellowstone National Park, USA

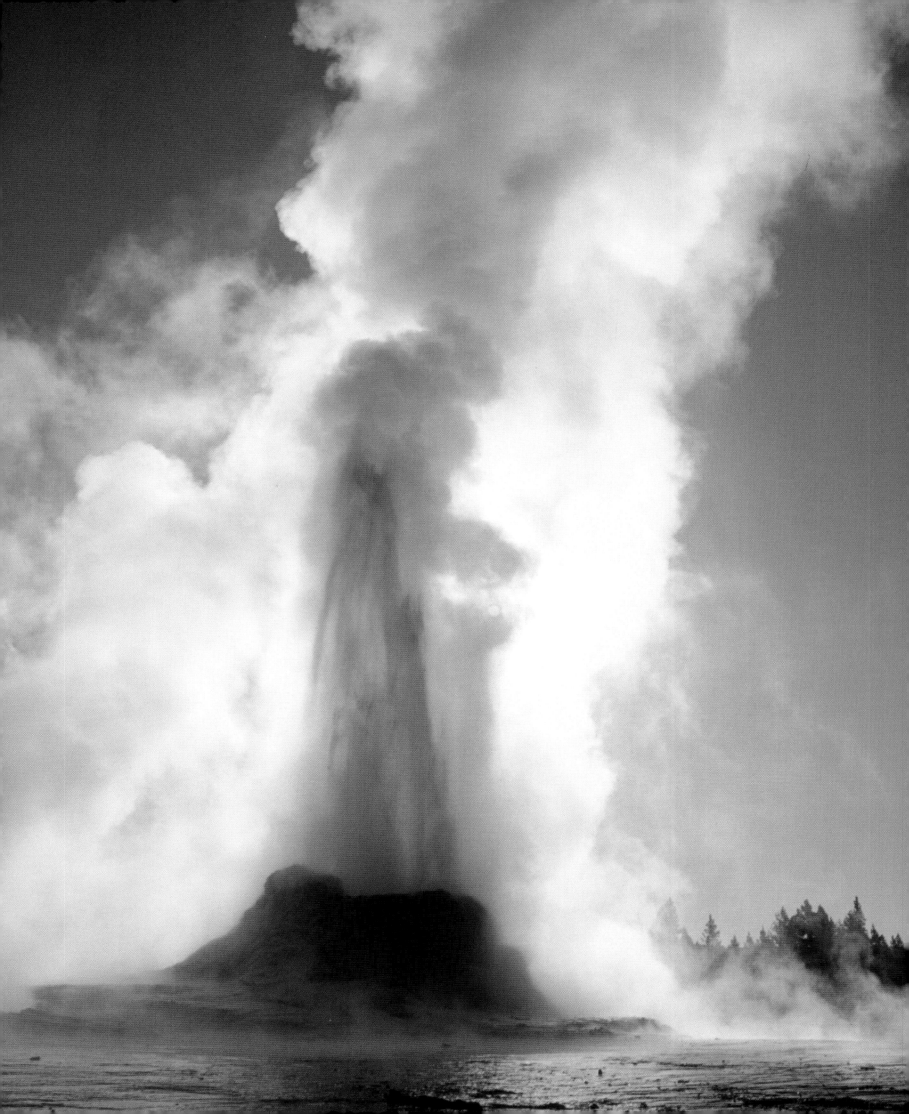

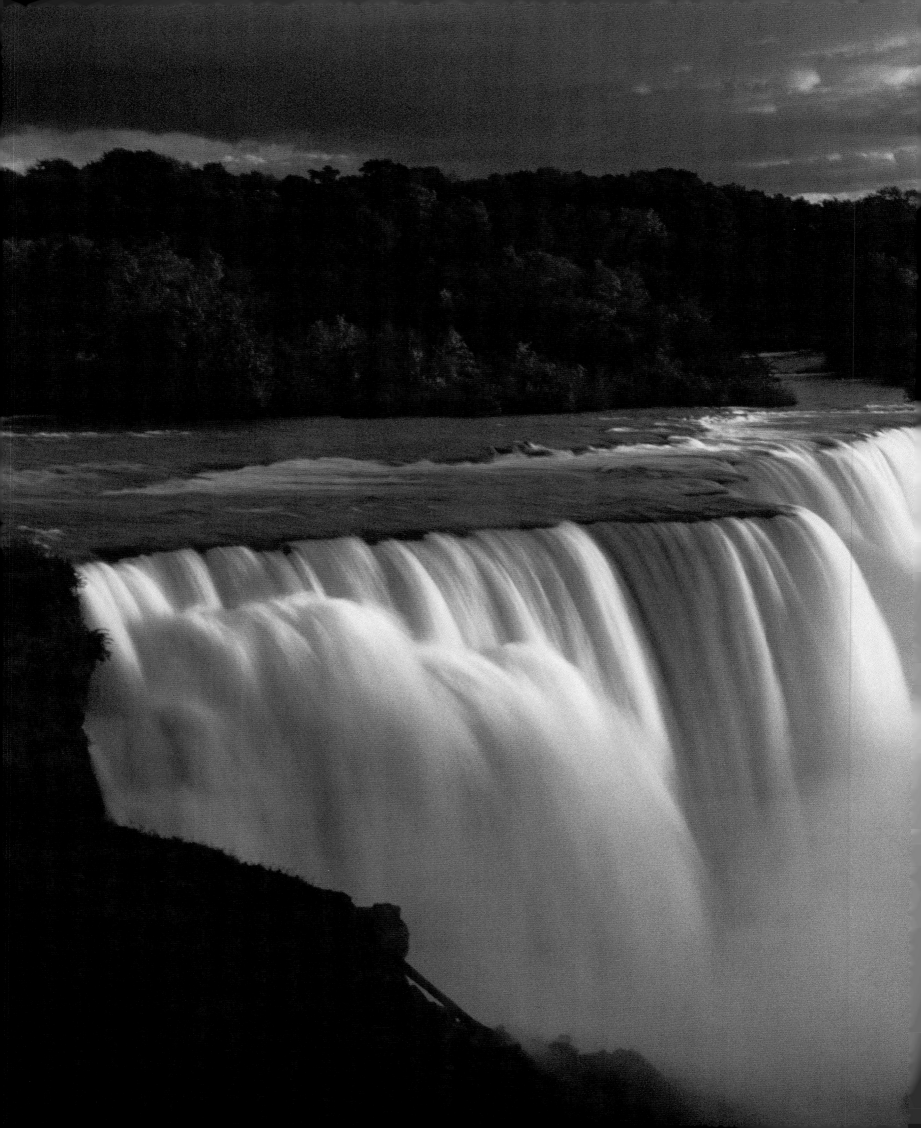

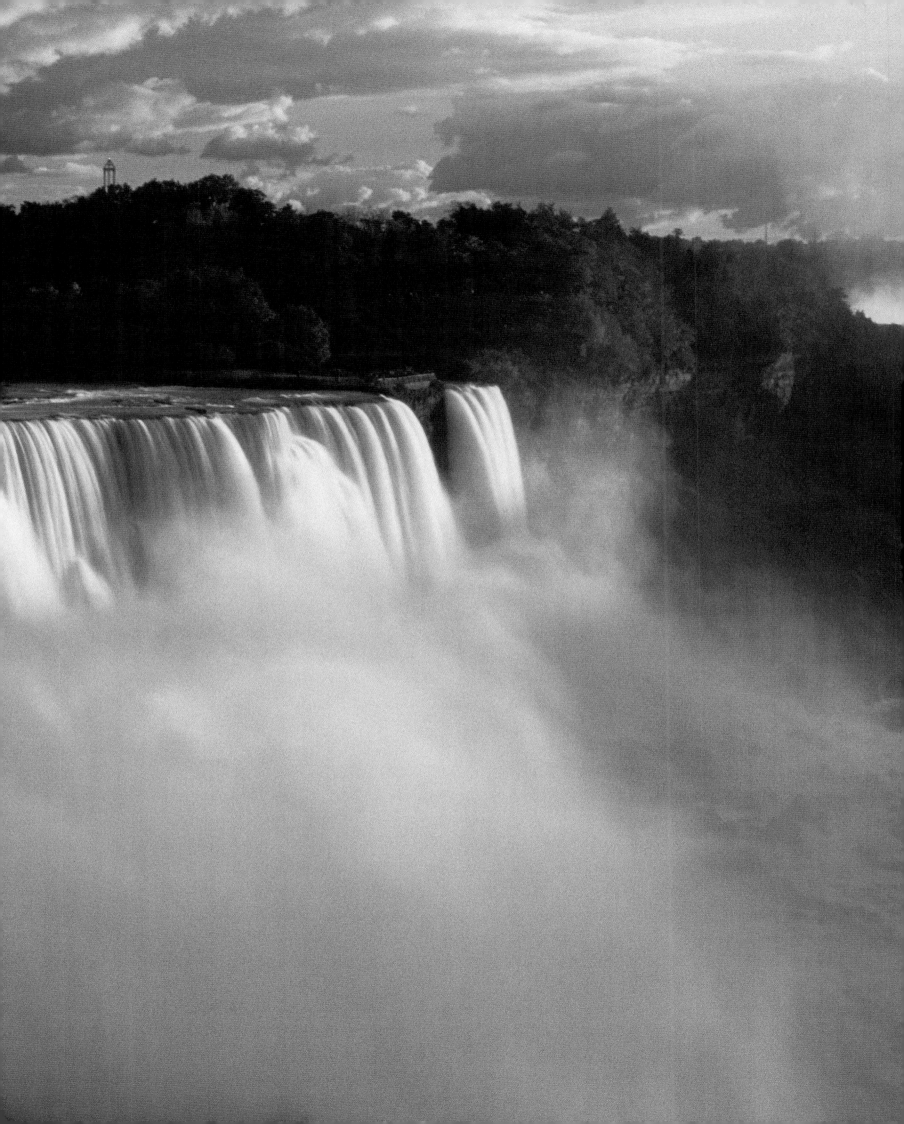

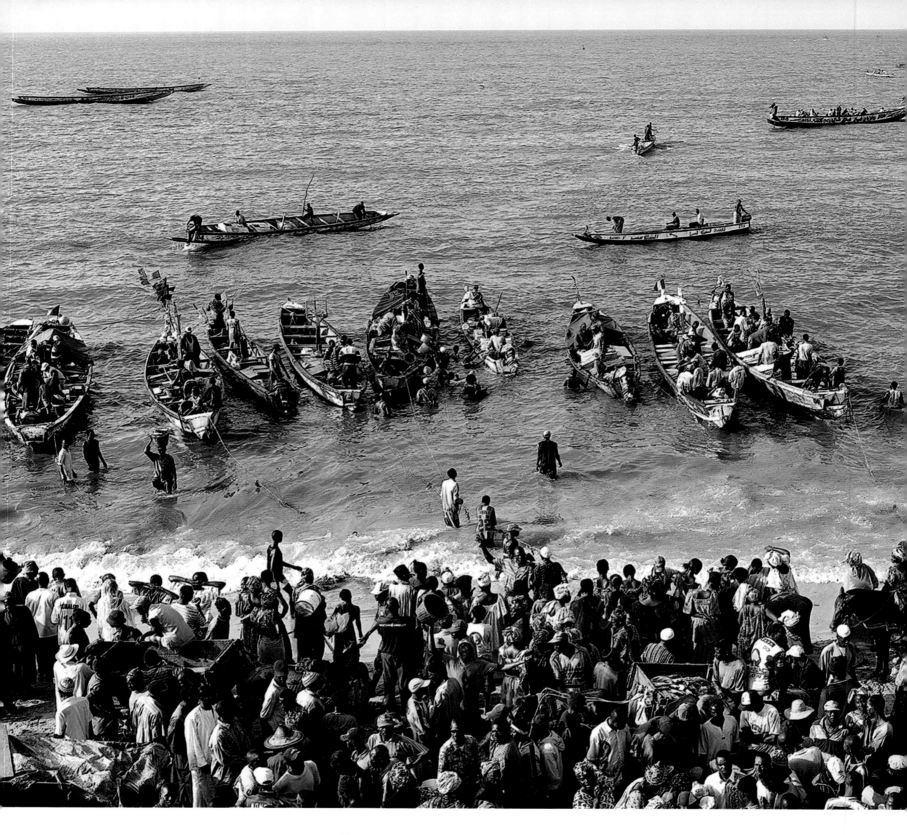

NIAGARA FALLS, CANADA AND USA

Preceding pages:

Located on the border between Canada and the United States, Niagara Falls is one of the most famous natural sites in the world. Its renown owes less to the height of the Falls than to their breadth, overall scale, and power. They were formed at the end of the so-called Wisconsinian Ice Age, about ten thousand years ago, when the Great Lakes of northeast America were created and the Niagara River itself began to flow. Niagara Falls in fact comprises three distinct sets of falls: the "Canadian Falls," the "American Falls," and the "Bridal Veil Falls." At their highest point, they fall some 171 feet (52 meters), while their broadest sweep, the "Canadian Falls," is more than 2,591 feet (790 meters). The flow is some 551,040 cubic feet (168,000 cubic meters) per minute, which is considerably reduced in summer, when much of the water is diverted to drive hydroelectric generators.

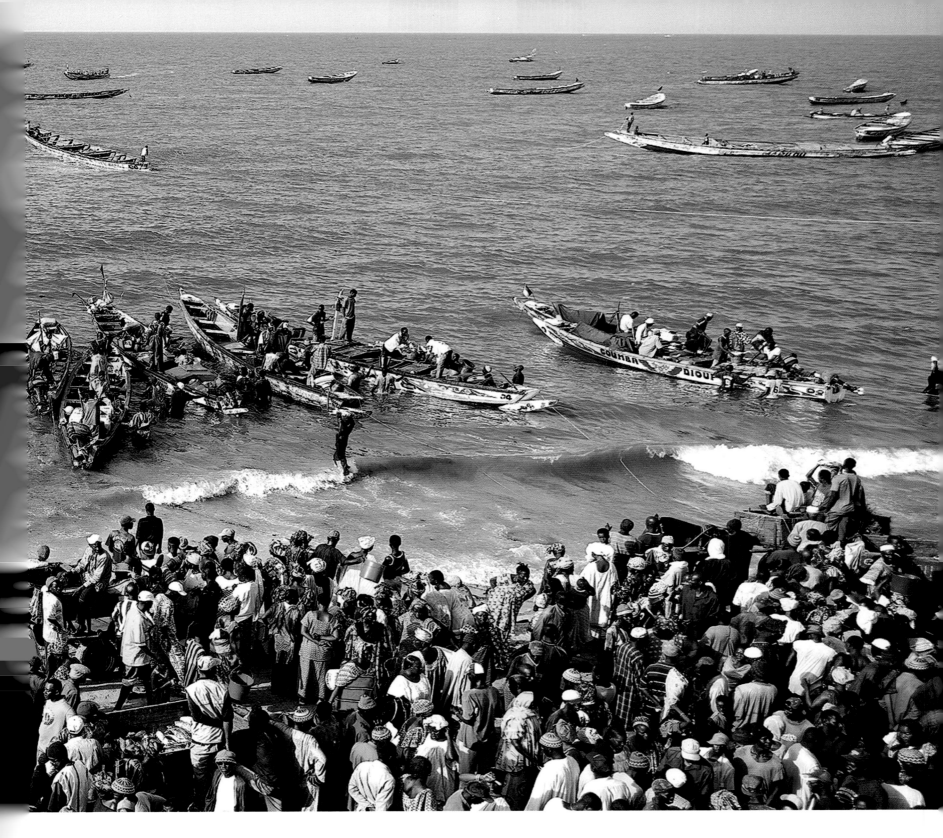

RETURNING FROM FISHING, M'BOUR, SENEGAL

Above:

Prosperity is based on the canoe here in Senegal's second most important fishing center, 53 miles (85 kilometers) south of Dakar. The neighborhood's entire livelihood appears to derive from fishing—a kind of craft fishing from large colorful dugout boats beloved of tourist photographers. When the boats return to port at the end of the day, the declining sun warms the multitude of colors, evoking unforgettable images. The nets are often overflowing with fish, which soon find their way to the large market, where they are put to dry before sale. Busy, fevered, and joyful, alive with the sounds, colors, and smells of West Africa, M'Bour is a town that buzzes with buying and selling.

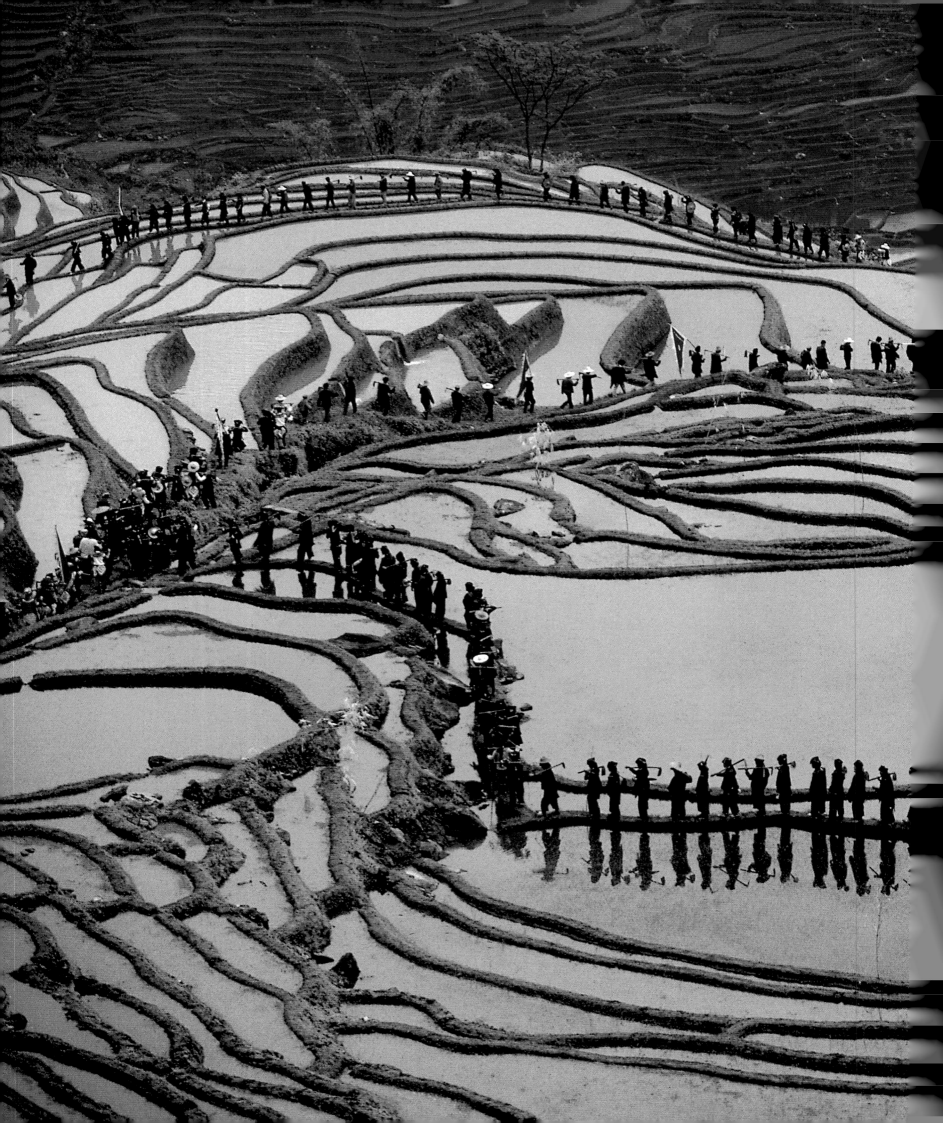

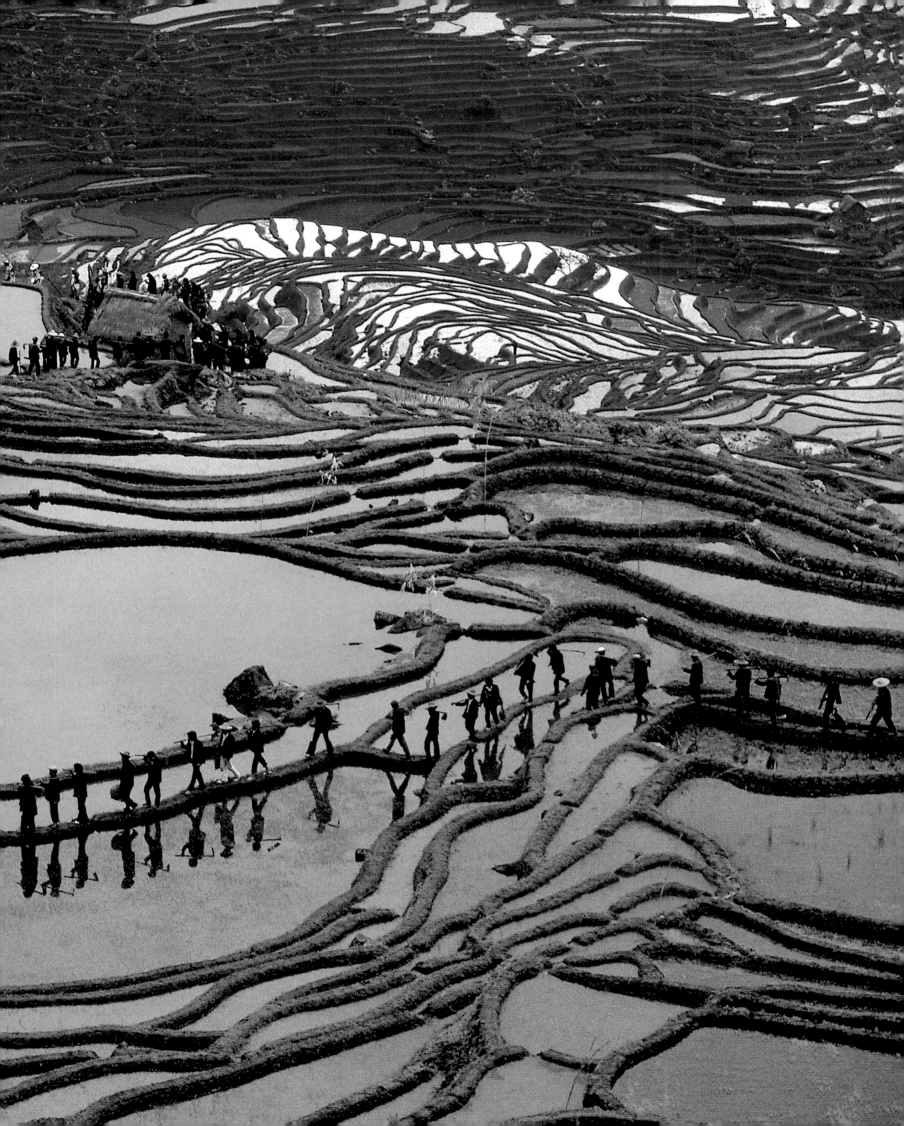

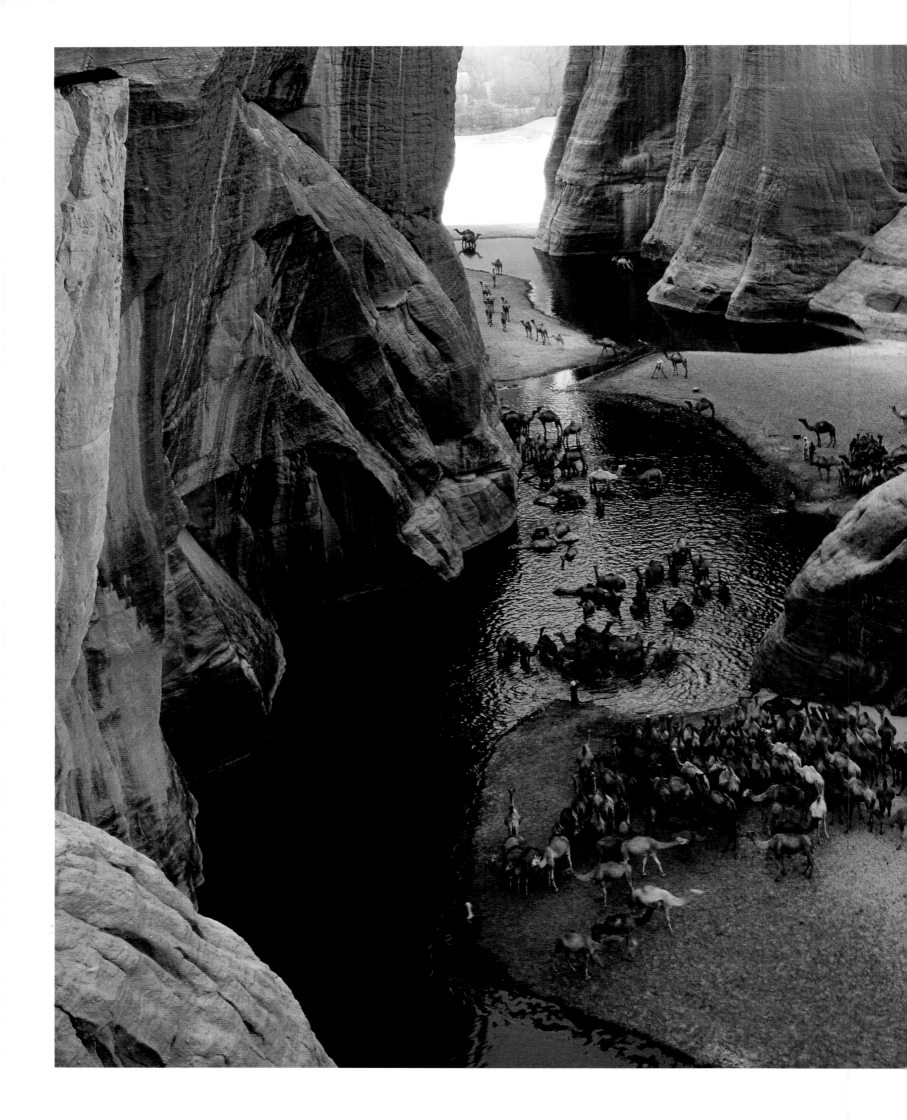

THE RICE FIELDS OF YUANYANG, CHINA

Preceding pages:

In southeastern China, the mountainsides are striped with terraced basins that, depending on the season, are either dazzling pools or carpets of verdure. Through the centuries the Hani, an ethnic group that has retained its ancestral traditions, have transformed the landscape into a network that seems to follow the contours of the land at an altitude of around 5,904 feet (1,800 meters). Earthen levees retain the water that is brought by bamboo conduits into these irrigated terraces, which the farmers themselves call "mirrors of the sky." The labor is collective and highly social. Each village sends a representative to the committee responsible for the distribution of water to the different terraces and growers. When young people marry, they receive a rice field newly established for them, thus increasing the planted surface and continuing the tradition of rice cultivation.

THE GUELTA AT ARCHEI, CHAD

Left:

Deep in the the Tibesti Desert, on the Ennedi massif, a distinctive mountain pass, the camels head for this water source, regardless of the crocodiles that are still found there. The red sandstone cliffs, which in places are as high as 656 feet (200 meters), are a playground for the dog-faced baboons, while the caves carved out by erosion contain paintings that are witness to ages of human habitation. At ground level in this imposing place, the water pouring from potholes is cool and the shade soothing. It is much appreciated as a stopover by the local nomadic herdsmen, the Bideyat.

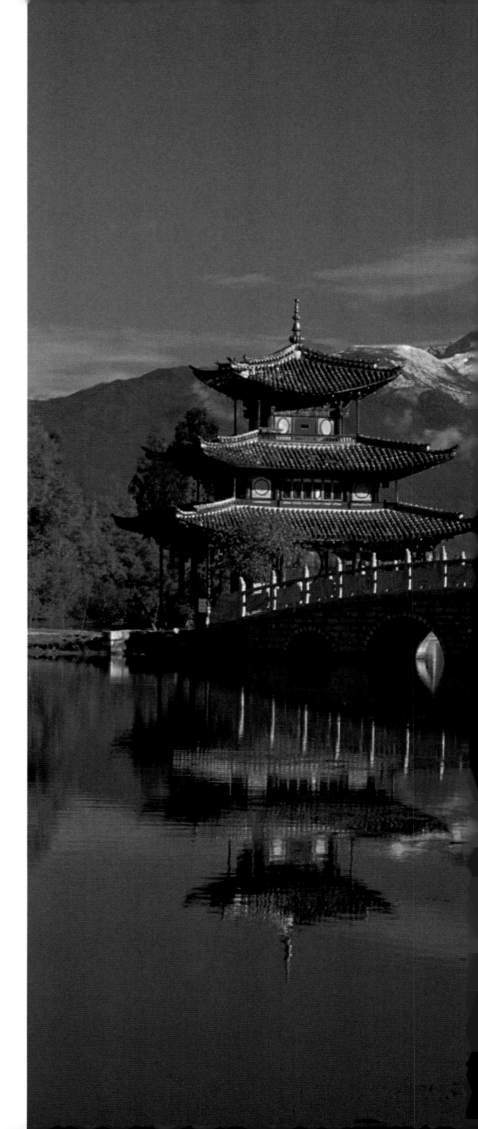

BLACK DRAGON POOL PARK, LIJIANG, CHINA

Right:

The park's curving architectural lines, in conversation with those of the horizon, recall the harmony of Chinese wisdom; between the water and sky they capture the "pavilion to embrace the moon." China's Lijiang Park is an impressive natural setting at the foot of Jade Dragon Mountain, rich in lakes and pools. A number of sanctuaries and monasteries, such as the Yufengsi Lamasery, have been restored in this region of Yunnan province in southwestern China. The district is the home of the Naxi people, whose priests use divination and whose customs continue to interest ethnologists.

A "WIND AND RAIN" BRIDGE, BAXI, CHINA

Following pages:

The Dong people dwell among their crops and rice fields across three of China's provinces—Hunan, Guizhou, and Guangxi. Certain districts possess many "wind and rain" bridges spanning rivers to connect fields to the gates of villages. These sacred bridges play a religious and social role as places to honor the spirits of rain and wind that protect the village as well as travelers. Built of spruce on solid masonry foundations, the bridges support richly decorated pagodas. The village community meets there to sort through crops as well as to hold celebrations where dancing and singing are obligatory. In every important life activity the Dong express themselves in song.

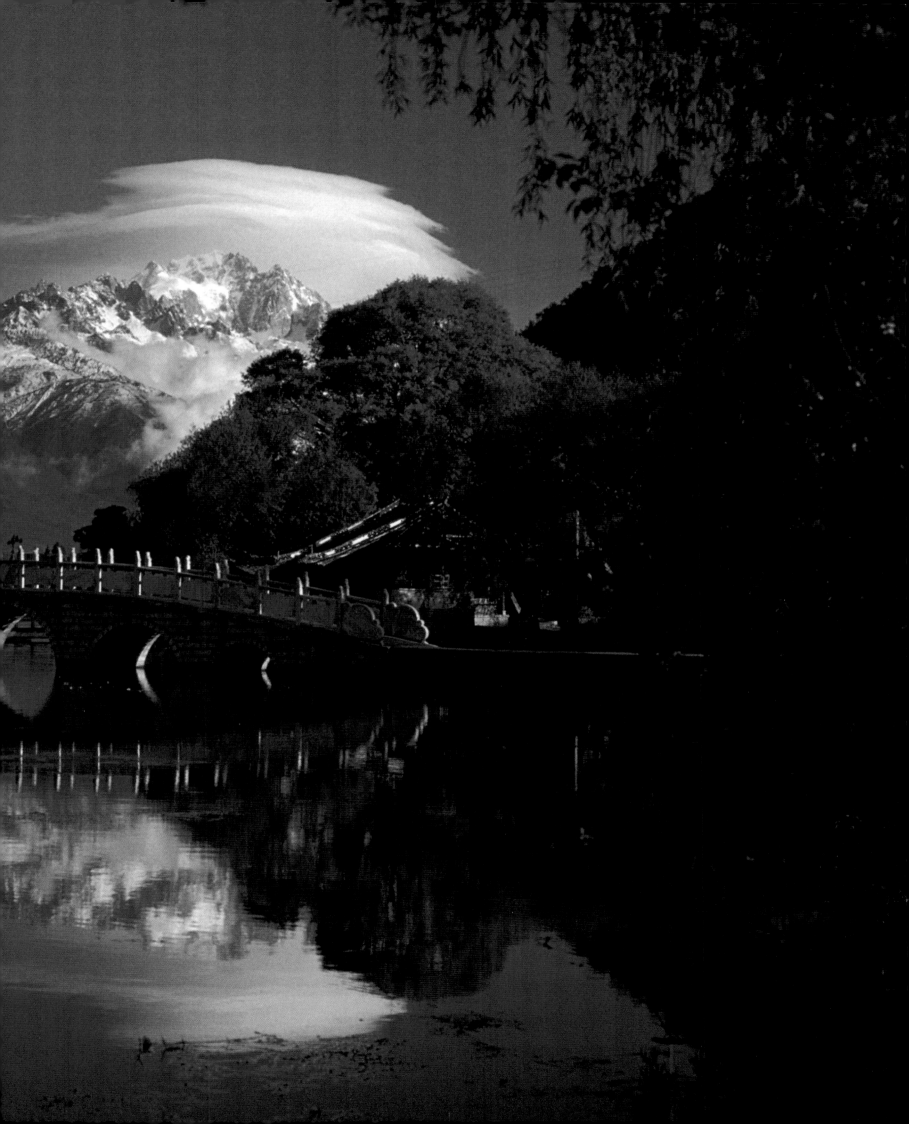

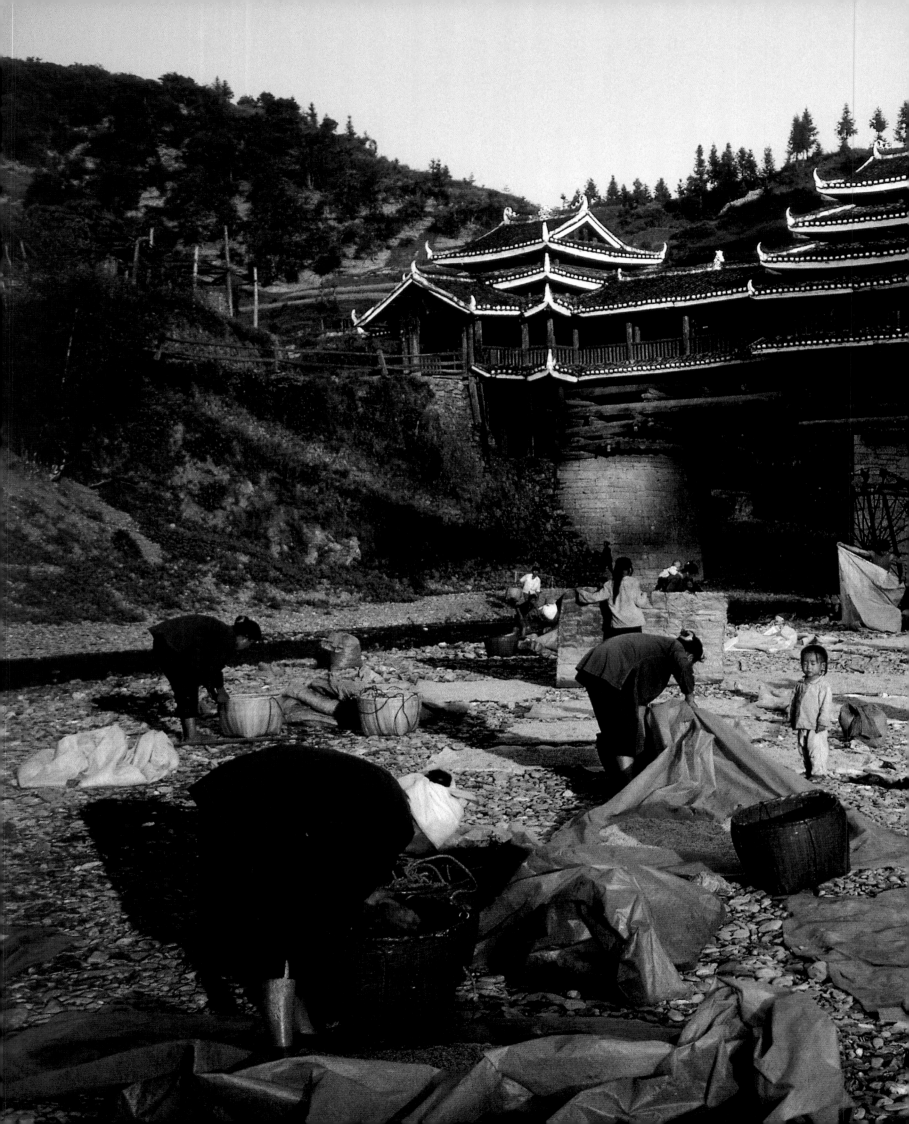

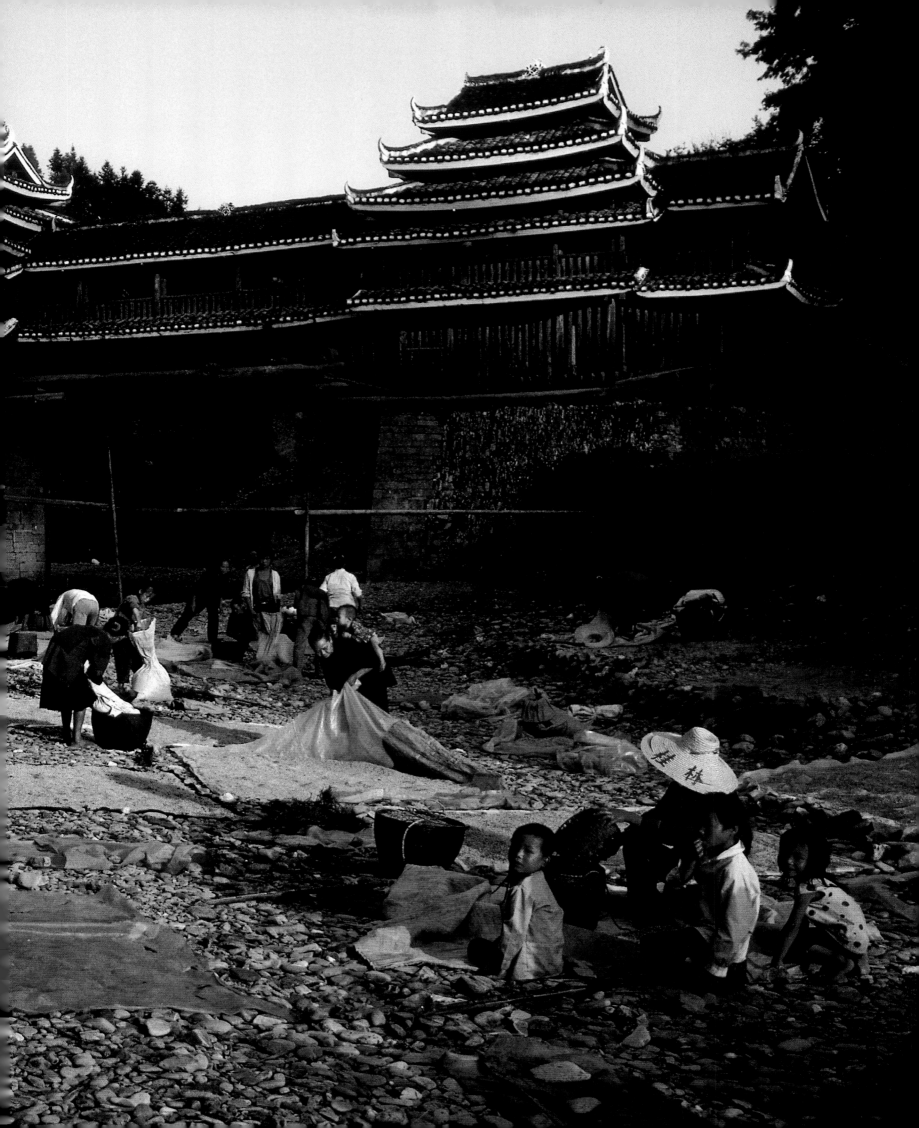

The Calahorra Bridge, Córdoba, Spain

Right:

Although Córdoba is famous for its mosque, with its forest of columns and two-tone arches, the history of Andalusia speaks of three communities living side by side—Jewish, Christian, and Muslim. It has left traces all over the city. Córdoba's old bridge is described as Roman, but that refers only to its distant origins; it was rebuilt by the Moors. Sixteen stone arches defend the tower across the Guadalquivir, the enchanted Andalusian river praised in Spanish poetry and song. Near the bridge a gigantic noria, used for irrigation, has been reconstructed: years ago it lifted water from the river to fill the fountains and pools of the Alcazar, where a highly elegant lifestyle once flourished.

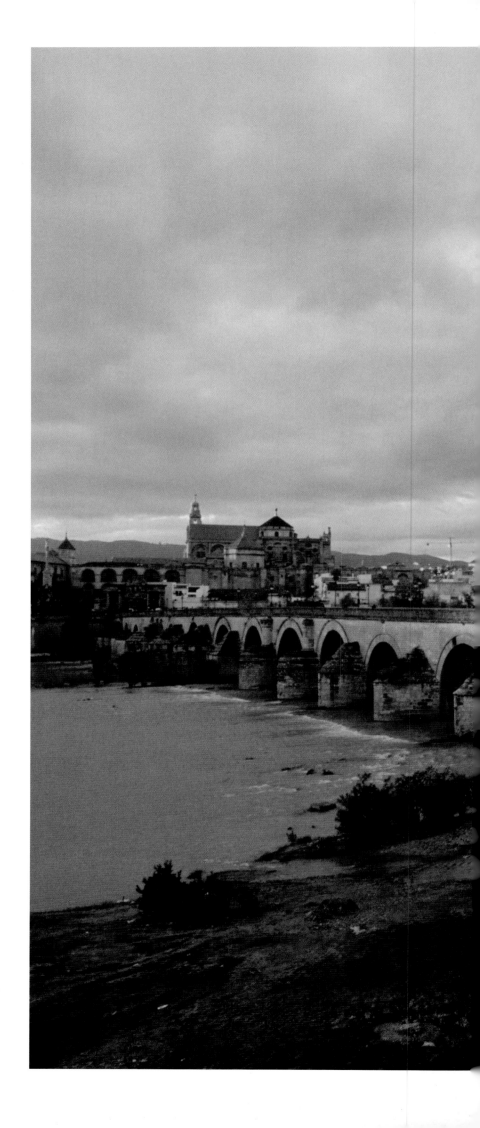

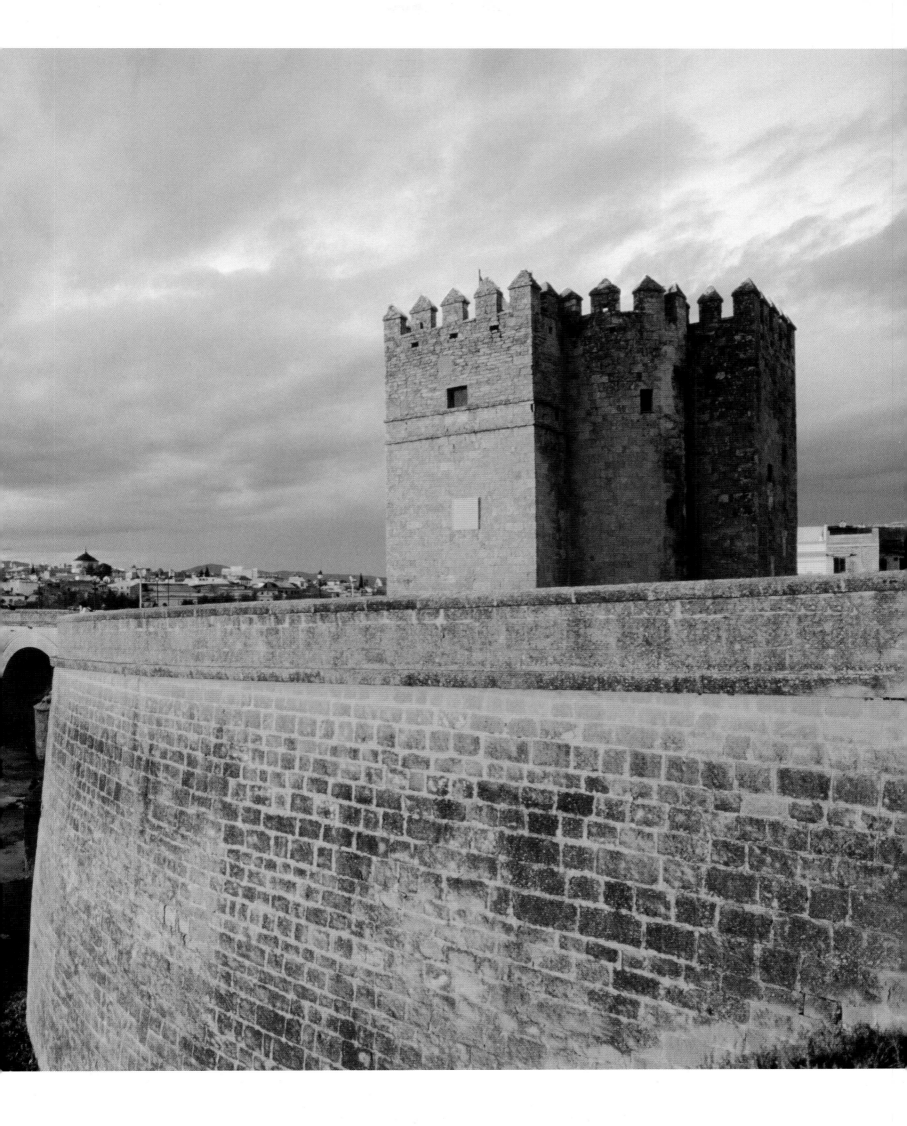

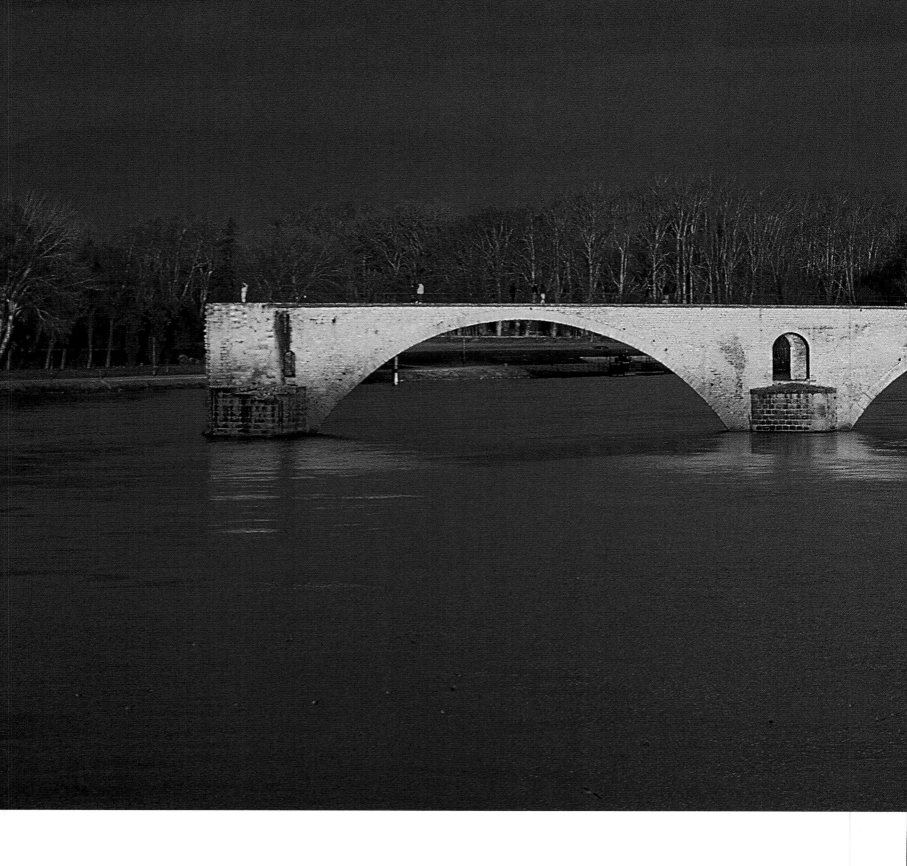

THE BRIDGE AT AVIGNON, FRANCE

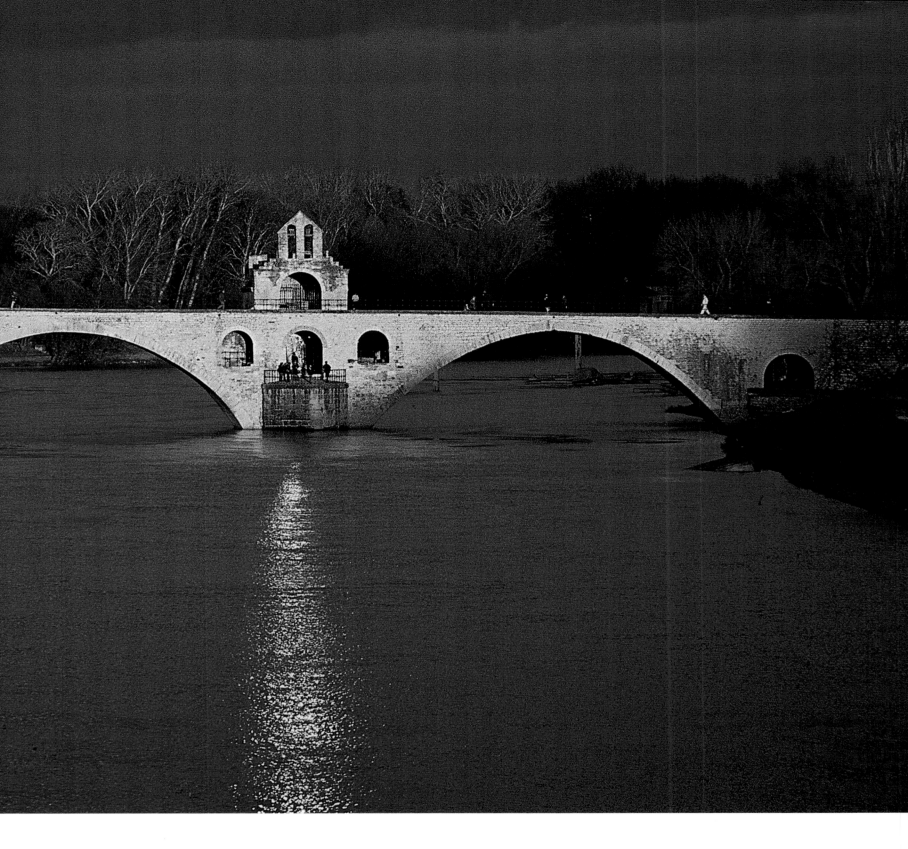

Above:

The singing and dancing popularized by the French nursery rhyme seldom take place today on the portion of bridge that has not been lost to the waters of the Rhône. But without the bridge, Avignon would not be Avignon. Roman foundations were used to sustain the first medieval bridge, which was initiated in 1177 by a certain Benezet, made a saint for his trouble. The bridge was rebuilt in stone in the thirteenth century, when it was 2,788 feet (850 meters) long and comprised twenty-two arches; two defensive installations protected its approaches. The fact that only four arches remain today is testimony to the power of the Rhône in flood. The bridge was abandoned in the sixteenth century, and the force of the water tore down most of the rest with the passage of time and the river.

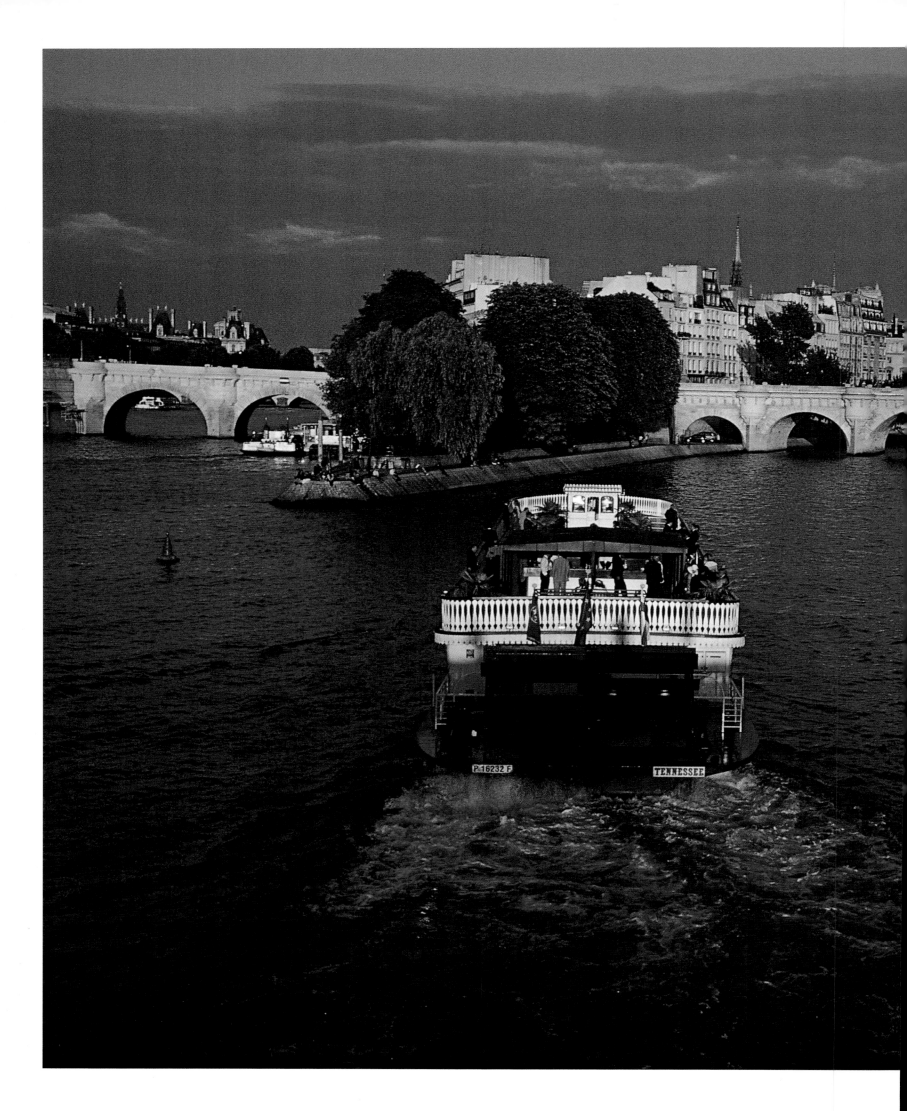

ÎLE DE LA CITÉ, PARIS, FRANCE

Left:

Its island shape is that of a ship anchored in the middle of the Seine, like the medieval ship on the city's coat of arms. And the cathedral of Notre-Dame is its mast. The prow is the Square du Vert-Galant, which abuts the Pont-Neuf, while at its rear is the moving Deportation Memorial, also sited in a square. Visible between these two extremities are the effects of nineteenth-century town planning, which rebuilt the Palais de Justice, the law courts, and the Hôtel-Dieu, the infirmary. Here, too, are reminders of the Middle Ages, when the Île de la Cité was the dense heart of Paris: Notre-Dame itself, with the archaeological crypt beneath its forecourt; the jewel of stone and glass that is Saint Louis's Sainte-Chapelle; and the towers of the Conciergerie, where Queen Marie-Antoinette spent her last hours.

TOWER BRIDGE, LONDON, ENGLAND

Following pages:

Tower Bridge, one of London's classic sites, is the glory of the city's river, the Thames. Opened in 1894, its roadways are still raised when a large boat needs to travel upstream into the old Port of London. The two matching roadways, which meet in the middle, are constructed of steel, as is the entire structure. Even the towers, which are faced in stone, are steel-framed. Elevators give access to the upper walkway between the two towers. The bridge's location in the heart of the city makes it a remarkable observation point.

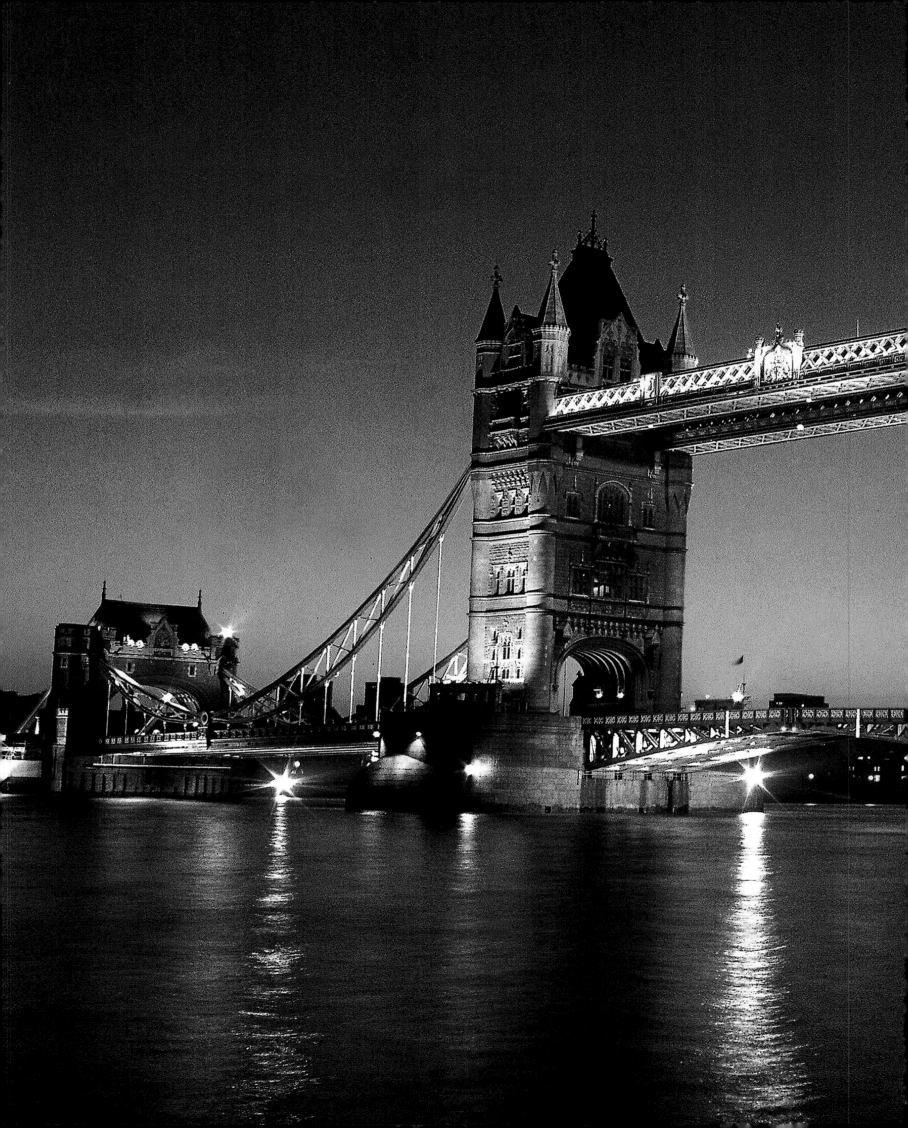

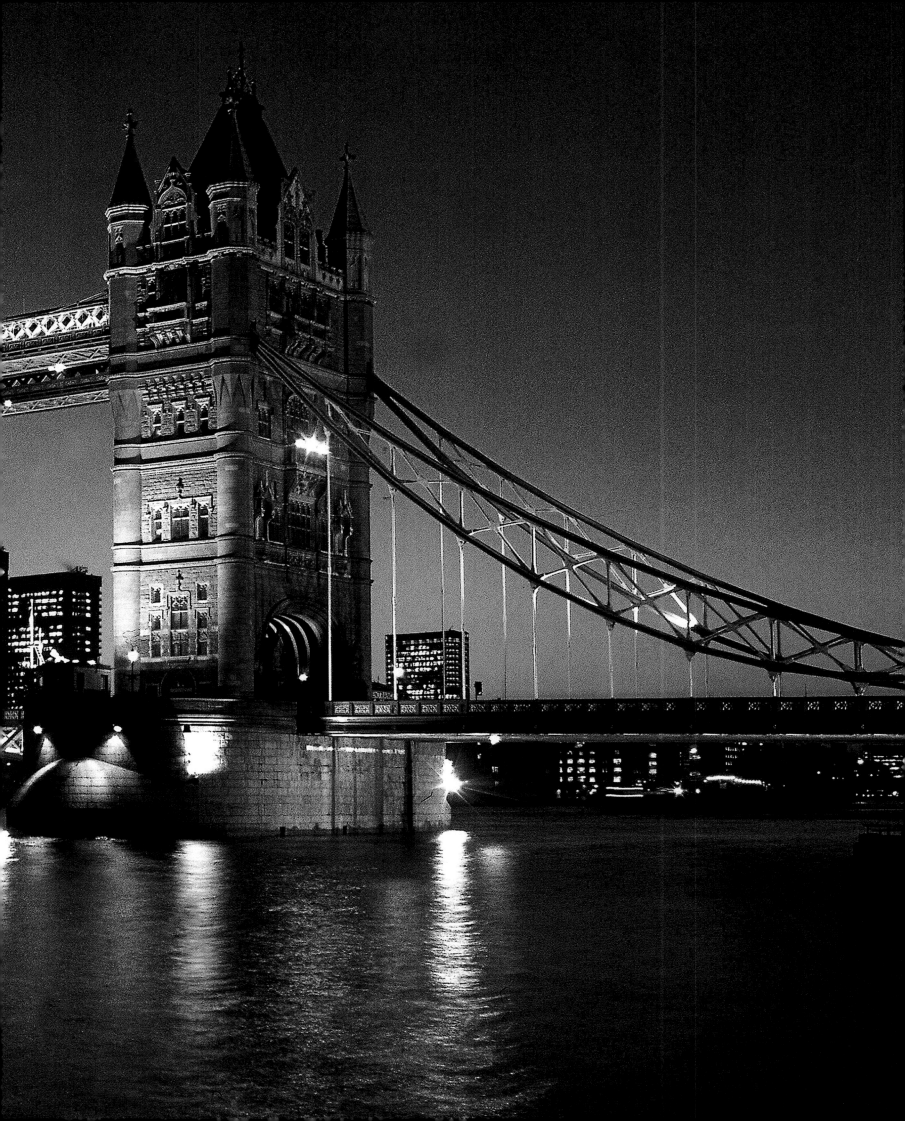

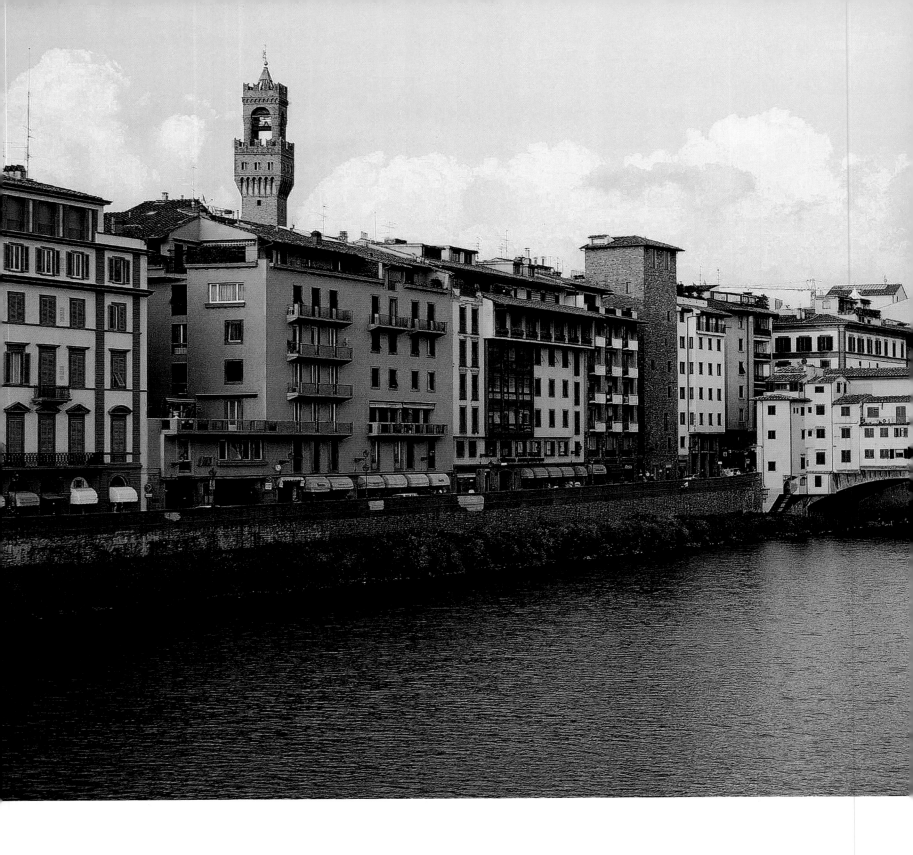

THE PONTE VECCHIO, FLORENCE, ITALY

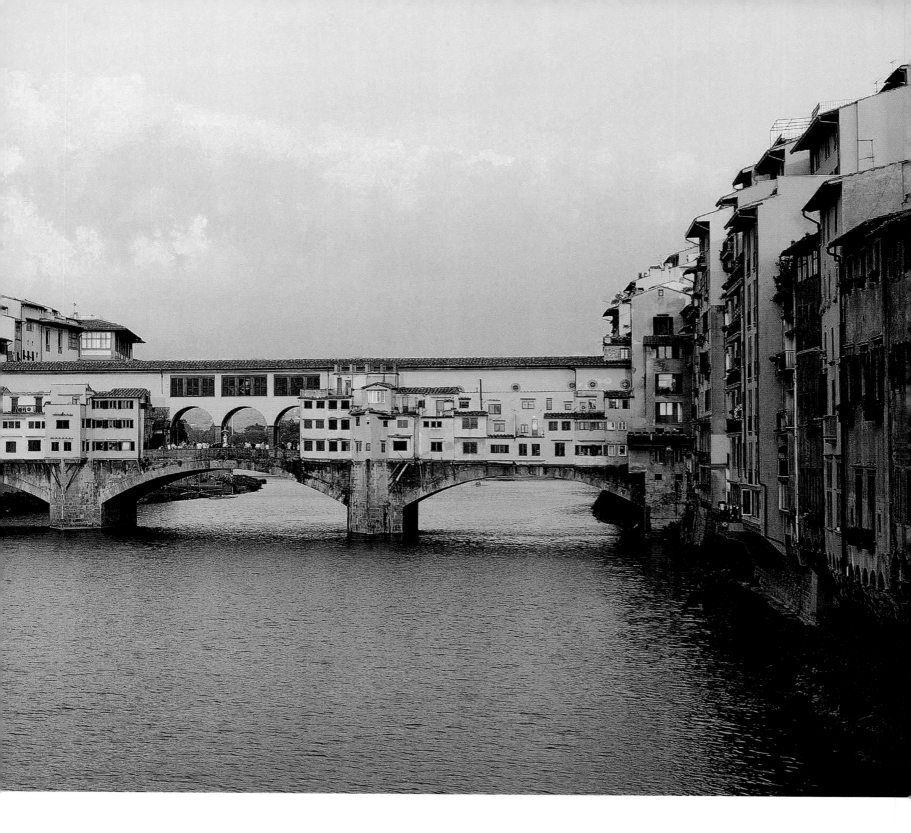

Above:

The Medici city grew up on the banks of the Arno River, in the enchanted setting of the Tuscan hills. In spite of its charm, the river is prone to violent flooding. For many centuries the famous Ponte Vecchio spanning the Arno has been covered in shops; and there is still an enclosed walkway across the top of the bridge. This corridor, sited between houses and above streets, provides an uninterrupted link between the Palazzo Vecchio (Florence's Town Hall and once the Medici's administrative offices) and the Palazzo Pitti. A "new" palace, the Palazzo Pitti was built in 1450 in the Renaissance style of the times and purchased a century later by the Medici family, who were doubtless weary of their old medieval fortress, the Palazzo Vecchio. Thanks to the bridge and its corridor, their commercial secrets remained secret.

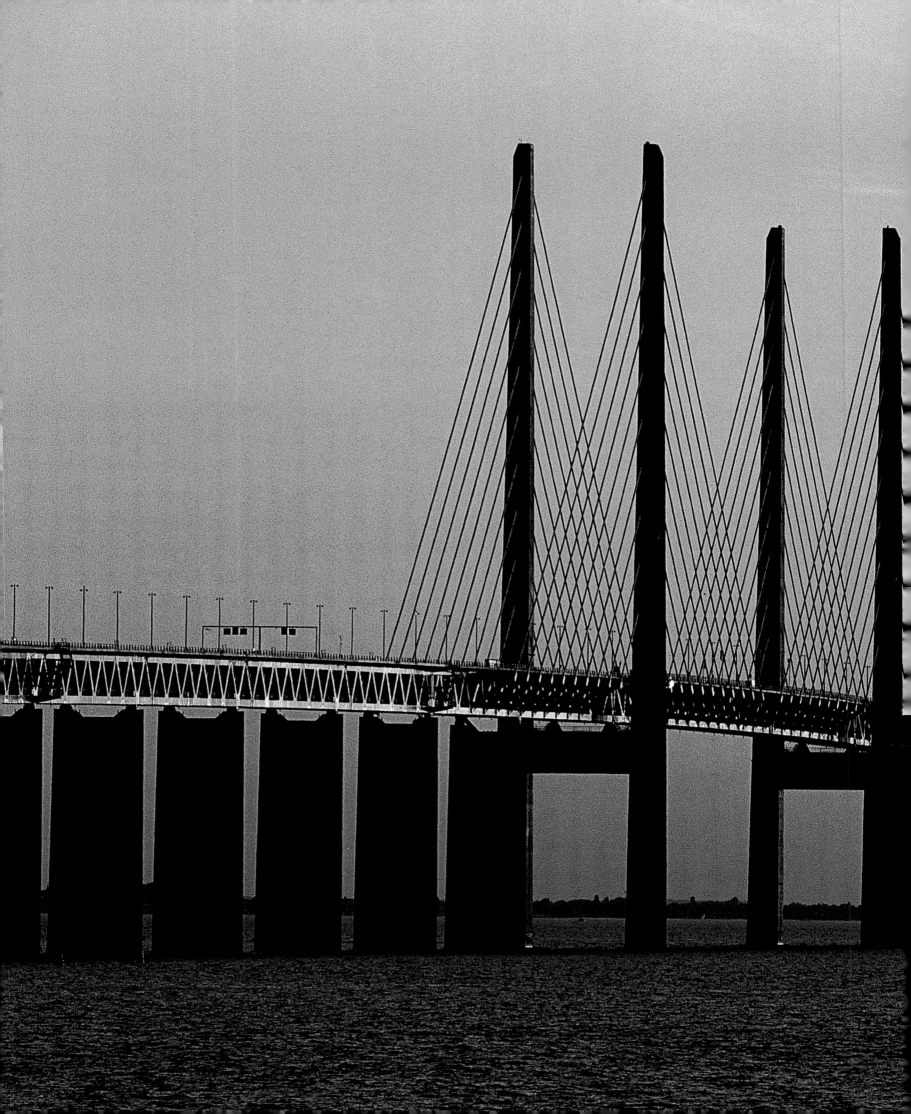

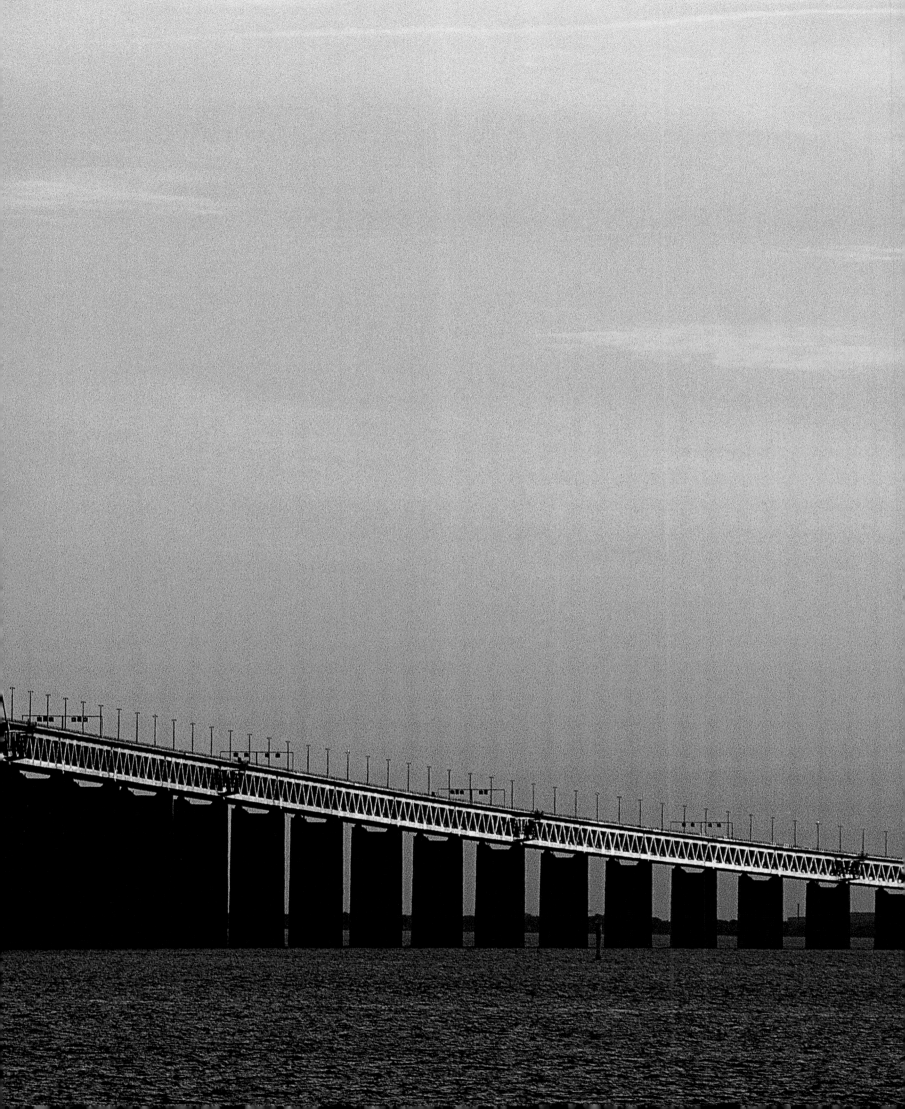

THE ØRESUND BRIDGE, DENMARK AND SWEDEN

Preceding pages:

The Øresund is the strait, 62 miles (100 kilometers) long and varying between 2 miles (3 kilometers) and 25 miles (40 kilometers) in width, separating Denmark from Sweden and linking the North Sea to the Baltic. The two countries are no longer totally separate, since from the year 2000 they have been joined by a bold feat of engineering that links Copenhagen in Denmark to Malmö in Sweden. Extremely shallow—in places less than 33 feet (10 meters) deep—the Øresund has always been a challenge to navigation, even though it remains a busy stretch of water. The strait's shallowness is ecologically beneficial, since it limits water exchange between the two seas. The bridge is the most visible part of a road and rail link 10 miles (16 kilometers) in length, which includes a sunken tunnel of 2.3 miles (3.7 kilometers) and an artificial island 2.5 miles (4 kilometers) long.

THE MILLAU VIADUCT, FRANCE

Right:

The slim, elegant profile of the viaduct connecting the Causse Rouge to the Causse du Larzac above the Tarn Valley is now an integral part of the highway landscape of the far south of France. Despite its technical prowess, it was built quickly, from the laying of the first stone in December 2001 to inauguration in December 2004. It took only three years to erect two buttresses and seven concrete piles, including the highest in the world, and to throw a metallic roadway across the valley longer than Paris's Champs-Élysées. The astonishingly light geometric lines of the bridge were designed by the English architect Norman Foster. He utilized the principle of the cable-stayed bridge, with cables supporting sections of roadway on either side of each pile.

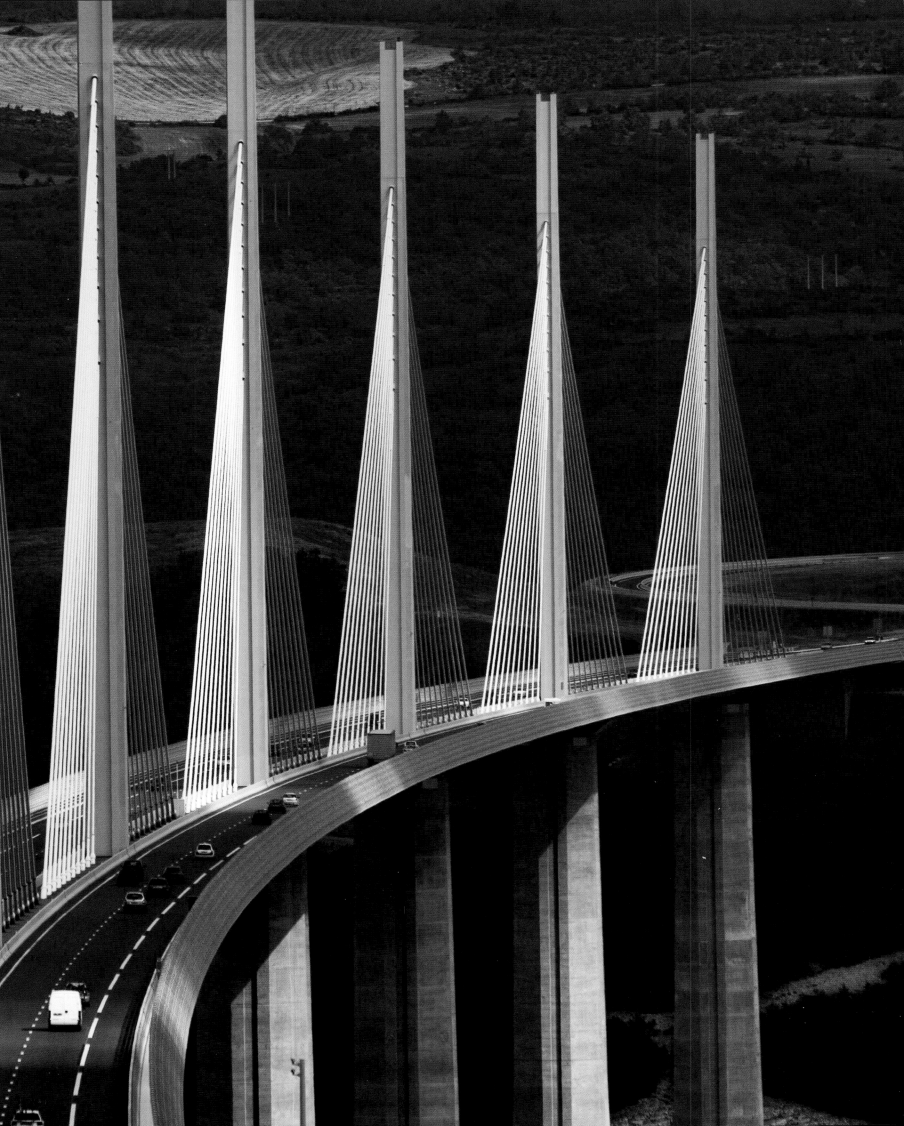

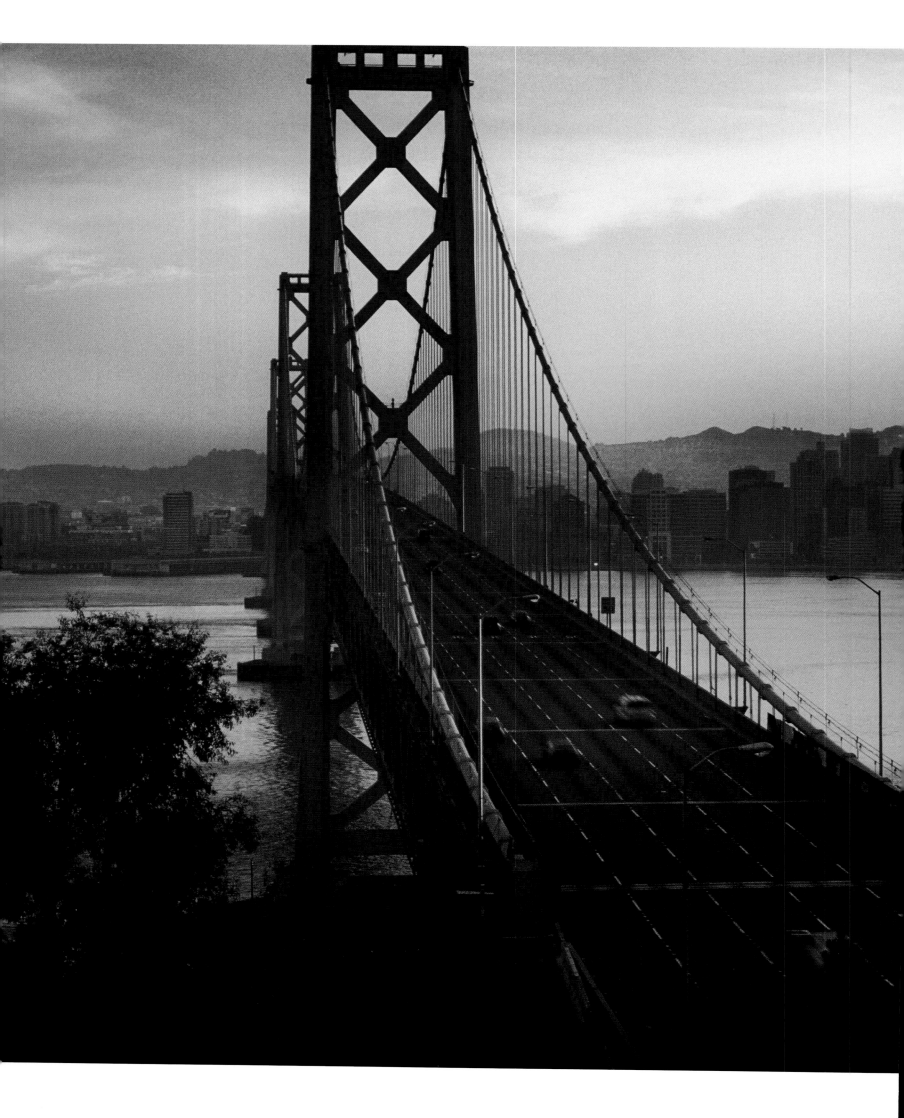

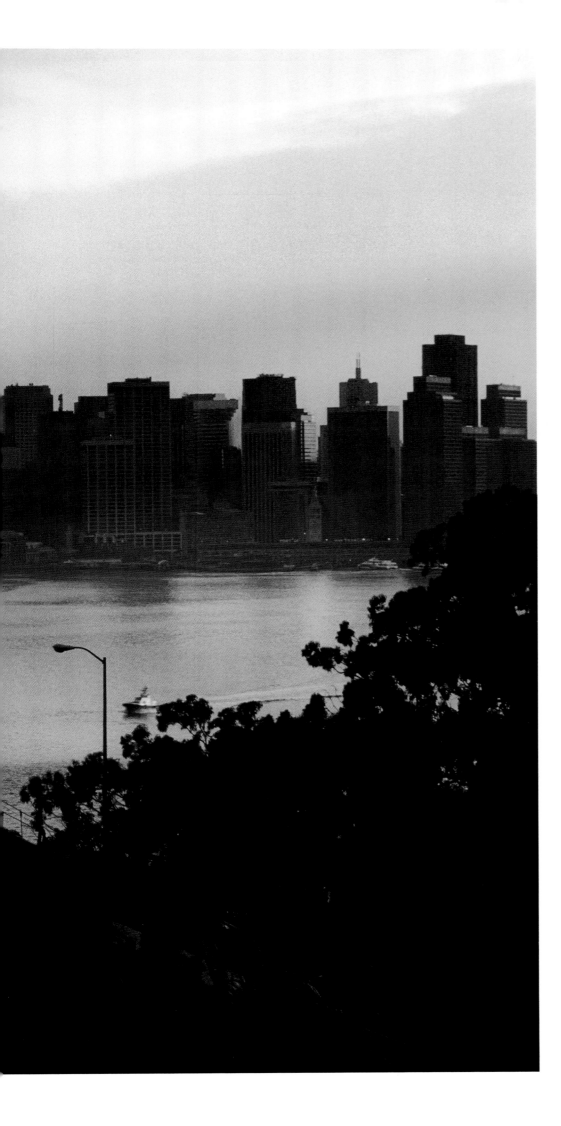

SAN FRANCISCO BAY AND THE SAN FRANCISCO–OAKLAND BAY BRIDGE, USA

Left:

Not simply a monument to technical achievement as it strides across San Francisco Bay, the Oakland Bay Bridge—known as the Bay Bridge—is also a magnificent work of art, an elegant rival to the iconic red-orange Golden Gate Bridge. Sitting astride the Bay, both gigantic suspension bridges have become famous emblems of the final stage in the epic American conquest of the West, the drive toward California. Although the Spanish had already founded a mission here dedicated to Saint Francis some centuries earlier, it was the 1849 Gold Rush that created the city, followed by the arrival of immigrants disembarking at the terminal stage of the first transcontinental railroad. The Bay Bridge connects San Francisco and Oakland, with an intervening link on Yerba Buena Island: its western span connects San Francisco to the small island in San Francisco Bay, and its eastern span connects Yerba Buena to Oakland. It comprises two suspension bridges, a tunnel, and another bridge leading to the eastern span—in other words, 9,223 feet (2,815 meters) of roadway carried by four immense metal pylons; 1,791 feet (546 meters) underground; and 10,145 feet (3,093 meters) over six spans supported by steel girders. The entire system, which was opened in 1936, took three years and four months to build. The bridge was designed to carry traffic on two decks, originally automobiles on the top level, and trucks and trains on the lower. Nowadays each deck takes a single direction of road traffic.

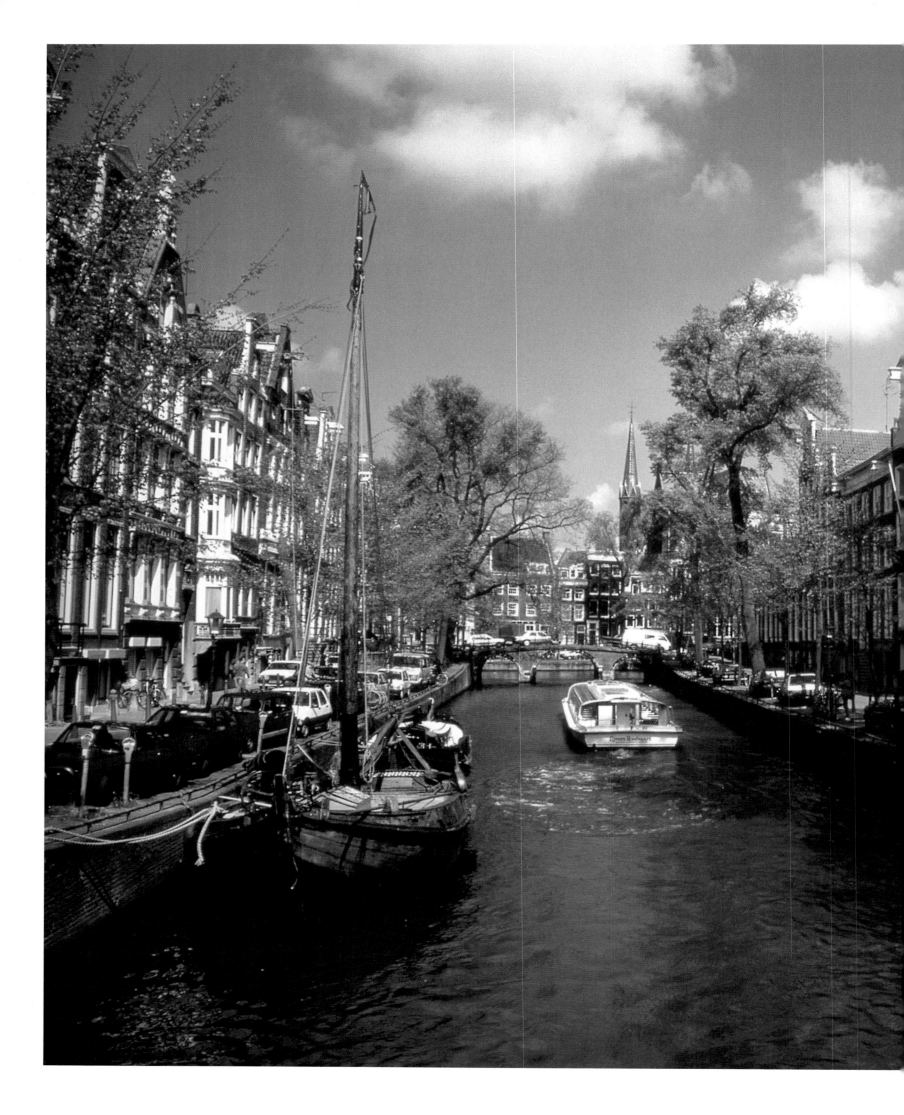

AMSTERDAM, THE NETHERLANDS

Left:

Much time separates the herring fishermen of the thirteenth century from the international assortment of seamen, businessmen, and traders who have turned Amsterdam into one of Europe's leading economic centers. Since the Middle Ages, Amsterdam has been a port and commercial hub. The seventeenth century was the city's "golden age," when its ships sailed throughout the world. A century earlier, the granting of religious liberty had seen the arrival of Jews, Huguenots, and thinkers regarded as too daring elsewhere, contributing to Amsterdam's status as an intellectual and artistic center of the first order. To assist expansion of the port, canals were dug to deliver merchandise to the heart of the city, where buildings were often constructed on stakes behind solid dikes. Still lively today, these canals, with their gabled houses, are vital to the charm of the heart of old Amsterdam.

THE SALUTE, VENICE, ITALY

Following pages:

From the wharves, the tall white mass of the Basilica di Santa Maria della Salute marks the entry to the Grand Canal. A jewel of the Venetian Baroque, it was erected in thanksgiving to the Virgin for ending a terrible outbreak of plague in 1630. The church's silhouette rears up like a monumental sign, offering holy protection for the gondolas that are moored close to Saint Mark's Square. A million wooden posts must have been driven into the lagoon's unstable silt to bear the edifice. Such was the system of building everywhere in Venice, a city threatened by the very waters that are the source of its attraction. Venice has always drawn its livelihood from the water, not least during the centuries of its dazzling prosperity, when the canals and lagoon opened to seas, oceans, and the world.

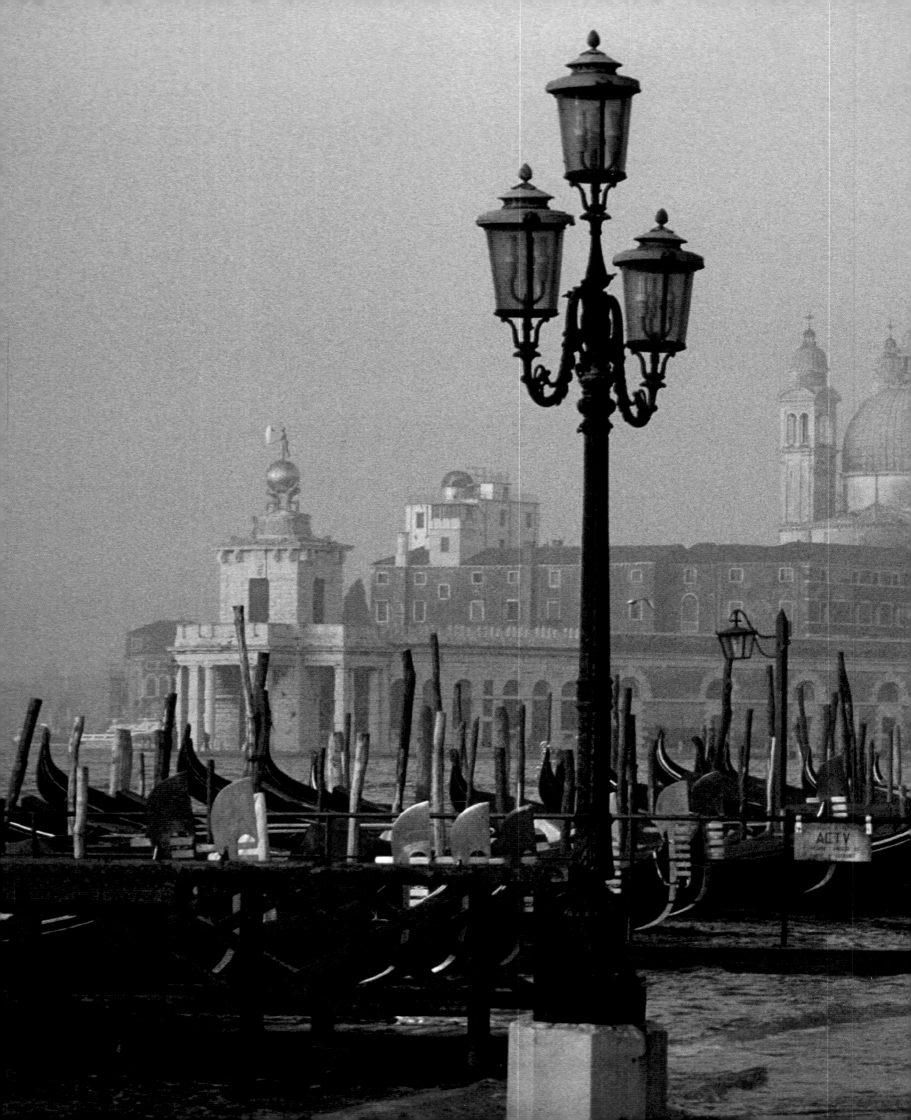

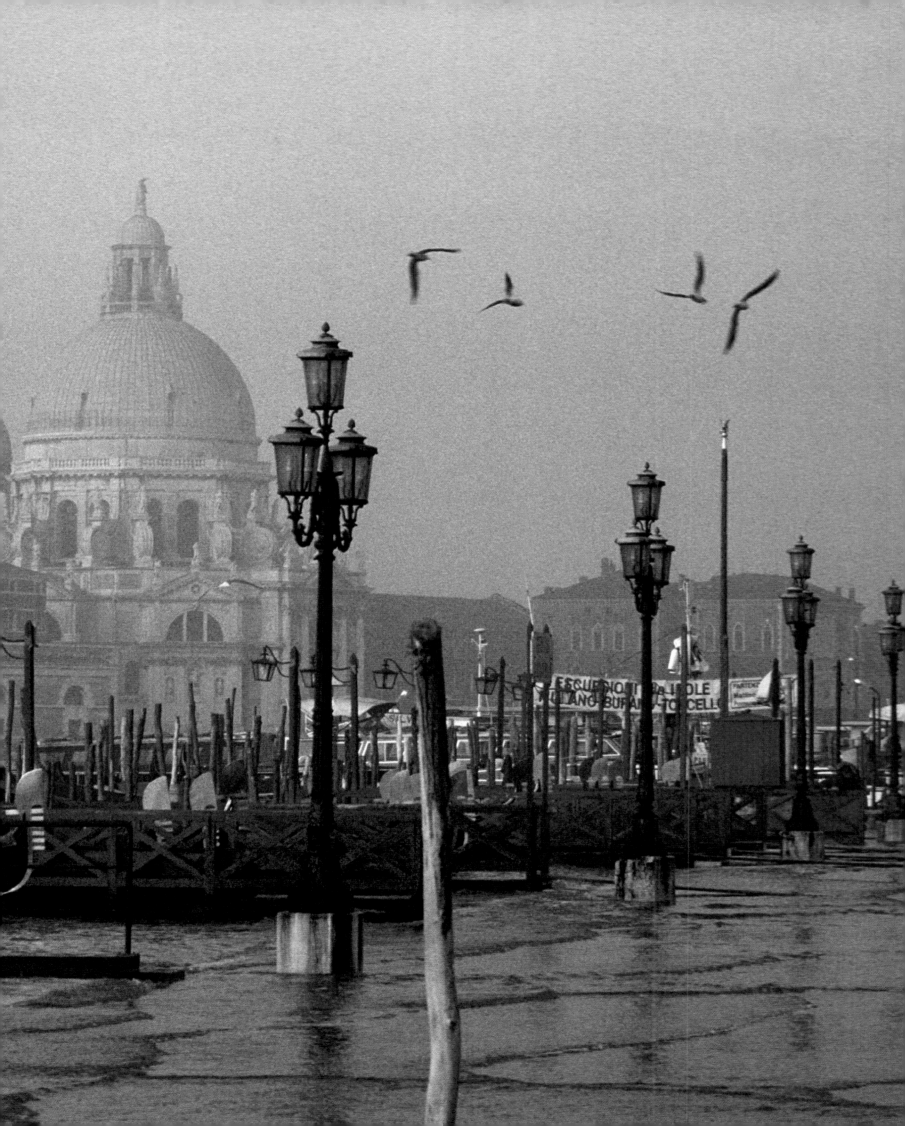

THE TREVI FOUNTAIN, ROME, ITALY

Right:

Here is a scene of Baroque profusion, the spirit of Rome expressed in stone as water spurts from an extravagant fountain in a tiny square. Rome's most celebrated fountain, designed in 1732 by Niccolò Salvi, depicts Neptune on his chariot drawn by Tritons. The grandiosity of the work is emphasized by its backdrop—a monumental portico set in the façade of a palazzo. It is customary for those wishing to return to Rome to cast a coin into the fountain, which is still fed by a Roman aqueduct dating from the time of Agrippa. Its construction is evoked on a bas-relief, while a second represents the young girl who was supposed to have shown the site of the primitive fountain to two of the emperor's soldiers. The fountain's name comes from the Latin *trivium*, meaning a junction of three roads.

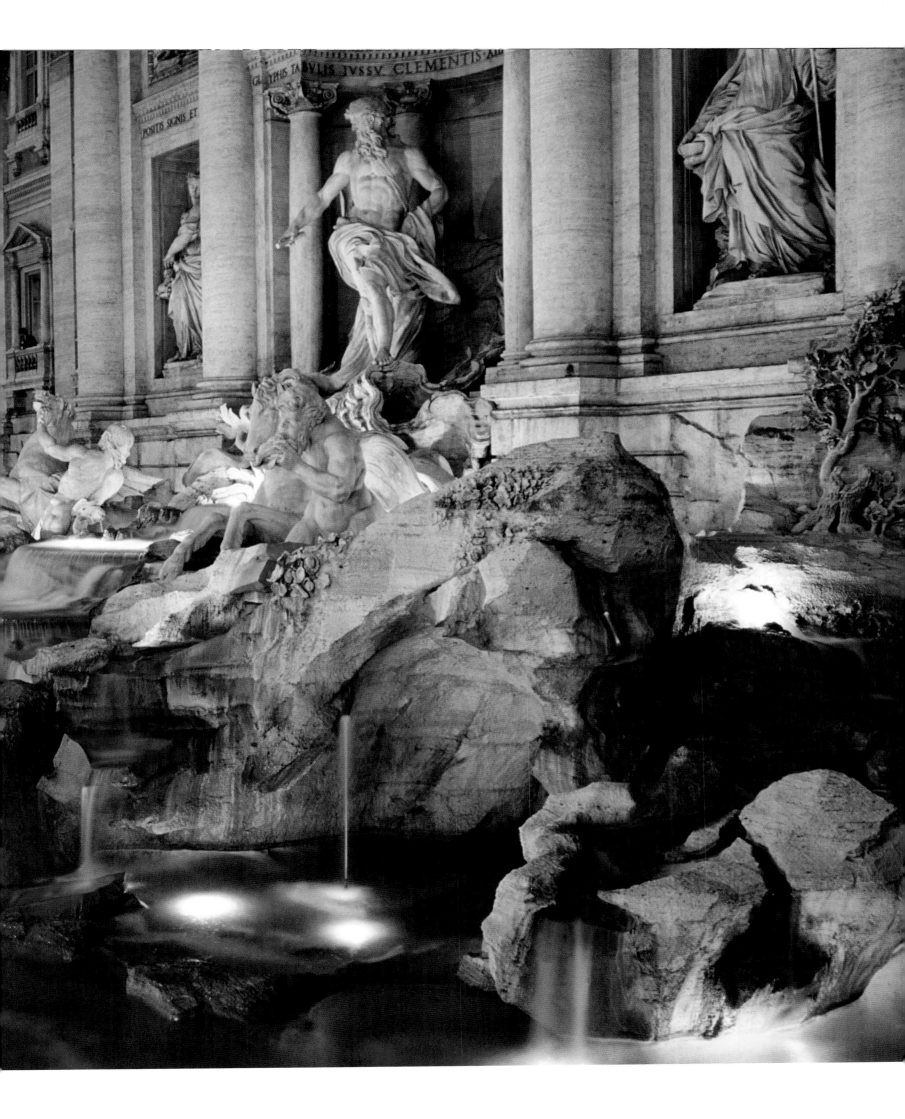

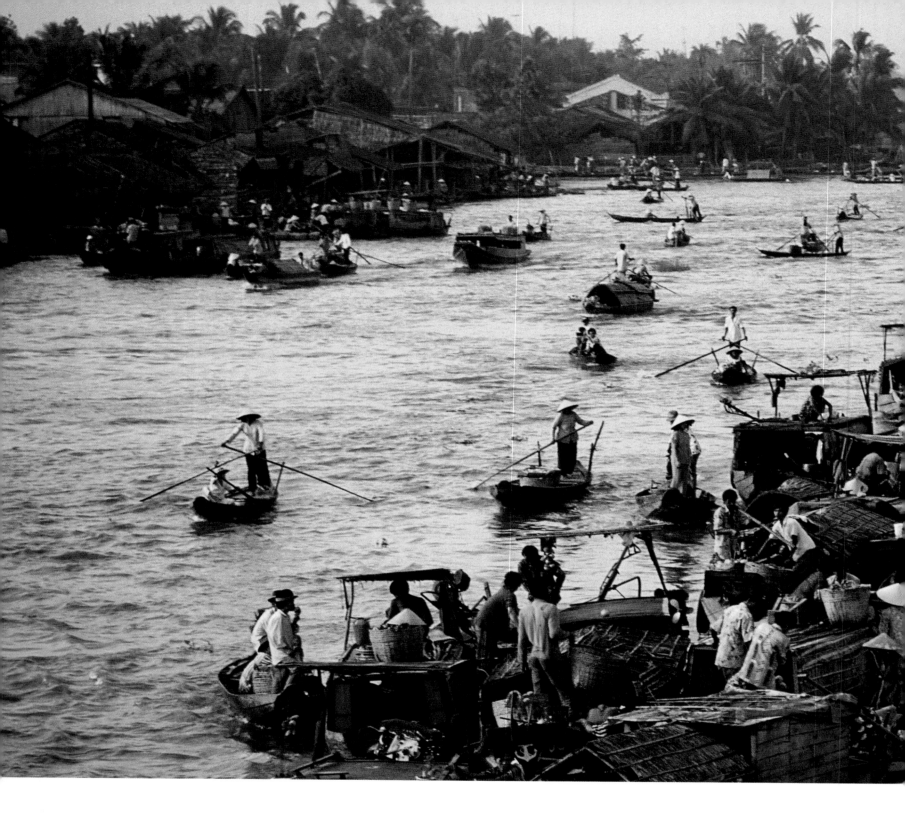

THE MEKONG RIVER, SOUTHEAST ASIA

Above:

The Mekong is the world's eighth largest river by volume of water, and Southeast Asia's longest. It rises at an altitude of 16,400 miles (5,000 meters) in the Tibetan massif and discharges into the South China Sea. Along its 2,976 miles (4,800 kilometers) it passes through China, Laos—where it marks the border with Thailand—Cambodia, and Vietnam. At least half of this distance is located within China, where the river rushes through gorges before finally calming down as it splits into multiple branches in an immense delta. Despite its importance, its resources in terms of fishing, irrigation, transport, and hydroelectricity have not yet been fully harnessed to benefit the 50 million people who live along its banks. The Mekong is navigable from the Chinese border to its delta, apart from the area around the Khone Falls, between Laos and Cambodia. The delta extends over some 27,620 square miles (44,548 square kilometers) among mountains and hills; here rice is grown and flat-bottomed boats, or sampans, are much used for transport.

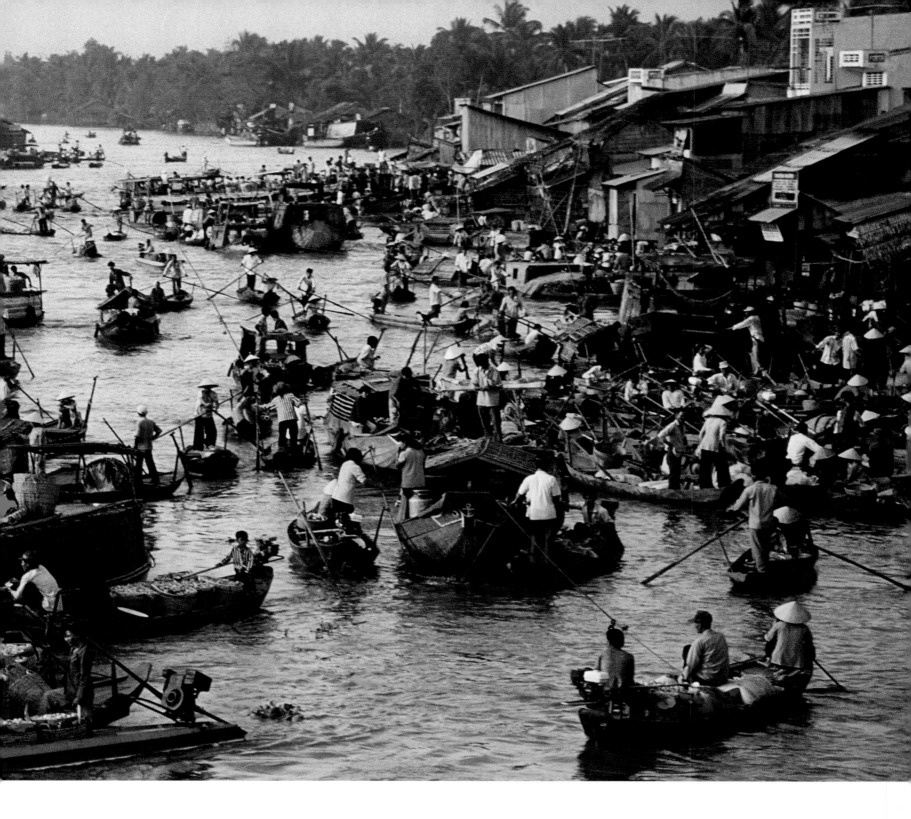

HA LONG BAY, VIETNAM

Following pages:

Local legend has it that the diving of an underwater dragon—Ha Long, in Vietnamese—caused the drowning of a mountain range whose summits alone can be seen today. But the bay, not far from the Chinese border, needs no legend to charm the beholder. More than two thousand rocks soar vertically from the sea, covered in vegetation and often riddled with caves. Dotted about are fishermen who live either on their boats or in houses built over the water. The bay's topography is karst in origin, the result of primeval limestone having been deeply eroded by tributaries of the Red River, by winds, and by the sea.

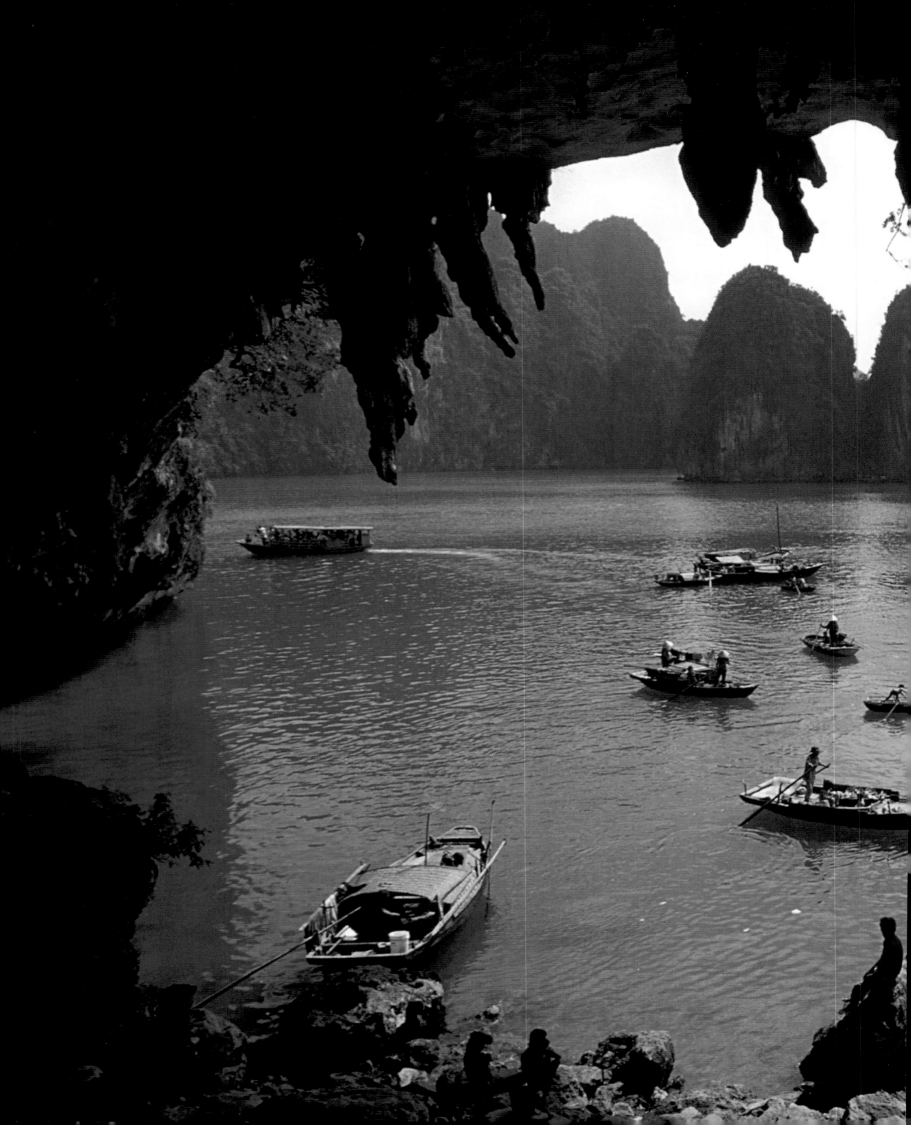

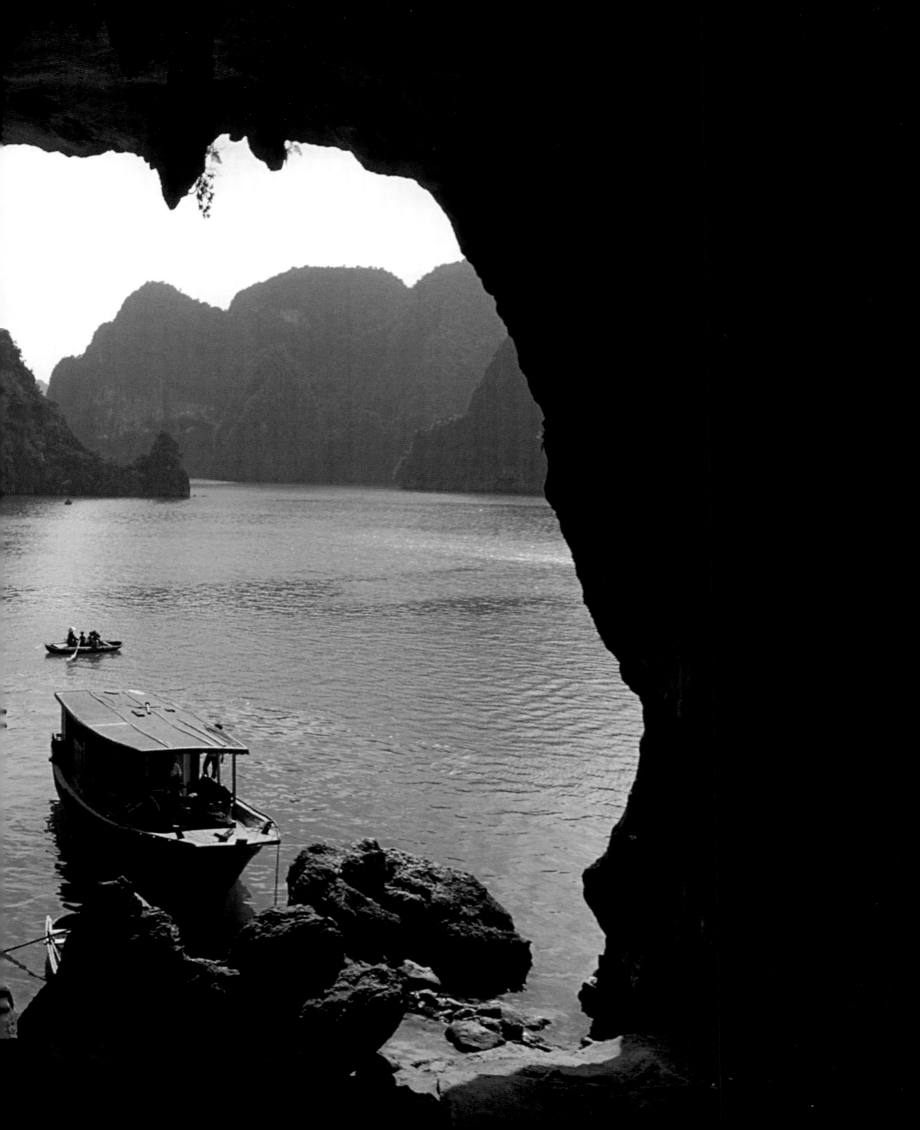

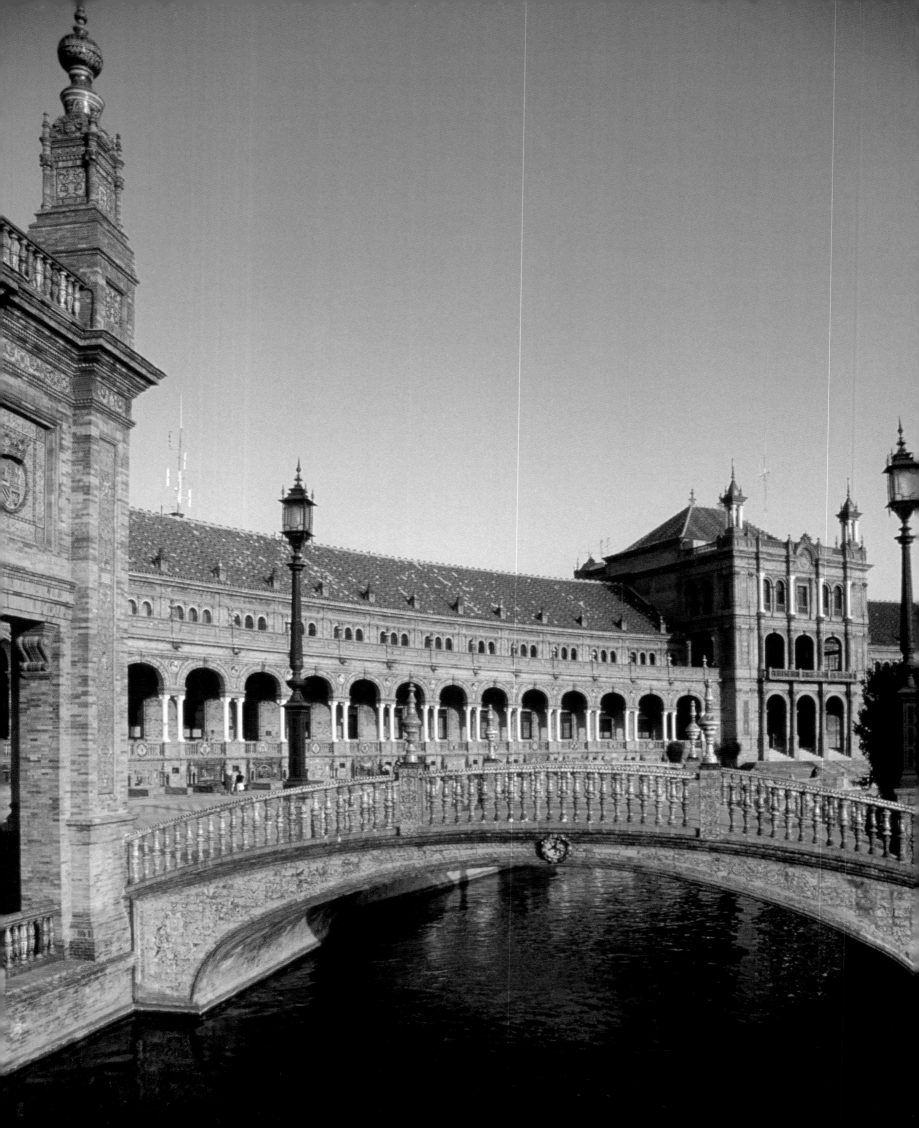

PROUD PALACES AND SEATS OF POWER

It is said that money makes the world go round. It certainly helped to demonstrate that the world was really round when, toward the end of the Middle Ages, caravans and caravels set off in every direction in search of gold. When Marco Polo and Christopher Columbus, followed by Magellan, sailed across the seas, it was not simply adventure that they were after. They were in search of Eldorado. As José-María de Heredia wrote in his poem *The Conquerors*: "They were going to conquer the fabulous metal / That Cipango matured in his distant mines." The great discoveries of the sixteenth century opened a new era of knowledge, economic exchange, and profitable settlement in which gold, the symbol of power—incorruptible and radiant as the sun—held pride of place. Thereafter, power would be identified with splendor, wealth would be conspicuous, and ostentation would become an art.

The appetite for richness was a universal phenomenon, and its influence lasted several centuries. We witness it first in the East—from Japan, the "land of the rising sun," where the late medieval Himeji Castle (pages 124–25) has the air of a heavenly bird, to Tibet, where the Fifth Dalai Lama made his capital at Lhasa (pages 118–19), building the red-and-white Potala Palace to serve as headquarters of a centralized theocracy. Meanwhile, in Ming Dynasty China, Beijing's Forbidden City (pages 120–21) in the fifteenth century had already been given its 9,999 chambers beneath roofs of yellow tiles; yellow is the aristocratic color reserved for imperial palaces. At this time in the West, such stirrings had barely begun, except in Italy, with its flourishing Renaissance. It fell to early-sixteenth-century King Francis I of France to prescribe Renaissance as the style for majesty. A courteous lover of pastimes, hunting, and dancing, Francis was also a patron of the arts; he invited Leonardo da Vinci to Amboise (pages 68–69). He also embarked on construction of what would be the most lavish château on the Loire, at Chambord (pages 128–29), even though it was never lived in! Perhaps Chambord's forest of pinnacles and chimneys was designed to dazzle Emperor Charles V, then master of half the world, who was invited to admire the building in 1539.

Whatever the truth of the assertion, absolutist splendor was certainly on the rise when Louis XIV, the Sun King of France, made his contribution. Prior to his reign, building stone had never expressed so much pride or self-aggrandizement. The Versailles (pages 117 and 142–43) of Louis XIV still fascinates. The château is a triumph of classicism, with its harmonious blend of straight lines, rigorous desire for symmetry—including the gardens—and perfect match of building to function. The greatest architects and designers of the period worked on it, including the architects Louis Le Vau and Jules Hardouin-Mansart, the landscape designer André Le Nôtre, and the decorator Charles Le

Plaza de España, Seville, Spain

Brun. Yet the palace interior contains Baroque treasures as well. There is gilt everywhere—the gold that, according to the moralist Boileau, "lends a hue of loveliness to everything, including the ugly"—from the Gallery of Mirrors to the Royal Opera, and from the ceremonial rooms to the bathrooms. In this last department, the king was content to use a chair with a hole in it at a time when the Chinese had already invented hygienic paper. But woes could befall anyone who insolently tried to hold a candle to the splendors of Versailles. When, in 1661, the minister of finance Nicolas Fouquet invited Louis XIV to a reception fit for the court at his own château of Vaux-le-Vicomte (pages 140–141), he was rewarded with life imprisonment for daring to outshine the king.

The splendor of Versailles radiated abroad. Late in the seventeenth century, it encouraged Sultan Moulay Ismail, one of the founders of the Alawite dynasty that ruled Morocco, to build the royal city of Meknes, often described since as "the African Versailles," though in truth its architectural style is closer to that of the Moorish-Spanish Alhambra Palace in Granada, Spain (pages 122–23). The sultan actually asked the Sun King for the hand of one of his legitimate daughters, Marie-Anne de Bourbon, Princess of Conti, whose charms he had heard about from an ambassador. Sultan Moulay Ismail was rejected, but he received four large Comtois clocks in compensation. Other courts in Europe entered the competition. Every new palace copied Versailles. None was its equal, but each had its unique elegance. Small replicas of Versailles were created at some German courts and in Sweden, Hungary, and Poland. Czar Peter the Great of Russia surrounded his Peterhof in St. Petersburg (pages 146–47) with majestic parks, gardens, and fountains, including a Grand Canal that flowed into the Baltic. In Austria the Habsburg monarchy embellished its summer residence at Schönbrunn (pages 144–45), near Vienna, never imagining for a moment that the future Empress Sissi would one day find it boring.

Along with the architecture, the etiquette invented at Versailles was no less influential. The way in which it sanctified every detail of daily life was copied by all aristocrats of substance, who invited a host of courtiers to their receptions and balls. They donned brocades and silks, dined off silver-gilt plate, used crystal glasses when they drank, and indulged in verbal jousts and battles of wit. There is no doubt that gold occupied their thoughts, just as it decorated their dwellings. The fabulous metal ripped from faraway mines still dazzles us when we contemplate the gilded palaces and seats of power of the past. But today no monarch or ruler would dare to outshine the Sun.

The Château of Versailles, France

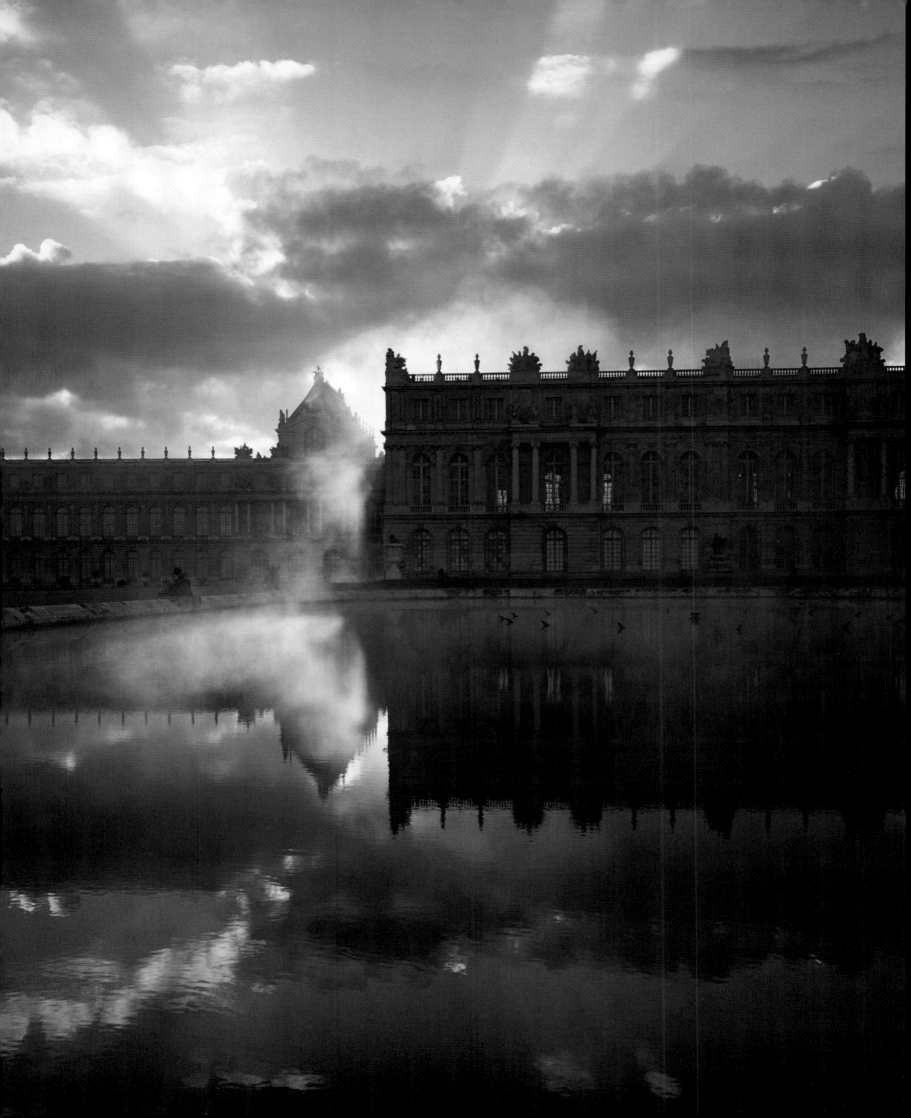

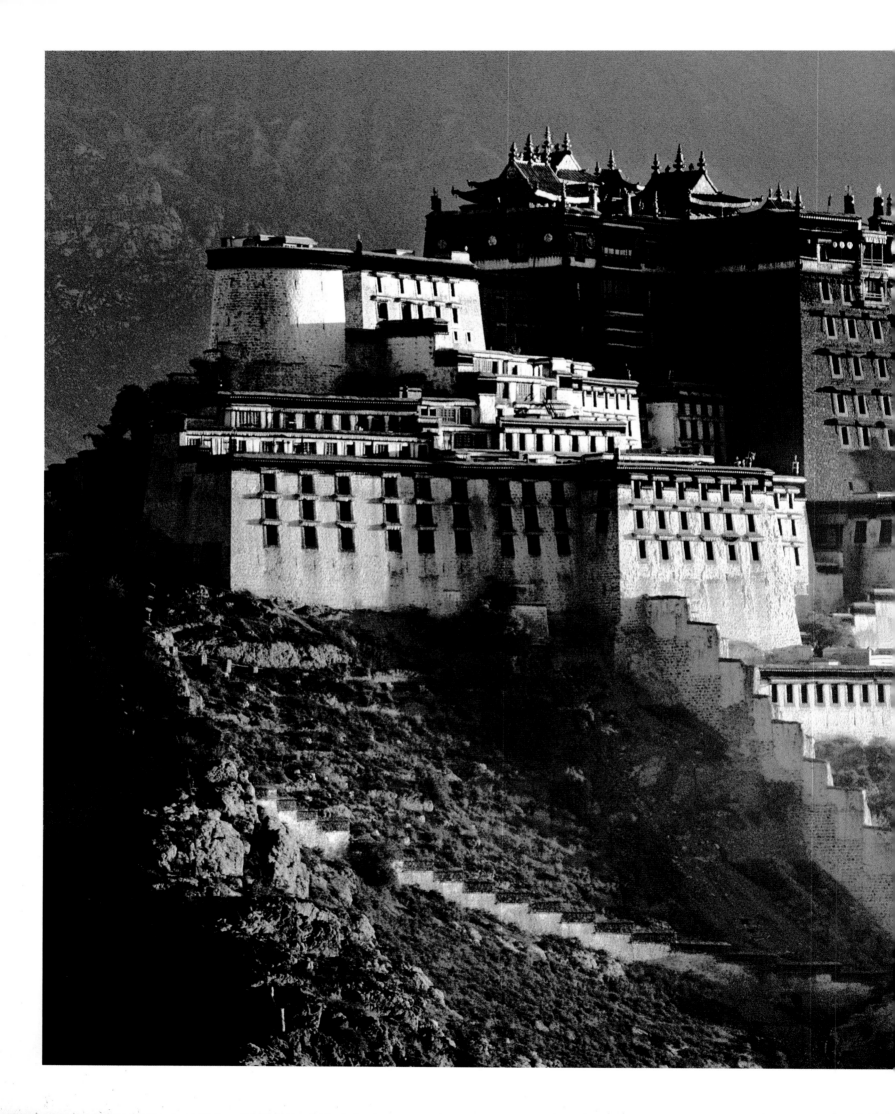

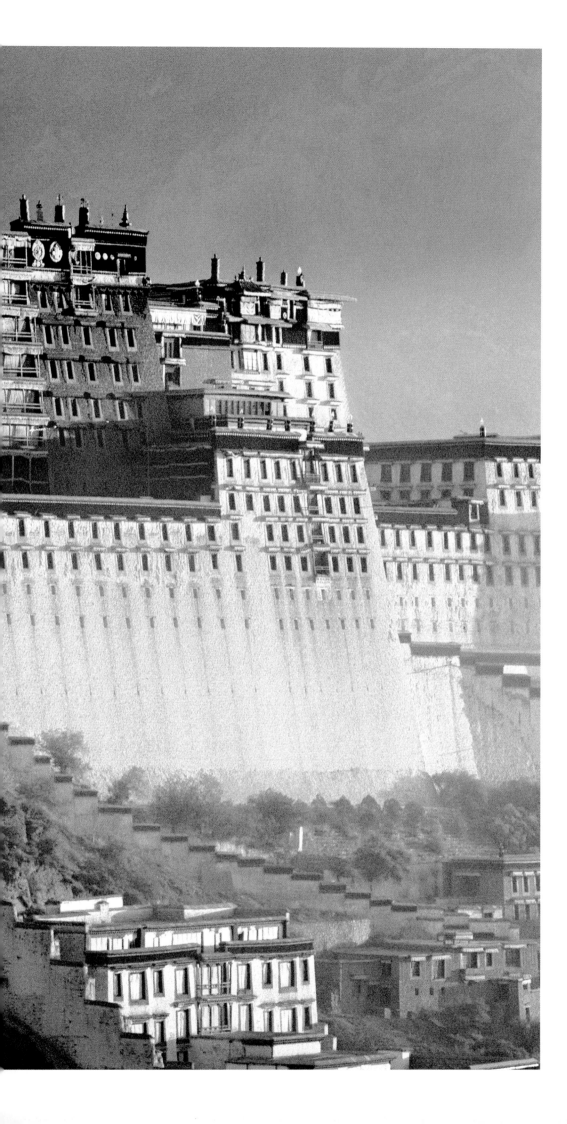

POTALA PALACE, LHASA, TIBET

Left:

Magnificently perched on a hillside in the heart of the Lhasa Valley, Potala Palace is often represented as Asia's largest monument. It is 1,312 feet (400 meters) long, 384 feet (117 meters) high, and contains about a thousand rooms with some 8 square miles (21 square kilometers) of murals. From the seventh century to 1959, Potala was the home of the Dalai Lama, who in 1959 was forced into exile in India by China's claims over Tibet. The Potala Palace was once the administrative and religious center of Tibet. It is a huge building comprising a central space and two wings that are lower but as broad. It is divided into a white palace and a red palace; the central and highest part, the red palace, contains eight stupas of Dalai Lamas covered in gold. The Chinese authorities have turned the palace into a national museum.

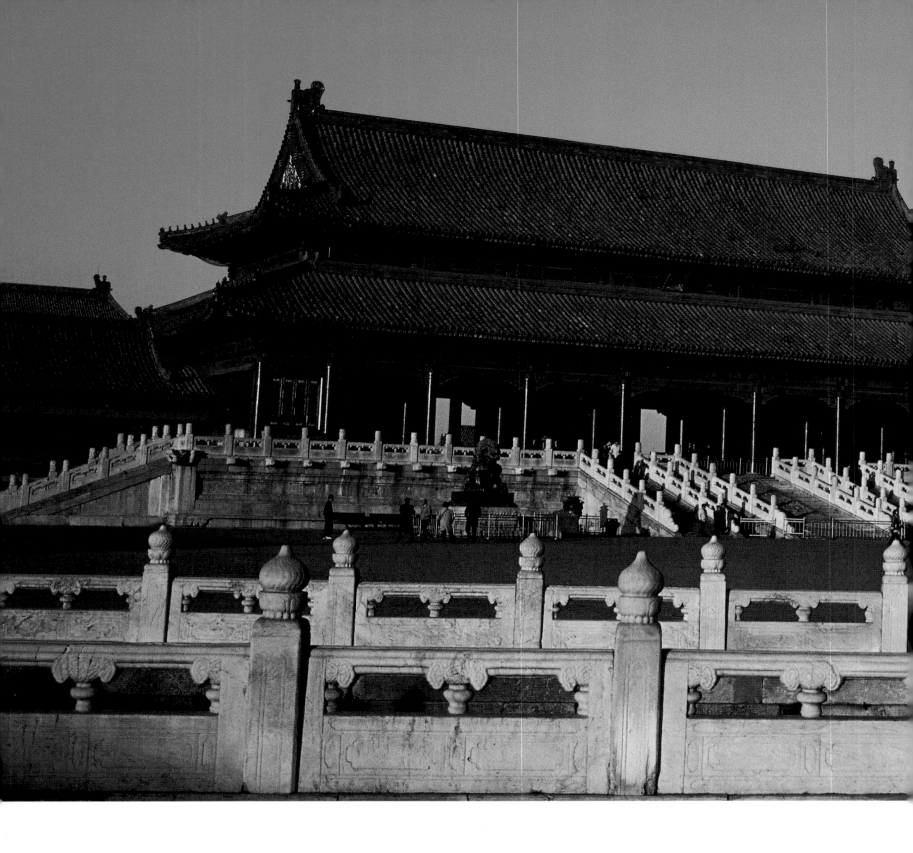

WUMEN GATE TO THE FORBIDDEN CITY, BEIJING, CHINA

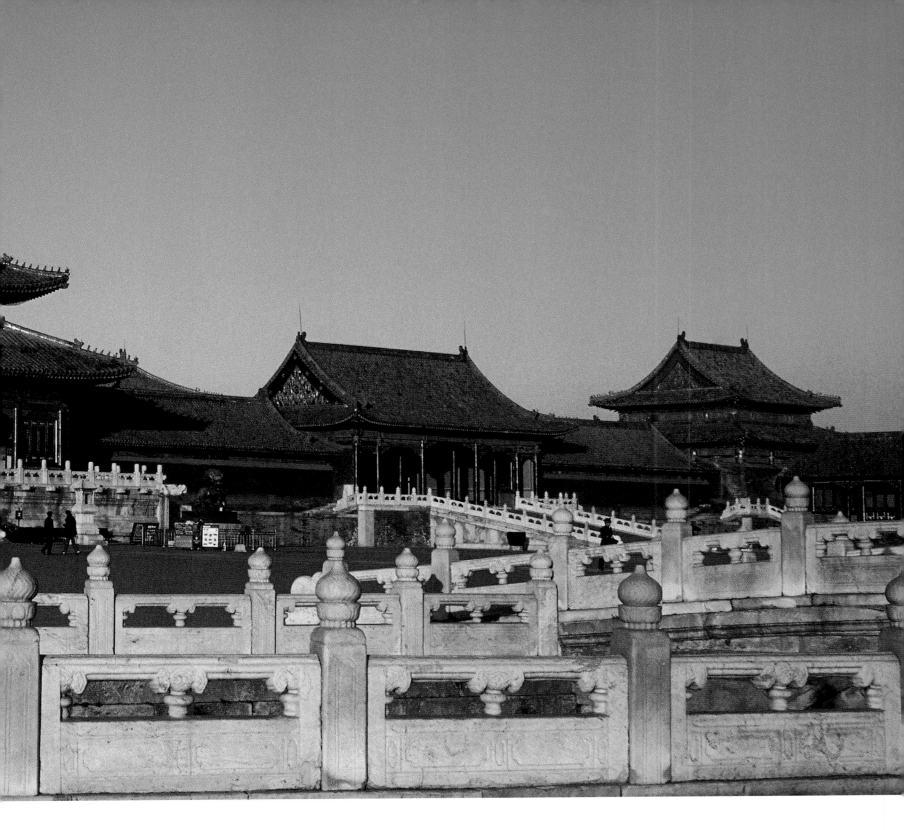

Above:

For 490 years, twenty-four emperors belonging to the Ming and Qing dynasties ruled in the Forbidden City, the huge imperial site in Beijing proclaiming itself as the center of the universe, residence of the "sons of heaven." Built between 1407 and 1420 and inaccessible to most of the population, it was ringed by a 2-mile (3-kilometer) wall equipped with four gates, one at each point of the compass. The southern gate—the Wumen, or Meridian, Gate—is the main and largest gate, leading from the famous Tiananmen Square. The plan of the Wumen Gate is rectangular; it has four pavilions, one at each corner and a fifth placed centrally on the main façade. The double roofs are highly individual and lend a noble, protective aspect. The central door was reserved for the emperor; even the empress was barred from using it except on her wedding day. The other doors were used by ministers, the imperial family, officers, and senior officials.

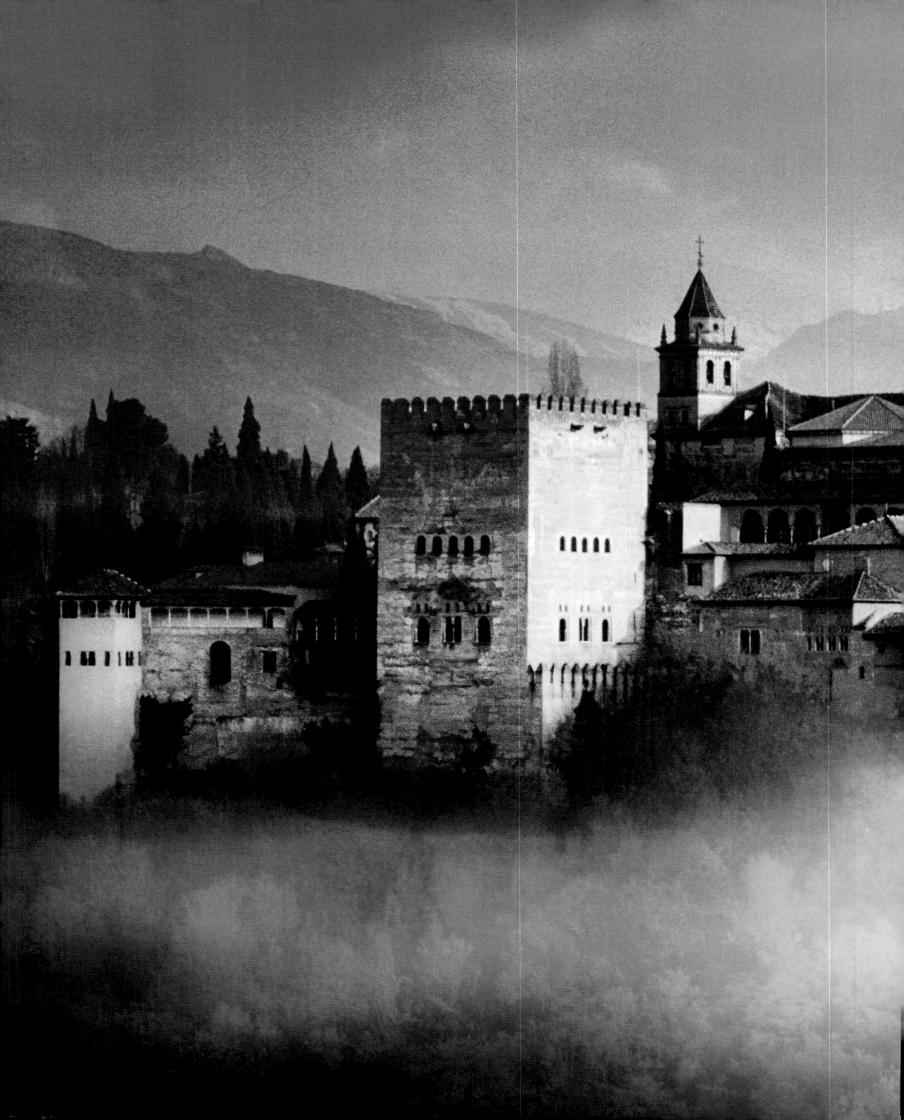

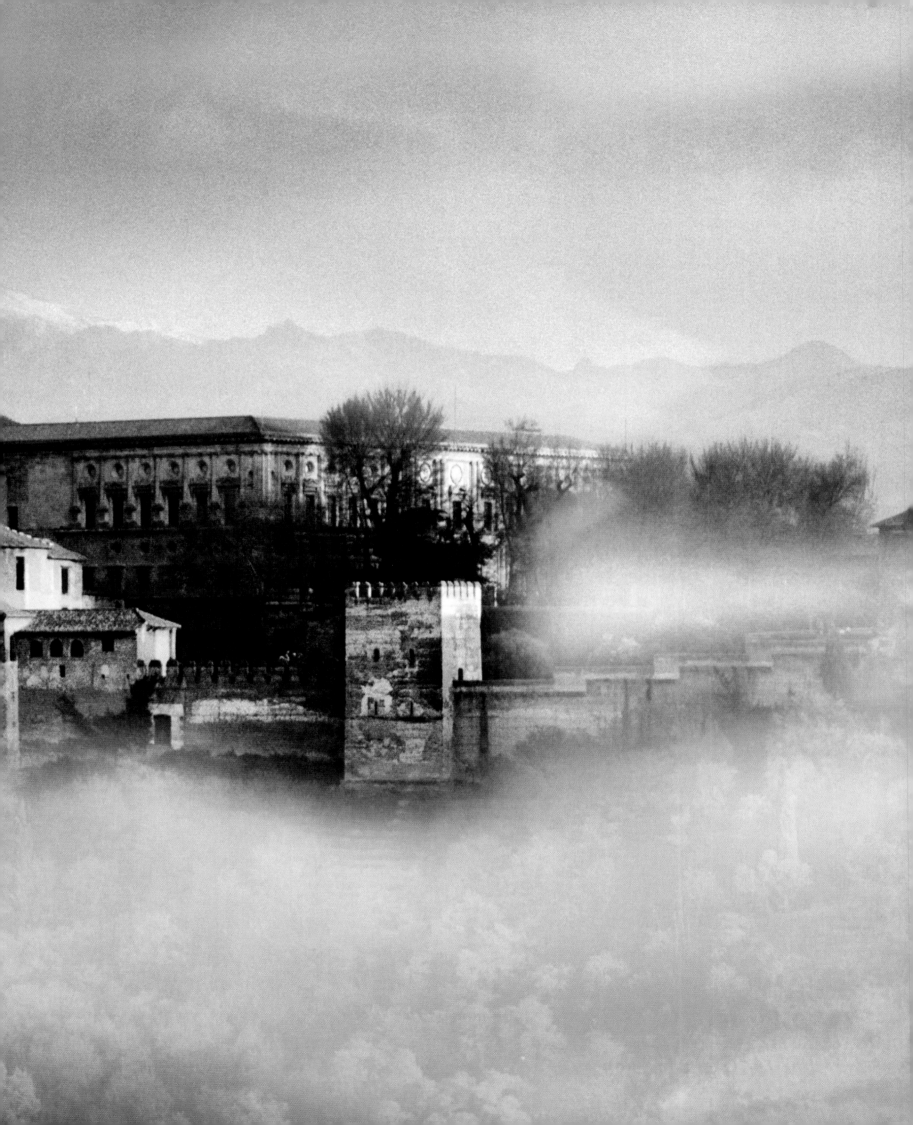

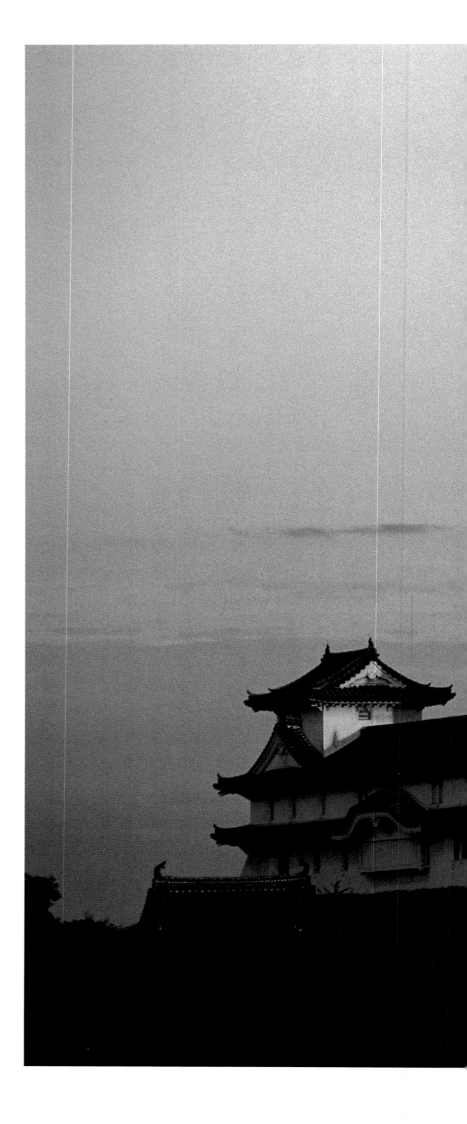

THE ALHAMBRA, GRANADA, SPAIN

Preceding pages:

Viewed in the setting sun from the neighboring Albaicin hill, the palace's interlocking walls project an unforgettable reddish hue against the blue sky and snow-white peaks of the Sierra Nevada. Apart from the beauty of its architecture and decoration, the Alhambra bears witness to the refinement of Andalusian civilization, where Jews, Christians, and Muslims, living together harmoniously, turned southern Spain into a remarkable center of culture. Overlooking the city, the Alhambra began as a fortress developed by the Moors in the ninth century. During the thirteenth and fourteenth centuries, the Nasrid monarchy provided its current aspect: the beautiful rooms, the famous Courtyard of the Lions, the delicate ceramic and molded-plaster decoration, and the marvelous gardens. Two centuries later, Emperor Charles V added a palace with a beautiful circular courtyard.

HIMEJI CASTLE, JAPAN

Right:

This place is never more lovely than when the cherry trees are in bloom. In spring, the pure white blossoms reflect the whiteness of the castle walls below the graceful lines of its curving roofs and triangular pediments. The Japanese castle of Himeji or Haakuro-jo (White Heron Castle) sits on a hillside planted with cherry trees above a village of the same name, about 31 miles (50 kilometers) west of Kobe. Remarkably well preserved, it was built of wood and plaster in the late fourteenth century and has since been modified several times. Only three buildings of its type and period survive in Japan, so Himeji is much valued and visited as one of Japan's key historical sites. The tallest tower, in the middle, forms the main body of the building, rising to 151 feet (46 meters) and giving the location its characteristic outline. Surrounded by magnificent parkland, it is often used as a film set.

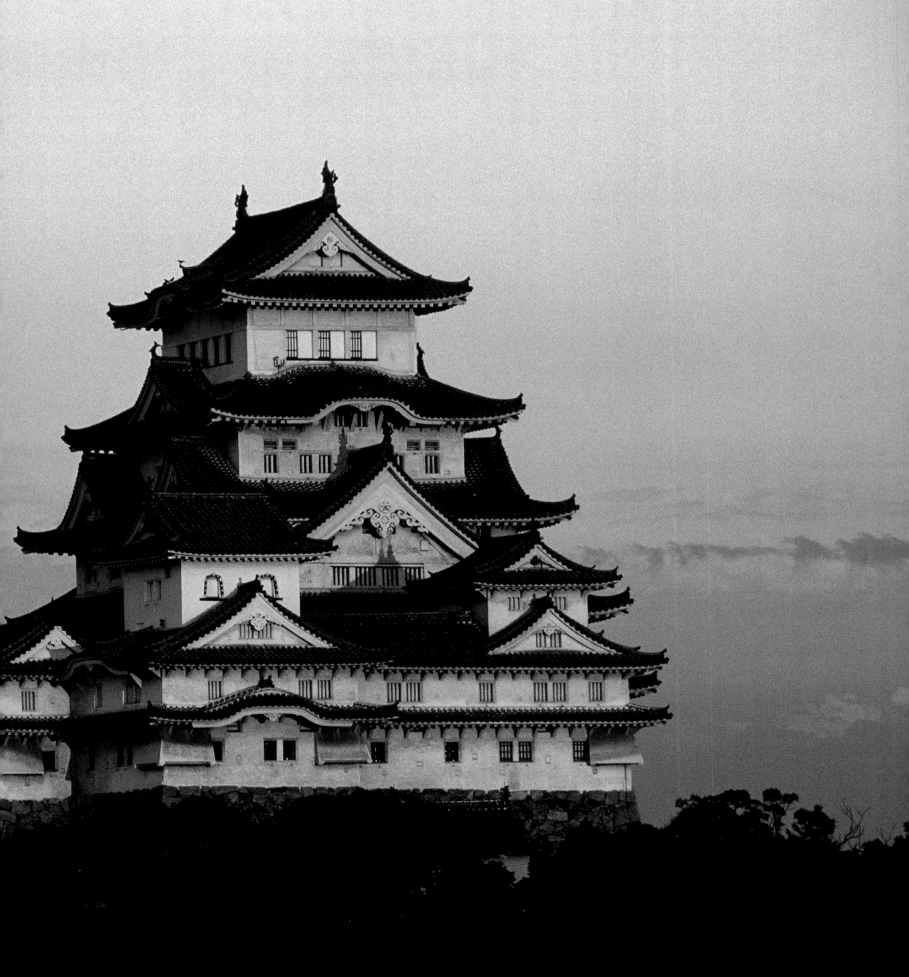

THE CHÂTEAU OF CHAUMONT-SUR-LOIRE, FRANCE

Left:

As early as the tenth century there was a stronghold here to protect Blois. Destroyed by Louis XI, the medieval castle was rebuilt starting in 1465. During the late fifteenth century, the Chaumont d'Amboise family continued the work in the Renaissance style then popular in the Loire Valley. Catherine de Médicis purchased Chaumont in 1560, but subsequently exchanged it for Diane de Poitiers' Chenonceau. The nineteenth century saw extensive restoration of the château in the neo-Renaissance style; and in 1884 the Prince de Broglie created a vast English-style park. Chaumont consequently discovered a new vocation; and it is currently home to the Conservatoire International des Parcs et Jardins et du Paysage (International Conservancy of Parks, Gardens, and Landscape), which holds an internationally renowned garden festival at the château every year.

THE CHÂTEAU OF CHAMBORD, FRANCE

Right:

Chambord is a national estate that remains an official hunting ground of the French Republic. The vast château that occupies a part of it, and which is sometimes attributed to Leonardo da Vinci, is instantly recognizable from the forest of chimneys and lantern turrets that decorate its roofline. What is certain is that the château, commissioned by King Francis I, is a paragon of the early French Renaissance, directly imported from Italy through the king's enlightened patronage. Building began in 1519 and lasted thirty years, without completing the entire project. Based on the design of a medieval fortress with sturdy round towers, the château's white stone, slate roofs, and, above all, its innumerable ornate windows, convey the look of a complex pleasure palace—"uninhabitable," some say—arranged around an ingenious double-helix staircase. Louis XIV further embellished the château, although he used it only for brief hunting visits.

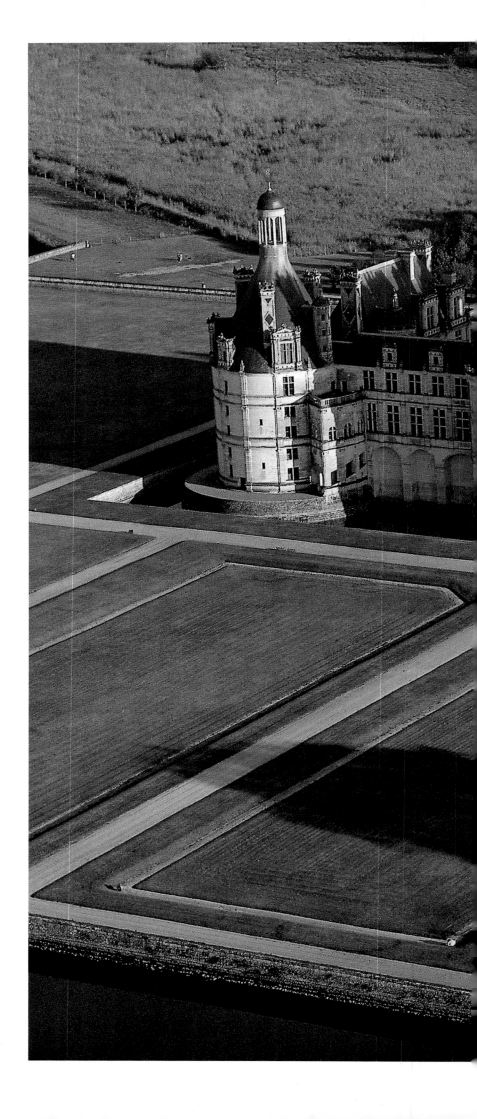

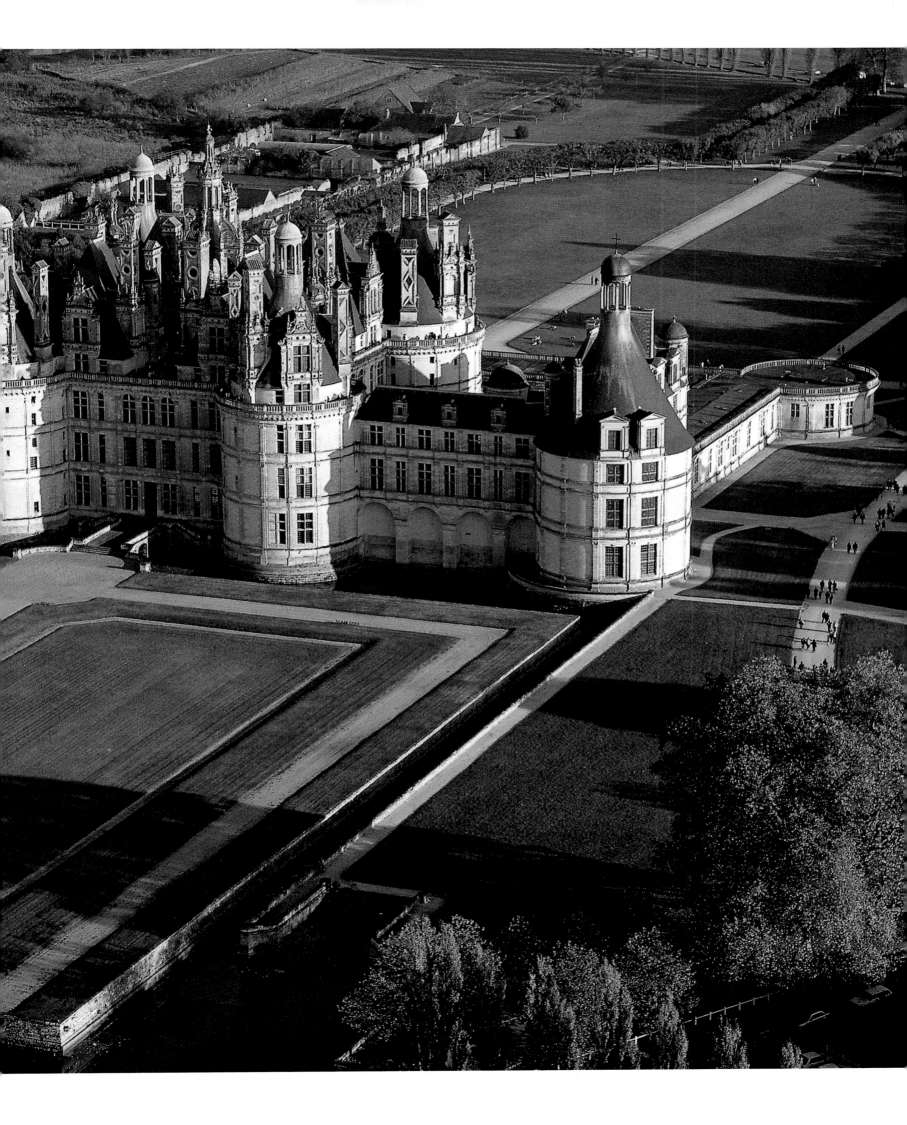

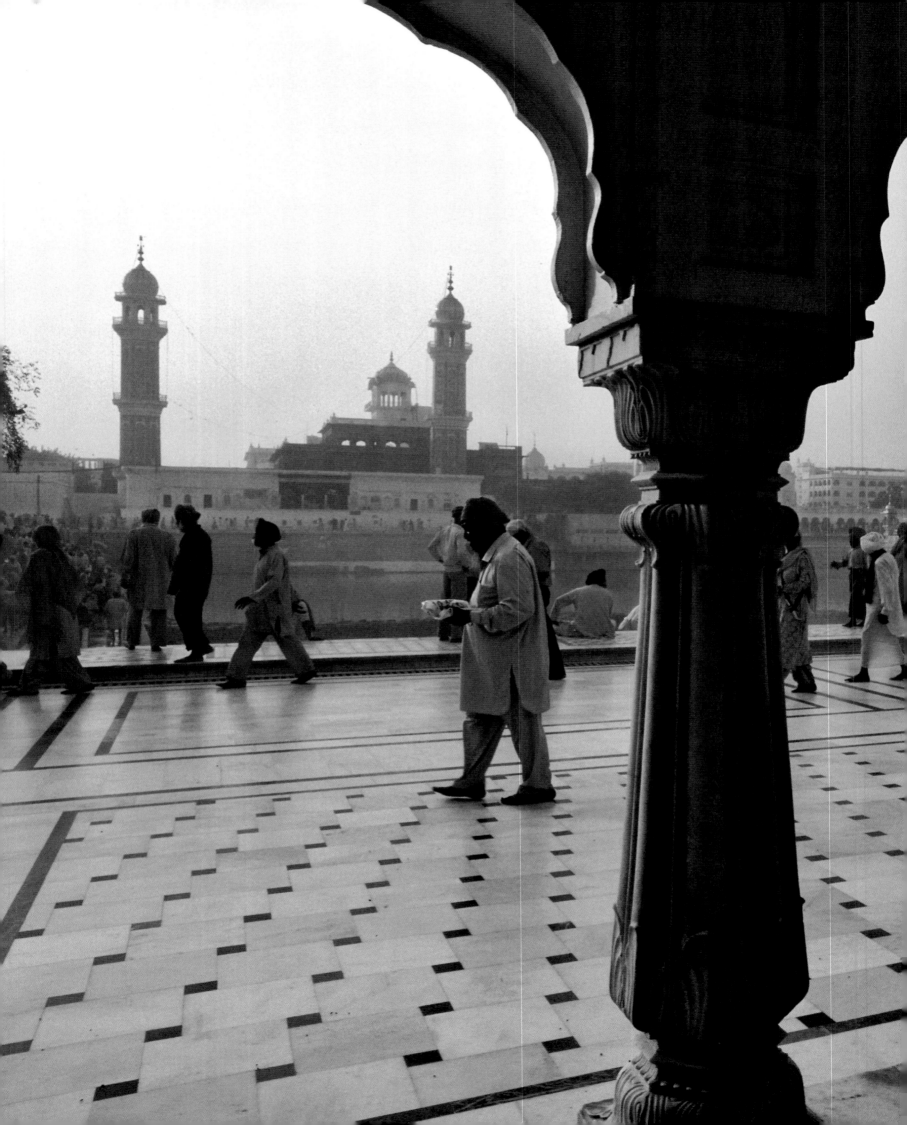

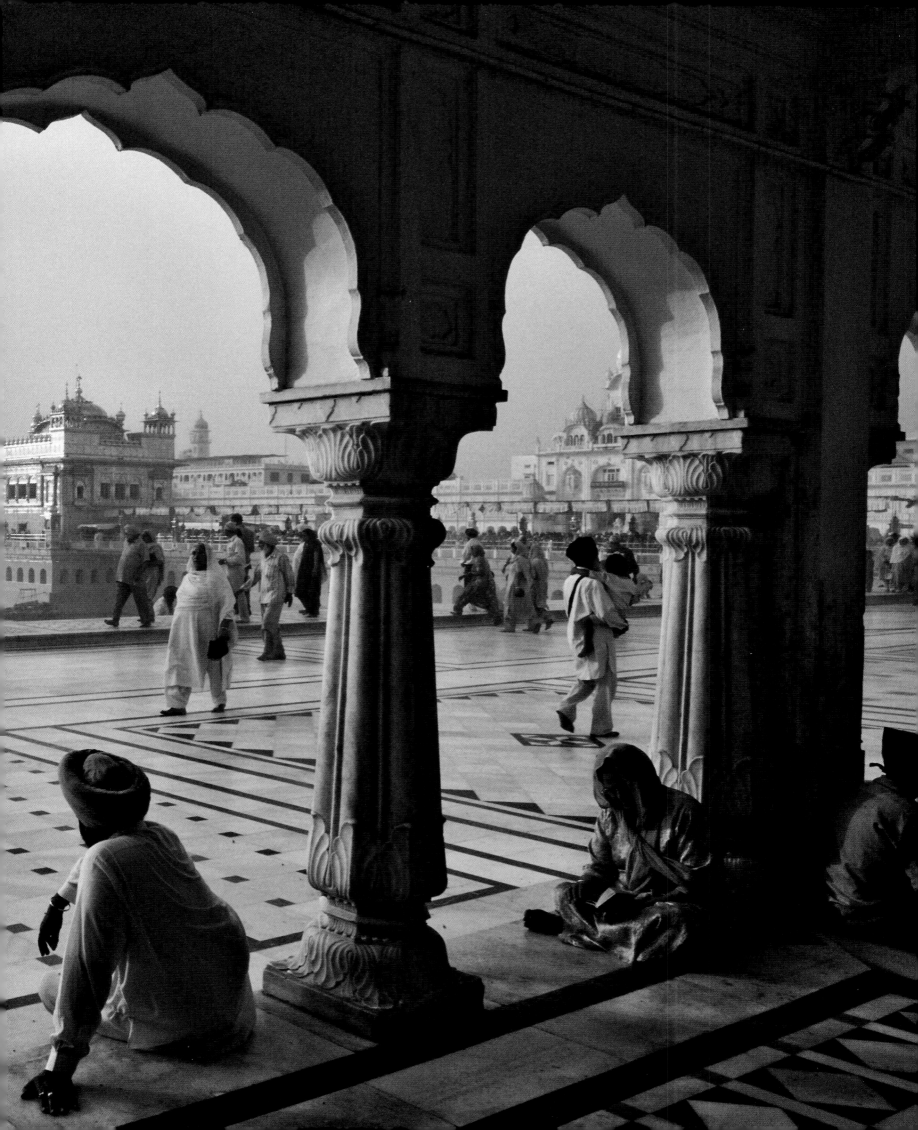

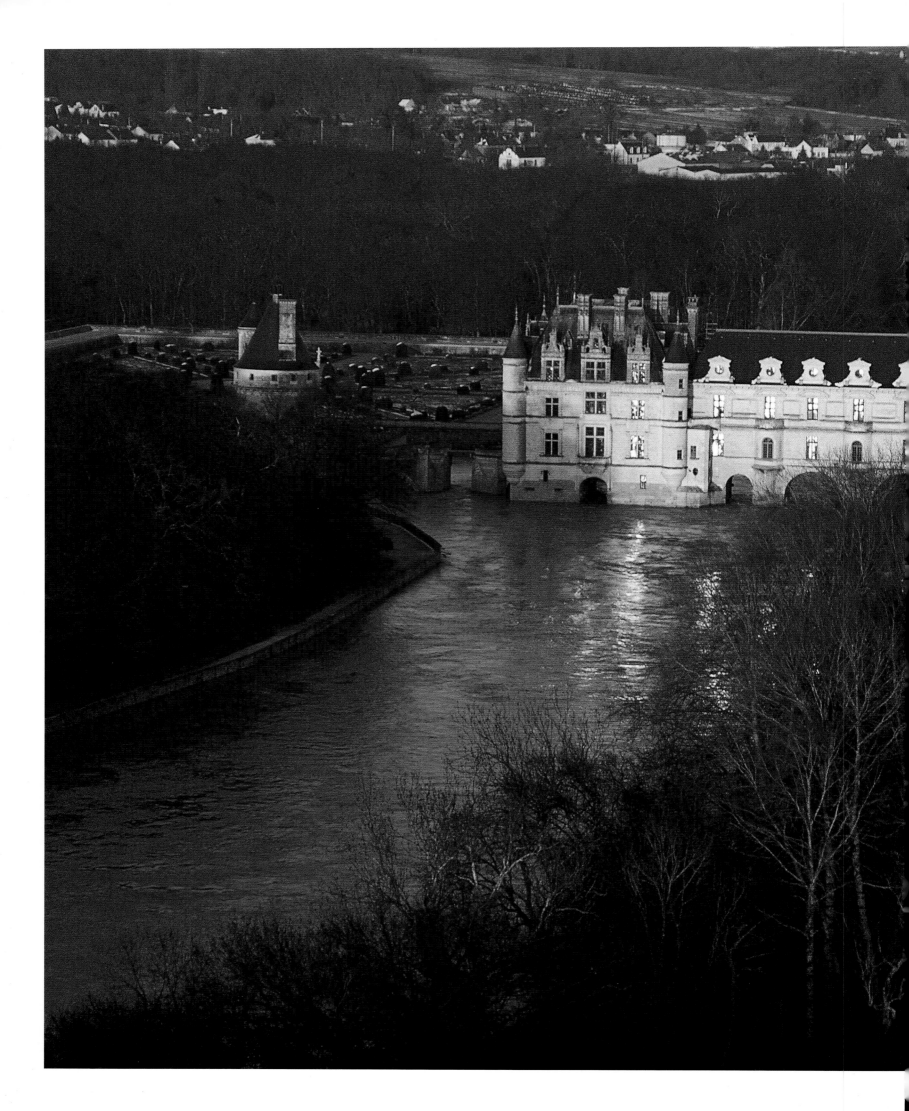

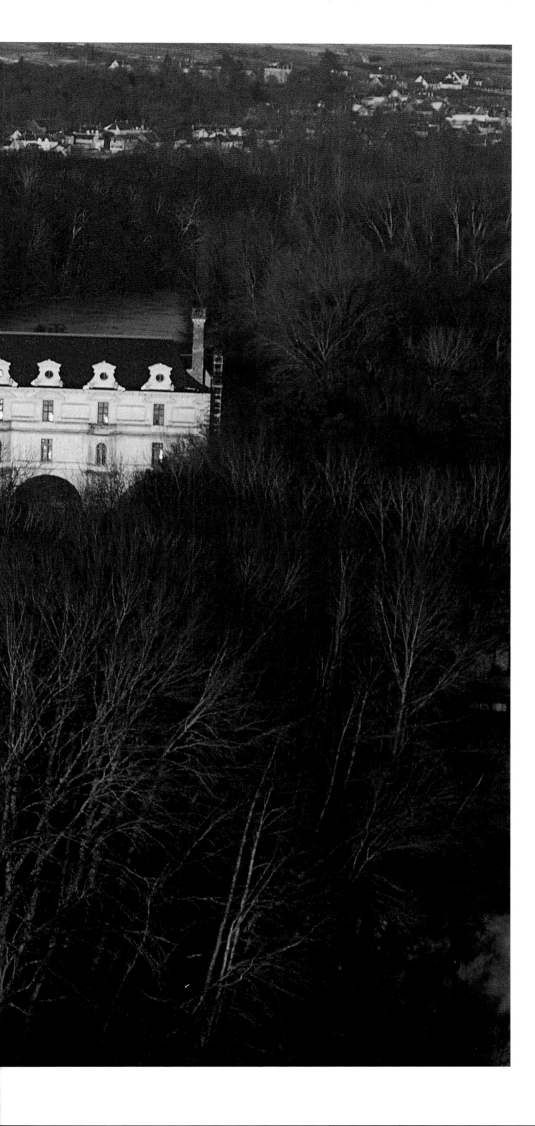

AMRITSAR, INDIA

Preceding pages:

Amritsar, in the north Indian state of Punjab, is the re-
ligious capital of the Sikhs. The building of the Golden
Temple here, between 1573 and 1601, when the Sikh re-
ligion was born, turned a small town into the city it later
became. Sikhism is a monotheistic religion with links to
both Hinduism and Islam. The city took its name from a
sacred pool, the Amrita-saras, "the lake of nectar." The ar-
chitecturally cubical Golden Temple is a shrine holding
the Sikh holy book, the Granth Sahib. Destroyed during
an Afghan invasion in 1757, the edifice was rebuilt eight
years later and covered in gold leaf during the nineteenth
century. The site of a bloody massacre perpetrated by
British troops in 1919, Amritsar experienced another
tragedy in 1984, when Indian troops burned the sacred
book during their repression of a Punjabi secessionist move-
ment that they saw as a revolution.

THE CHÂTEAU OF CHENONCEAU,
FRANCE

Left:

The waters of the Cher River, in the region of France's
Loire Valley, give Chenonceau its thoroughly feminine
elegance. Its charm works wonders, for it is the most vis-
ited château in France after Versailles. Built in 1513 on
the foundations of a former mill, the château was a gift of
King Henry II of France to Diane de Poitiers. Although
Diane made improvements, it was Catherine de Médicis
who had the gallery built above the water, where the
lights, during festivities, could be reflected. Set in a
wooded park that opens to a garden with formal French-
style flowerbeds, the château was a jewel of the
Renaissance. The riches inside, in terms of furniture and
paintings, are equal to the architecture, where now, as in
the past, elegance is the order of the day: eighty thousand
flowering plants contribute to the twice-weekly renewal
of the floral arrangements throughout the château.

THE KREMLIN, MOSCOW, RUSSIA

Right:

The history of all Russia is found in the Kremlin in the heart of Moscow. The name more often conjures up political intrigue than the treasures of art and history that are found in this city within a city. Like its churches, most buildings in the Kremlin were constructed between the fourteenth and seventeenth centuries. Behind the red walls and their many towers is a mix of white stone palaces and onion-domed churches on a chaotic street plan inherited from the Middle Ages. The oldest archaeological remains have been dated to the eleventh century, but reconstruction of the fortress began during the fifteenth century. The most recent of the Kremlin's buildings dates from the Khruschev era, built to house meetings of the Communist Party's Central Committee; it sits in the shadow of the cathedral where for five centuries the czars were crowned.

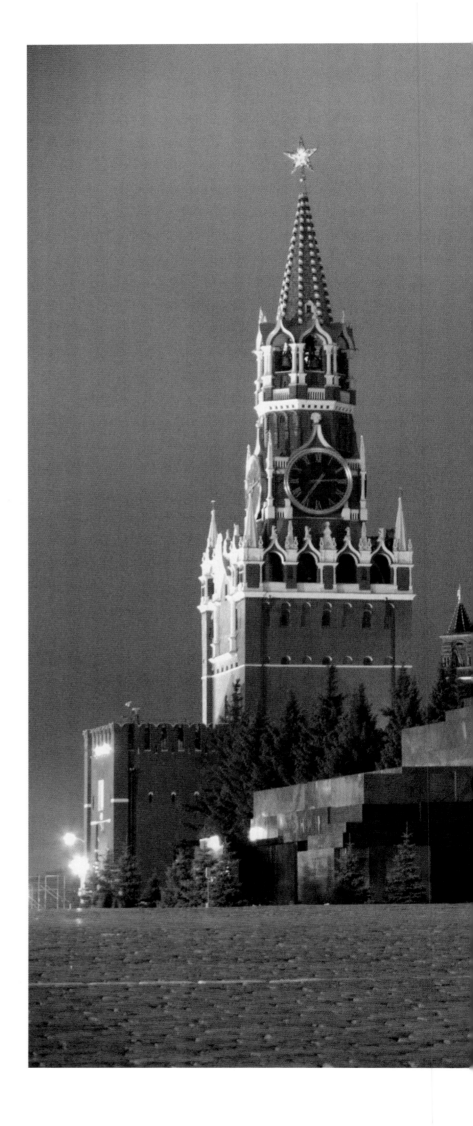

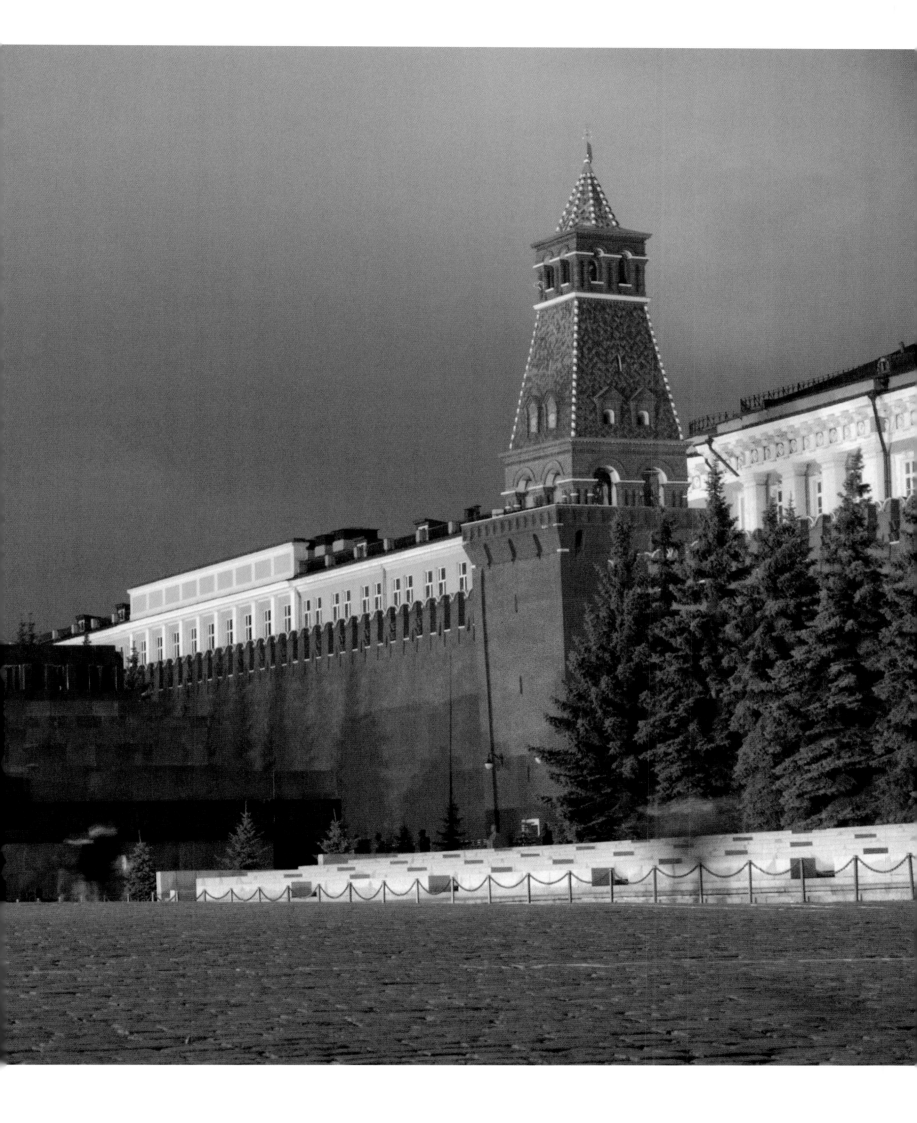

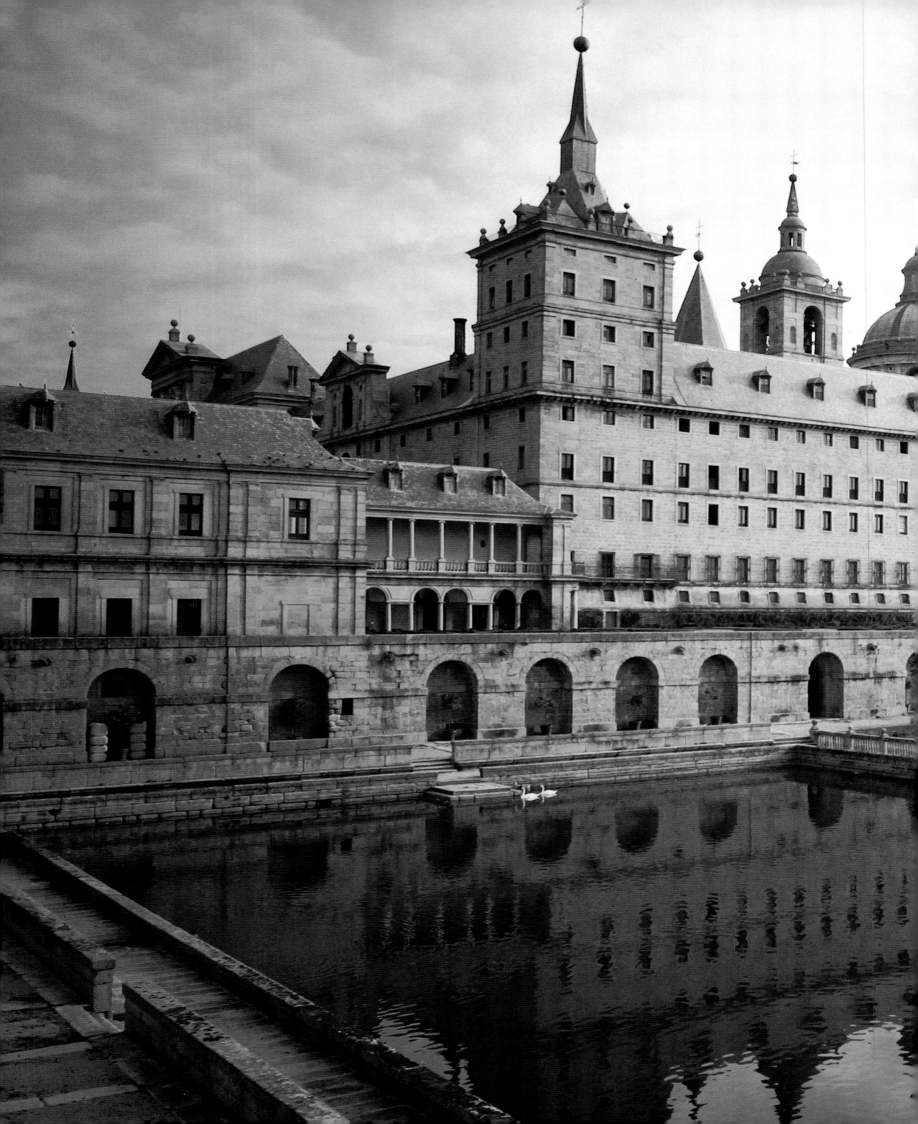

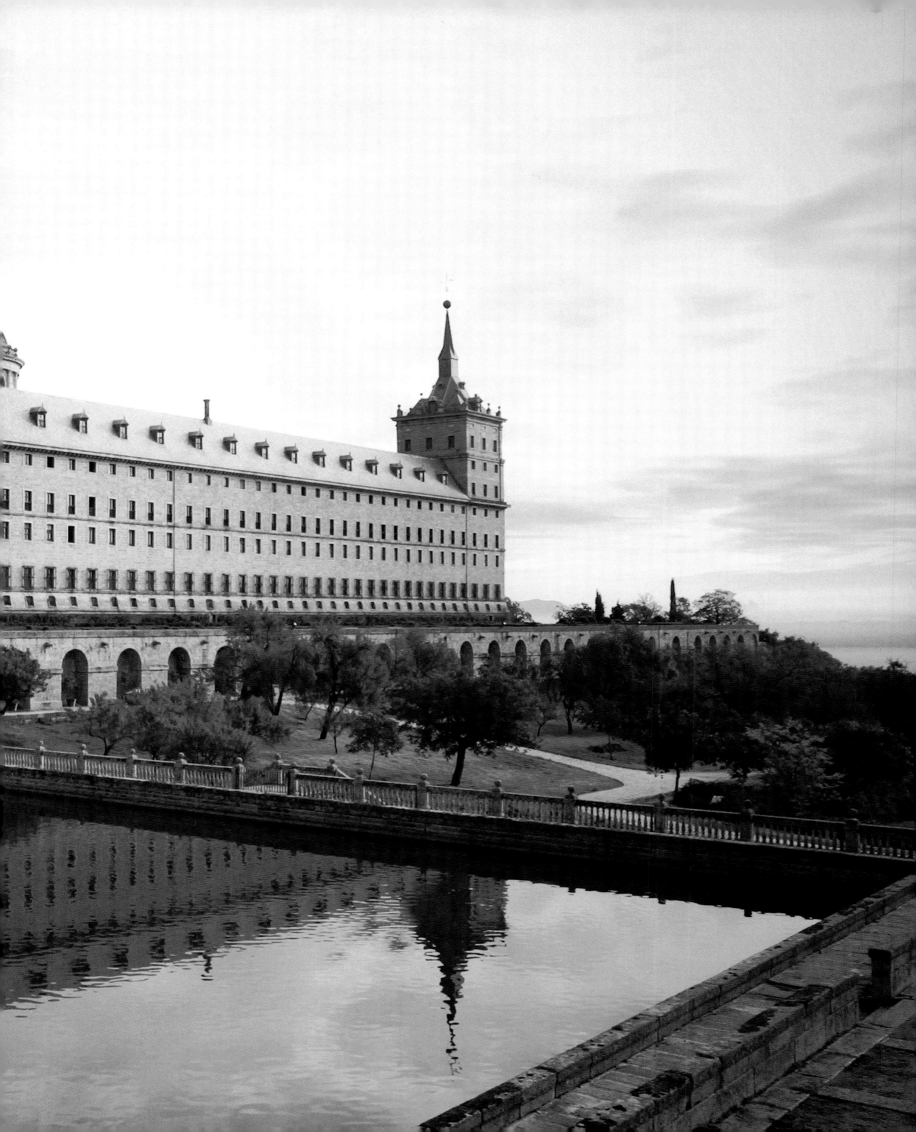

The Escorial, Spain

Preceding pages:

Roughly 28 miles (45 kilometers) northwest of Madrid at an altitude of more than 3,200 feet (1,000 meters), and close to the Sierra de Guadarrama, lies the sober mass of the Escorial, a severe and imposing edifice whose basilica's dome and belfries are visible from afar. Its orthogonal layout, comprising some impressive buildings (with more than three thousand windows!) arranged around numerous courtyards, has the appearance of a grill, supposedly harking back to the martyrdom of Saint Lawrence, the saint who is honored here. The Escorial was built by King Philip II of Spain to fulfill the vow he made when Saint Quentin was taken, in 1557, and to provide his family with a place of burial. Constructed between 1563 and 1584, it contains twenty-six royal tombs. The sumptuous interior contrasts with the rather plain exterior; abounding in religious iconography following the Church Council of Trent (1545–63), this monument also glorifies Spanish history.

Villa Mansi, Italy

Right:

The Veneto and Tuscany are two regions where the lifestyle that was born in the Italian Renaissance and evolved up to the nineteenth century is often expressed in country houses of matchless charm. Some of these villas were built as the headquarters of large agricultural estates, while others were conceived as country residences used to escape the city's summer heat. The architectural principles displayed in their construction were balance, harmonious proportions, and subtle elegance. The Villa Mansi in the Lucca region was built in the late sixteenth century and decorated with rich painted ornamentation. In 1634, it was acquired by a family that had become wealthy in the silk trade; its façades and splendid gardens were transformed to reflect the sophisticated rules of Classical perspective.

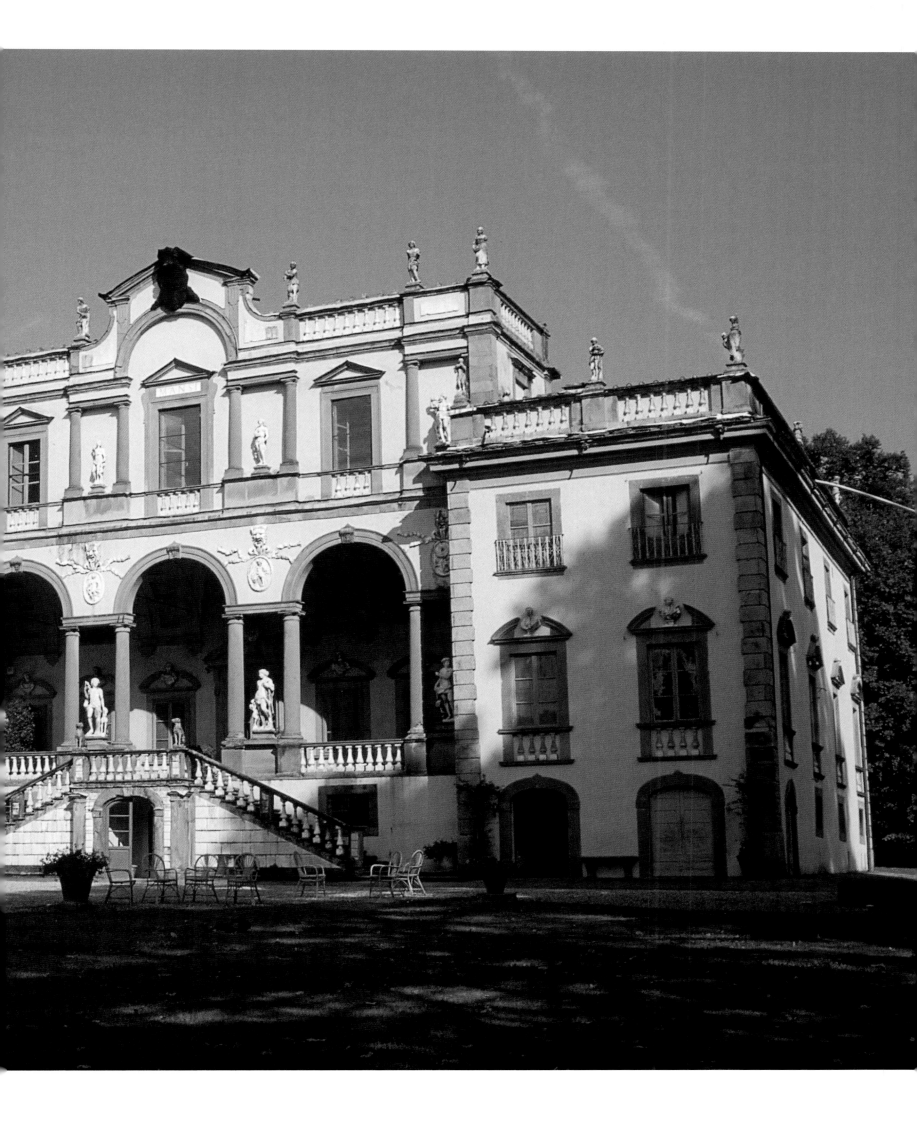

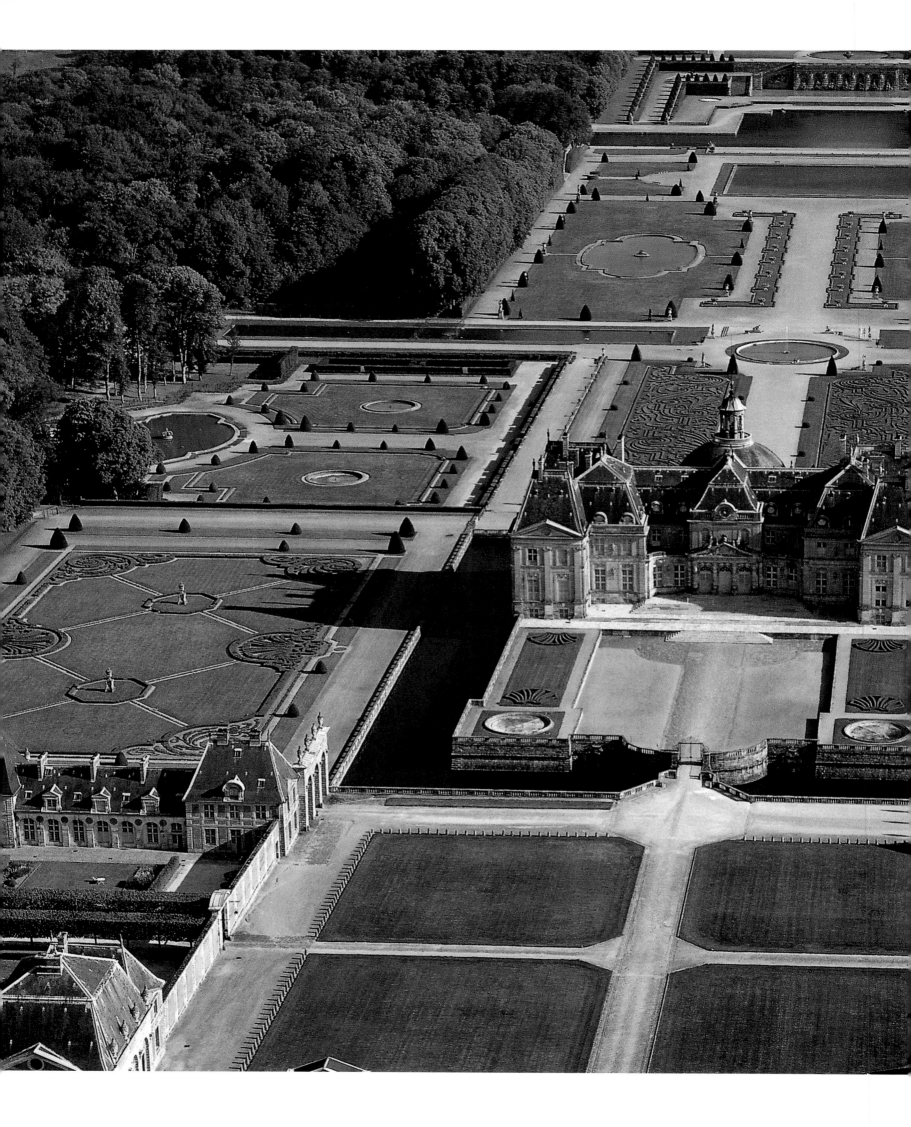

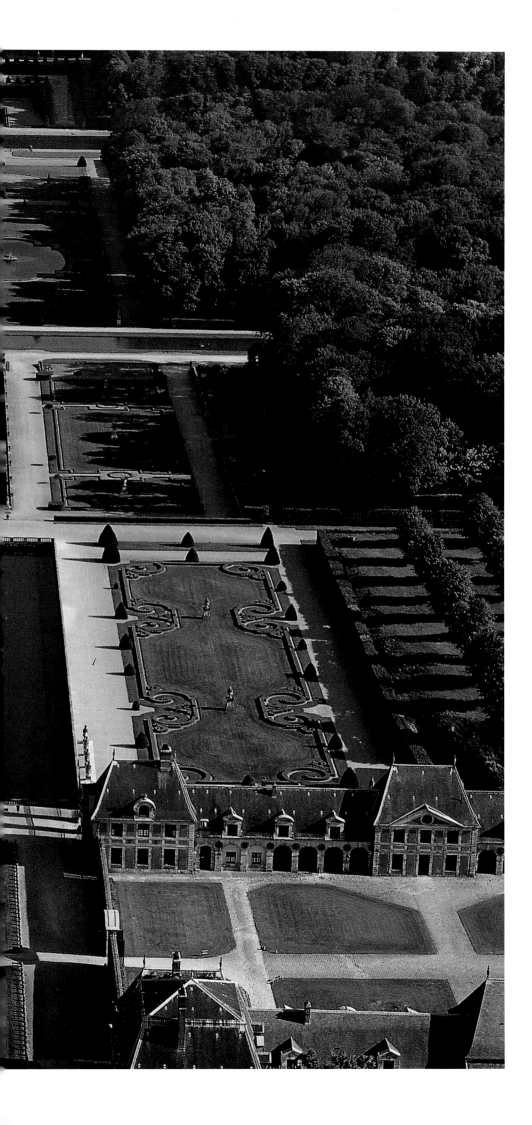

THE CHÂTEAU OF
VAUX-LE-VICOMTE, FRANCE

Left:

Appointed Superintendent of Finances by Cardinal Mazarin at a time when the kingdom's coffers were empty, Nicolas Fouquet (1615–1680) knew how to fill them up again, and he managed to make a fortune for himself at the same time. A friend and patron of the arts and literature, he invited King Louis XIV to his château at Vaux, east of Paris, in August 1661. Here he put on the most lavish festivities on 99 acres (40 hectares) of grounds, where Louis Le Vau's building, decorated by Charles Le Brun, overlooked parkland designed by André Le Nôtre. Vaux was the quintessence of French contemporary art. Already teased by Fouquet's splendor, power, and wealth, the king's jealousy boiled over. A month later, the finance minister was arrested and put in prison, where he remained until his death. Versailles was then free to take the limelight.

THE CHÂTEAU OF VERSAILLES,
FRANCE

Following pages:

For those who did not know Louis XIV as the Sun King, Versailles was meant to show them. Only the biggest and most beautiful might do him justice. Even enlarged by the architect Le Vau, the hunting lodge built by his father, Louis XIII, was too modest for Louis XIV. In 1668, Versailles became a vast building site; ten years later, it was the official royal residence. Jules Hardouin-Mansart directed the work, and the Hall of Mirrors was opened. Development of the château continued under Louis XV and Louis XVI until the Revolution; and it was the point of reference for French art during the seventeenth and eighteenth centuries.

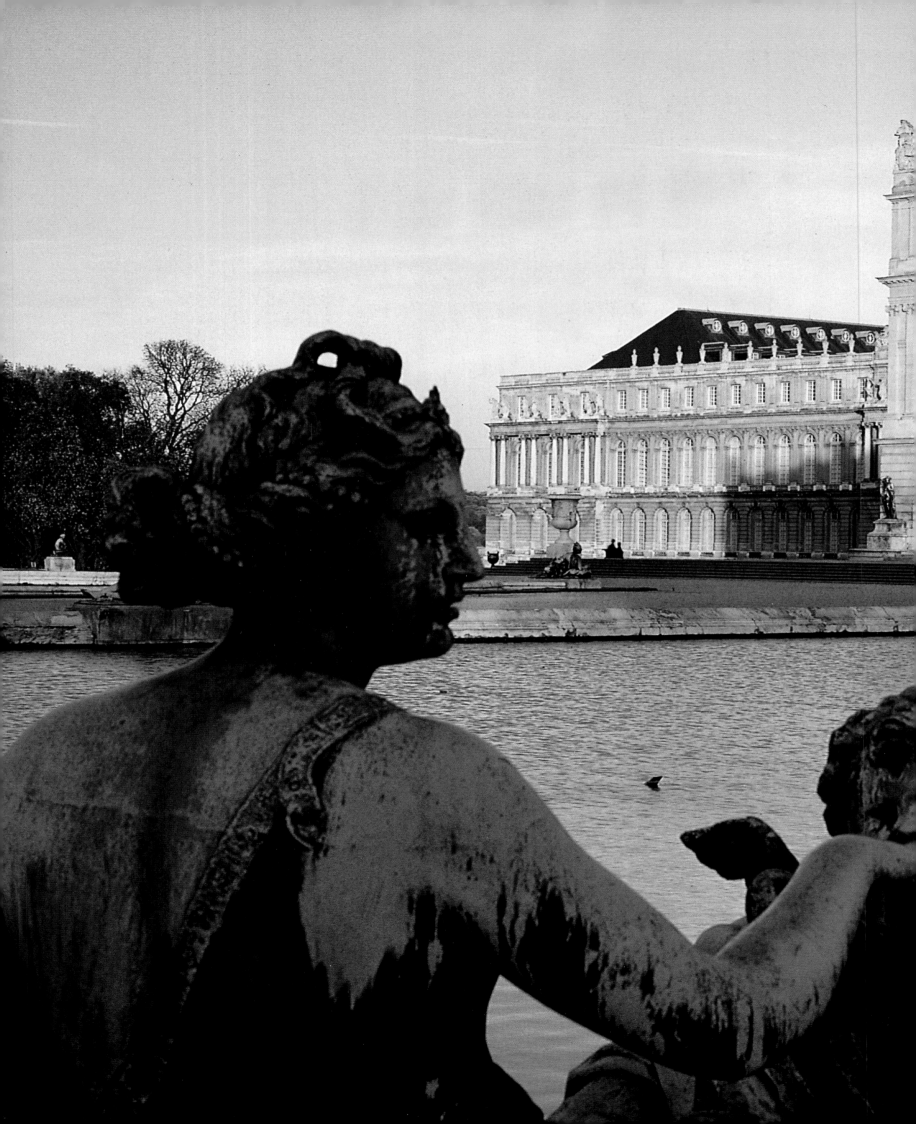

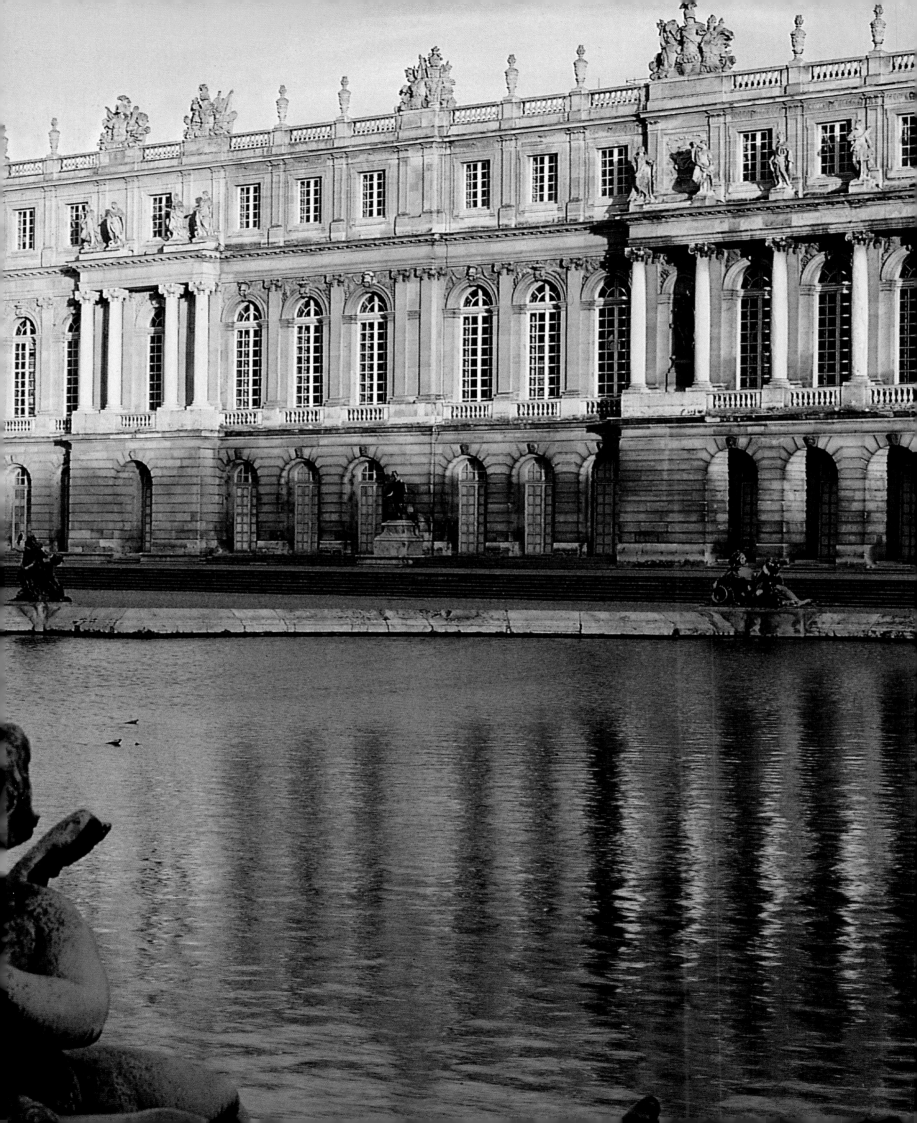

SCHÖNBRUNN PALACE, AUSTRIA

Right:

Schönbrunn Palace, just outside Vienna, was the residence of the Habsburgs, the Austrian imperial family, from the eighteenth century until 1918. It was already an imperial residence even before then, Emperor Maximilian II having bought the property in 1569. Seduced by the magnificence of Versailles, Emperor Leopold I had a new palace built here in the late seventeenth century; but the alterations by Empress Maria-Theresa turned it into the rococo gem we admire today. The park, which had for a long time included the world's first zoological garden, also took on its current aspect at that time. For most visitors, two other figures are associated with the palace: Emperor Franz Joseph and his wife Elisabeth, the famous Sissi. Schönbrunn was their main and preferred residence.

ST. PETERSBURG, RUSSIA

Following pages:

The Leningrad of yesteryear has yielded to the eternal St. Petersburg. Such is the message that the city seems to proclaim, as it rediscovers its pride as Russia's imperial capital and makes the most of its rich heritage. The city dates from 1703, when Czar Peter the Great established it on the Neva River delta. From 1712 the court met in Saint Petersburg, and all of Russia's nobility settled there with competitive pomp. As if to pay for its prestige, the city of magnificent palaces and numerous churches was at the heart of the revolutions of 1905 and 1917. Today, with its 4 million inhabitants, St. Petersburg is at the cutting edge of Russia's development. Here the "new rich" frequent surroundings conceived by the czars along the riverbanks and near the Hermitage—one of the best-stocked museums in the world—Palace Square, and the Nevski Prospekt.

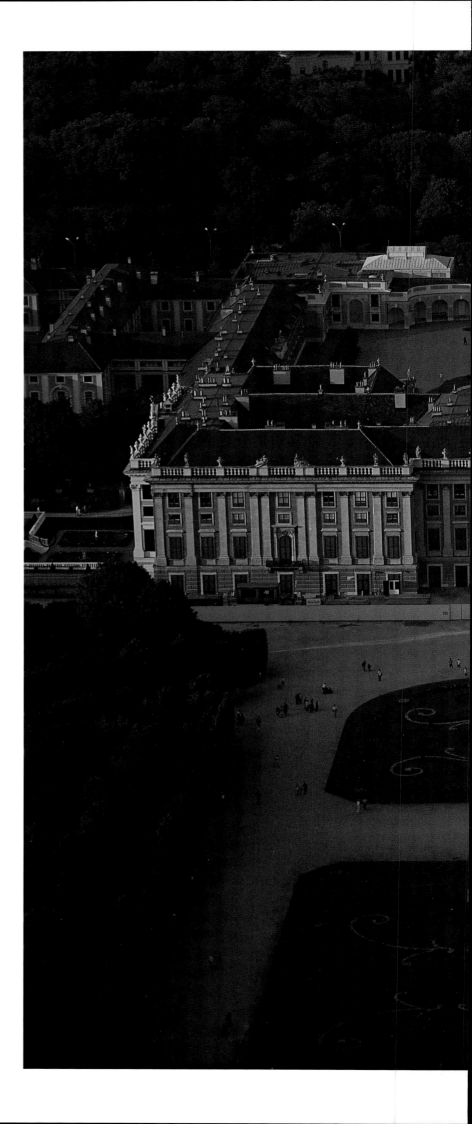

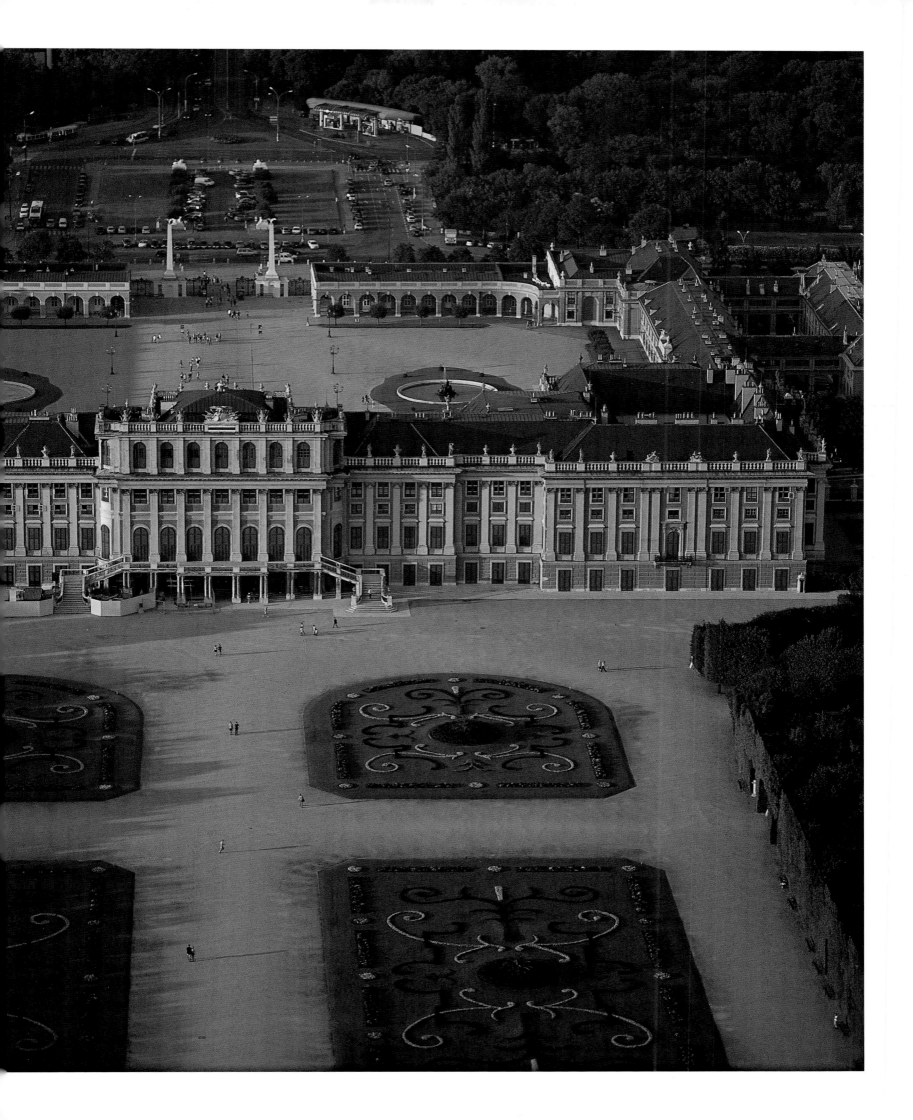

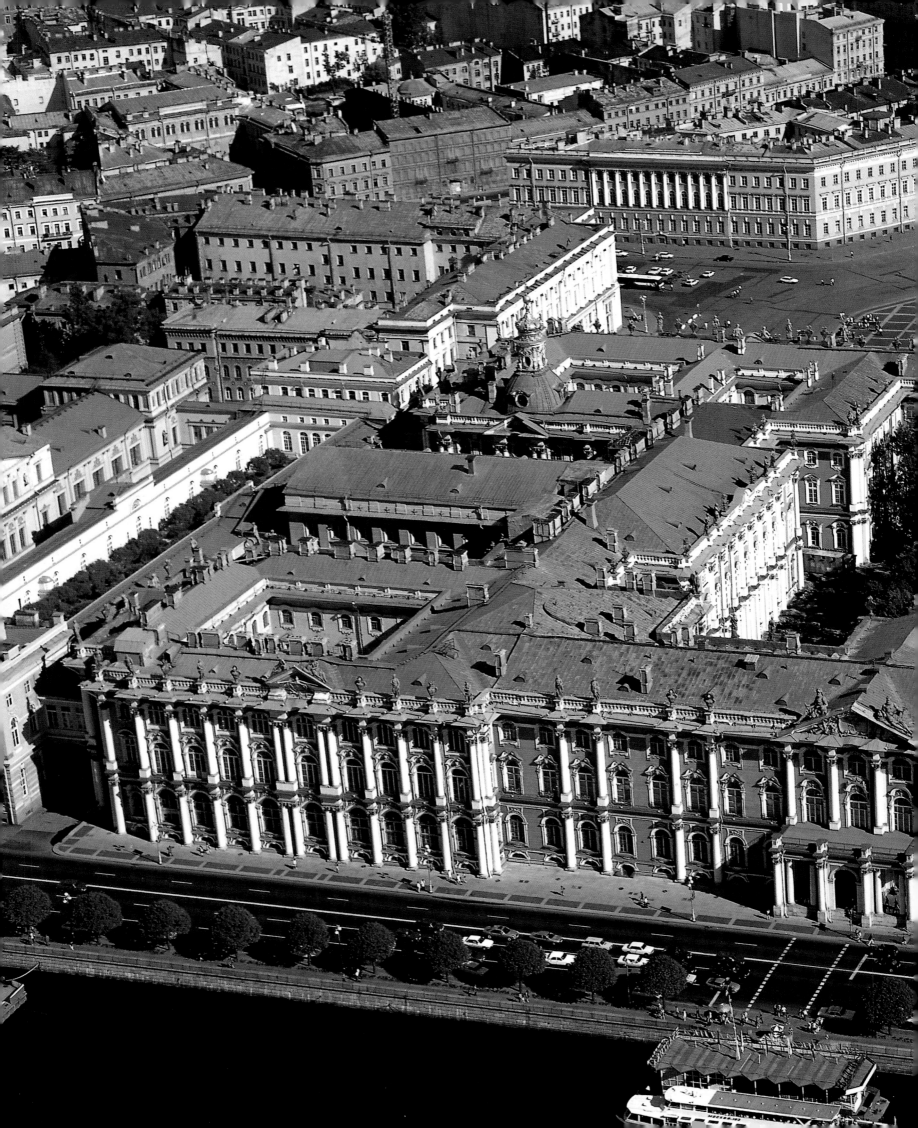

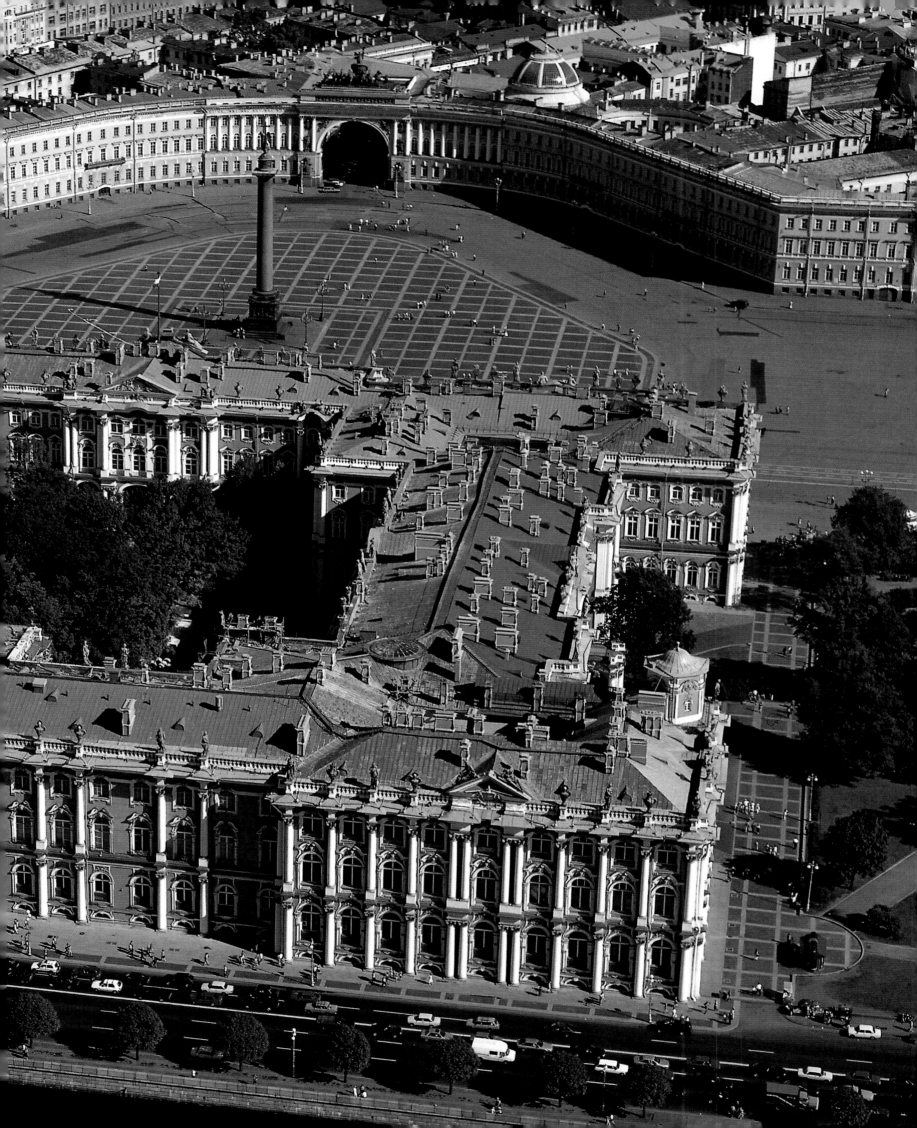

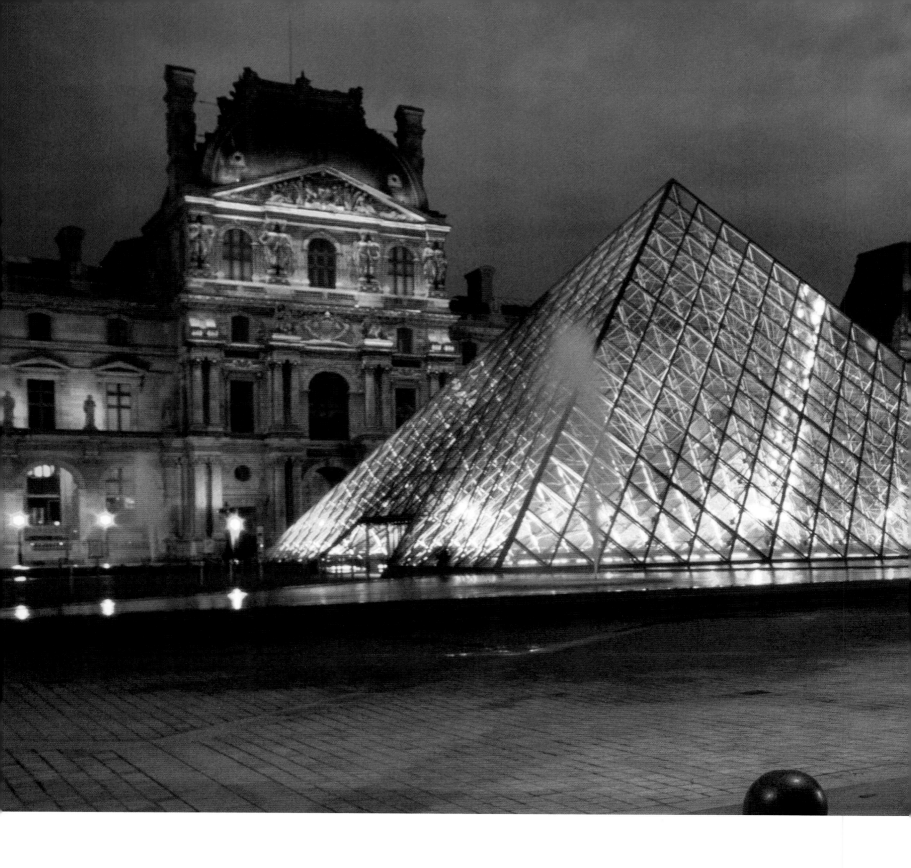

THE LOUVRE PALACE AND MUSEUM, PARIS, FRANCE

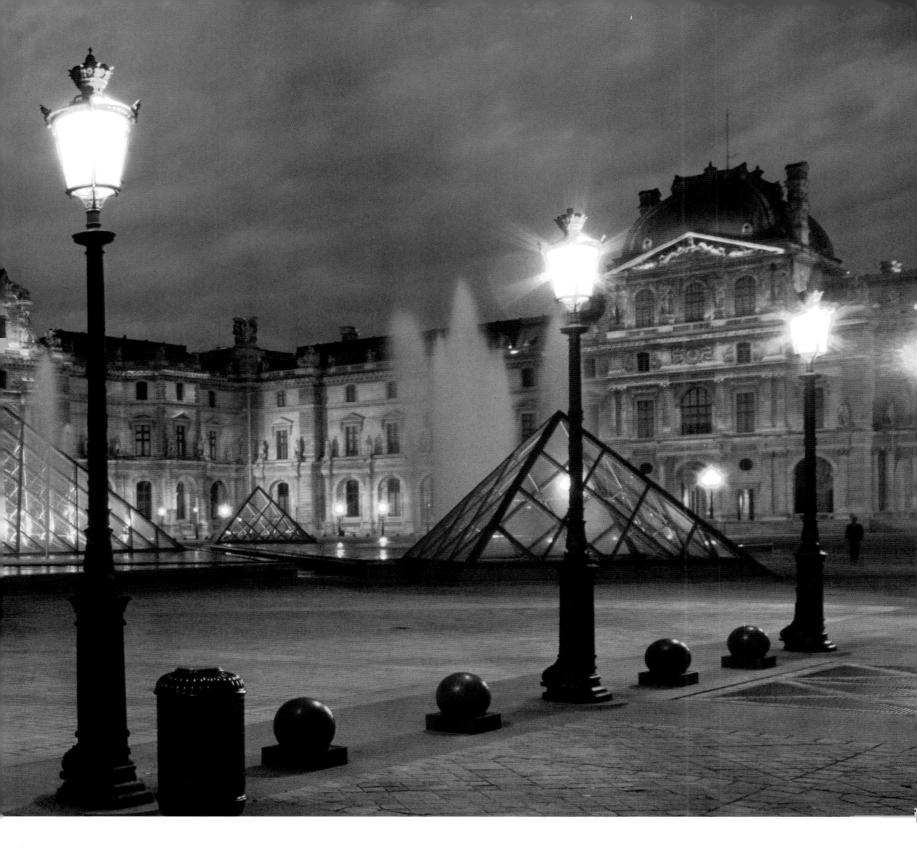

Above:

The largest and most handsome museum in the world was in need of a suitable entrance, which took the form of this pyramid of glass designed by the American architect I. M. Pei and opened in 1989. It sits in the courtyard of the huge palace, a royal residence whose origins lie in a fortress built by Philip Augustus around 1200. Substantial reconstruction during the reign of Francis I, the first French Renaissance king, turned it into a palace. Francis I (1494–1547) began to accumulate works of art at the Louvre when he decided to live there, sowing the seeds of the museum that opened to the public after the Revolution. The museum was further enhanced by Napoleon I, and Napoleon III enlarged the premises. Recent building has extended the museum's functions throughout the former palace. With its services and storerooms it runs to 524,000 square feet (160,000 square meters), and it welcomes nearly 8 million visitors annually.

FREDERIKSBORG CASTLE, DENMARK

Right:

During the full flower of the Danish Renaissance, King Christian IV engaged the Dutch architect Hans van Steenwinckel the Elder to build what was quickly recognized as a masterpiece on three islands in a lake at Hillerød. It was a momentous decision, for Frederiksborg was to become the residence of the Danish court and the place where many future kings of Denmark would be crowned. It took essentially from 1602 to 1630 to build Scandinavia's largest palace, comprising three main wings and a fourth lower terrace wing. Beneath its green copper roofs and red brick walls are sandstone ornaments, sculptures, and statues that enliven grounds laid out in the seventeenth century and often likened to the gardens at Versailles. This key site of historic Denmark houses the Museum of National History, and the palace chapel contains a famous old organ. These and other treasures were rescued from a tragic fire in 1860. Erupting while the king was in residence, the conflagration wreaked havoc on the castle and the magnificent collections it contained.

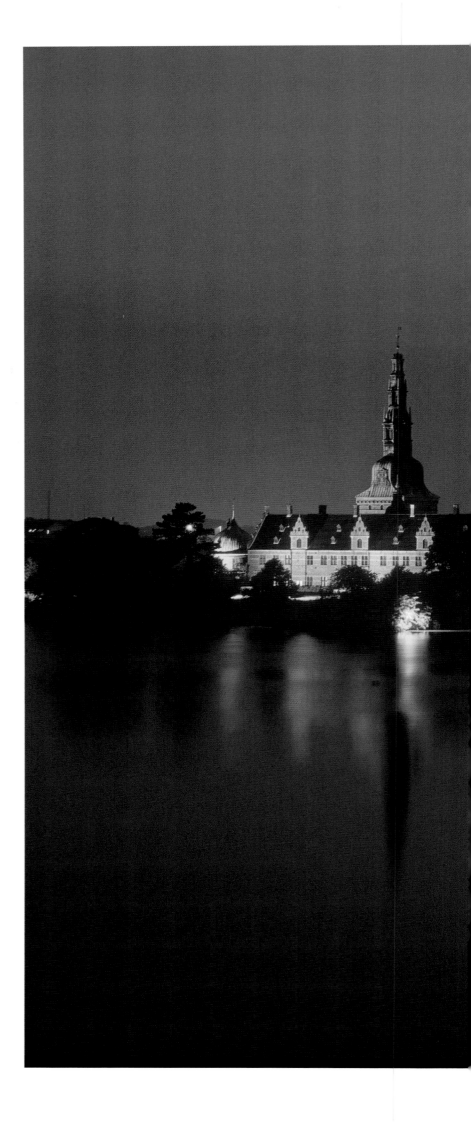

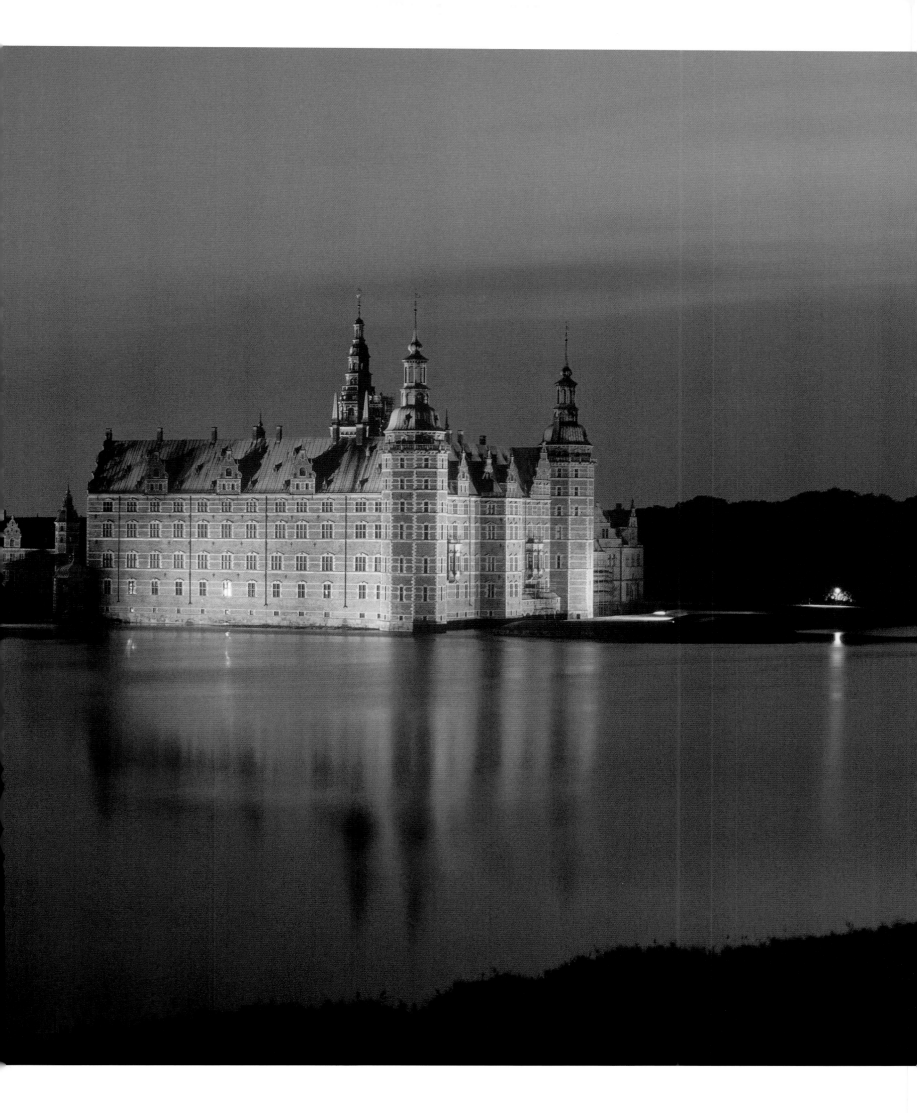

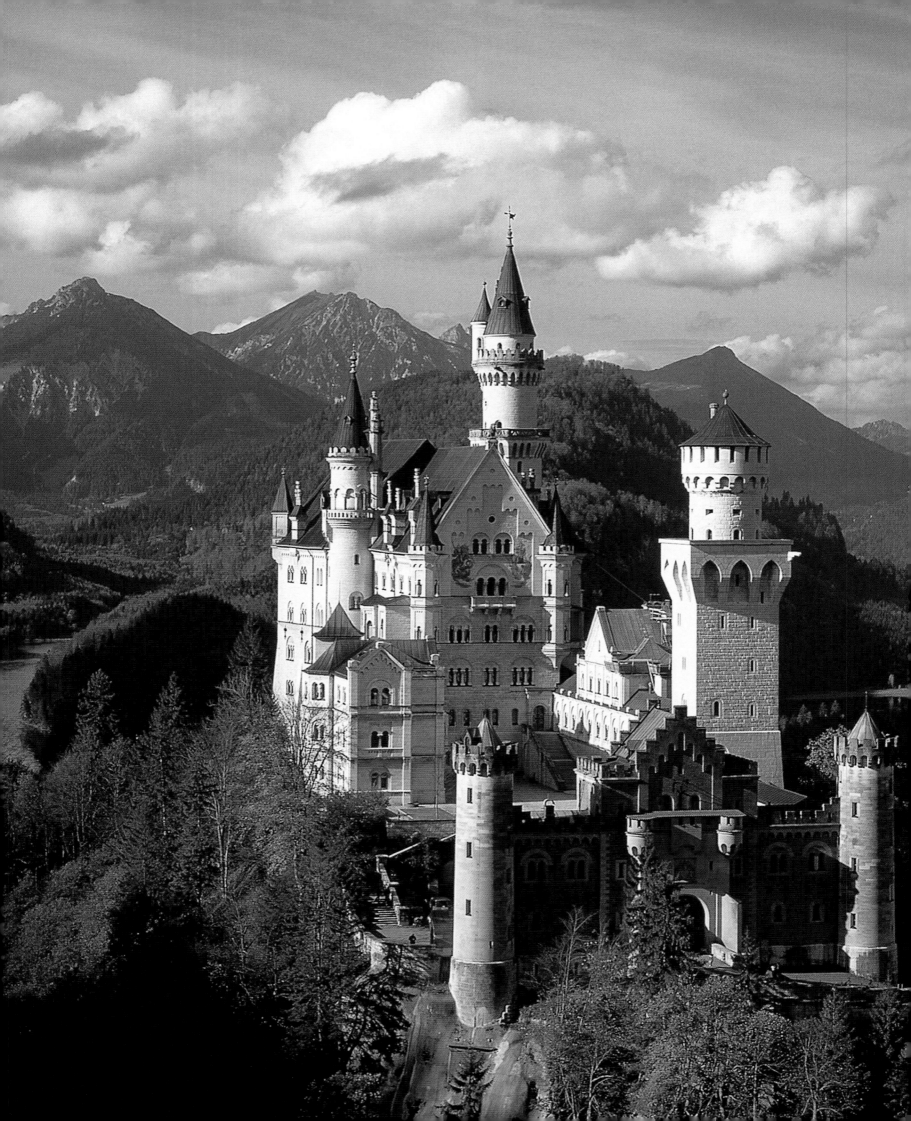

THE CASTLE OF NEUSCHWANSTEIN, BAVARIA, GERMANY

Left:

Ludwig II of Bavaria was no longer a child in 1869 when he began building the castle that sits like an eagle's nest on a rock amid dark forests in the shadow of the Bavarian Alps. He was twenty-four years old and had reigned for five years. Was he mad? Some think so. He was certainly eccentric; he himself said he wished to remain one of history's mysteries. His astonishing castle, which was to inspire the one in Walt Disney's *Sleeping Beauty*, was somewhat like him. In the mind of the young Ludwig, who lived in an illusory world, the castle was undoubtedly inspired by the deep Germanic roots expressed in the operas of his idol, Richard Wagner. The king lived only two years at Neuschwanstein before he met an unexplained death in 1886. Neuschwanstein was never finished.

PALACE OF THE WINDS, JAIPUR, INDIA

Right:

The Hawa Mahal in Jaipur has been described as looking like a pipe organ in pink stone or like a piece of lace. In reality, its odd façade, although several dozen feet long, is only about 7 feet (2 meters) deep. The buildings of the palace proper lie behind it. The Palace of the Winds was built by the Maharaja of Jaipur in 1799 to satisfy the curiosity of the women of his harem; it is essentially a pile of tiny chambers with hidden balconies—953 in all—from which his wives could observe the city's activities without being seen. The breeze that circulates through its many windows kept this "palace of the winds" cool during the monsoon season.

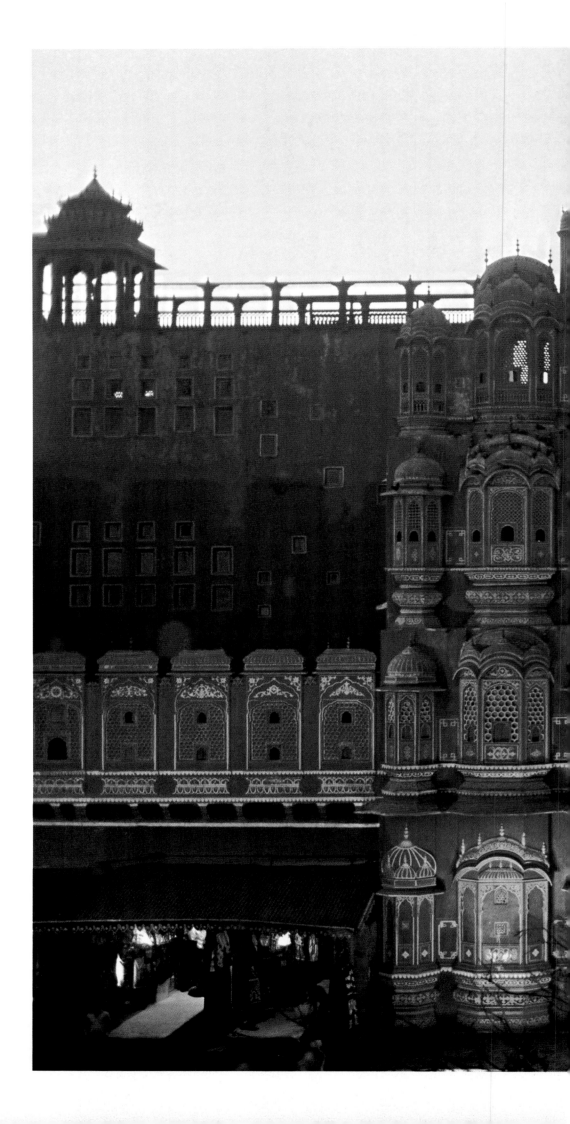

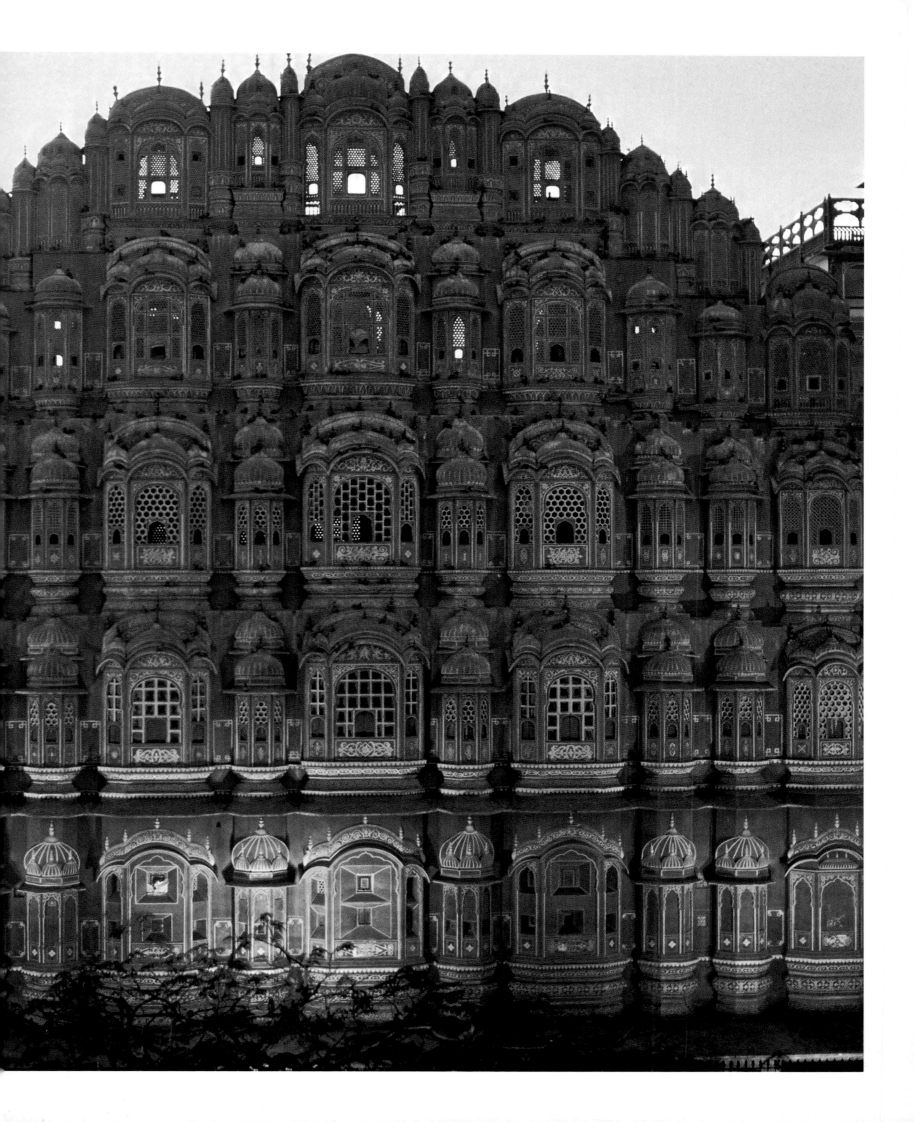

THE CITY, FUTURE OF HUMANITY

Some cities are criticized for being sprawling, monstrous, anonymous, lonely. Others are viewed as provincial, languishing somewhat behind their ancient stones, but pleasant places to meet and walk. Some cities floodlight their buildings and nurture their beauty, proud of their historic features and the monuments they present to admirers. Others throw themselves headlong into the future, erecting towers of steel and glass, defying their rivals to build even higher. When the French poet and novelist Louis Aragon famously predicted more than half a century ago that humanity's future would be female, he might have added that it would be urban as well. For by 2030, more than half the world's population will live in cities, whether conventional metropolitan areas, capital cities, cities of culture, or some combination. The drift of people toward cities has been continuous for more than two hundred years, and it shows no sign of slowing down, as China prepares to build four hundred new cities in the coming decades to house the 300 million people expected to leave their rural homes.

Today's urbanization is driven by the euphoria of globalization in the developing world, just as the growth of European cities during the nineteenth century was driven by the Industrial Revolution. The appearance of Europe's cities changed in varying degrees during the early years of modern capitalism. London was rebuilt by Sir Christopher Wren after the Great Fire of 1666; Paris was given new perspectives by Baron Haussmann in the 1850s and 1860s during the Second Empire. With their broader, less crowded, and more attractive thoroughfares, both cities became more hospitable to trade, the most important economic force after manufacture. The new "get rich" creed was dominant, espoused especially by the middle classes who could establish businesses on every street corner. Temples of consumption were built—Harrods in London and the Bon Marché in Paris, both examples of imposing steel-frame construction, the same method used in building London's Tower Bridge (pages 194–95) and Paris's Eiffel Tower (page 193). It did not seem to matter if the city's rear courtyards were not so fine, or that the air was laden with factory smoke and the residue of railroad locomotives as they steamed into stations located in the center of town. No one wanted to miss the train to modernity—which was also the train to employment. Between 1850 and 1913, Europe's urban population climbed from 40 million to 160 million.

But the city was breaking new ground elsewhere. Across the Atlantic in the United States, a large part of Chicago was destroyed by fire in 1871, and a sudden rise in the price of land for building forced real estate speculators to think anew. William Le Baron Jenney blazed a trail with his First Leiter Building (1879), which lacked a load-bearing façade and instead supported floors with cast-iron columns. It was followed in 1885 by the Home Insurance Building, built of brick and steel with elevators by the now-famous Elisha Graves Otis; arguably the first skyscraper in history, it had

Sixth Avenue, New York, USA

The City, Future of Humanity ⮑ 157

ten stories and was 138 feet (42 meters) tall. Chicago was joined by New York (pages 218–19), Los Angeles, and many others. The American city, which was now attracting generations of immigrants, was altering its appearance. With its linear avenues and right-angled street grid divided into "blocks," it was a model that could be easily exported. As soon as they went up, buildings like the Chrysler and Empire State (page 220) became as closely identified with New York as the Statue of Liberty (page 221). Erected in the early 1930s, these skyscrapers are over 1,000 feet (310 meters) tall.

Now it is Asia that aims high. China's Hong Kong has more than 7,500 buildings 12 floors or higher. The Asian "reach for the sky" is represented within these pages by the impressive skyline of Shanghai's brand-new Pudong district (pages 238–39) and by the towers of Tokyo's Ginza (pages 226–27) with their bright lights and flashy signage. But it is the oil-rich Emirate of Dubai that is currently on schedule to have the tallest building in the twenty-first century, to complement its seeding of the desert and the "map of the world" it is building with artificial islands in the sea.

Meanwhile, Europe has withdrawn from the race to build high, preferring other values and pleasures. "Cities carry the stigmata left by the passage of time and occasionally the promise of eras to come," wrote Marguerite Yourcenar. And it is, indeed, to the past that the cities of the old continent are looking to build their future. Many of Europe's ancient cities have rediscovered their former character, cleaned up and rehabilitated their historic centers, created automobile-free zones, and removed parking lots, offering instead an urban environment where it is pleasant to stroll around. Among them are Florence (pages 200–1), the glory of the Medici; Barcelona (page 209), the queen of Art Nouveau inspired by Gaudí; Venice (pages 196–97), with its memories of the Doges; and Dubrovnik, the pearl of the Adriatic. Then there are the European capitals: Paris (page 190–91), Vienna, London (pages 176–77), Prague (pages 186–87), Amsterdam (pages 104–5), Rome (pages 204–5), and Budapest (pages 184–85) are taking care of their heritage, polishing up their domes and spires, and giving their museums a new look. Those cities with the good fortune to have a river running through them are turning it to their advantage, whether by converting docklands, as in London on the Thames, or by creating a summer beach, as in Paris on the Seine.

With all that is happening, can there be any doubt? Whether as a place to live or to visit as a tourist, whether sprawling or contained within the framework of old stones, the city definitely holds the future of humanity.

Hohensalzburg Fortress, Salzburg, Austria

GHARDAÏA OASIS, ALGERIA

Above:

The M'zab Valley, 372 miles (600 kilometers) south of Algiers, lies on the edge of the Saharan vastness. Its often imposing rocky landscape contains some superb oases irrigated by a skillful network of channels. Ocher, white, and blue in aspect, ancient fortified villages are perched on the hills. Ghardaïa is the "capital" of the M'zab, a region of rich, well-preserved customs. Above the palm groves, its walls enclose concentric traditional buildings that swarm toward the main mosque. A "summer town" has grown up outside the walls. The simplicity of form and the functionality of Mozabite architecture, composed of cubical terraced houses in plain rendered brick and linked by innumerable covered walkways, have been a source of inspiration to modern Western architects.

SAN'A, YEMEN

Right:

"You must see San'a, though the journey be long" is an ancient Arabian proverb. From its valley 7,200 miles (2,200 meters) above sea-level, San'a served as an important missionary center for Islam in the seventh and eighth centuries. But the settlement is more than 2,500 years old, having an Ethiopian and Ottoman past that predates the Islamic period. It is characterized by an earthen architecture, with tall structures—some of the houses have six stories—decorated with relief motifs and friezes, and enlivened by white or bright colors. Its fortified citadel preserves no fewer than 103 mosques, 14 hammams, or baths, and 6,500 houses built prior to the eleventh century. Small alleyways, steps, covered walkways, souks, not to mention gardens, contribute to making San'a one of the Arabian peninsula's most beautiful ancient towns.

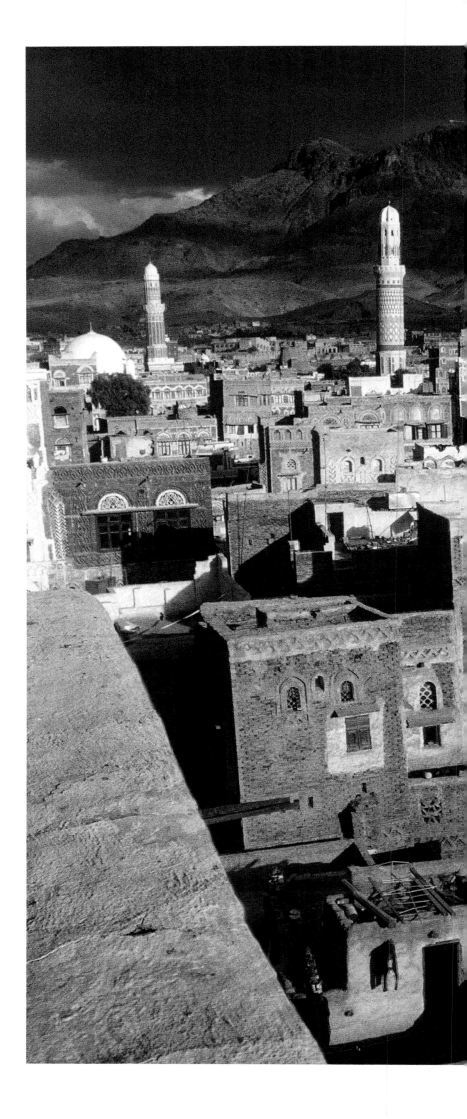

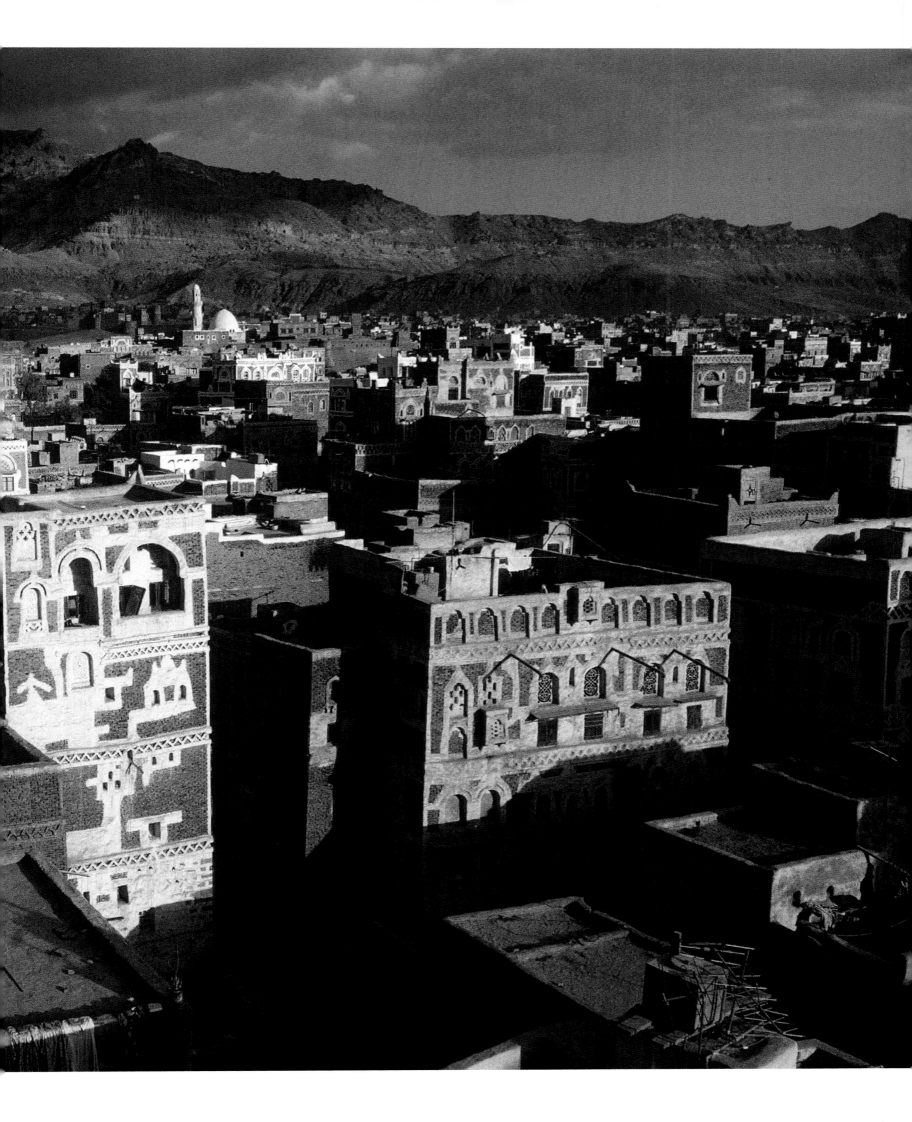

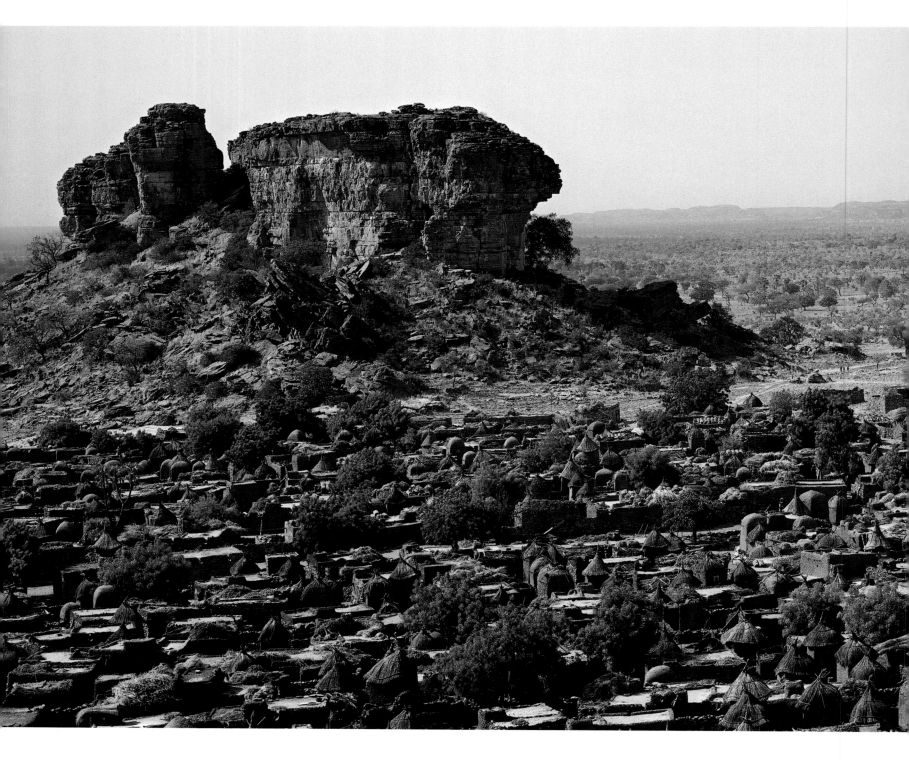

SIWA OASIS, EGYPT

Preceding pages:

Siwa is a vast Saharan and Berber oasis lost in the Egyptian desert just 43 miles (70 kilometers) from Egypt's border with Libya. More than 19 miles (30 kilometers) long by 12 miles (20 kilometers) wide, it is, despite its encirclement by desert sands, a micro-climate irrigated by two lakes bordered by date palms, olive trees, and vegetable plots. In addition to the main urban area, El-Suk, Siwa's foremost architectural structures are to be found in two extremely ancient settlements and in the Adrar, a vast burial site called the "Mountain of the Dead." The region has always been very isolated from the rest of the country. It is the only Berber settlement in Egypt, with its unique traditions and customs. The language spoken is Siwi, a variant of Amazigh, the Berber language.

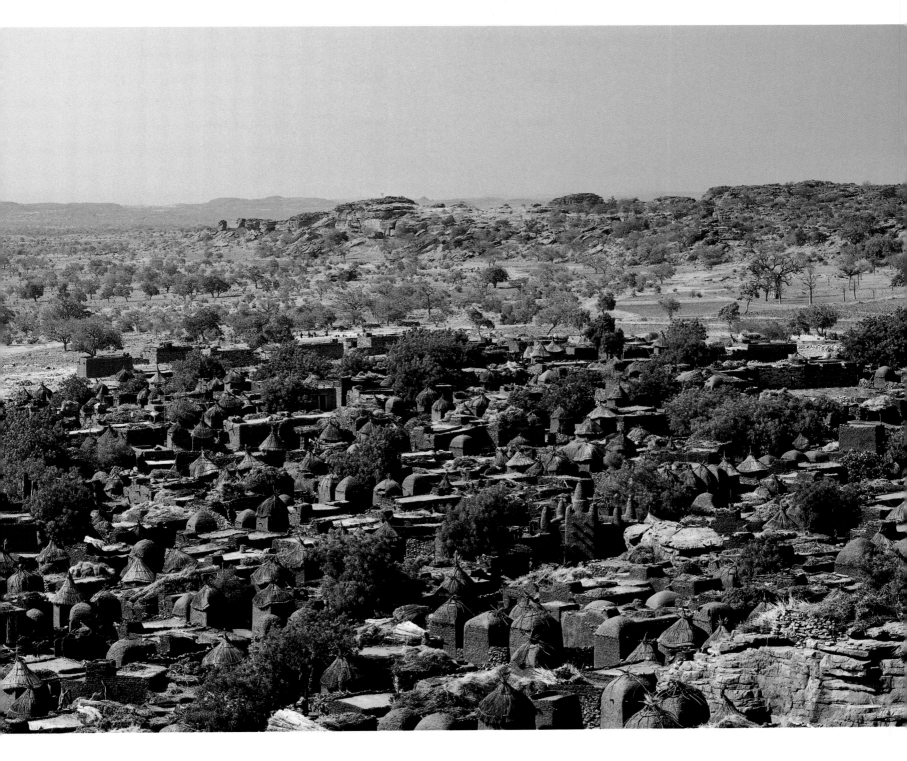

SONGHO, MALI

Above:

Songho is a Dogon village, rich in customs and traditions that are carefully respected by its inhabitants. The architecture within this meander of the Niger River has a natural beauty, constructed of dry brick or *pisé* (rammed earth) with conical roofs, reminiscent in color and form of the soil and cliffs. Important rites, like the circumcision of young boys, take place in caves whose walls are decorated with paintings associated with animist religion. The Dogon are one of West Africa's most ancient peoples, possessing a very rich culture. The group has been a favorite subject of study by ethnologists of the French school. One hopes that the development of tourism, which is already very evident, does not adversely affect the area's cultural richness.

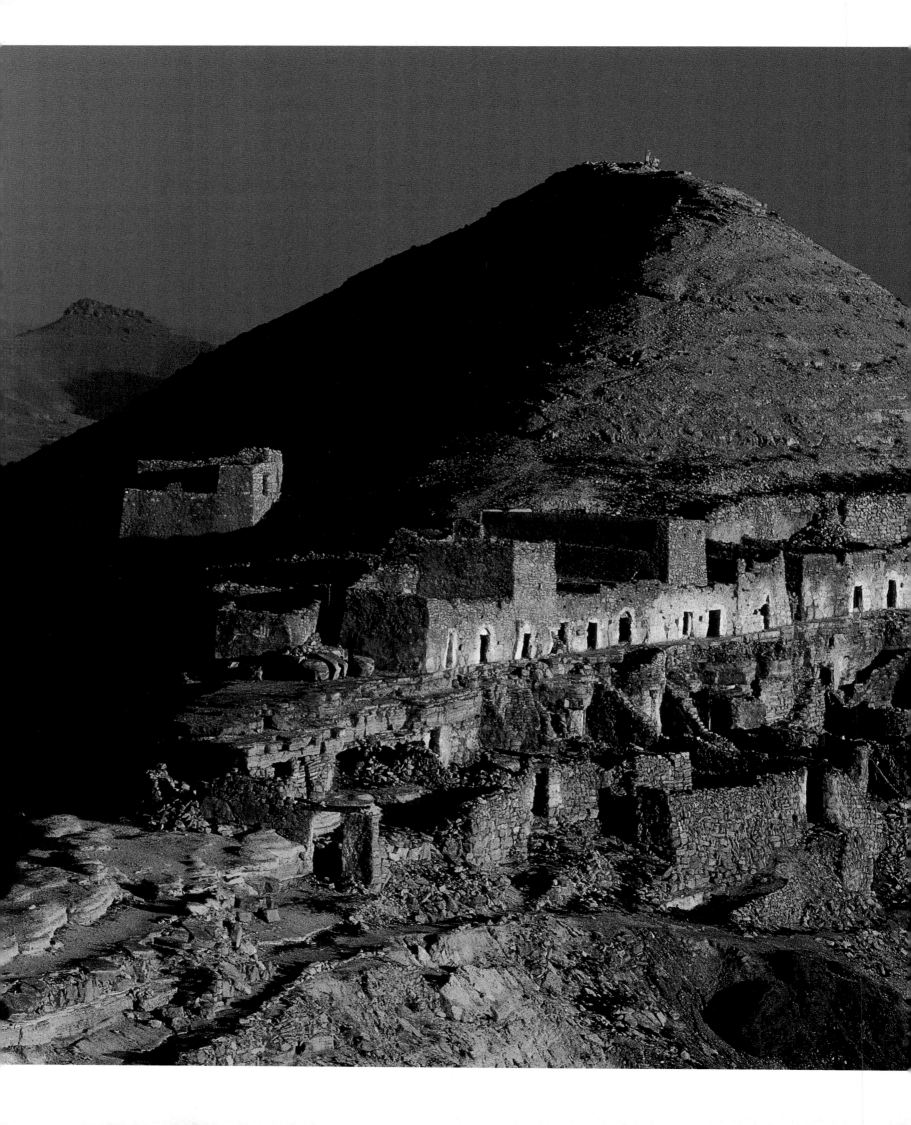

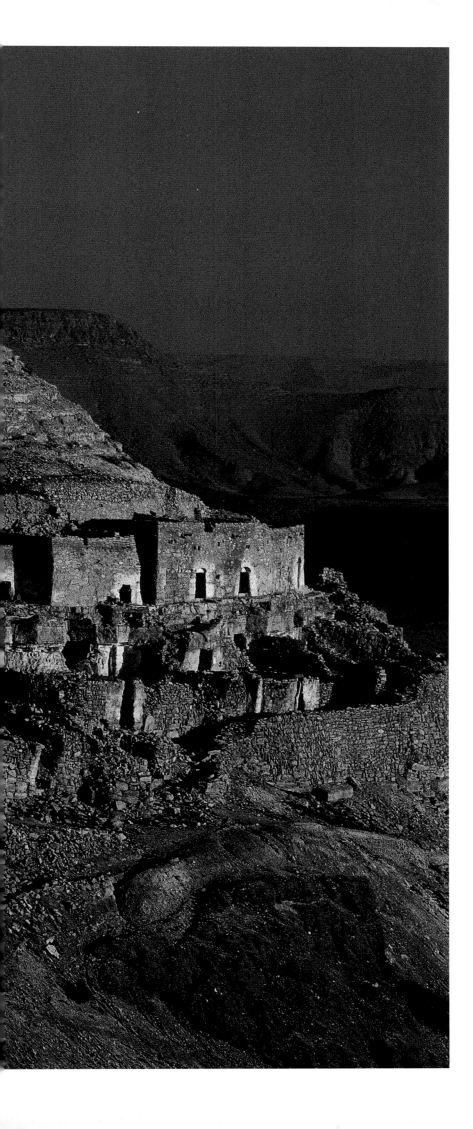

THE TROGLODYTE VILLAGE OF GUERMESSA, TUNISIA

Left:

In an arid part of the Dahar massif in Tunisia, where there are big plans to develop fig and almond cultivation, the wadis—dry riverbeds that fill with water when it rains—have cut into the plateau to form canyons or waterfalls. They fertilize land that is cultivated in terraces. Further south, the Berbers continue to be nomadic; but others, who rear livestock and fiercely guard their traditions, have settled in caves in startling troglodyte villages, such as Guermessa, that cling to the slopes of a rocky peak. Today, however, they prefer to live in a modern village down in the plain rather than to inhabit the caves.

JEMAA-EL-FNA SQUARE, MARRAKECH, MOROCCO

Following pages:

No matter how numerous, tourists cannot rob Jemaa-el-Fna of its authenticity. One of the world's most famous market squares, it provides Marrakech's ancient heart, the medina, with room to breathe. Spilling out of the quarter's narrow streets, leaving behind the souks that are as diverse as they are beguiling, the crowd fills the square toward sundown. Then fires are lit that power the open-air kitchens for the nighttime's meals. Snake charmers, water carriers, musicians and storytellers, female henna artists, tradespeople, and idlers of all sorts are still there. Since morning they have been making the place as lively as it ever was. In their own way, they sustain the captivating atmosphere of Morocco's southern capital, which increasingly attracts and seduces visitors from all over the world.

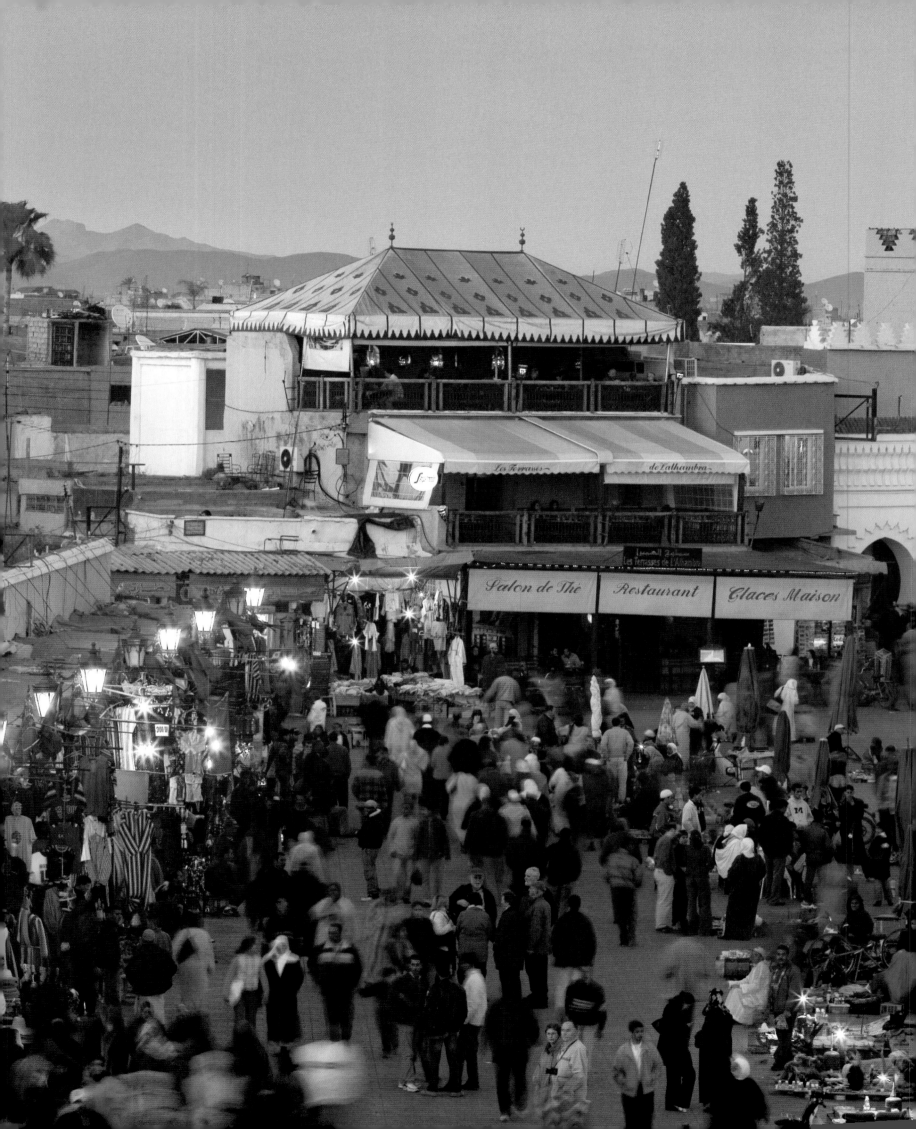

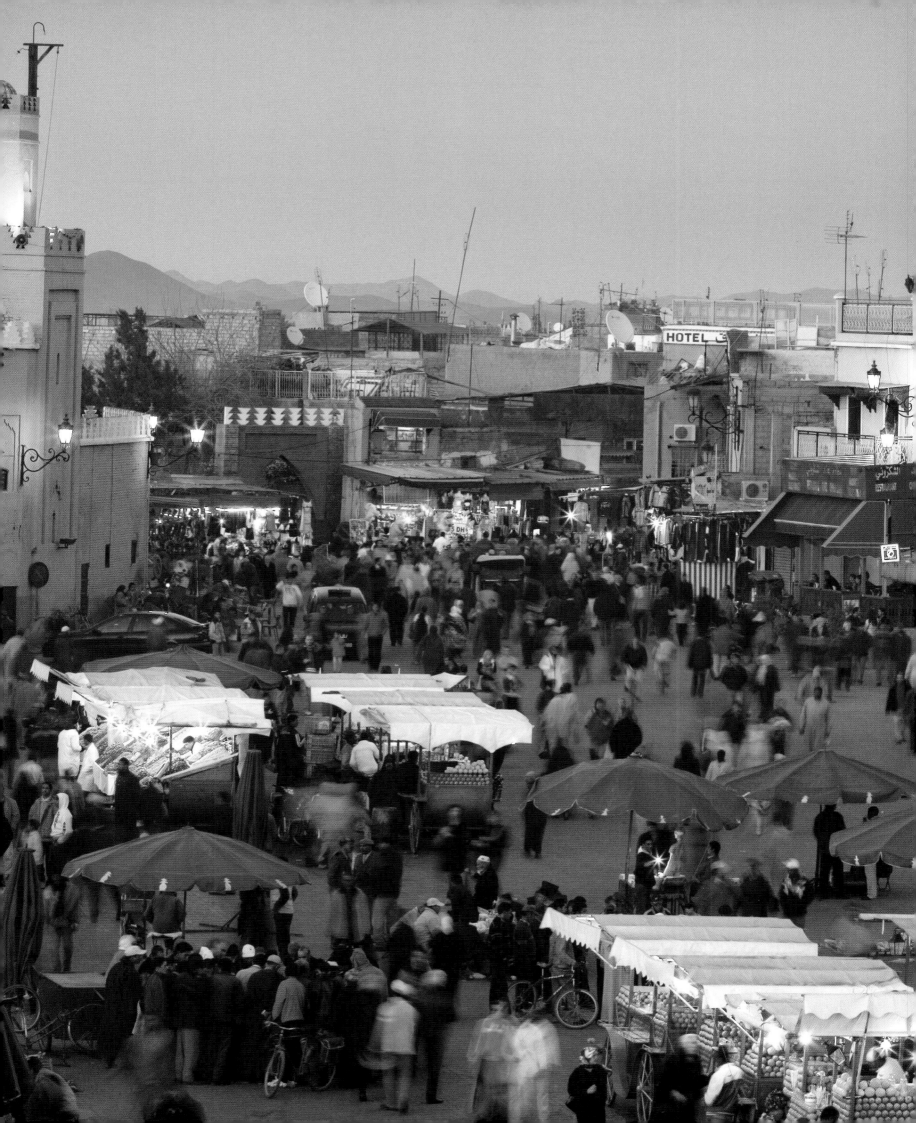

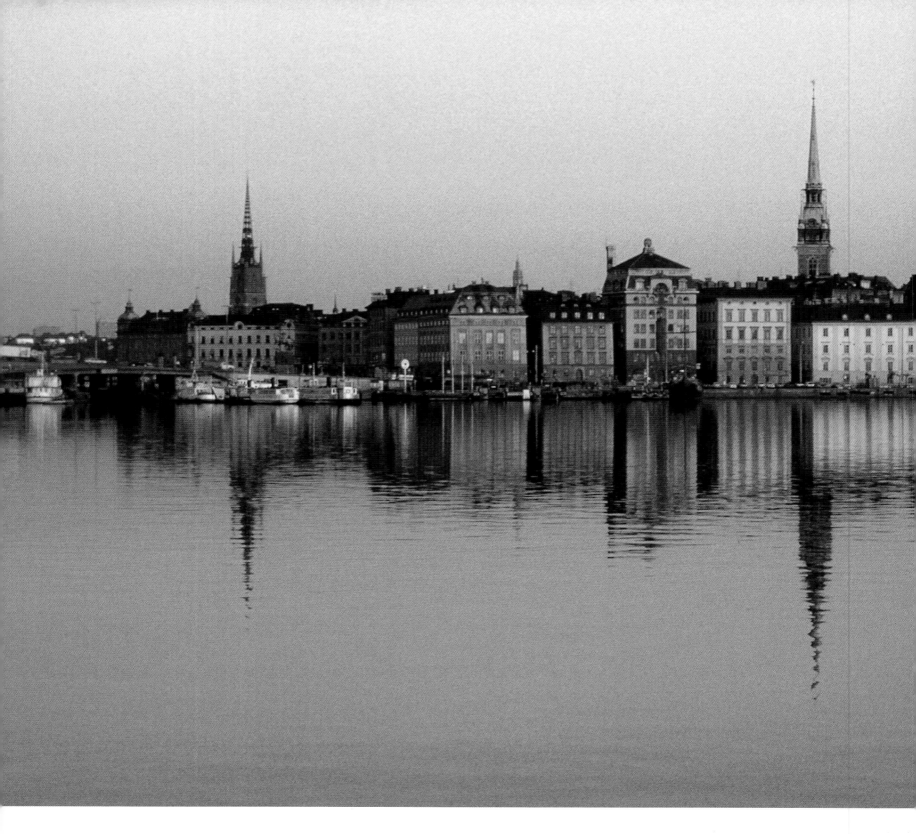

STOCKHOLM, SWEDEN

Above:

Another "Venice of the North"? Sweden's capital may be thought to merit the title, since it appears to sit on the waters of the Baltic in which its buildings are mirrored. Built on several small islands, the city was originally a modest defensive emplacement constructed during the thirteenth century on Gamla, one of the islands. It quickly expanded through success in trade, and the young city became a member of the Hanseatic League of great northern European ports. By the end of the thirteenth century it was the largest city in Sweden, becoming the country's capital in 1419 and playing an important role in Sweden's struggle to throw off its alliance with Denmark. Today's royal capital is a dynamic city that manages to combine a wholesome modernism with its ancient heritage. Its history can be read in its buildings.

ÅLESUND, NORWAY

Following pages:

Ålesund is a town built on islands off a mountainous coast where some of Norway's most beautiful fjords are situated. A commercial and fishing port founded in the eighteenth century, it was built mainly of wood, as was customary then in Scandinavia. An enormous fire ravaged the town in 1904, which aroused great sympathy throughout Europe. Its reconstruction three years later resulted in its current appearance, with more than three hundred buildings, public and private, erected in stone or brick in a style very close to Art Nouveau. Their colorful façades are decorated with sculpted reliefs, adding to the interest drawing the many annual visitors to the town. Ålesund remains commercially very active, and is Norway's foremost herring port.

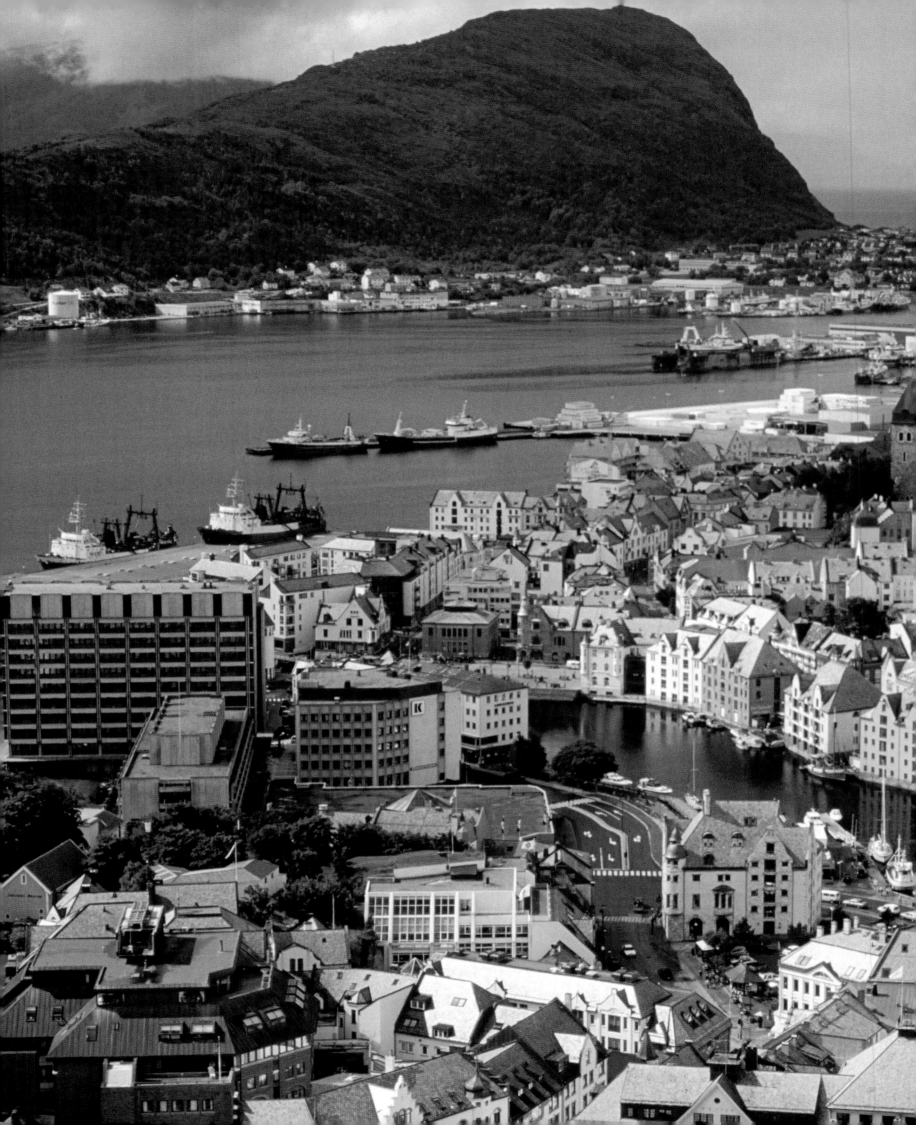

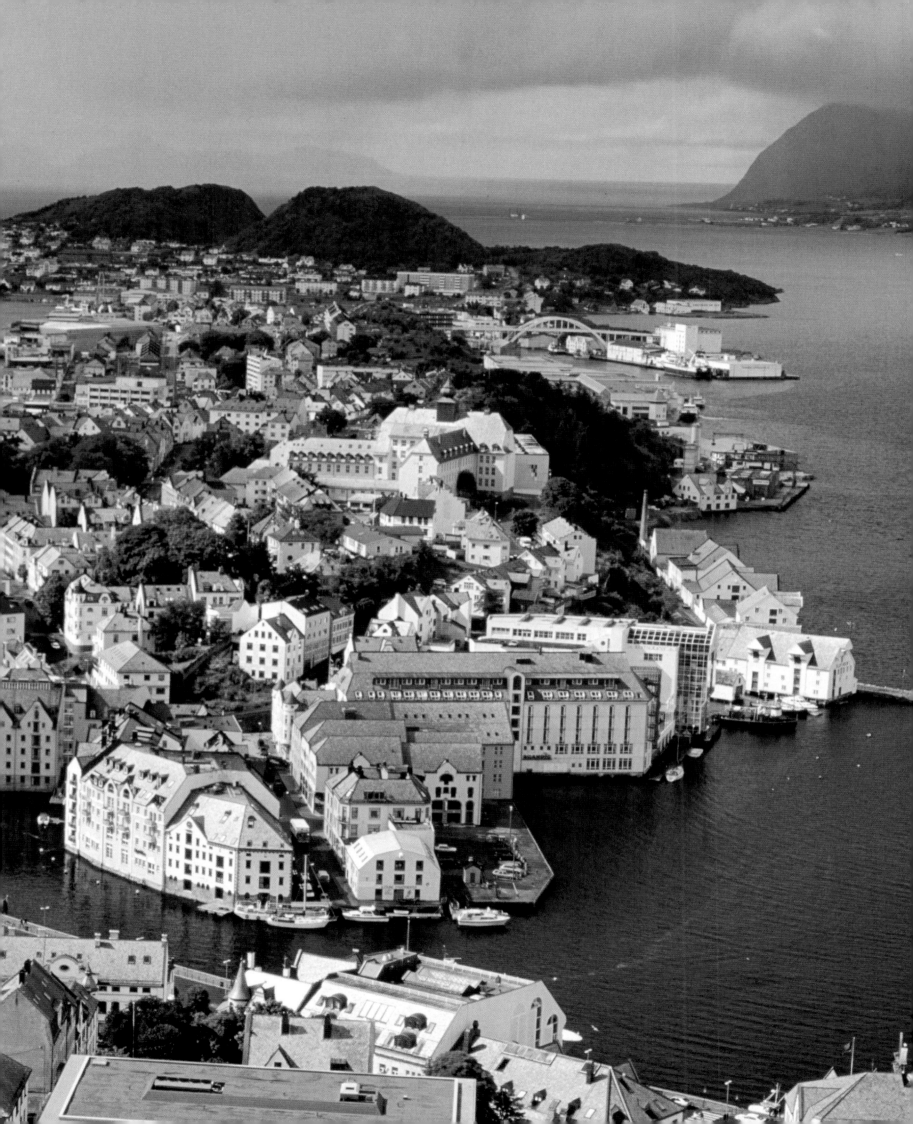

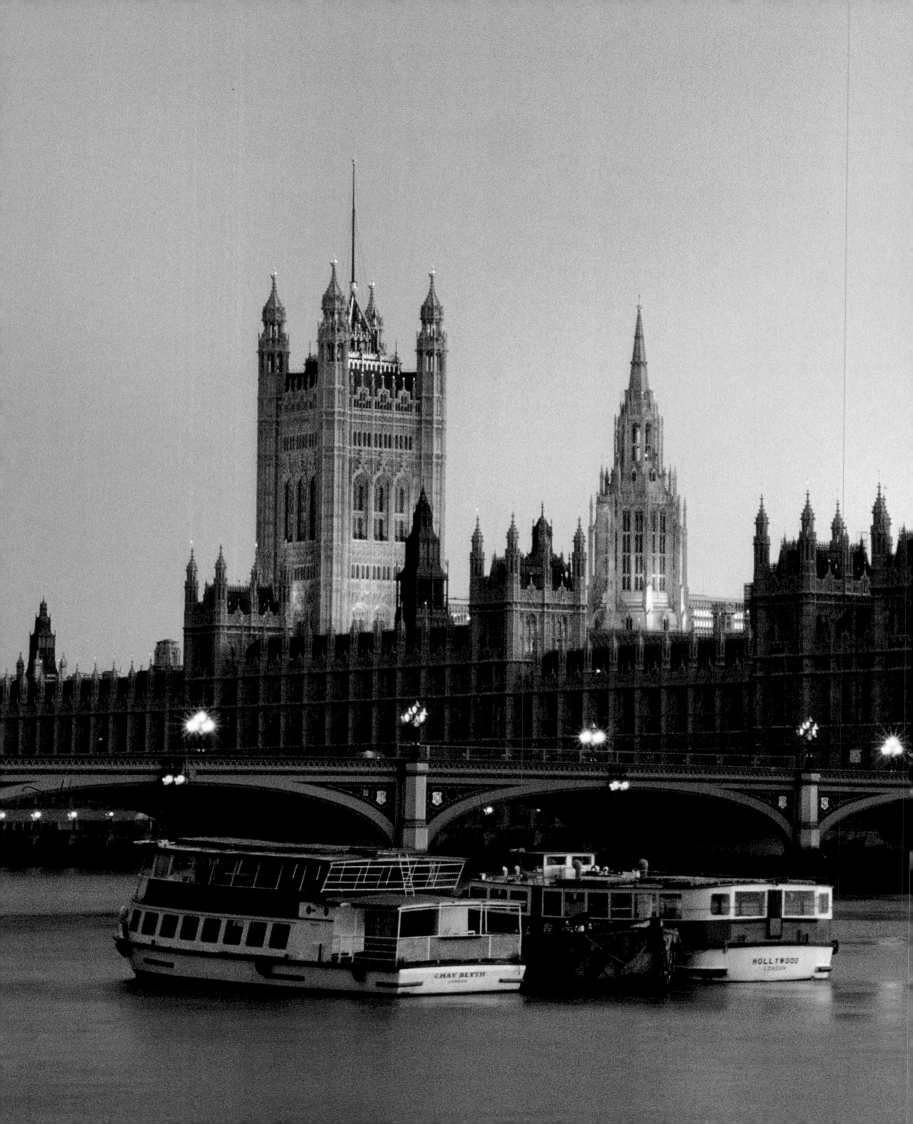

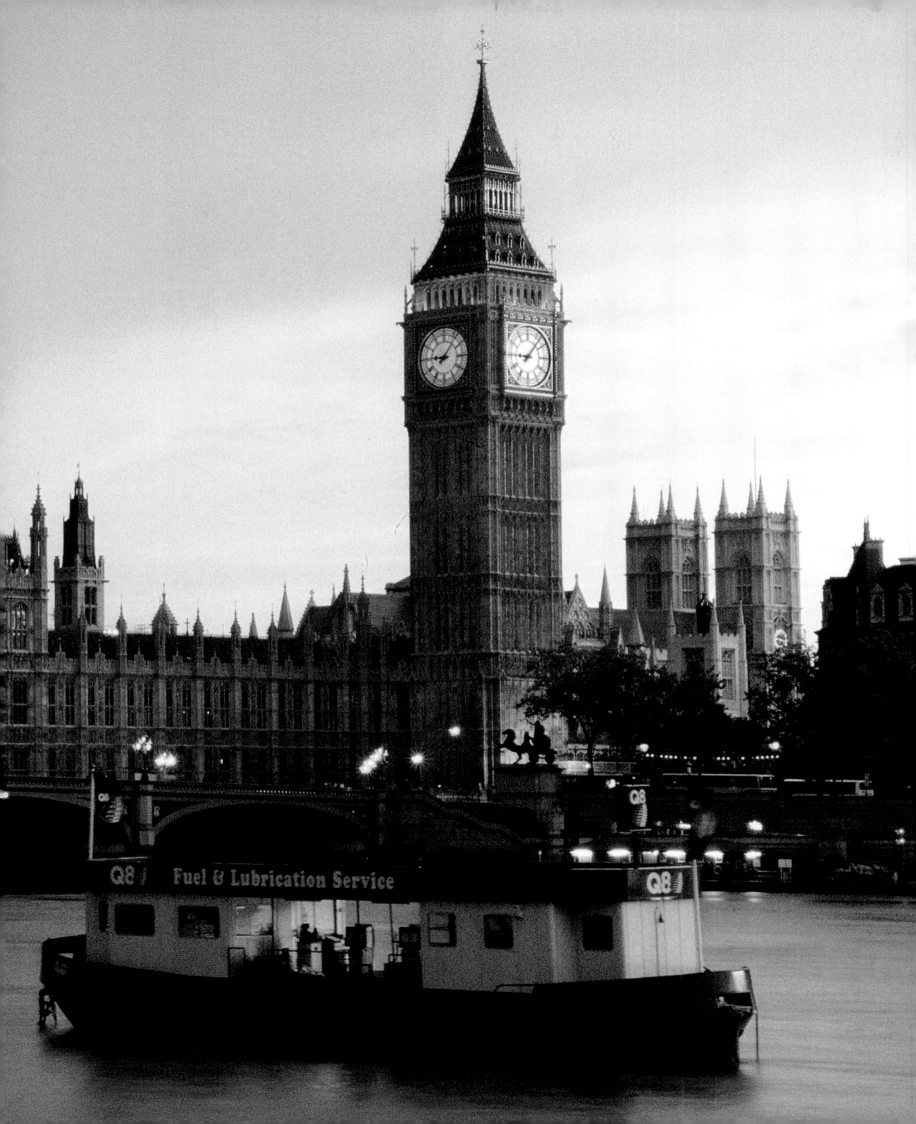

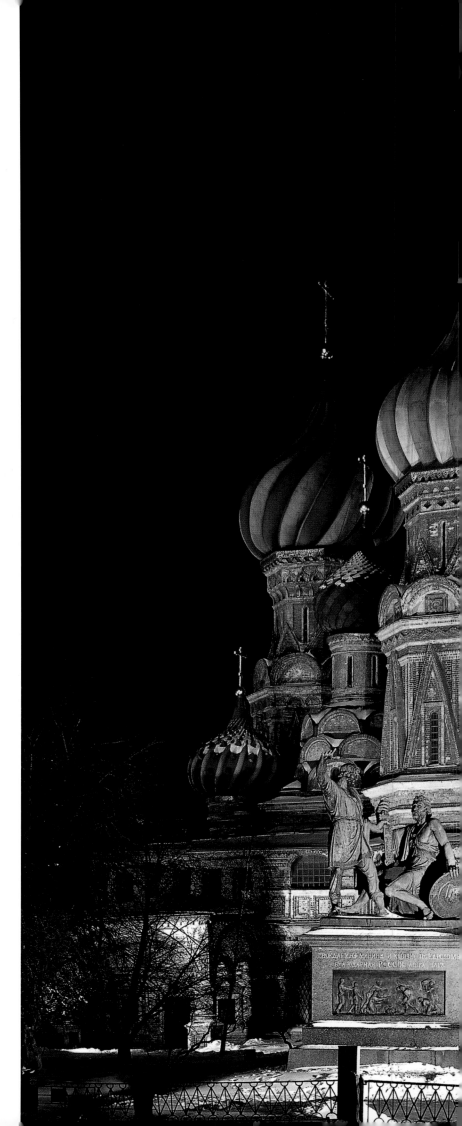

BIG BEN AND WESTMINSTER, LONDON, ENGLAND

Preceding pages:

Every great world city has its iconic monuments. Big Ben is one of London's. The name is often applied to the clock tower of the Palace of Westminster; but strictly speaking, it belongs only to the clock's bell, which weighs thirteen and a half metric tons. The clock's faces are actually a huge 23 feet (7 meters) in diameter. Built along the north bank of the Thames, Westminster Palace, which takes its name from the nearby abbey, is home to the two chambers of the British Parliament, the House of Commons and the House of Lords. After most of the palace was destroyed in 1834, the vast building was reconstructed around its medieval remnants in the mid-nineteenth century in a Neo-Gothic style then in vogue in Britain. The regular, highly ornate, long façade is very typical.

THE CATHEDRAL CHURCH OF SAINT BASIL THE BLESSED, MOSCOW, RUSSIA

Right:

Saint Basil's Cathedral is one of the many consecrated buildings within the Kremlin, itself a city within the city of Moscow. Commissioned by Ivan the Terrible in 1561, the monument was finished only in 1670, with its colorful onion-domed towers overlooking what was to become Red Square. It is said that its number of chapels (originally eight) represents the number of the czar's victories over the Tatars. The monument's diverse and whimsical decoration—"recolored" on completion—has a lot to do with its popular attraction, but the church nonetheless follows the rigorous plan of a Greek cross with chapels situated in the angles. Tradition has it that the czar had the architect blinded to prevent him from designing a rival masterpiece.

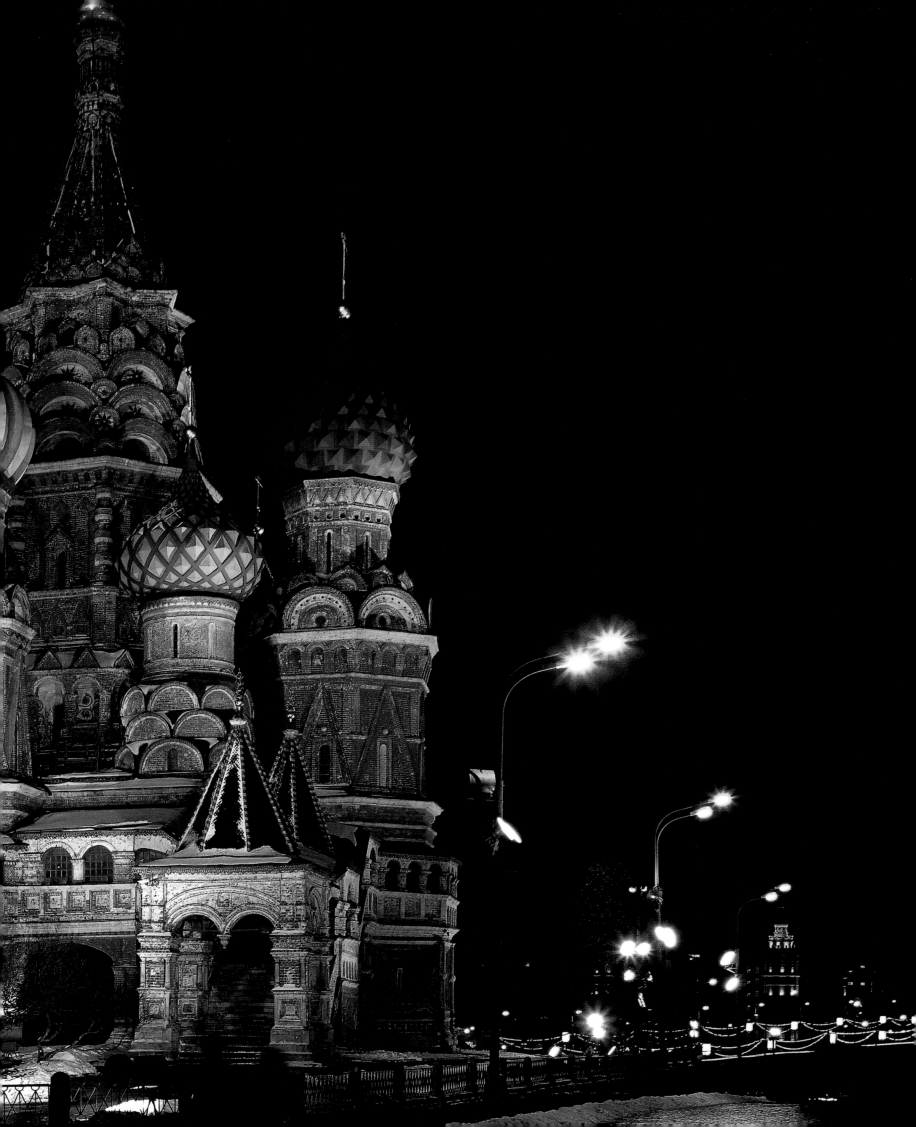

THE GRAND-PLACE, BRUSSELS, BELGIUM

Left:

The Grand-Place dates from the eleventh century, when a large open-air market was opened near the castle that gave birth to the town. Soon after, it acquired a roof and houses were built around it. By the fifteenth century, the square had become the main focus of commercial and civic life; it was also the spot where executions took place. Following bombardment by the armies of Louis XIV in 1695, the square was refashioned; and it was further restored after damage caused by the French Revolution. Many of the sumptuous mansions on either side of the fifteenth-century Town Hall complete with tower are the houses of guilds—watermen, archers, joiners and coopers, dairy and poultry merchants (*graissiers*), bakers, mercers, and butchers. The Grand-Place is the living center of Brussels and is still the frequent site of festivities and demonstrations. It is never more lovely than when carpeted by flowers.

STRALSUND, GERMANY

Following pages:

Stralsund, on the German Baltic coast, played an important role among the towns of the Hanseatic League during the fourteenth and fifteenth centuries. For a time it came under Swedish rule, and the town evolved a very characteristic brick-built architecture that accounts for the present-day charm of its ancient center. Brick has been the building material of choice in every period, which has provided a certain visual unity in spite of stylistic differences. Tourism is an essential activity, but Stralsund has not forgotten what it owes to the sea. Its most famous pirate, Klaus Störtebeker, is still celebrated; and the German Museum of the Sea with its stock of ancient ships, not far from the modern shipyards, is well worth visiting.

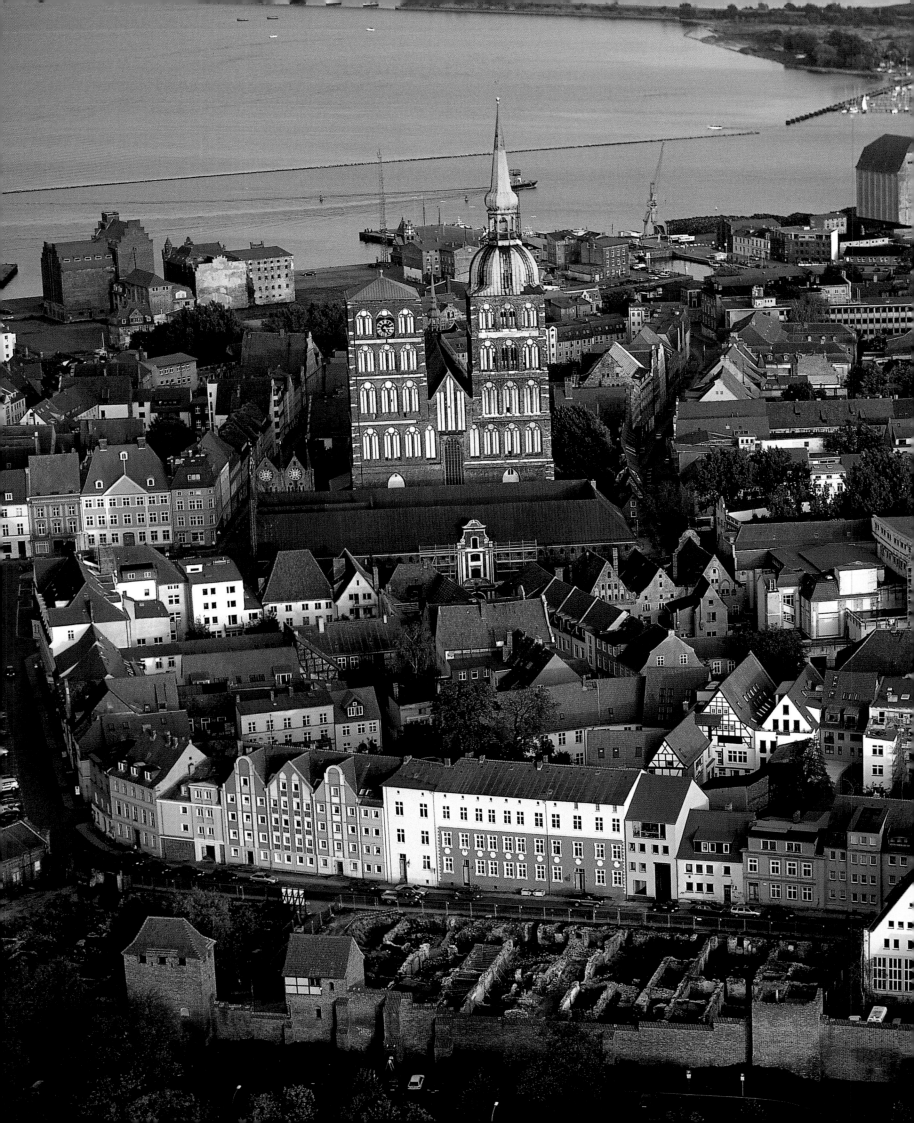

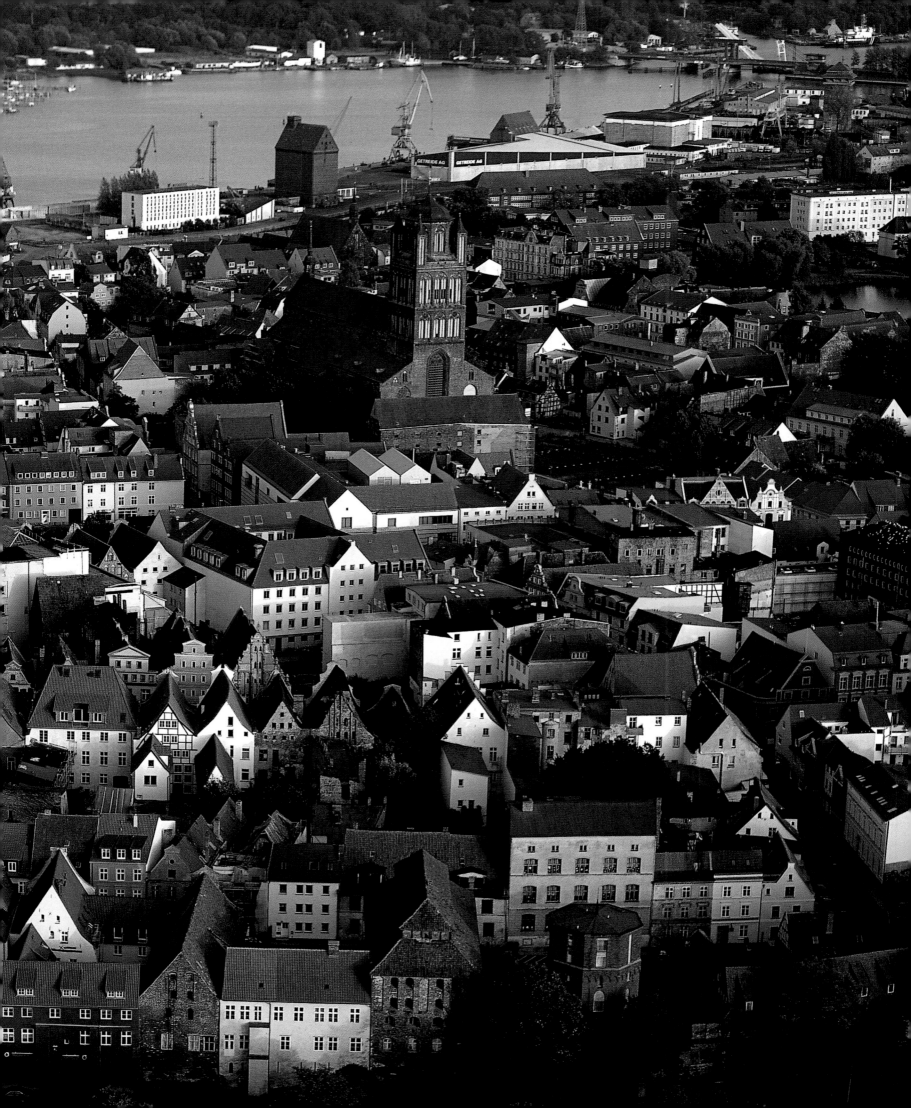

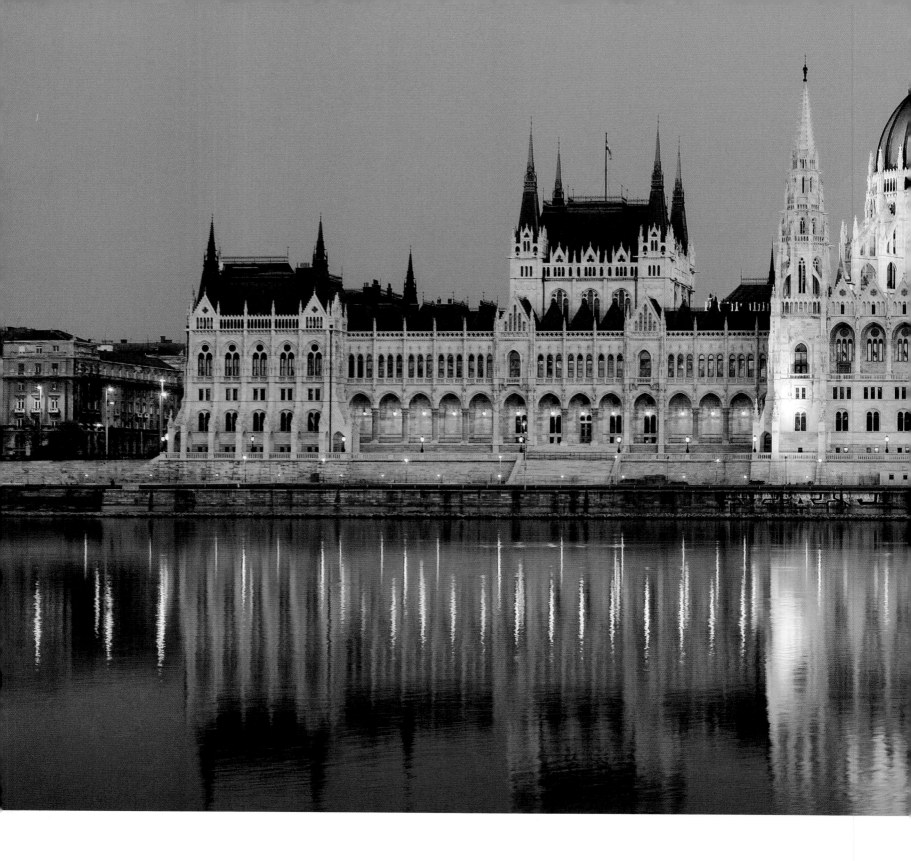

BUDAPEST, HUNGARY

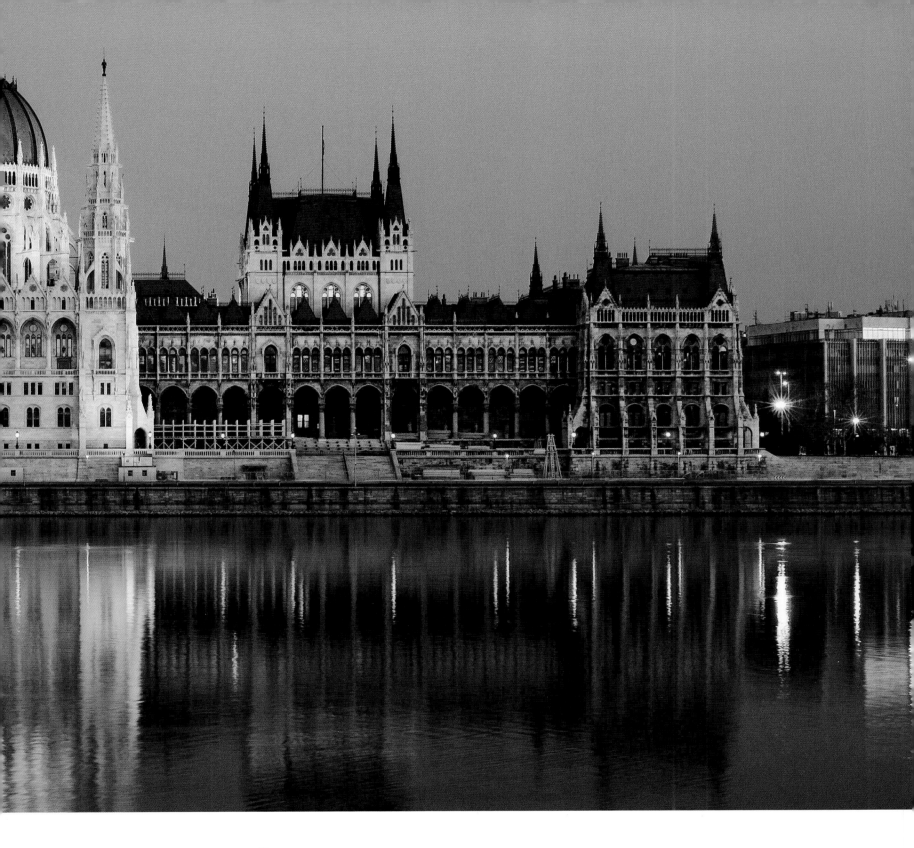

Budapest, whose Parliament façade (1903) is shown here, was created in 1873 when the towns of Buda and Obuda on the west bank of the Danube River merged with Pest on the east. Originally a Roman town, Buda was the capital of the kingdom of Hungary since the fourteenth century, with a break during the conquest of the country by the Ottoman Empire. With its 1,700,000 inhabitants, Budapest is a city of art with a rich past that has left many tangible signs, including fortifications, a royal palace, museums, and churches: the Church of Saint Stephen in Buda holds the famous crown of King Stephen. The synagogue is the second largest in the world; and the city prides itself on having one of the oldest underground railways in the world, a train station built in 1896 by Gustave Eiffel, and some famous Turkish-style public baths.

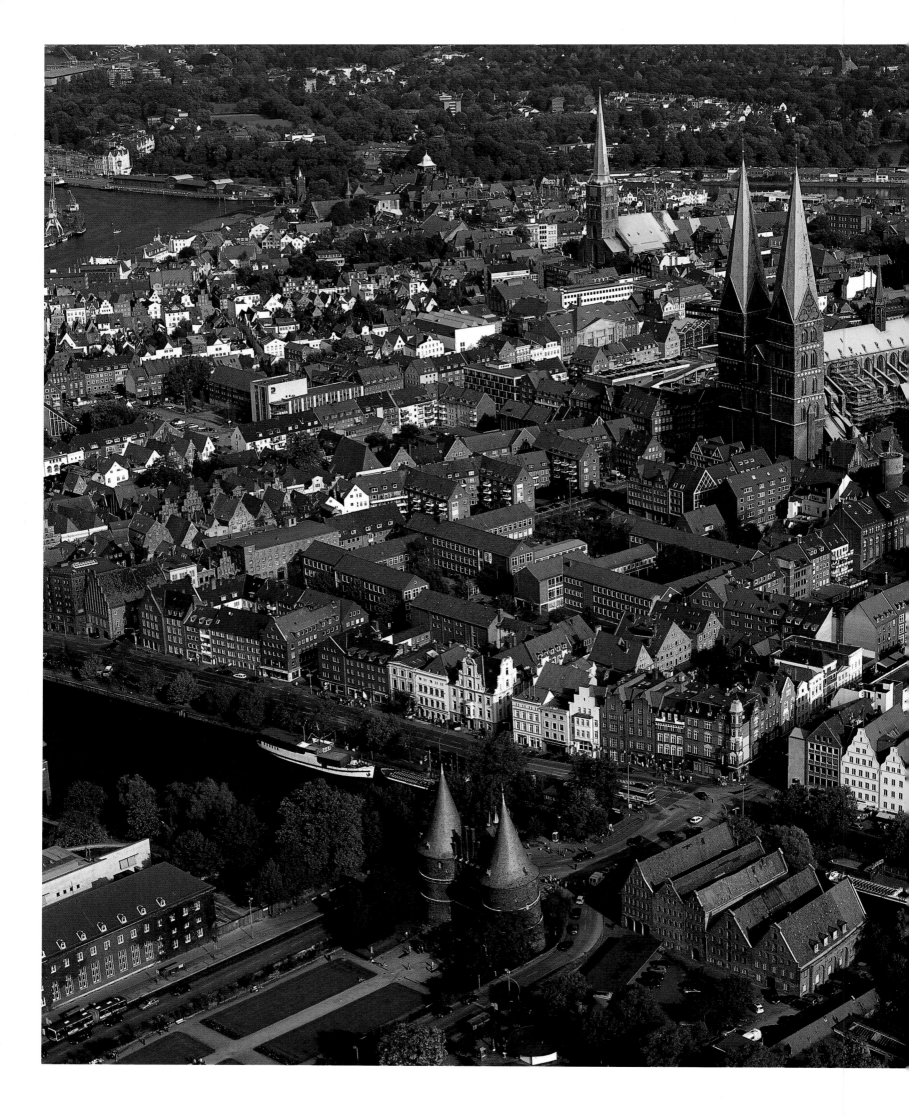

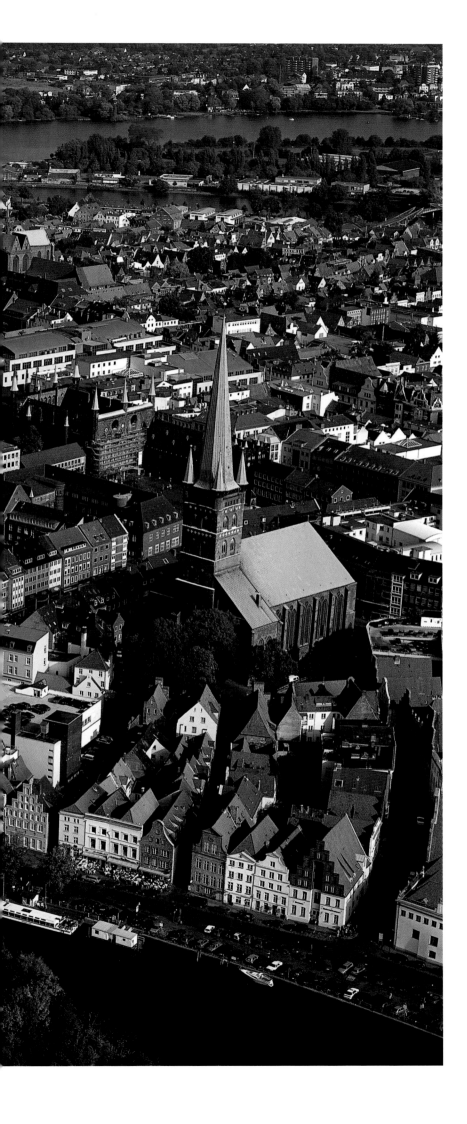

LÜBECK, GERMANY

Left:

Originally a Slavonic city, the north German city of Lübeck lies within the territory of Schleswig-Holstein. Ruled by a prince-bishop and an imperial city in the thirteenth century, it enjoyed considerable prosperity throughout the Middle Ages owing to the activity of its Baltic port. Indeed, it was the capital city of the Hanseatic League, which united and organized the commercial life of northern Europe at the time. Lübeck shared its command of the seas with its neighbor, Hamburg. The city suffered during the Second World War, when it was bombed a number of times. A Gothic district happily survived, as did several monumental structures like the Rathaus, or town hall, and the Holstentor, or Holstein Gate. Enough of the city's heritage survives to reveal the economic and cultural position of northern Europe during the period when the modern world was being forged.

PRAGUE, CZECH REPUBLIC

Following pages:

Prague's harsh winter does nothing to diminish its beauty. The Czech capital is known as the "city of a hundred steeples," although in reality there are no fewer than 550 of them—enough to demonstrate the richness and dense history of the city on the banks of the Vltava, also known as the Moldau. The city grew up beneath its castle, established in 870 and the residence of the kings of Bohemia. Once a capital of the Holy Roman Empire, Prague is also the Baroque city where Mozart's *Don Giovanni* premiered, as well as a hotbed of anti-Soviet freedom where the Prague Spring of 1968 and then the Velvet Revolution of 1989 took place. The city is indeed one of Europe's historic, artistic, and cultural capitals; and its contemporary creativity remains loyal to that long tradition.

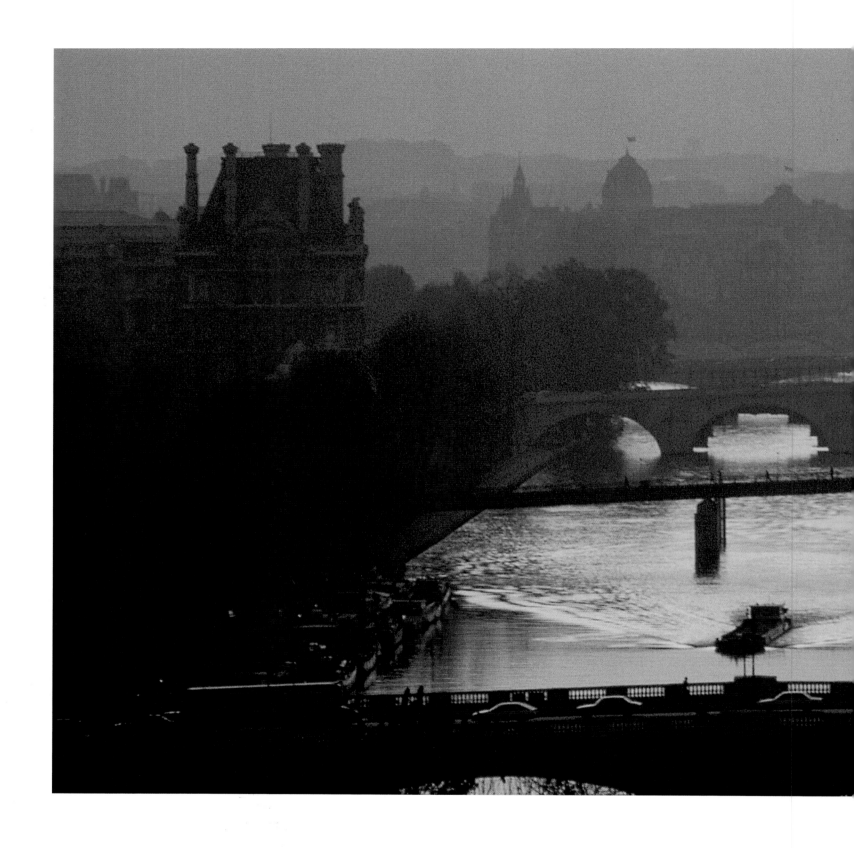

THE SEINE RIVER, THE EIFFEL TOWER, AND THE PLACE DE LA CONCORDE, PARIS, FRANCE

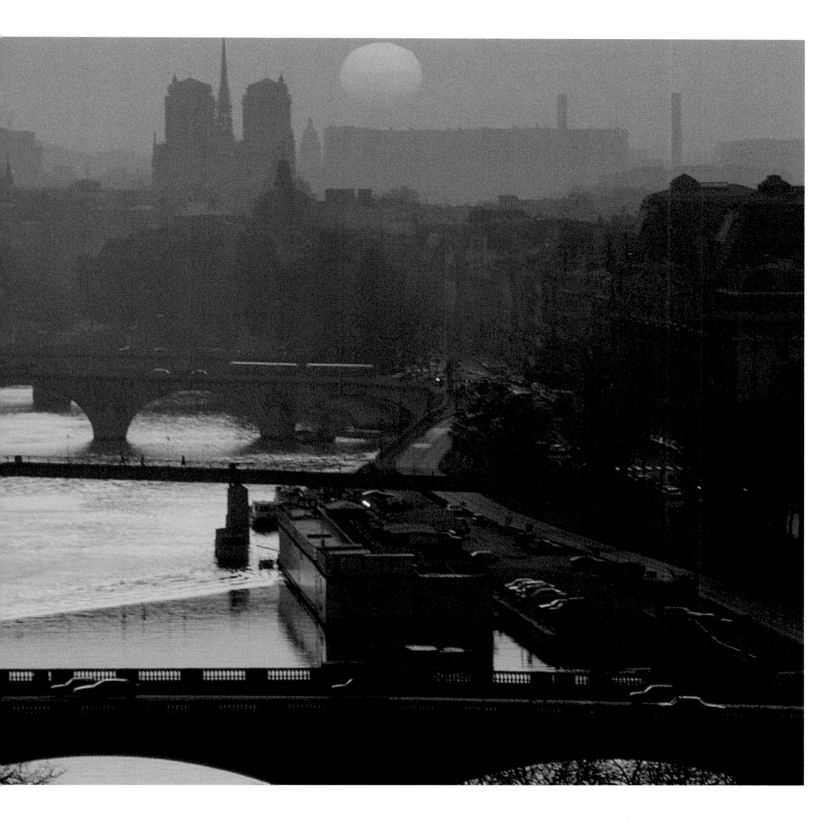

Above and following pages:

Paris is a city of white light. But it is also a city of colors—for example, when the rising sun creates golden reflections in the Seine or the Eiffel Tower shimmers slightly red in the heat of a summer evening. Here the photographer's skill has captured together two of the French capital's iconic images: the ancient obelisk, with its distant Egyptian past, and the metal Eiffel Tower. Paris is a place of contrasts and surprises, where daring juxtapositions are ultimately embraced in the city's secret harmony. Every city has its palette of colors, enhanced here or there with a brush stroke or a detail. The statues and fountains on the Place de la Concorde provide just that sort of ornament, a mere short walk from the river that symbolizes this city. Among cities, is Paris the fairest of them all?

BEAUBOURG, PARIS, FRANCE

Right:

Its official title is Centre National d'Art et de Culture Georges-Pompidou, although Parisians simply call it Beaubourg, for the name of the site on which it is built. The building caused a scandal even before it opened in 1977. Some thought this degree of architectural experimentation in the heart of Old Paris too high a price to pay for what was, among other things, a new national museum of modern art and a large public library. Then, as the years passed, people became accustomed to the lively and colorful space that revived an entire district with its air of cosmopolitan vitality. The building's success has been tangible: six million people a year visit the most plentifully stocked museum of modern art in Europe, where they can see the exhibitions, use the library, eat in the restaurant, or simply spend time in the great hall or on the transparent walkways that offer superb views of the heart of Paris.

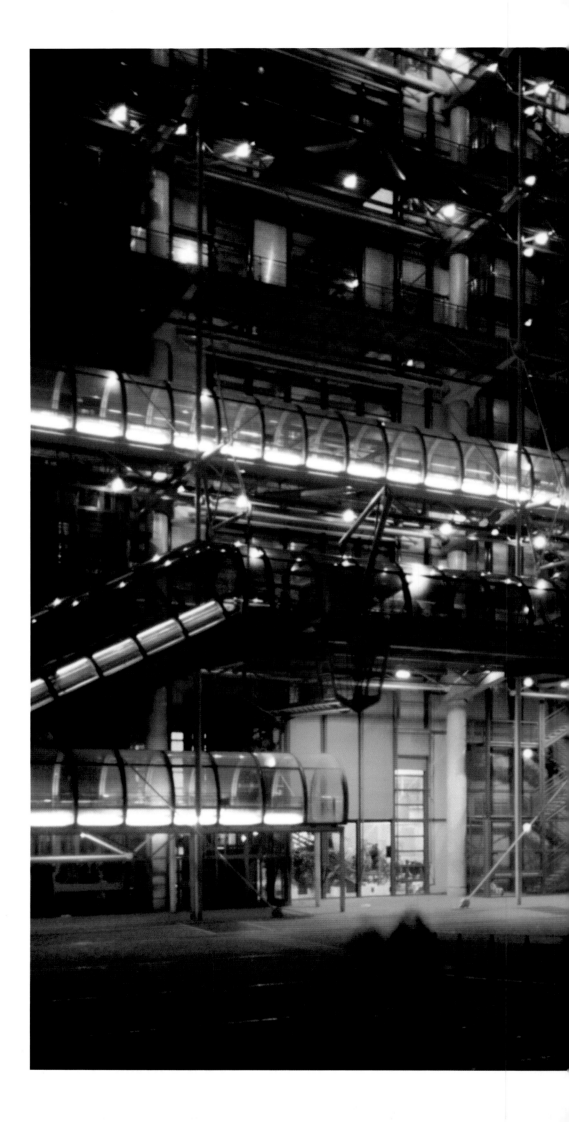

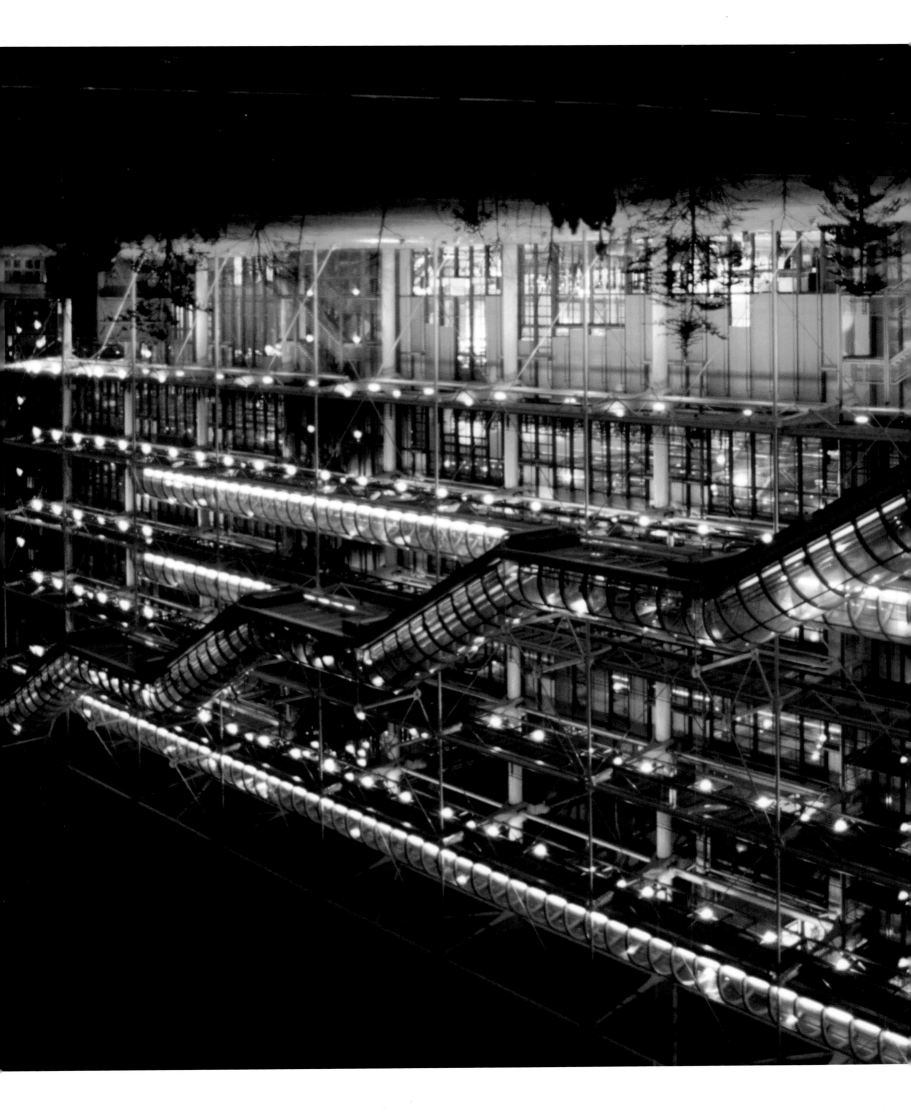

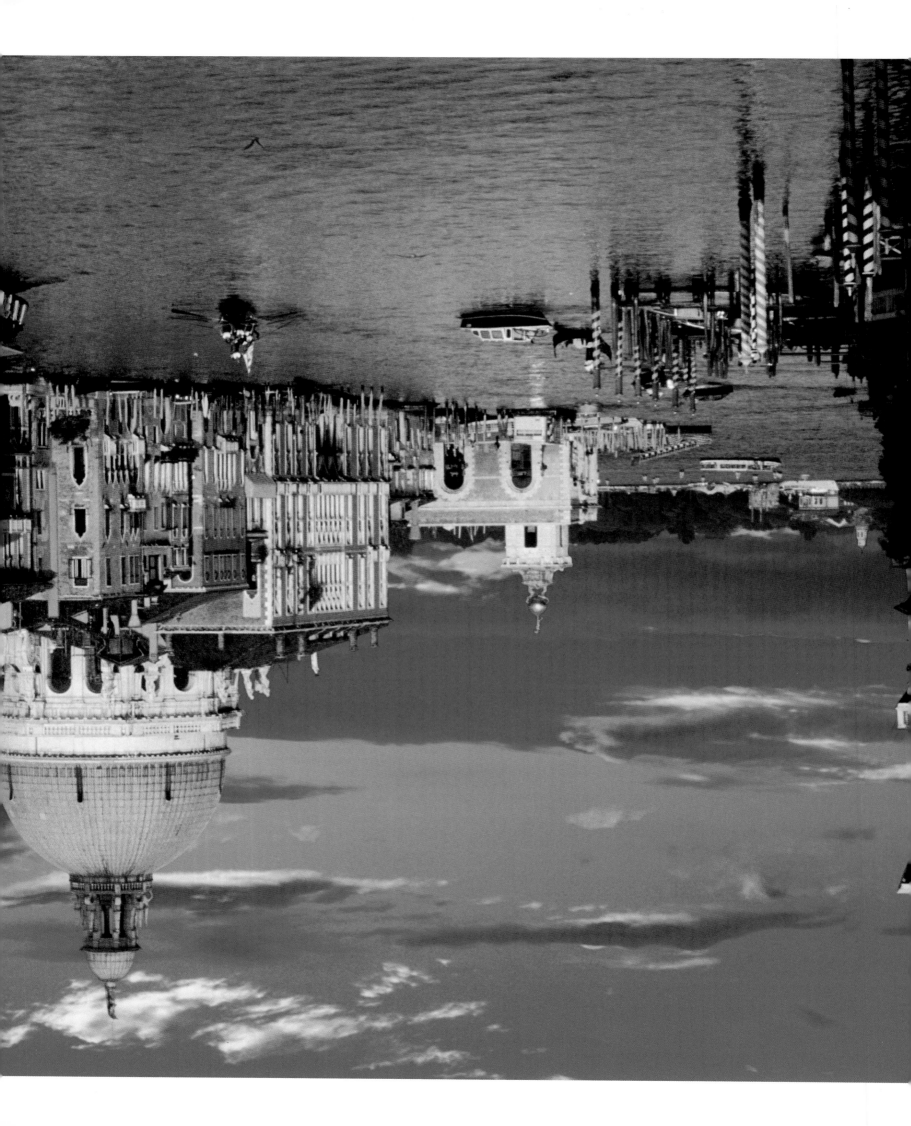

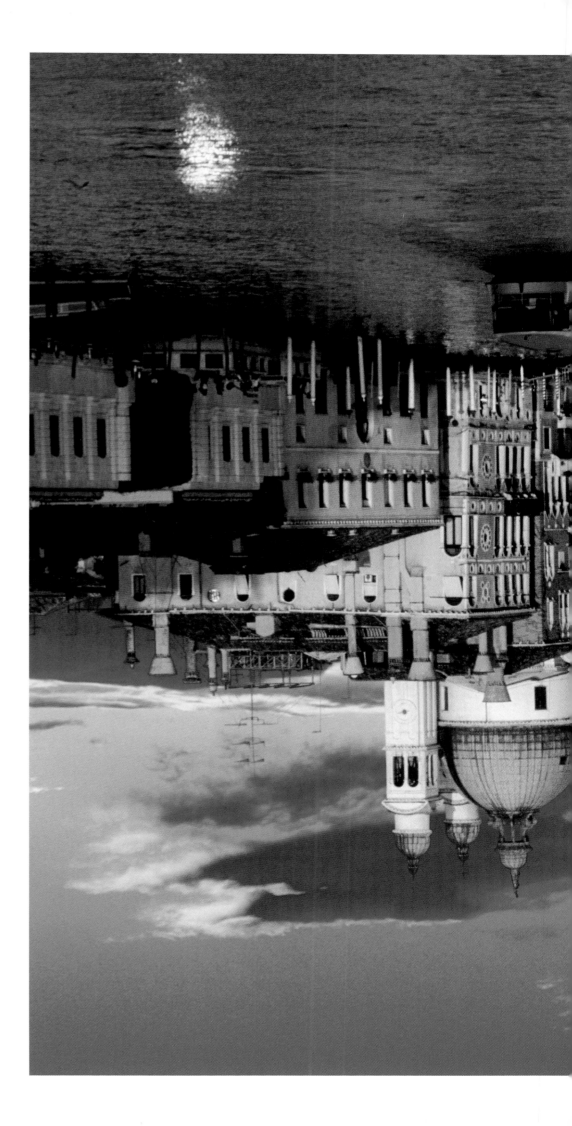

VENICE, ITALY

Left:

The small band of refugees on a marshy island trying to escape the invading Lombards in the sixth century could scarcely have imagined the glamorous future awaiting the small settlement they founded. But defended by the waters, Venice soon discovered its glorious destiny; and the city of the doges dominated the sea trade with the East and rivaled Eastern splendor. The sea has always made Venice what it is. From the thirteenth to the nineteenth centuries, churches and palaces in growing numbers saw their shapes reflected in the canals, and La Serenissima, the City Republic, dictated artistic developments. Not until Napoleonic times was its glory dimmed, that bright light that had inspired Vivaldi, Goldoni, and so many painters it is impossible to name just one. Then began another age, that of the Romantic Venice, with its tourists, gondolas, Bridge of Sighs, and pigeons swooping down from the cupolas of Saint Mark's to fill their beaks before its doors.

SIENA CATHEDRAL, ITALY

Following pages:

As if to distinguish it from the pinkish ocher, bronzed by the sun, that is the city's general hue, Siena's cathedral stands out boldly in its white marble with stripes of dark green stone. The balanced and harmonious atmosphere of Siena, like that of Florence, saw the kindling of the artistic revolution of the Renaissance, as its painters, sculptors, and architects gradually freed themselves from medieval norms. Thanks to its rich patrons, Siena Cathedral is a fine example of the phenomenon. Its structure is Gothic, begun in the thirteenth century and finished in the late fourteenth; but its magnificent tower is an older Romanesque form. Giovanni Pisano was the building's main architect, and his rich pavement matches the polychrome walls. Frescoes, paintings, and furnishings all combine to make the Duomo di Siena a key monument in the history of Western art.

FLORENCE, ITALY

Right:

The Roman city on the banks of the Arno began to enjoy phenomenal artistic success at the end of the Middle Ages, when its aristocracy and merchant bourgeoisie such as the Medici decided to devote some of their wealth to patronage. The locality's churches, palaces, and villas supported work by extraordinary artists who represented a changed world. Florence became the prolific artistic center that gave shape to the Renaissance, the crucible in which great artists could create works that would radiate throughout the West. The names of Giotto, Donatello, Fra Angelico, Botticelli, Leonardo da Vinci, and Michelangelo became indissolubly linked with Florence, surpassing the rivalries and plots that fed its everyday politics.

THE LEANING TOWER OF PISA, ITALY

Following pages:

Construction of a new bell tower in Carrara marble for Pisa Cathedral began in 1173 and ended, after several interruptions, two hundred years later. The builders kept to the same beautiful and airy Tuscan Romanesque style throughout. The 179-foot-high (54.5-meter) tower began to lean while it was being built. Reckoned to be at an angle of 1.47 degrees in the fourteenth century, the lean had increased to 5 degrees by 1990, and access to the tower was forbidden. Large-scale yet delicate engineering operations were then used to prevent it from moving further: a metal structure was placed in the center of the tower, and a large portion of the clay subsoil supporting the tower's 14,450 metric tons was replaced by deep concrete piles. It is estimated that the tower will now be stable for at least a century.

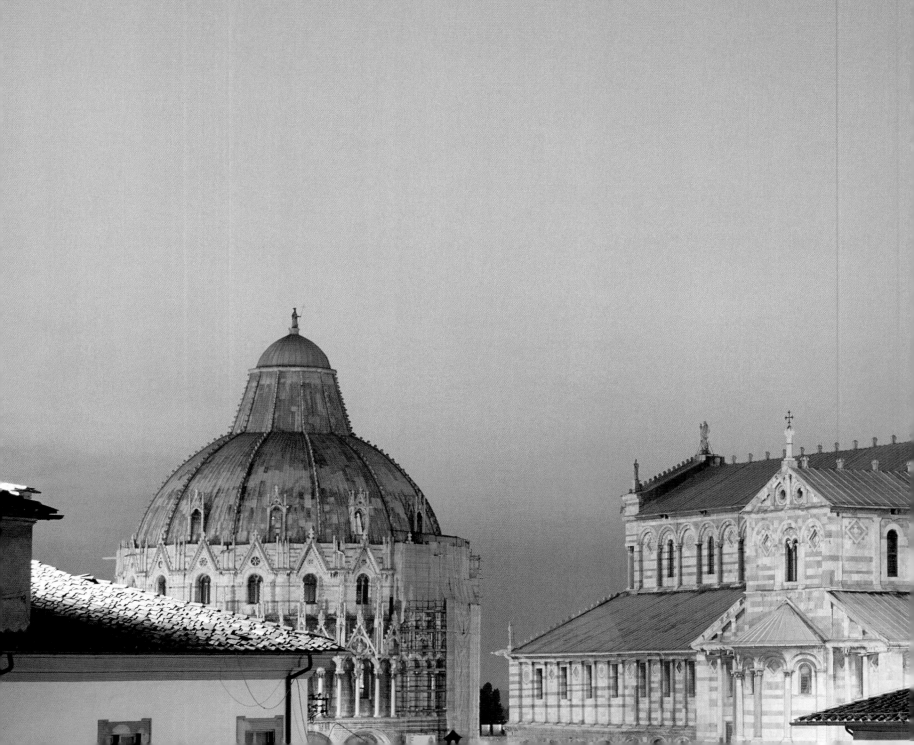

SAINT PETER'S SQUARE, ROME, ITALY

Right:

When the task of designing the grand plaza of Saint Peter's Basilica in Rome was entrusted to Bernini, much was at stake. The square had to work liturgically, religiously, and politically. It had to represent the power of the Church, glorify the papacy, and physically prefigure the grandeur of the huge basilica. The elliptical layout is entirely successful in realizing these aims. Its two colonnades, built between 1656 and 1667, constitute two welcoming arms, while sustaining the 140 statues of saints that recapitulate the Church's glorious history. The architect is thereby able to achieve a real piece of Baroque stage design that makes the space simultaneously dynamic and symbolic: he centers it on an antique obelisk and two fountains, admirably setting off the rhythm of the columns. What is being staged is the Church Triumphant.

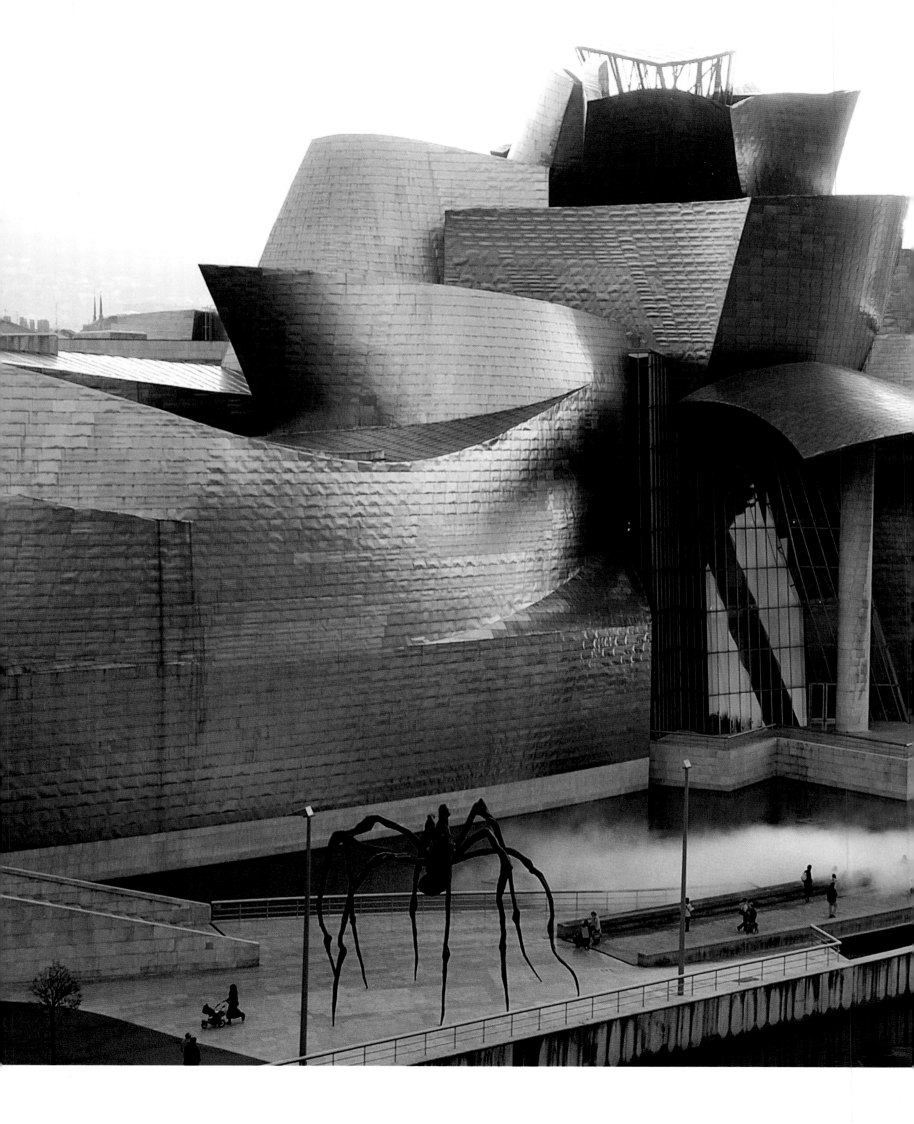

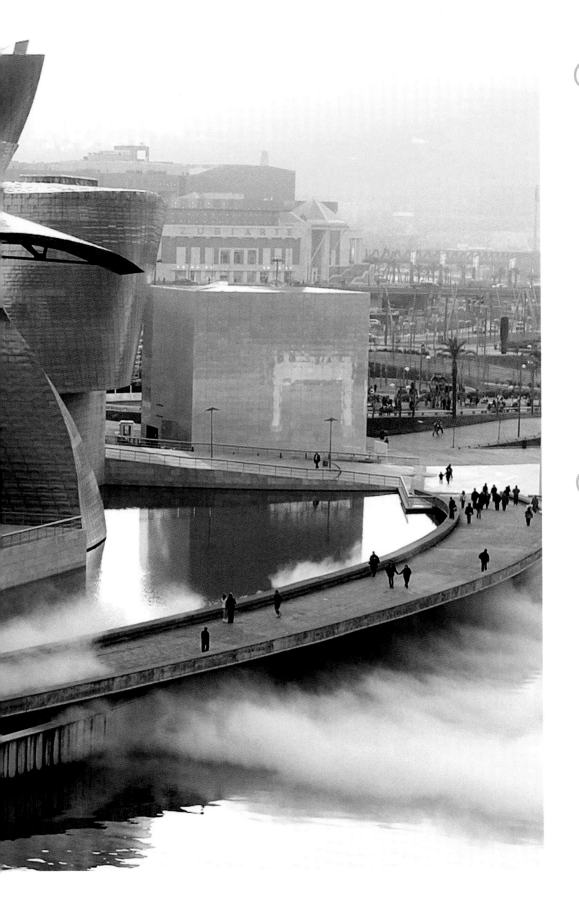

THE GUGGENHEIM MUSEUM, BILBAO, SPAIN

Left:

The bridge entering the city seems about to be swallowed up by the dramatic architecture that bathes its feet in the Nervión River. The building's assertive forms, resembling the multiple wings of an insect, are softened by walls of beautiful, slightly curving limestone adjacent to the surfaces of reflective titanium. This dynamism of form makes the structure's spaces seem to move as if alive. The deconstructed surface of architect Frank Gehry's museum, with its breaks, twists, and curves, creates a nervous energy and movement that makes the building an image of the paradoxical, dissonant art of our time. Inside, that very same art is displayed in an entirely appropriate setting, filled with suspended walkways, transparent elevators, and open-frame stairways. In a space that is so expressive of its function, certain artworks seem almost to merge with the architecture conceived for them.

THE ALCAZAR, SEVILLE, AND THE CASA BATLLÓ, BARCELONA, SPAIN

Following pages:

The sensual yet mystical character of Spain is expressed with a daring and innovation that can take the onlooker by surprise. For instance, at the Alcazar in Seville, in juxtaposition with gardens that are utterly seductive, the royal palace is an affirmation of Islamic architecture. Paradoxically, this apparently Moorish palace erected during the fourteenth century in the style so typical of Muslim Andalusia was actually built by Catholic kings. The workers who constructed the palace were a mix of Jews, Christians, and Muslims. This is also the place where the Holy Roman Emperor Charles V was married. No less fertile in its own way is the architecture of Gaudí in Barcelona. It vibrantly symbolizes the pre-eminence of the Catalan middle class around 1900, a group that was visibly eager to make bold statements, given the startling ceramic façades with which it adorned the most prestigious avenues in the city.

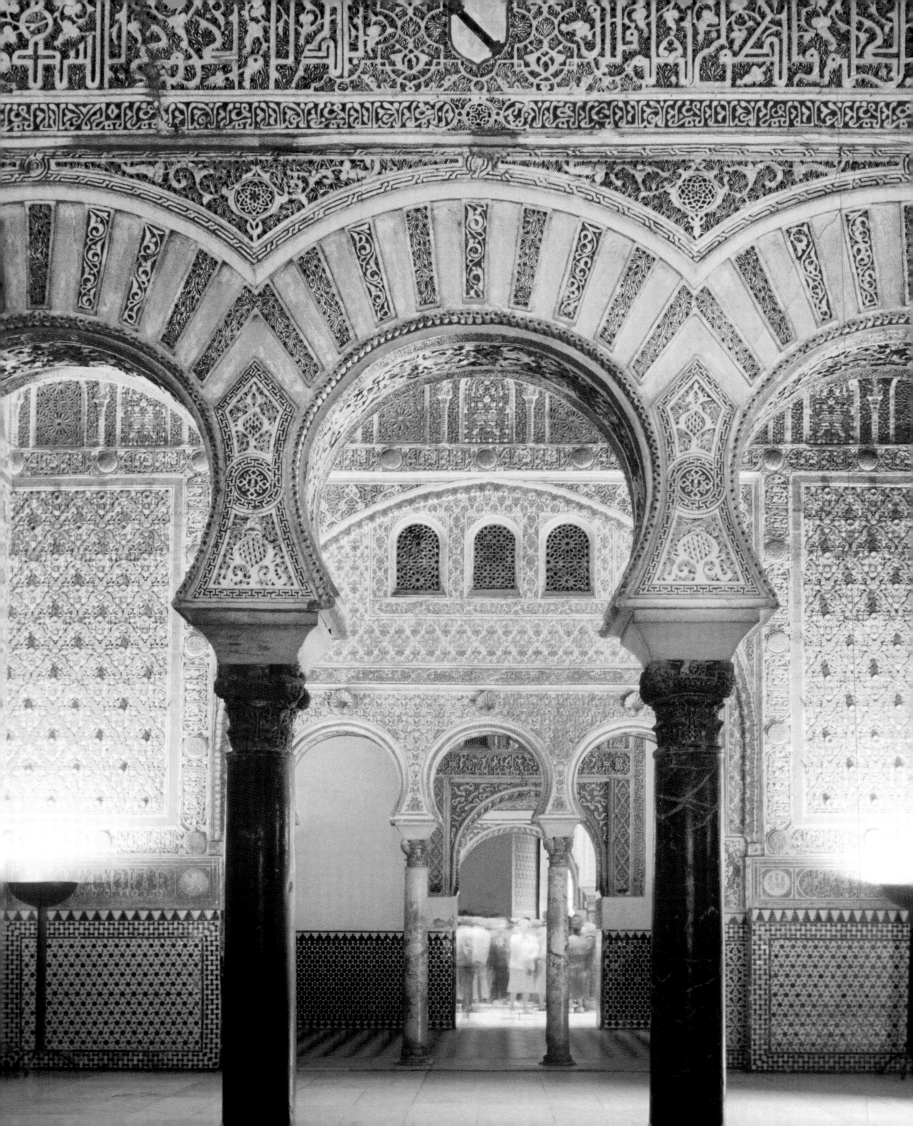

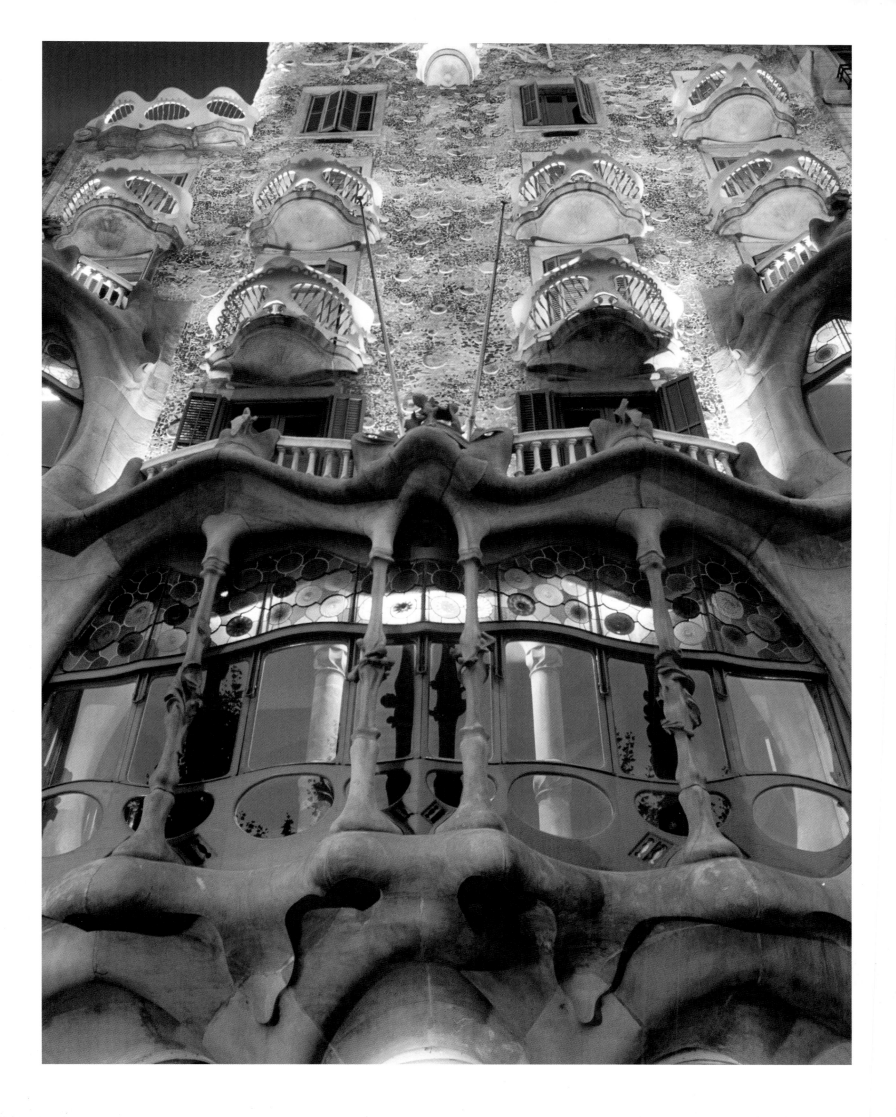

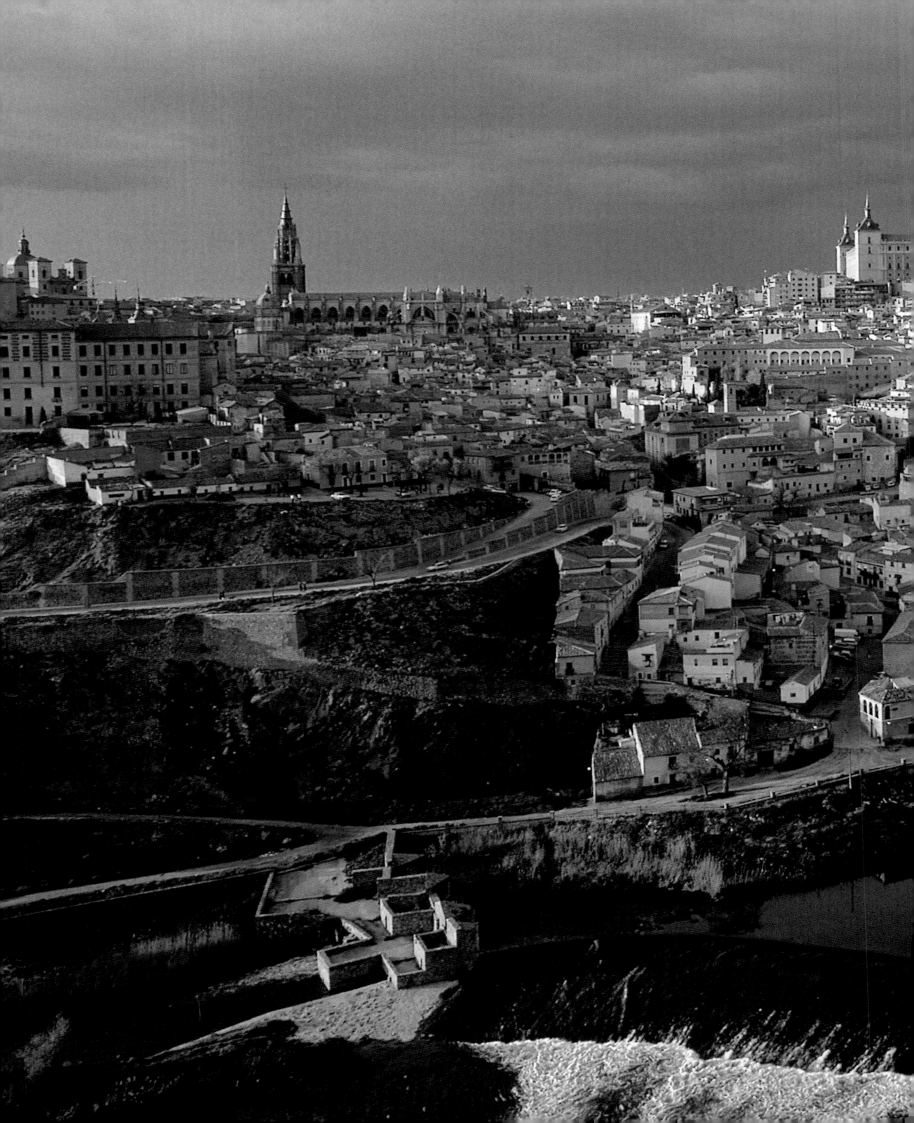

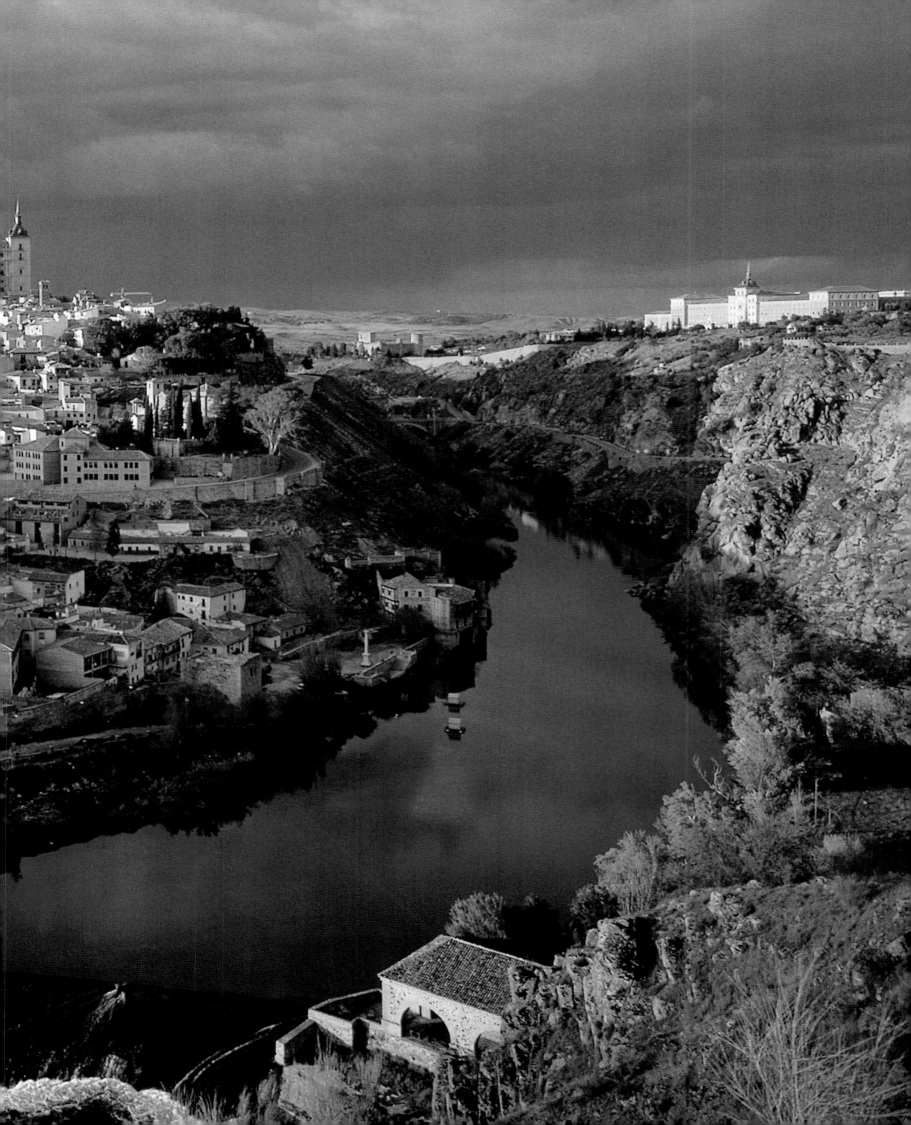

TOLEDO, SPAIN

Preceding pages:

Toledo is the city where El Greco lived and worked. So it is not surprising that skies typical of El Greco's paintings highlight the bold, concentrated, and often dramatic colors of the Old City's buildings, crowded together above the Tagus River. At the top is the Toledo Alcazar, a medieval fortress that later, during the sixteenth century, was turned into a palace. It presides over the labyrinth of alleyways, stairways, and passages that endow Toledo with its special atmosphere dating from the time when it was the capital of Spain. The towers and spires of the city's defensive wall, with its nine gates, cannot compete with those of the cathedral and the many churches, not to mention mosques and synagogues; Santa Maria La Blanca, founded as a synagogue in 1203, and the fourteenth-century Sinagoga del Tránsito are two famous old synagogues that were later converted into churches. In its time Toledo seems to have witnessed all of Spain's history and taken on every possible cultural identity. A Roman city, a Visigoth capital, a Moorish city under the Caliphate of Córdoba, then reconquered by the Catholics in 1085, it was known as an amazing center of cultural cohabitation by some of the greatest minds of Judaism, Christianity, and Islam. An example for our own time, perhaps.

SANTORINI, GREECE

Right:

Plato suggests that Santorini, a small Greek island of the Cyclades scattered in the Aegean Sea and already inhabited in 1450 BC, may be the remains of Atlantis, the mysterious vanished continent. In any case, experts agree that a serious earthquake led to the current shape of the island. The consequences of such a seismic event would have been considerable throughout the eastern Mediterranean seventeen centuries before Christ, encouraging the various myths and legends sometimes supported by archaeology. Coming into port, the visitor sees what clearly looks like the rim of an enormous crater. Down below, close to where the boats arrive, are houses almost in the water; at the top, perched giddily on almost sheer slopes, are the lime-washed houses of the main settlement. Between the two runs the steep path used by donkeys as well as tourists.

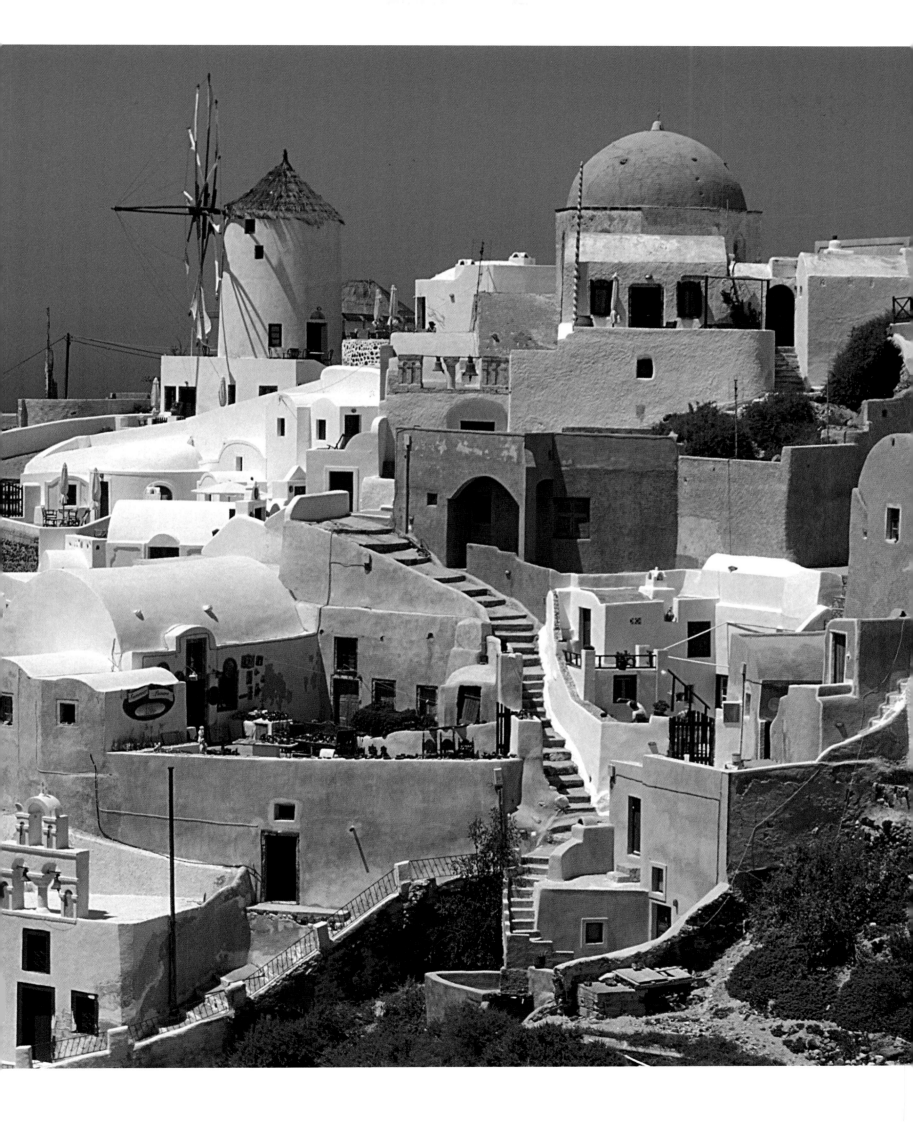

QUEBEC CITY, CANADA

Above:

Magnificently situated above the St. Lawrence River, partly atop the promontory of Cape Diamond, the capital of the French-speaking province of Quebec would have been called Ludovica, in honor of King Louis XIII, if Samuel de Champlain, who founded the city on July 3, 1608, had had his way. Not long afterward, the early trading town was fortified, and the Old Town remains North America's only walled city. Apart from the citadel built between 1820 and 1850 in the style of Vauban, the site is dominated by the huge Château Frontenac. A symbol of the city, which is invaded nowadays only by river-borne ice floes, the château dates from 1893, when it was built by the Canadian Pacific Railway as a luxury hotel in the neo-Renaissance style. Its enormous central tower was not added until 1926. Surrounding the monumental citadel and château, Old Quebec includes a number of public buildings, among them the National Assembly of Quebec, the Musée National des Beaux-Arts, and the Musée de la Civilisation. The Upper Town (Haute-Ville) together with the Lower Town (Basse-Ville) constitute historic Quebec, the fortified colonial city. But modern Quebec City is also a contemporary metropolis, with a population of 720,000, a dynamic harbor, and a significant economic and cultural presence.

ISTANBUL, TURKEY

Following pages:

Dreams of the Orient on Europe's doorstep: that is how the Romantics viewed the city, with its multiple identities, on the banks of the Bosphorus. Byzantium, Constantinople, Istanbul—Greek, Roman, Byzantine, Ottoman, and finally Turkish—the capital of an empire or the metropolis of a Muslim republic, Istanbul has always been a cosmopolitan city. The city is a melting pot of civilizations—with its wooden houses descending the picturesque narrow streets; the proximity of Roman ruins to the shadow of the Blue Mosque (the Sultan Ahmet Mosque, in the foreground here); and beyond, the dome of Saint Sophia, once a church, then a mosque, and now a museum. The Bosphorus is a maritime corridor that unites rather than separates Europe and Asia. The 11,320,000 inhabitants of modern Istanbul are scarcely conscious of exchanging one continent for another when they cross it.

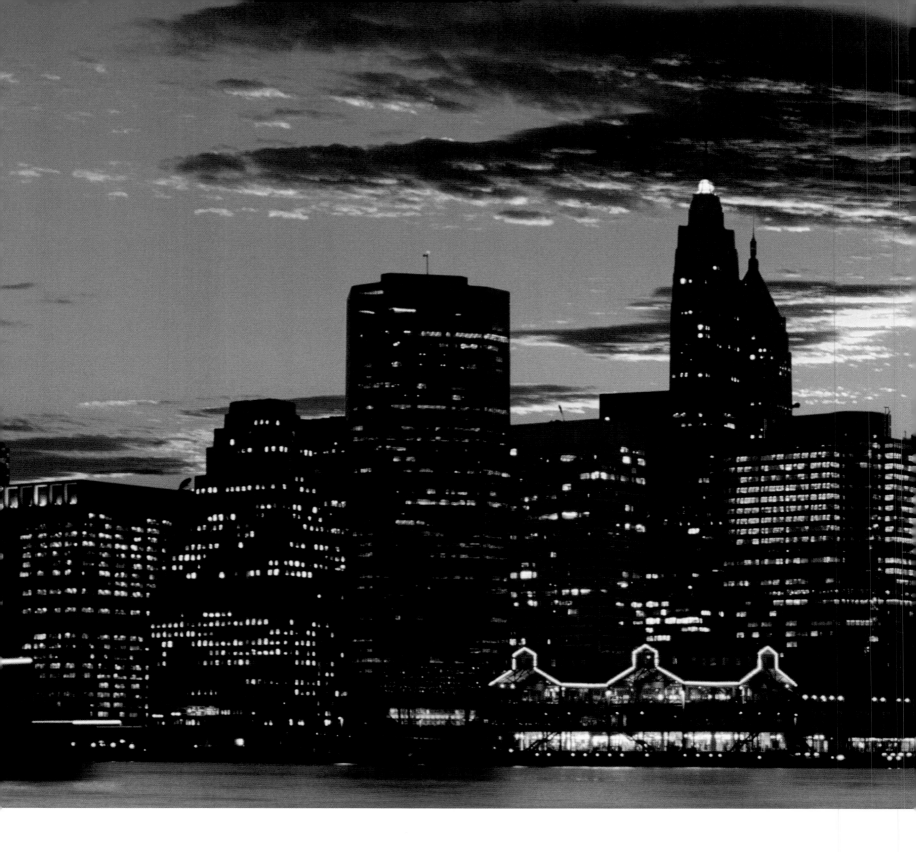

THE EMPIRE STATE BUILDING AND THE STATUE OF LIBERTY, NEW YORK, USA

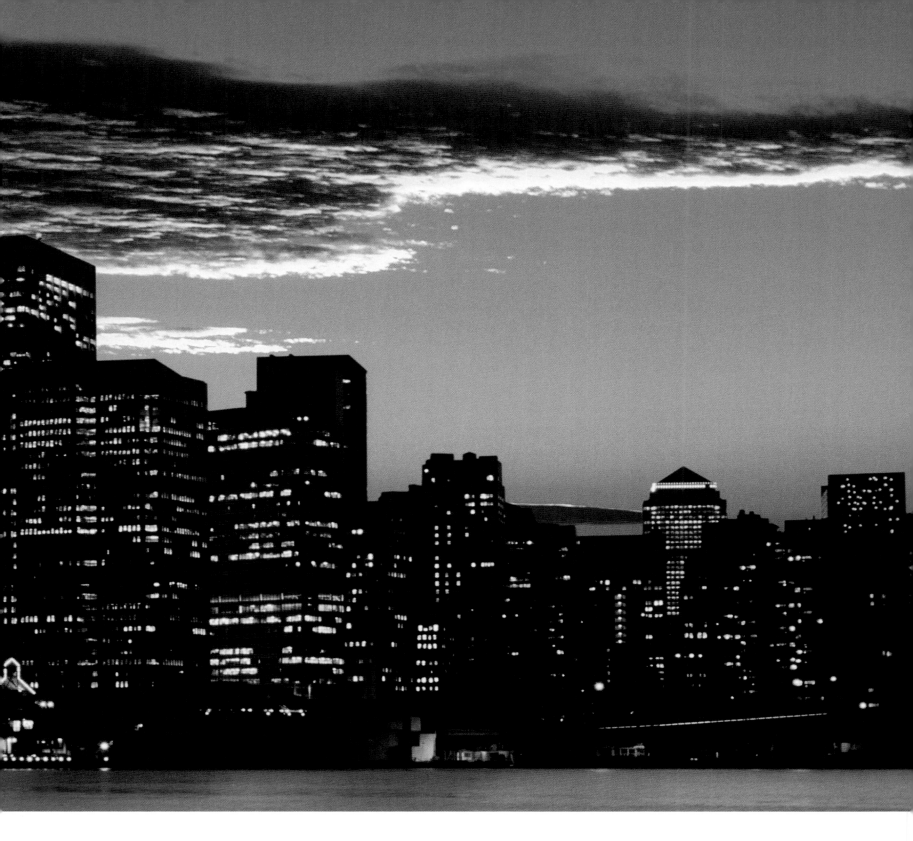

Above and following pages:

There are a number of cities in the world that have attained mythical status. New York is one of them. In fact it is almost archetypal, with its excesses and extravagances, its shabby districts and luxury avenues, its brownstones on tree-lined streets and the bold, now historic, skyscrapers that comprise its iconic vertical skyline. It is one of a handful of cities where people from every nation and goods from every part of the world can be found. Here the city is a world in itself, where people lose themselves and find themselves, and where the torch of liberty continues to be held high. The American Dream: how many have found it here, in the times since Dutch colonists in 1624 founded the town of New Amsterdam, which sixty years later became New York?

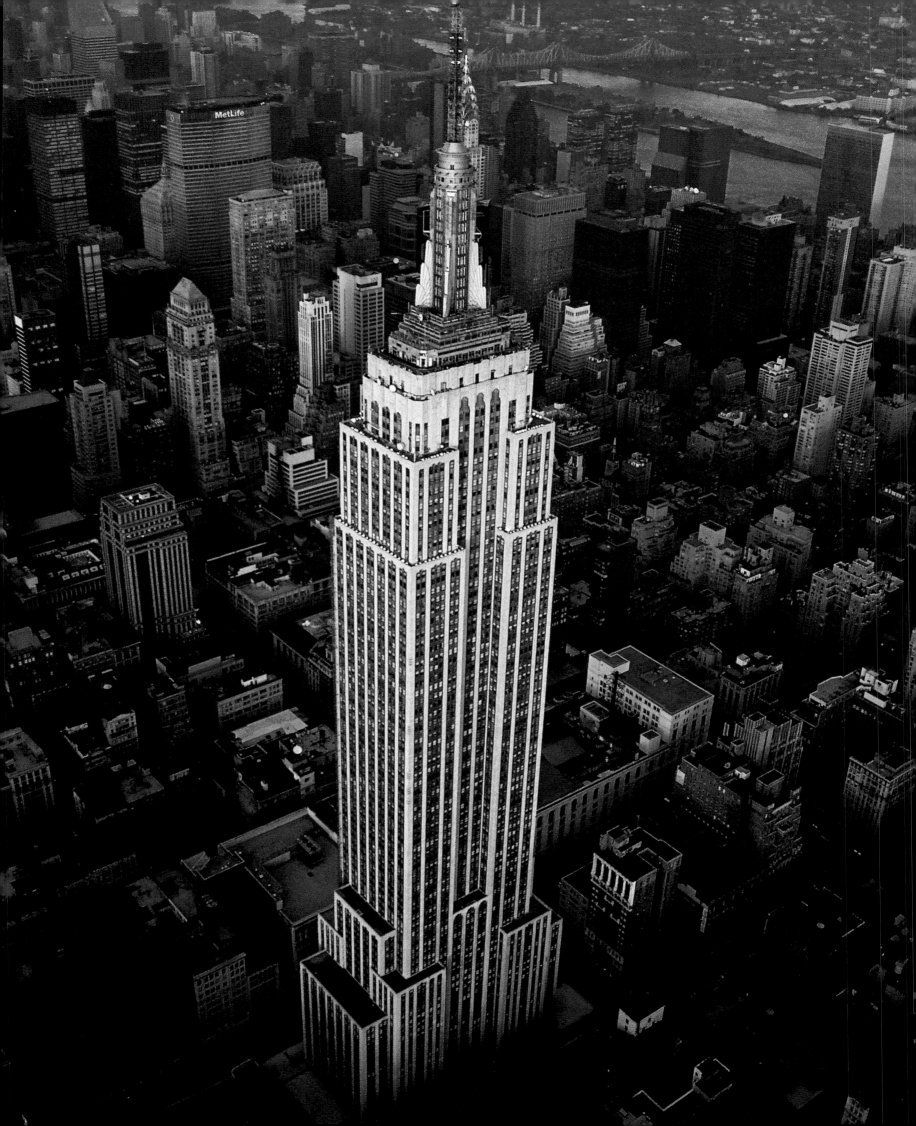

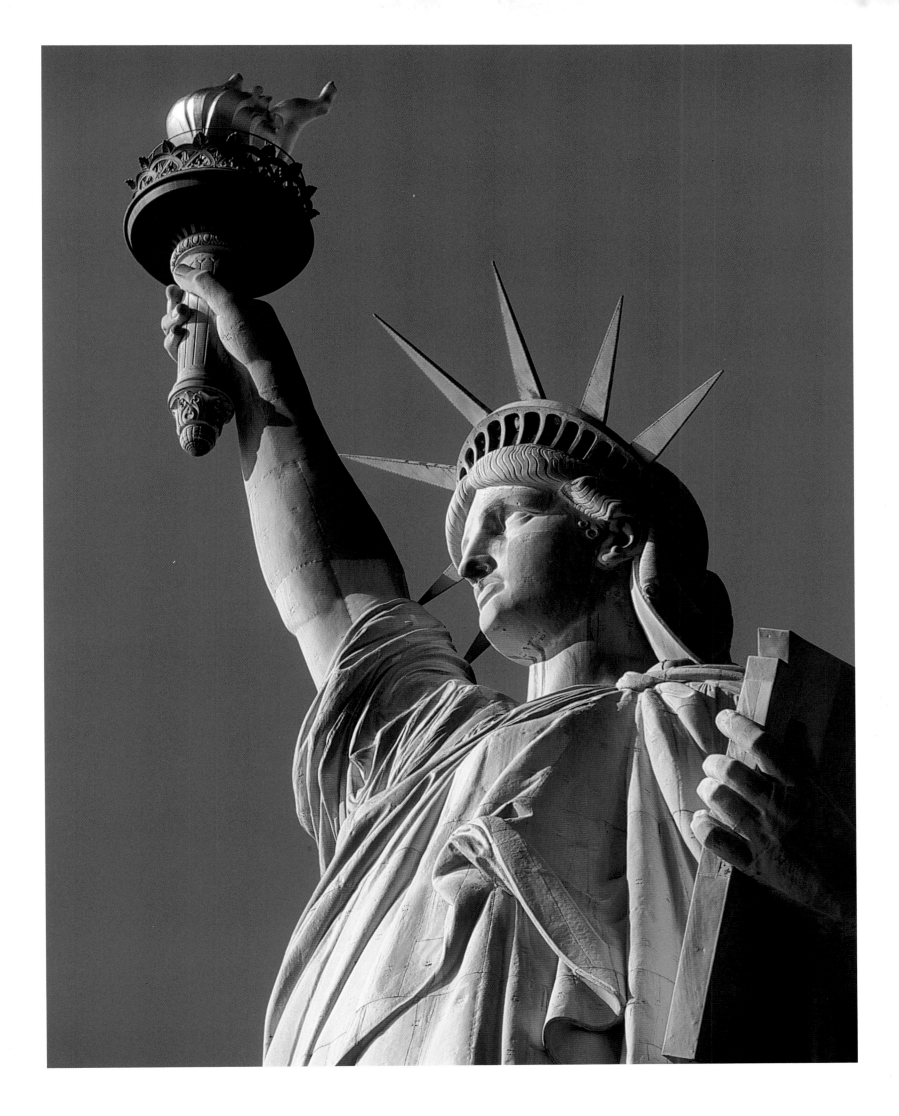

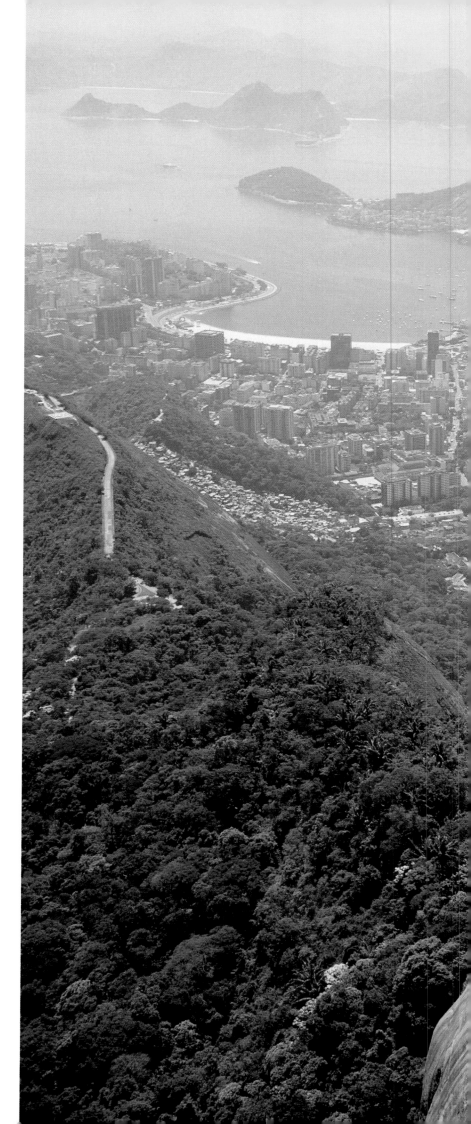

RIO DE JANEIRO, BRAZIL

Right:

Standing at 2,329 feet (710 meters) above sea level on Corcovado Hill, the statue of Christ created in 1931 by the French sculptor Paul Landowski looks down to embrace the broad sweep of the city that, until the construction of Brasília, was Brazil's capital. Simply a trading post between Native Americans and Portuguese in the sixteenth century, it has become the largest city in the country, with more than 6 million inhabitants, known as Cariocas, who are often pictured in costume singing and dancing, such is the fame of their Carnaval. Nevertheless, Rio is a city of paradoxes: conspicuous wealth and dream beaches alongside the violence and poignant misery of the favelas, the vast shantytowns that fringe the megalopolis.

BRASÍLIA, BRAZIL

Following pages:

The glass and concrete forms of Brasilia make a modernist statement amid the vastness that is Brazil. Brasilia was intended as a contemporary capital, suitable for a young country, consigning to history the great colonial cities of the coast, Rio and São Paulo. It symbolizes an affirmation of the Brazilian dream, the conquest of the country's interior, and the people's demand for modernity. The first administrative buildings opened in 1960, other districts followed, and by 2000 the population had grown to 2 million. For a lover of architecture the city is a gift, even if the concepts of its urban planners are often criticized. Many of its buildings are authentic successes, like the cathedral, in the foreground, with its "crown of thorns" open to the sky, or the twin towers of the state ministries.

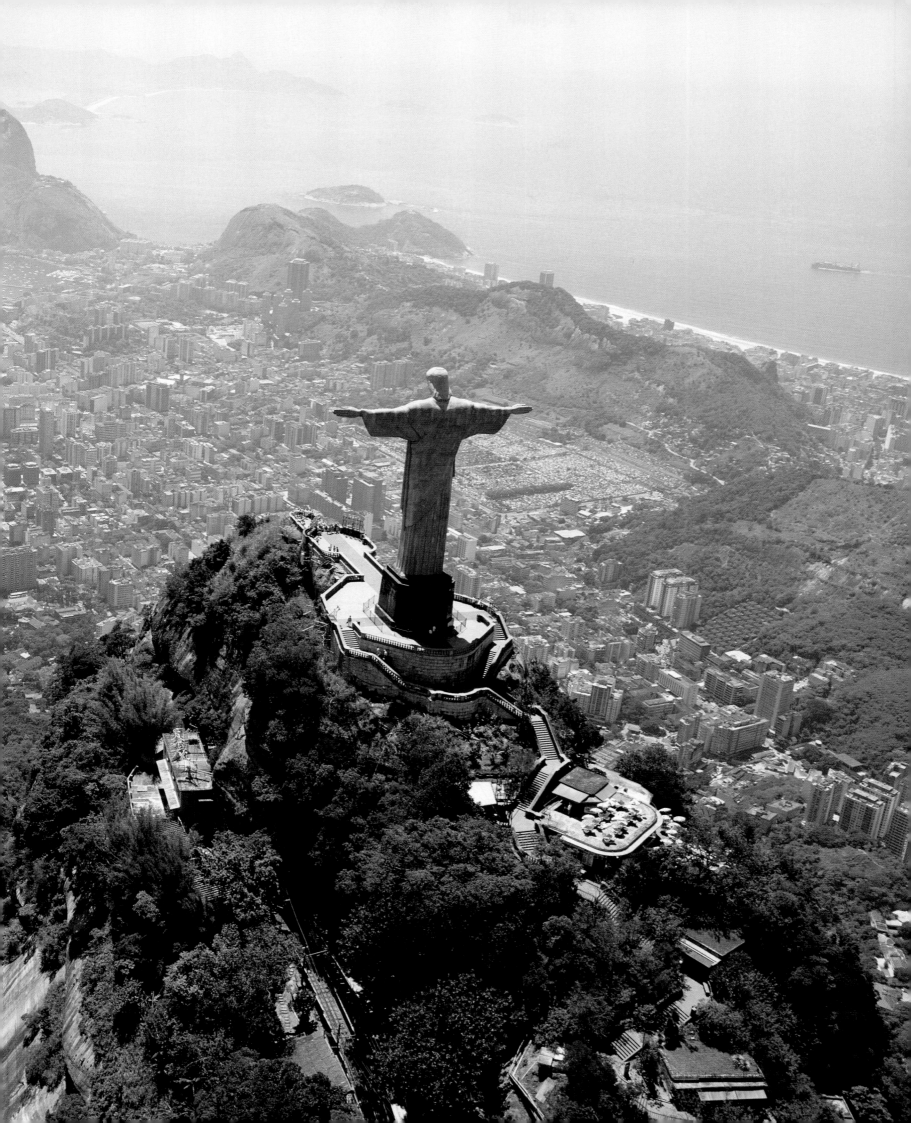

TOKYO, JAPAN

Left:

Tokyo, formerly known as Edo, has been Japan's capital since 1868, when it assumed that function from the historic city of Kyoto. Devastated by earthquakes and the Second World War, the city was quickly rebuilt, but without a coherent plan, and continuous expansion added to the confusion. Reputedly, even the 30 million inhabitants of Tokyo's vast urban network—the greatest in the world—sometimes lose their own way in it. Within its great muddle of buildings, the imperial palace occupies a very large area. Here and there, temples and pagodas rebuilt in traditional style anchor the huge city in Japan's ancestral culture; and the most famous and lavish pagodas are tourist haunts as well as places of prayer within Tokyo's omnipresent modernity.

BANGKOK, THAILAND

Following pages:

Since the late eighteenth century, when the city was designated the royal capital by the first king of the current dynasty, Bangkok has continued to grow on both sides of the Chao Phraya River. The west bank is "the Venice of Asia," where canals, or klongs, replete with boats lend a special charm to the city; on the east bank, office skyscrapers overlook palaces and ancient temples. One such temple is Wat Pho, which houses a large reclining Buddha; another, Wat Traimit, holds a golden Buddha weighing five and a half metric tons, the largest gold statue in the world. Bangkok is thus a megalopolis, an Asian metropolis, a holy city, and a major center of culture and tourism.

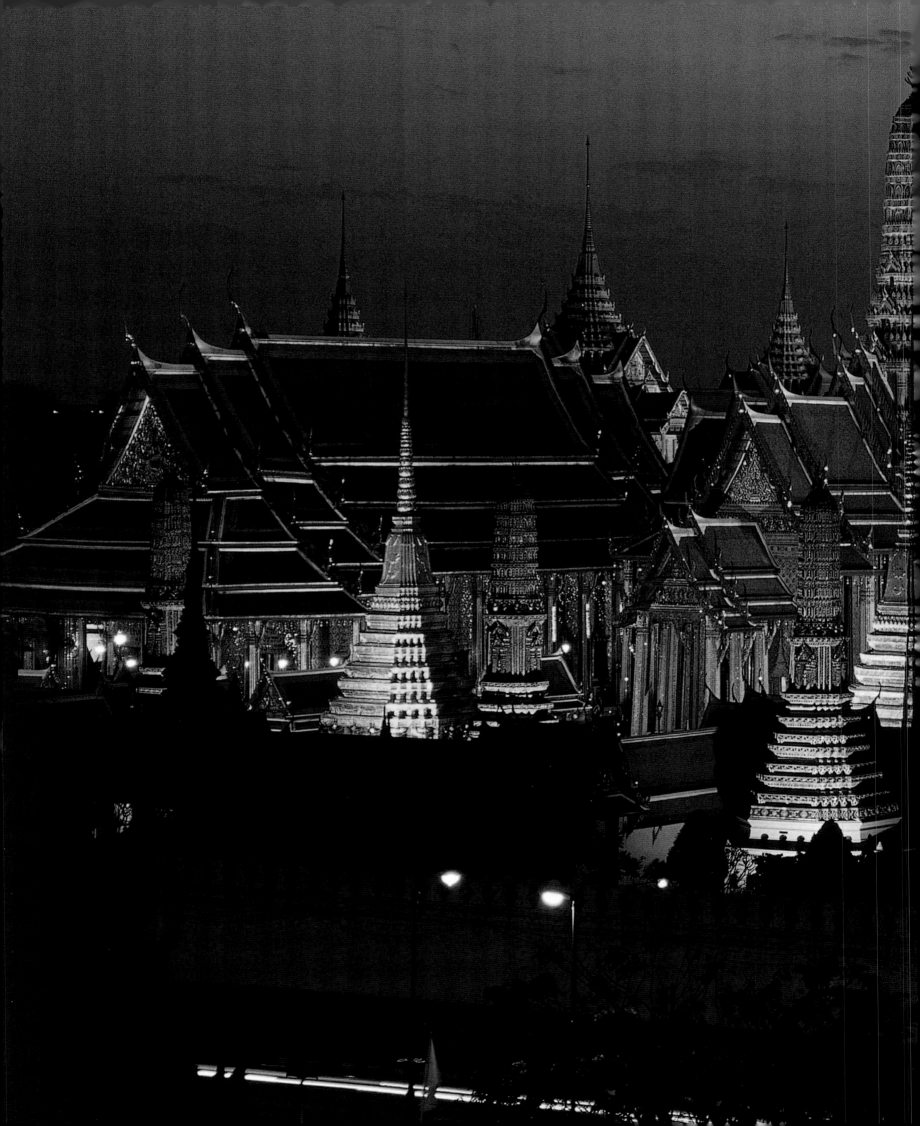

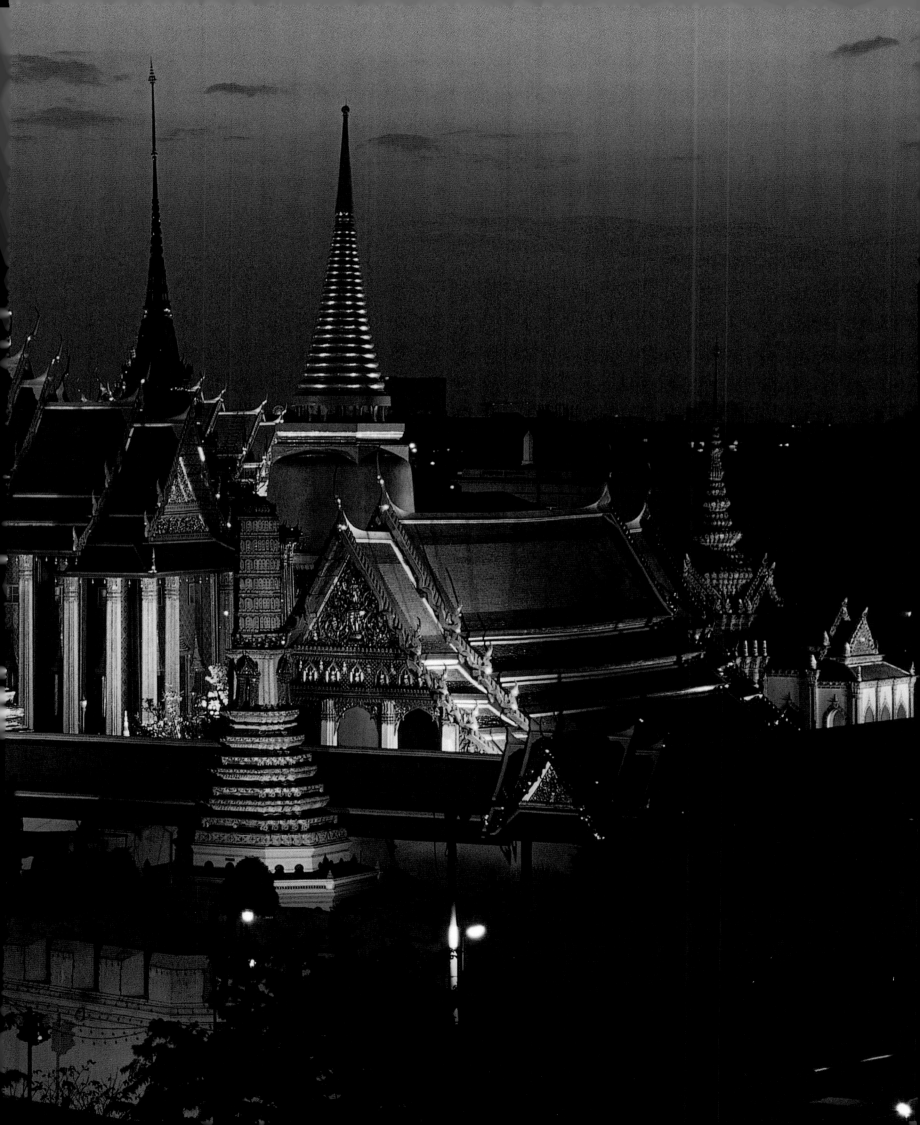

JODHPUR, INDIA

Right:

Until the fifteenth century, the Rathore clan's capital in Rajasthan, a vast region in northwestern India, was Mandore. But in 1459 Prince Rao Jodha decided to found a new capital on the edge of the Thar Desert and gave it a name to honor himself—Jodhpur. Originally a military position, it had the added advantage of being a staging post on the silk-and-spices trade route. A wall of no less than 3 miles (10 kilometers) in length equipped with seven gates still encloses the Old City in the shadow of the largely seventeenth-century Mehrangarh citadel, the "magnificent fort." The citadel is extensive enough to contain several palaces. One curious aspect of Jodhpur is the number of houses in the old districts that are painted blue, which has earned it the nickname "the blue city."

GUANAJUATO, MEXICO

Following pages:

Colors blazing in the sunshine, a musical hubbub, people busy everywhere, perfumes and aromas—this is most definitely a Mexican city, although it was originally Spanish when founded in the late sixteenth century. In a valley of the Sierra Madre, the 450-year-old city walls still stand, holding within them a labyrinth of tiny streets and stairways, some cut into the very rock and others underground. Here are Baroque churches, innumerable religious sites, church towers and domes, palaces with their luxuriant gardens alongside the most modest dwellings. In the streets and squares, workers in the gold and silver mines mingle with civil servants, students, and tourists; the population is even greater during Guanajuato's celebrated theater festival.

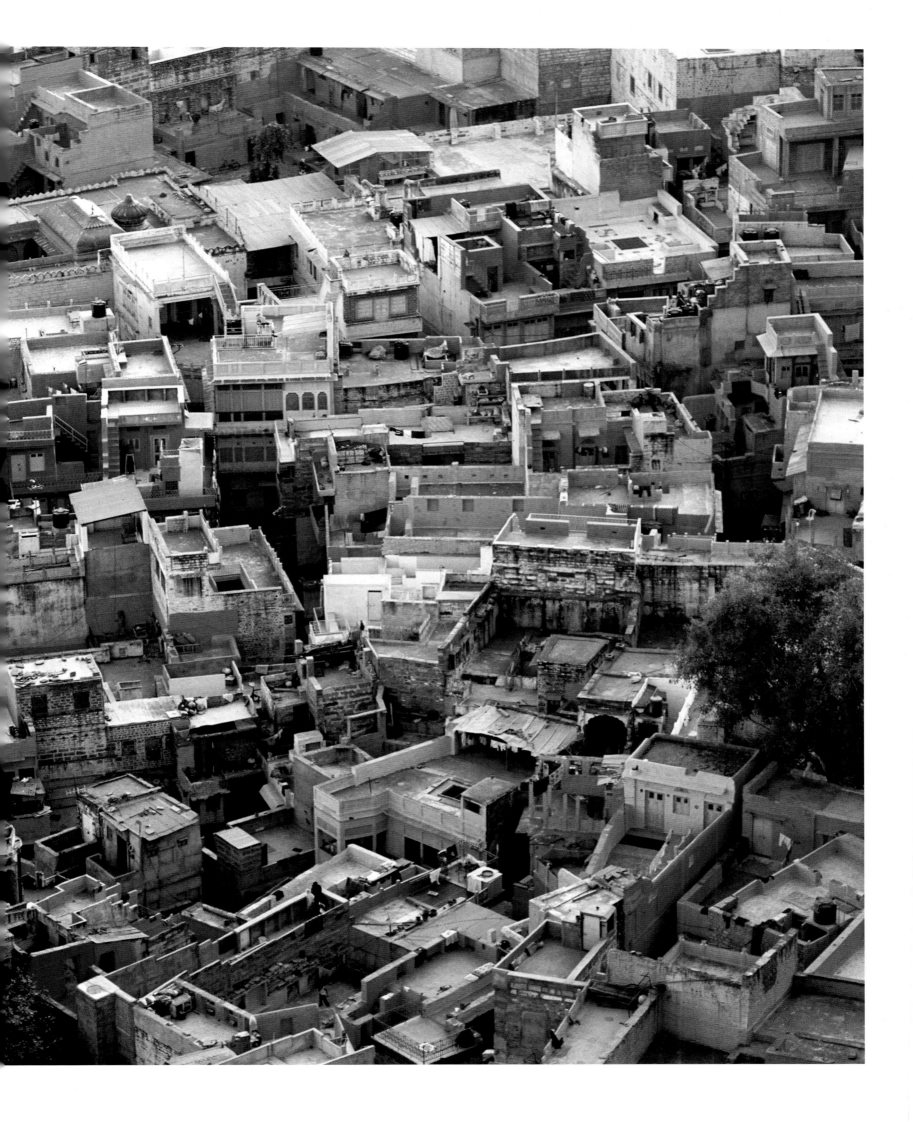

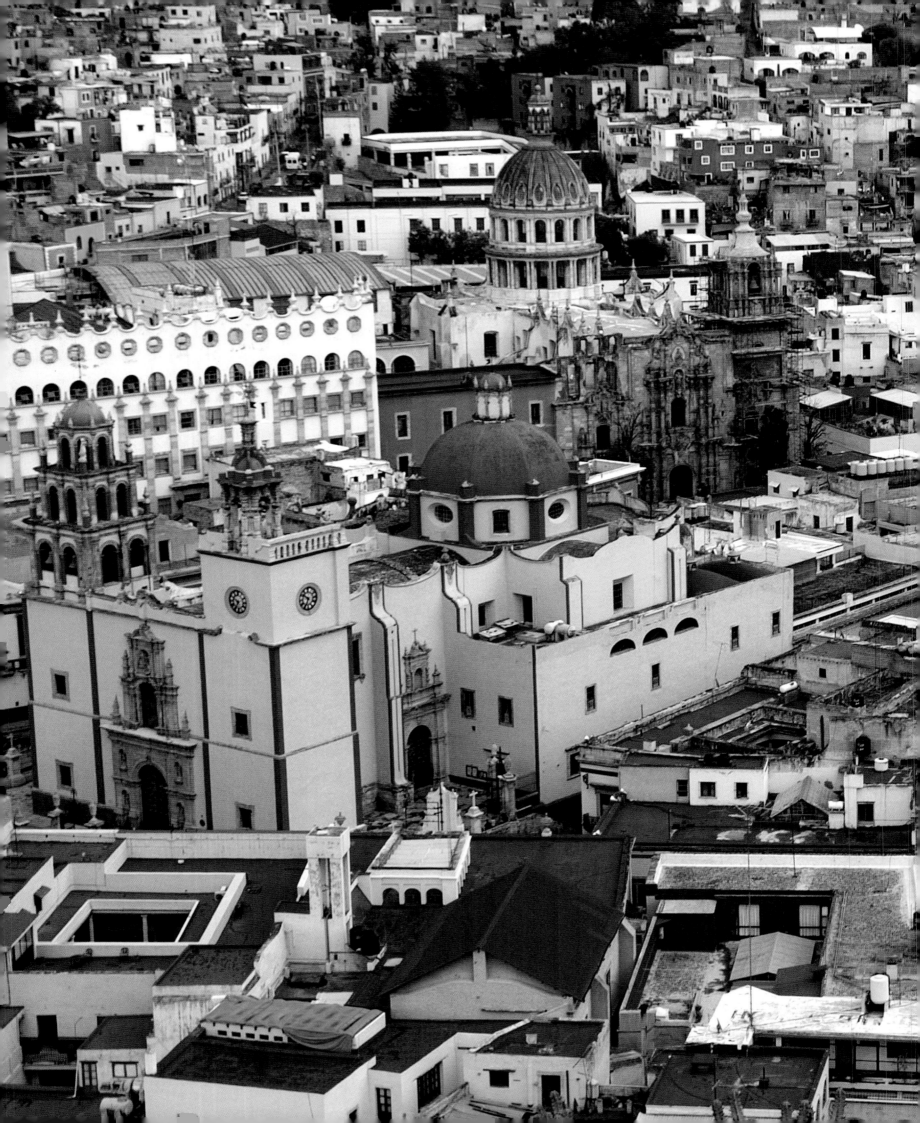

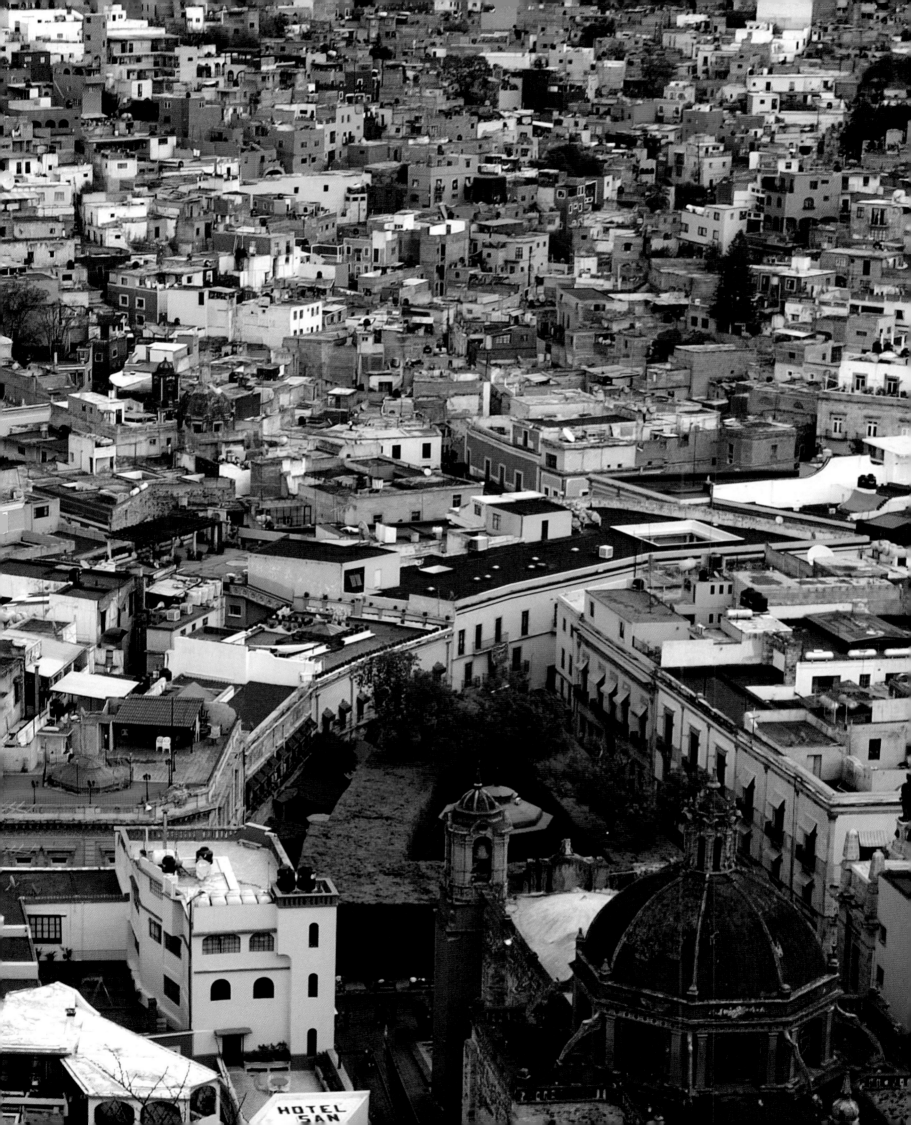

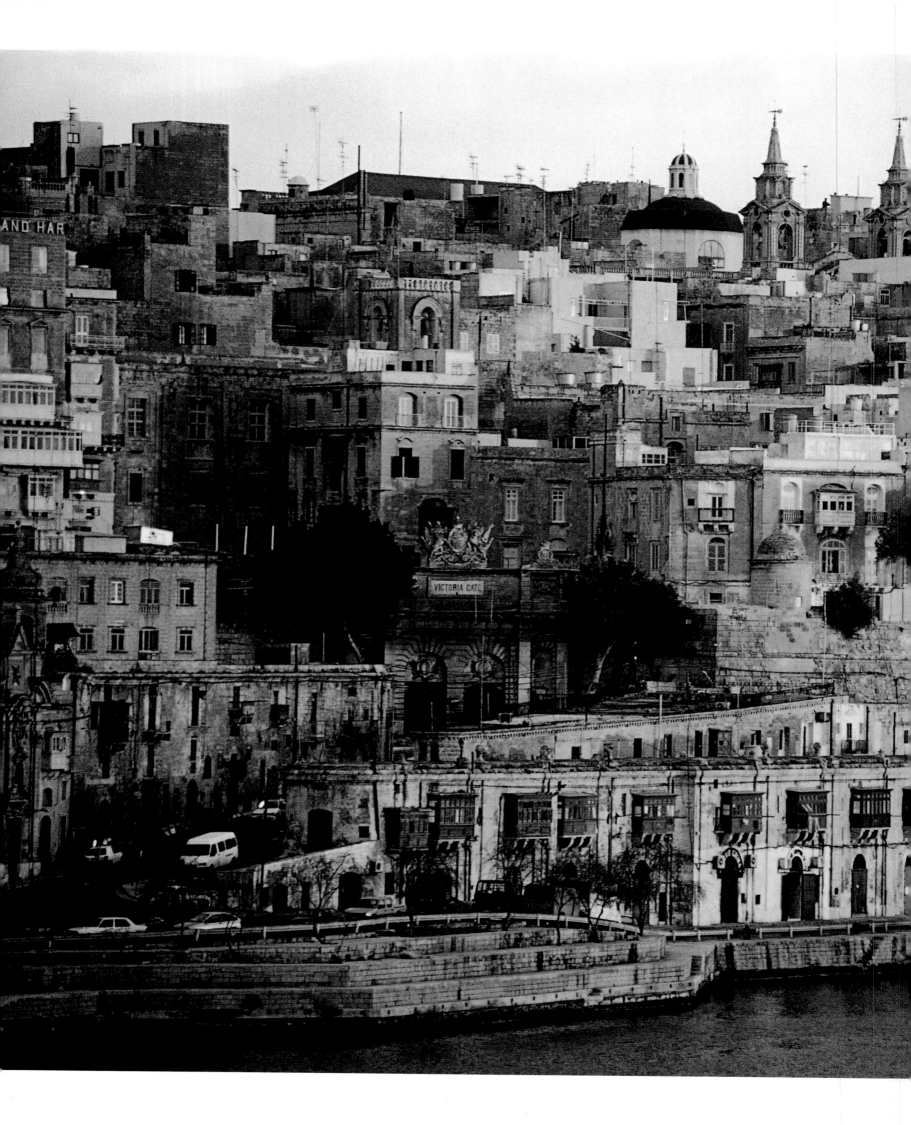

VALLETTA, MALTA

Left:

Through the centuries, the capital of the island of Malta has been hemmed in by the narrow peninsula on which it sits, and its houses have had to find room as best they can. Hence the impression of piled-up masonry and jumbled spaces that only the setting sun can unify. The city is, however, a beautiful adornment on a small island of just a few thousand inhabitants with a proud and noble history. Situated at a crossroads between Italy and Tunisia, Malta saw a succession of cultures set foot upon its small territory before the Knights of Malta, the former Hospitalers of Saint John of Jerusalem, retreated there when the Crusades turned disastrous. They were responsible for Valletta's medieval heritage, including the cathedral, the Grand Masters' Palace, and the knights' hospital. The island has since been marked by English influence, giving this very Mediterranean land a unique character.

SYDNEY, AUSTRALIA

Above:

Australia's largest city is instantly recognized throughout the world by the divergent scales of its shell-fishlike Opera House surrounded by the sea. It strikes a bold modern image befitting a country that justifiably proclaims its youthful vitality. The city itself dates only from 1788, and its developers have given priority to its parks and vegetation as well as its ocean locality. Framing this view of the Opera House is the Sydney Harbour Bridge, completed in 1932 and another of Sydney's iconic landmarks. The Opera House, which opened in 1973, was designed by the Danish architect Jørn Utzon. It took about fourteen years to construct this masterpiece of twentieth-century architecture.

THE PUDONG DISTRICT, SHANGHAI, CHINA

Following pages:

The Chinese dragon is awake. In Shanghai, its disproportionate presence reveals itself in the Pudong district, where the skyline is being transformed into one of the most impressive in the world. With its more than 20 million inhabitants, Shanghai has "gone vertical," the site of more than 150 skyscrapers over 325 feet (100 meters) tall. Built on former marshland in less than fifteen years, Pudong looks like something out of a futuristic cartoon strip. Everything is out of scale in a district given over to finance, international exchange, and cutting-edge technology, with a main thoroughfare, Century Boulevard, that is 3 miles (5 kilometers) long. Pearl Tower, which has come to symbolize the city, is 1,535 feet (468 meters) high; and the end of 2008 is to see the opening of a world financial center that will be one of the tallest in the world, with 101 stories reaching to a height of 1,614 feet (492 meters). Pudong's vertical expansion is provoking disquiet in some quarters because of the human and environmental problems it poses.

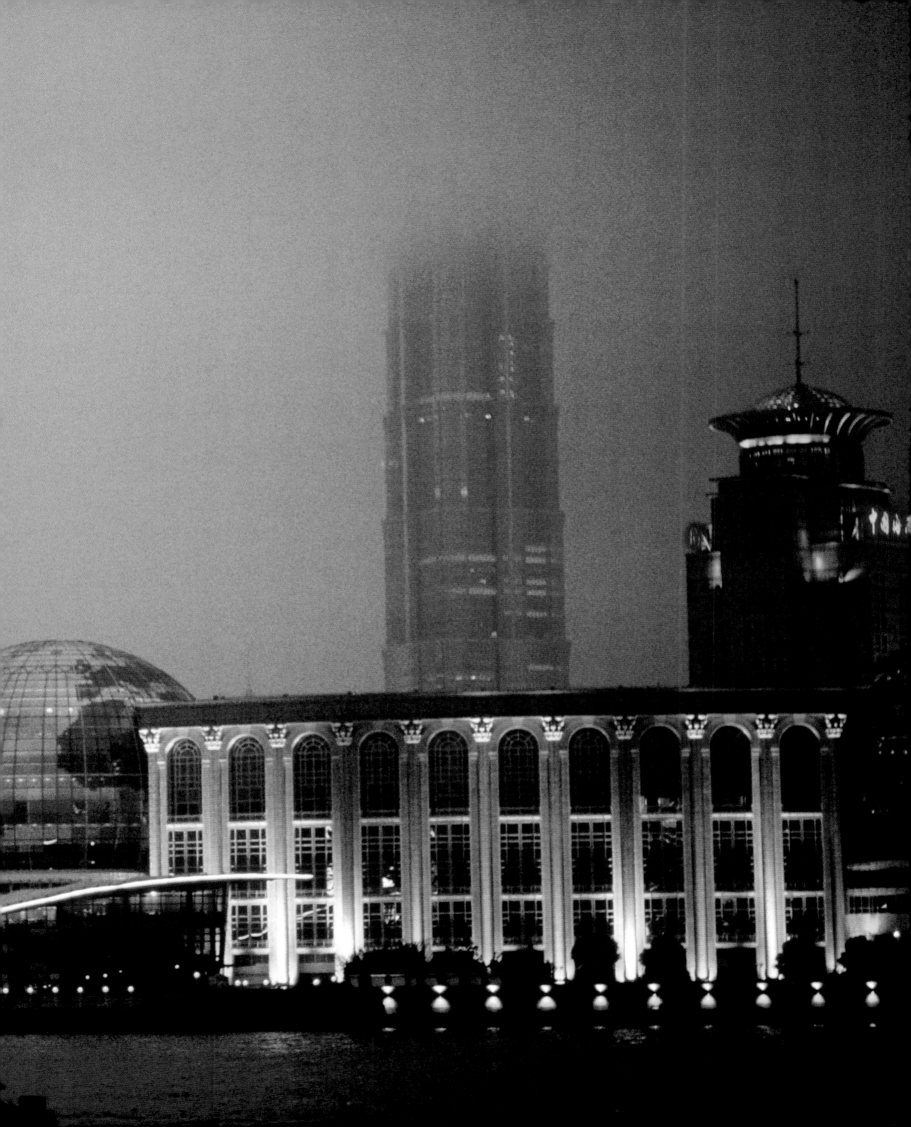

TEMPLES AND PANTHEONS IN MAJESTY

The primary goal of human beings throughout history has always been survival and propagation. But people have also tended to believe that there exist deities who are concerned with the nature of the world and its inhabitants' eternal—and daily—lives. Never mind the various shapes and faces that the gods have taken, from the avatars of Shiva in Hinduism, with its 800 million adherents, to the reincarnations of Buddha, venerated by 340 million Buddhists—quite apart from the One God of the Jews, worshiped by 14 million; the Christians, with 2 billion believers; and the Muslims, with 1.2 billion faithful. To venerate, worship, believe, and pray remain core human preoccupations. A wealth of creative energy has gone into the erection of pantheons and temples, a phenomenon that led the philosopher Alain to venture: "Art and religion are not two separate things; they are two sides of the same coin." It is therefore not surprising that the world should possess a wide range of extraordinary sanctuaries rich in finely crafted carved stone, stained glass, or colorful imagery, full of life and ingenuity.

In the beginning there was light. The cult of the Sun, so important in the pre-Columbian civilizations of America, had an essential place among the Incas of Peru. The sacred district of Machu Picchu (pages 38–39), the lost city of the Andes rediscovered in 1911, was dedicated to the sun god, Inti. The source of life had his own temple, the only round building to be found in the stone city perched high among the clouds at an altitude of 7,872 feet (2,400 meters). The Maya, who worshiped the plumed serpent Kukulcán, resorted to a type of "astro-architecture" when building the pyramid of Chichén Itzá in Mexico (pages 252–53). Here there are 365 steps, each one representing a day in the year; at the time of the solstices, the outline of the steps in the light symbolized the writhing body of the divine reptile that had come to fertilize the Earth. But the sixteenth-century Spanish conquerors had no time for the subtleties of indigenous mythology. As they destroyed and massacred, they imposed the cult of the unifying One God of Christianity, whom the Native Americans later went on to worship in sumptuous Baroque churches like San Cristóbal de Las Casas (pages 282–83), long before the statue of Christ the Redeemer was erected to bless the Bay of Rio de Janeiro (pages 222–23).

The Roman Catholic Church had many models of sacred architecture to export. From the Church of the Holy Sepulchre, beneath its opulent domes in the Old City of Jerusalem, to the granite-clad Saint Peter's Basilica (pages 204–5) in the Eternal City, Rome, there was no shortage of sanctuaries dedicated to Christ and his apostles. The most inspired stonemasons of the Middle Ages built spires soaring to Heaven, especially in France, which remains one of the world's treasure troves of religious monuments. In Vézelay's cathedral, a masterpiece of Romanesque architecture in France's

The Hassan II Mosque, Casablanca, Morocco

Morvan region, the redoubtable Bernard of Clairvaux in 1146 preached the Second Crusade. At Mont-Saint-Michel in Normandy (pages 48–49), pilgrims threaded their way across the shifting sandbanks to reach the Gothic marvel of "Saint Michael's in Peril of the Sea." Amiens (pages 266–67) and Chartres (pages 264–65) similarly possess magnificent cathedrals with tapering spires, stone tracery, and brilliantly colored rose windows.

Other parts of the Christian world have produced some amazing religious sites, too—the sanctuaries carved out of the hillside at Lalibela in the Christian kingdom of Ethiopia (pages 278–79), or the citadel-like walled monastery of Saint Catherine on Mount Sinai (pages 274–75), possibly the place where Moses received the Tablets of the Law. Not to mention the temerity of the Greek Orthodox monks who erected their monastic retreats on the summits of the Meteora (pages 44–45), sheer rock piles that, according to legend, were sent from Heaven to enable ascetics to pray in peace.

Meanwhile, Islam had come into being. Its prohibition of human representations has brought about some extraordinary artifacts and decorative forms: ornamental calligraphy; highly elaborate mosaics and stucco work; babbling fountains, like those that cool the inner courtyards of the mosque at Córdoba (pages 258–59) in Spain. Whether built of earth (*pisé*), as at Djenné (pages 272–73) on a bend in the Niger River, or of concrete, as in Dubai, that symbol of modernity in the heart of the United Arab Emirates, minarets everywhere call the faithful to prayer.

We cannot overlook the exuberant and populous Indian subcontinent, whose colorful gods are ascribed lives and attributes galore. Each has his or her "vehicle," encompassing a fabulous bestiary in which every character has a specified function. The sacred sagas, rich in avatars and underhand tricks, still find their echo on the cracked walls of Angkor (pages 254–57), where Asparas dance in the Cambodian forest. That was before the great Buddha tried to bring some compassion to the farthest reaches of Asia, for example, dispensing his teaching on the carved cliffs of Dazu, in China (pages 286–87).

Despite the extremely diverse aspects of the temples and sanctuaries seen here, a simple truth emerges. Each in its own way tells the same story, that of the human race, which has never ceased believing that its destiny was of interest to a higher power, be it Ganesha wearing an elephant head, or Jesus bearing the marks of martyrdom. Everywhere, convinced of the need to attain nirvana or paradise, human beings have tirelessly deployed their genius to honor their gods—to the degree that there appears to be some truth in the premise that art and religion are woven from the same cloth.

The Sagrada Familia, Barcelona, Spain

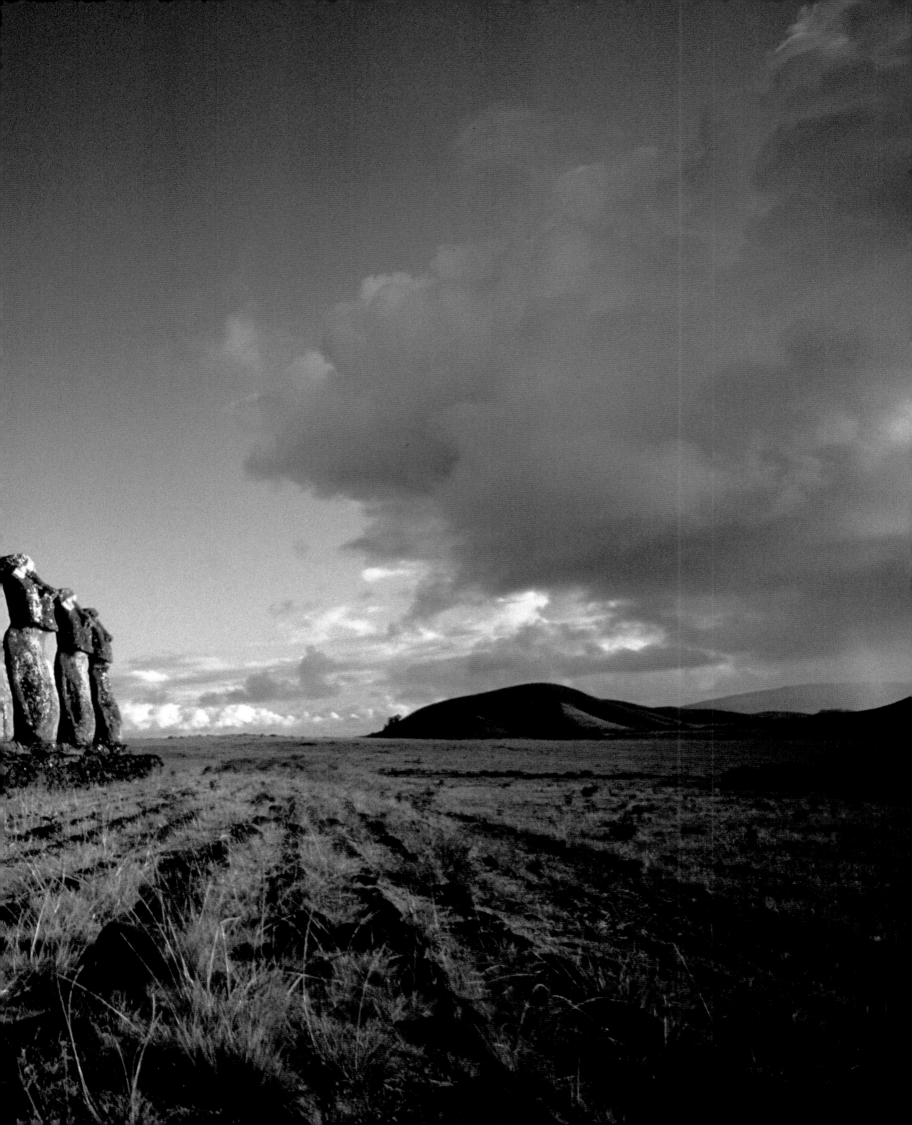

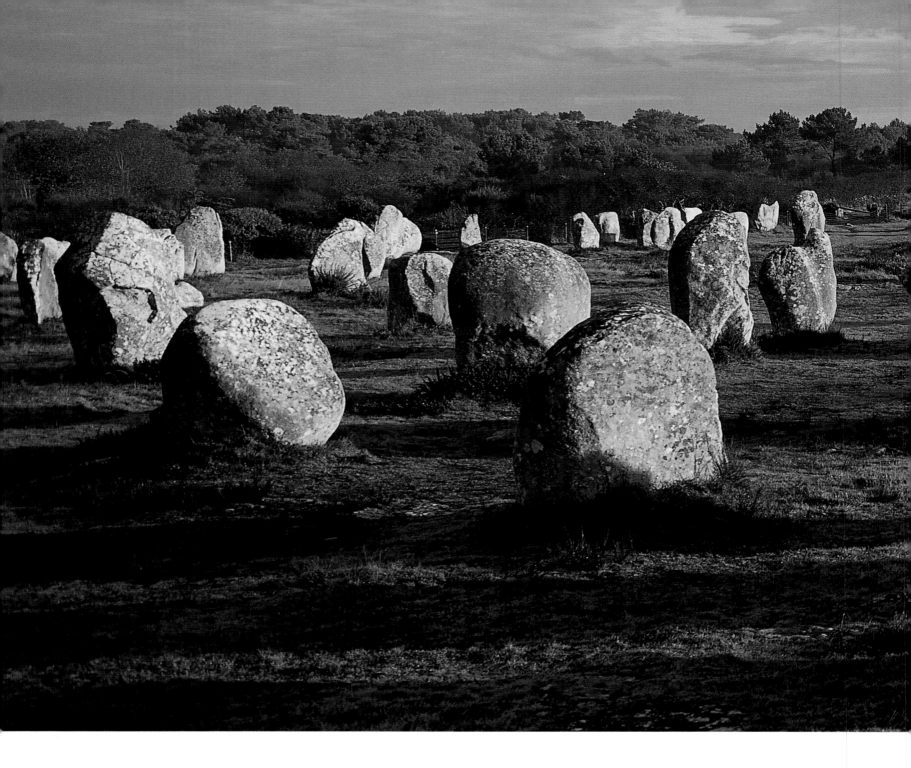

EASTER ISLAND, SOUTH PACIFIC

Preceding pages:

Easter Island is undoubtedly the most isolated piece of land in the world: the nearest shore to its 73 square miles (117 square kilometers) is 1,240 miles (2,000 kilometers) away. Even so, before its "discovery" in the early eighteenth century, it had plenty of inhabitants. Archaeology still has much to tell us about these first inhabitants, cannibals who had come from Polynesia or from South America. And there is still a mystery about the origins of the famous *moai*, the giant statues carved out of basalt—the island is volcanic—found upright, thrown down, or still unfinished in quarries. Their eyes of bone encrusted with coral or obsidian contribute to their mysterious aspect, and we still do not know their exact purpose, probably cultural, nor how they were created. Although many outlandish theories have been advanced, Easter Island's colossal statues still retain their mystery.

THE MENHIRS AT CARNAC, BRITTANY, FRANCE

Above:

There are no fewer than 2,935 raised stones, or menhirs, lined up in various sites on Breton moorland in the Morbihan *département* of France. Very little is known about them except that the oldest are Neolithic (4500–4000 BC) and that the most recent date from 2500–2000 BC. In other words, there is plenty of scope for the most fanciful interpretations and countless legends. The fact that most of the alignments appear to be dictated by astronomy have encouraged the view that they may have been connected to sun worship. Tumuli—dolmens or mounds that on occasion contain more than one earth-covered chamber—are also common in the region. These burial sites are even older.

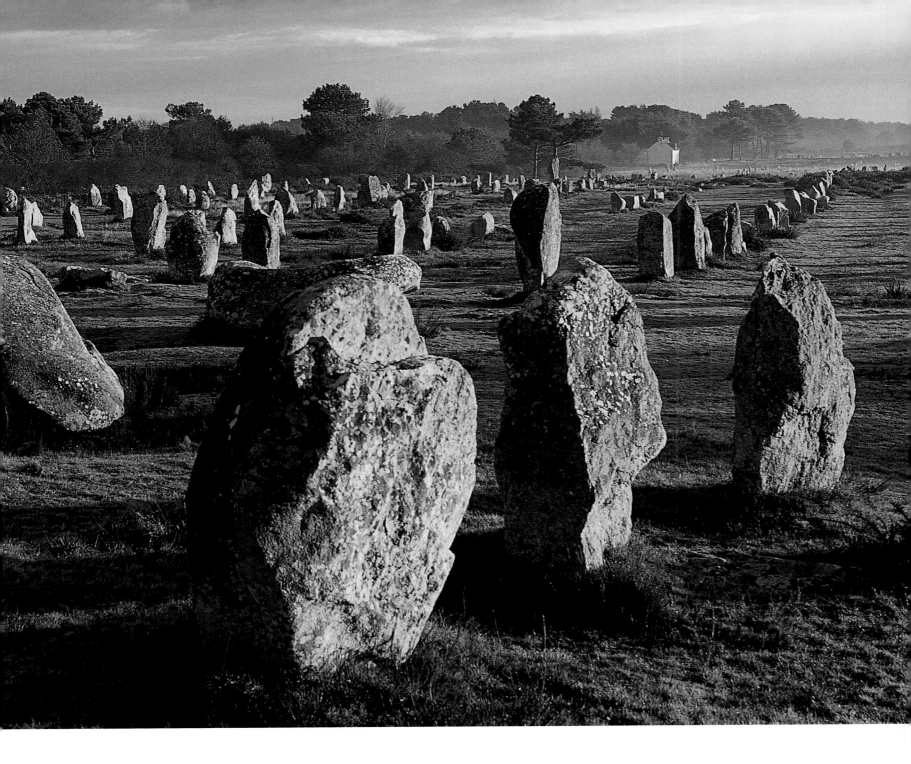

STONEHENGE, ENGLAND

Following pages:

Stones raised on a moor; a mysterious circle corresponding to cycles of the sun and moon: Stonehenge excites the imagination—especially since the stones, located not far from the city of Salisbury in southern England, have not yet given up their secrets. An enclosure dating from 2200 BC rich in burials; a double circle of stones erected between 1700 and 1500 BC; another circle, the best preserved, comprising thirty stones erected about a century later—such are the components that make up one of the most famous prehistoric sanctuaries in the world. Is it a sanctuary? If so, of what religion? What God? The placing of the stones creates a monumental solar dial. Is it a temple to the sun? An astronomical observatory? Another mystery concerns the origin of the stones in faraway quarries in Wales. Why should they have been brought such a long distance to Stonehenge? Undoubtedly it was a place of assembly. For some, Stonehenge may even be a place of welcome for extraterrestrials.

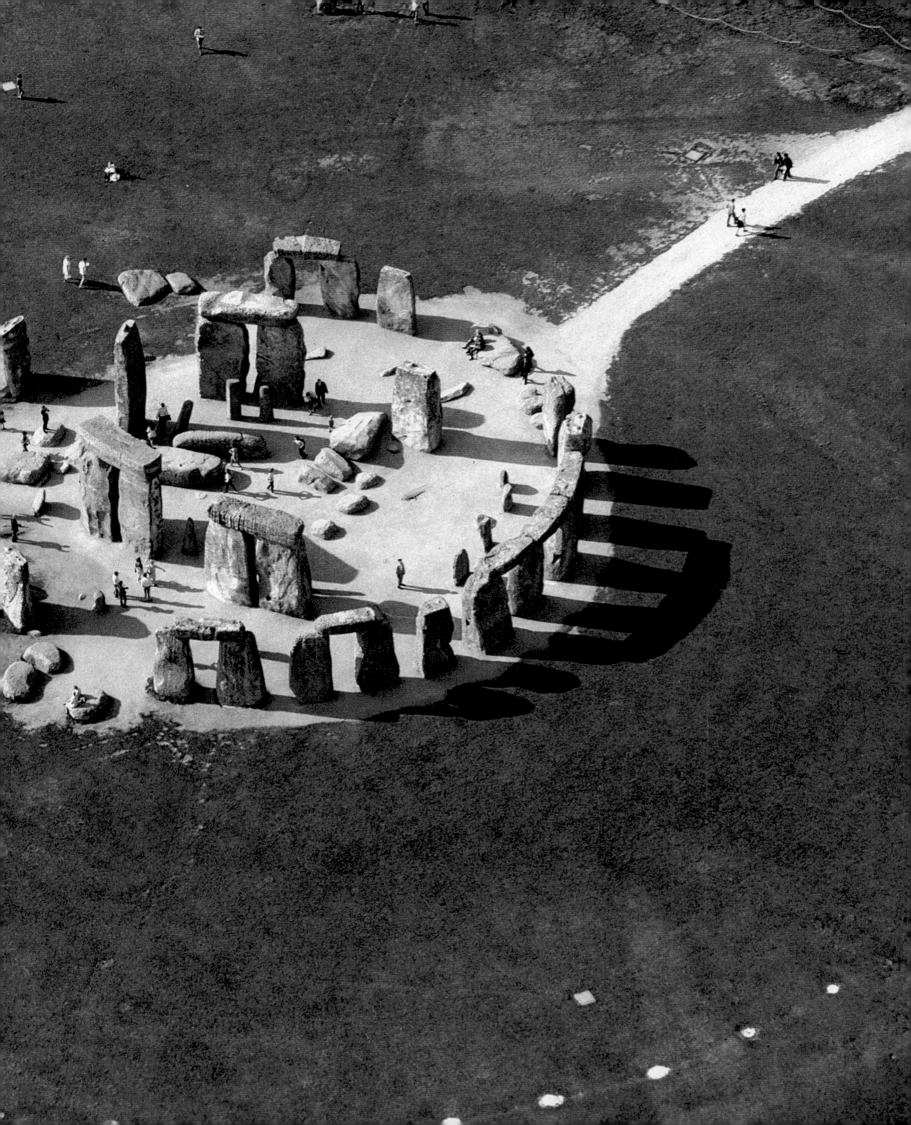

UXMAL, YUCATÁN, MEXICO

Right:

The majestic Mayan sites of the Yucatán Peninsula radiate breadth, power, and mystery. One such site is the sacred city of Uxmal, with its population of twenty-five thousand. Founded prior to 700 AD, the city was abandoned in the tenth century, possibly because it was captured by the Toltecs. Uxmal was laid out according to astronomical criteria around a ceremonial space overlooked by the pyramid shown here behind a building with a row of pillars. Knowing nothing of its function, the Spanish named it the "Pyramid of the Seer." Altered several times since the sixth century, the 98-foot- (30-meter-) high pyramid contains effigies of the god Chac and of the cosmic serpent whose mouth serves as the entrance to the upper temple. According to the native people, passage through it leads to a new life.

THE EL CASTILLO PYRAMID, CHICHÉN ITZA, MEXICO

Following pages:

On a site of 740 acres (300 hectares) are found many monuments belonging to one of the most important Mayan cities on the Yucatán Peninsula, comprising temples, an observatory, a space for sacred games, porticos, terraces, and pyramids. Chichén Itza prospered from the seventh to the ninth century, and then afresh under the Toltecs, who came from central Mexico a century later. The El Castillo Pyramid, with its terraces 79 feet (24 meters) high, dates from the eighth century and was altered by the Toltecs, who added themes from their own mythology to its carved décor. The stairs on each face are directed toward the four compass points; it is sometimes considered to be a gigantic calendar, since there are 365 steps in all. At the top is a temple dedicated to Kukulcán, the plumed serpent, a very important Toltec divinity.

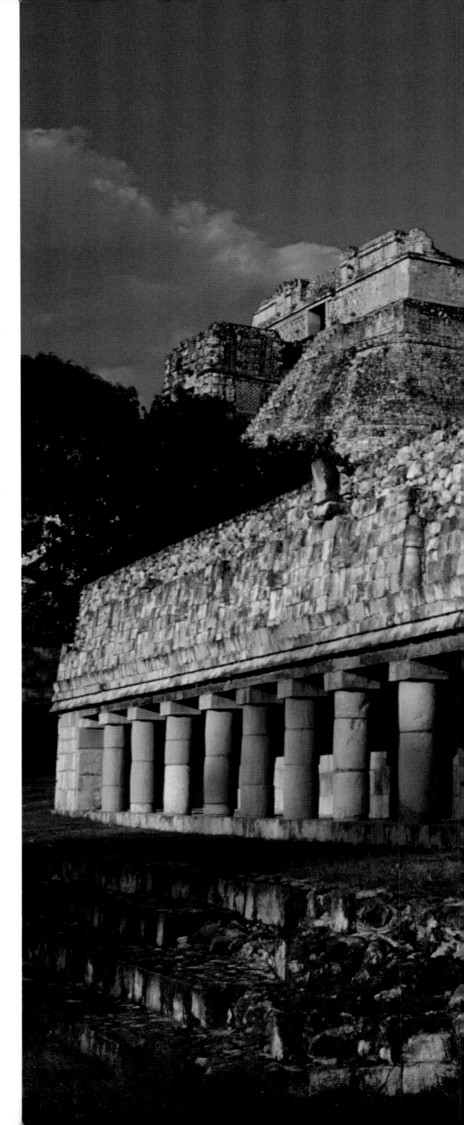

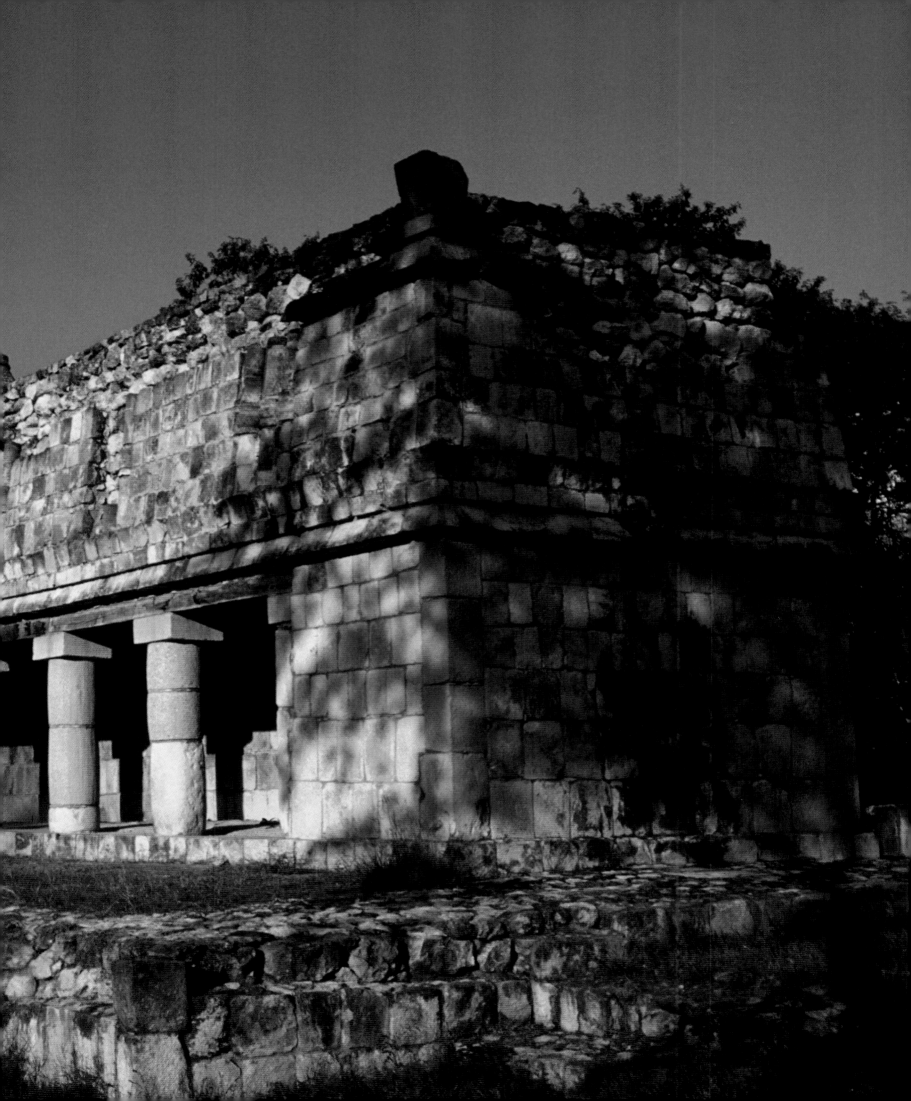

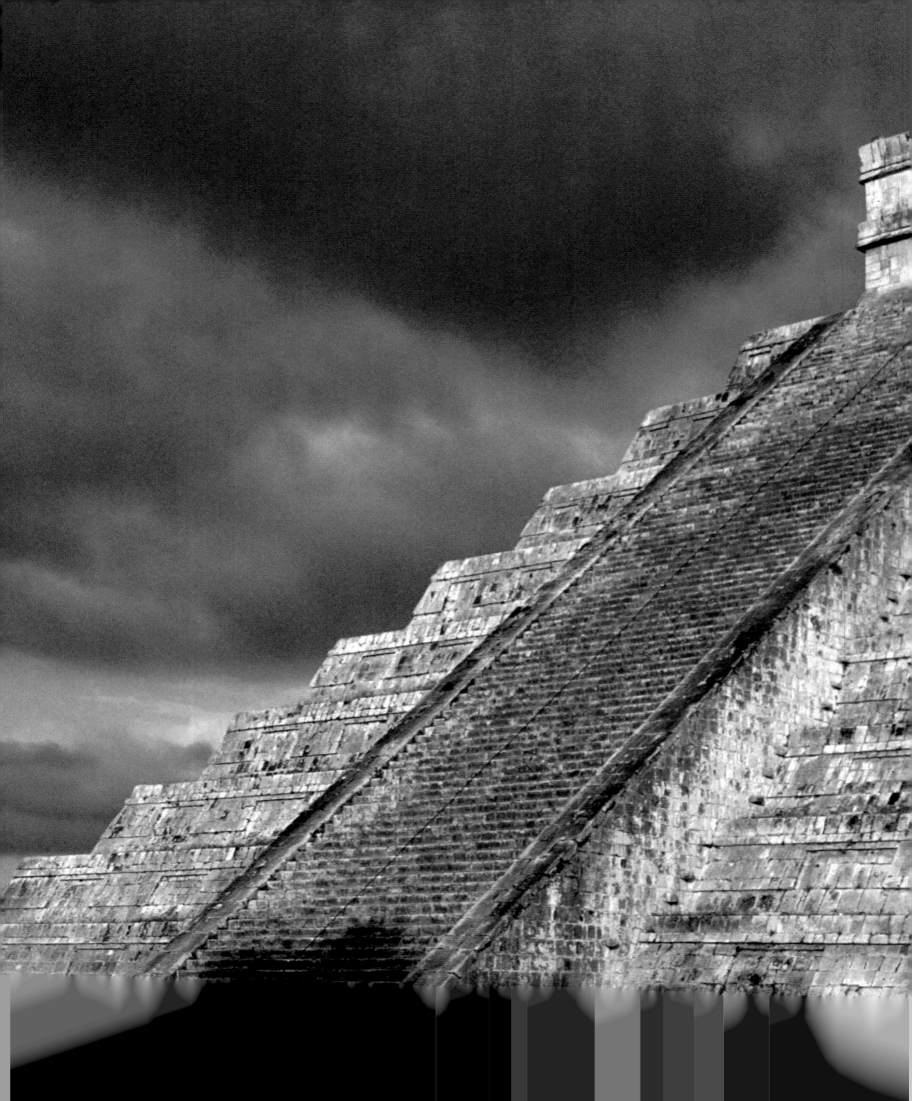

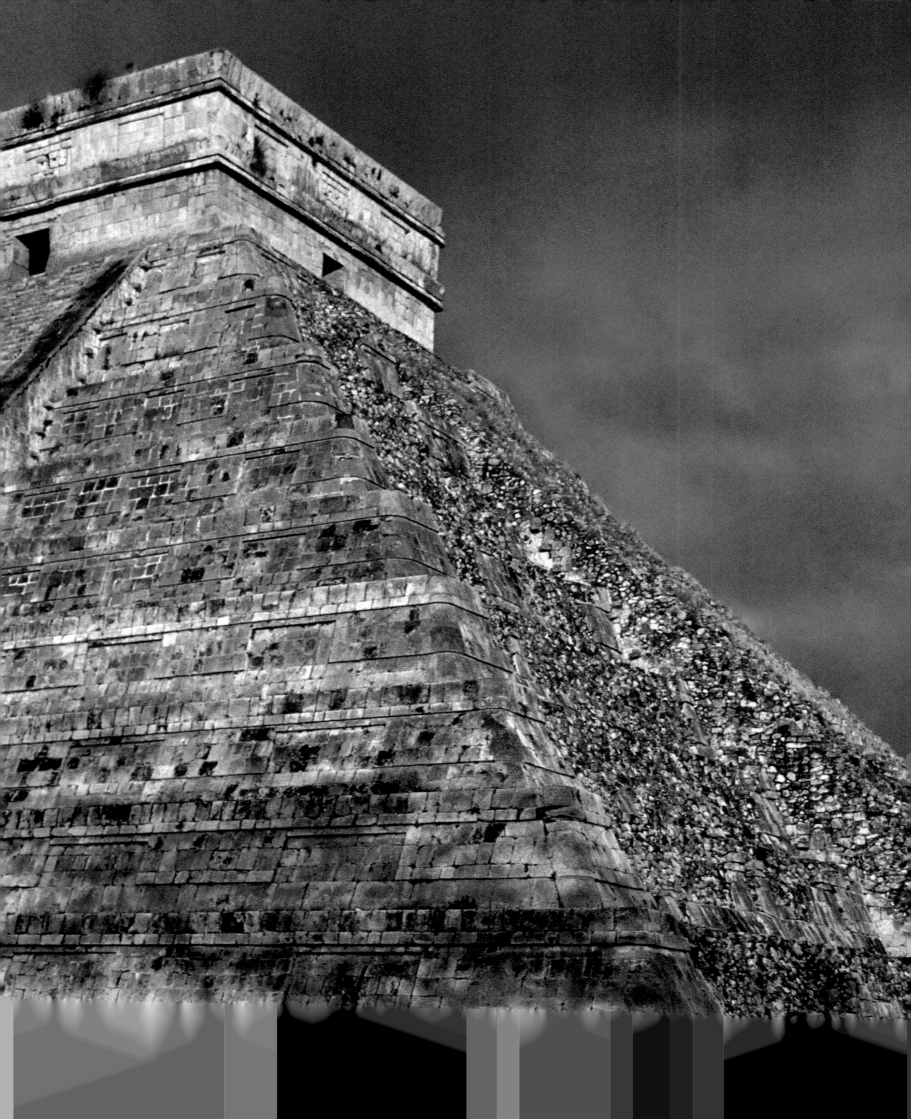

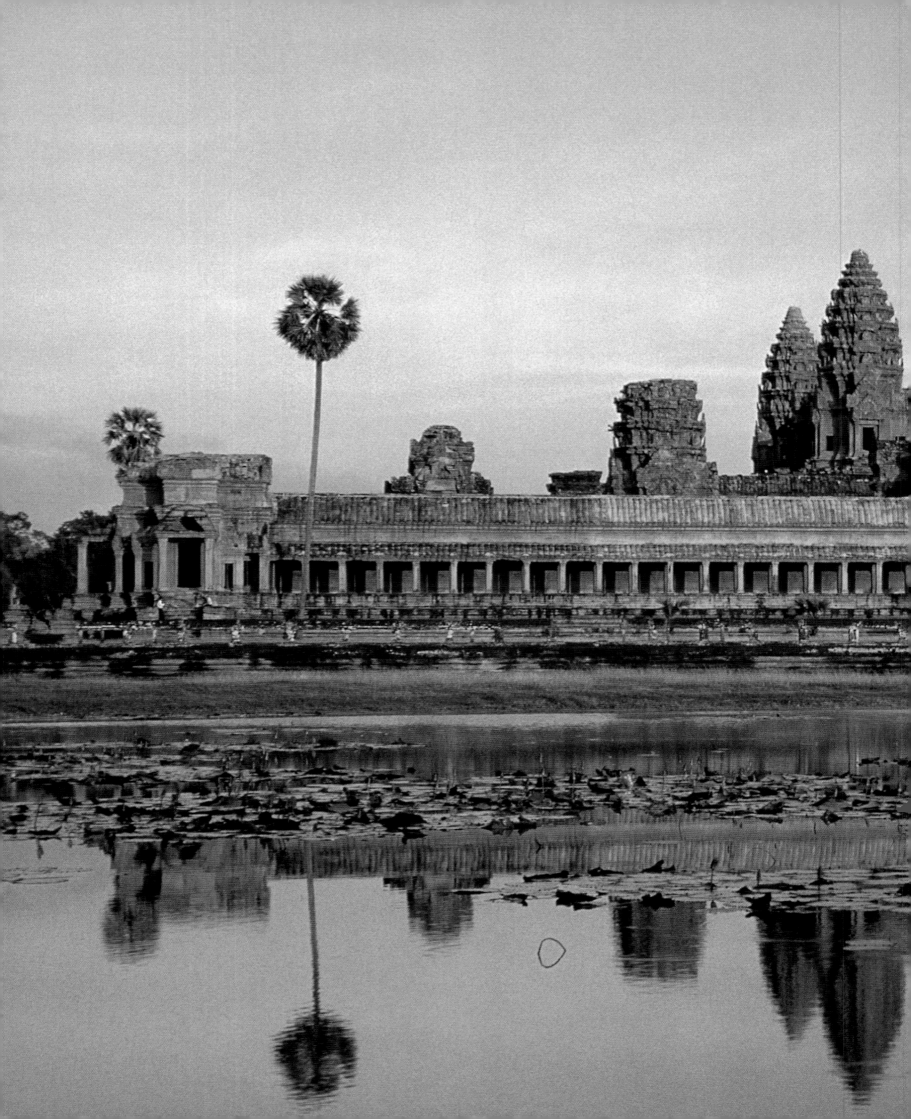

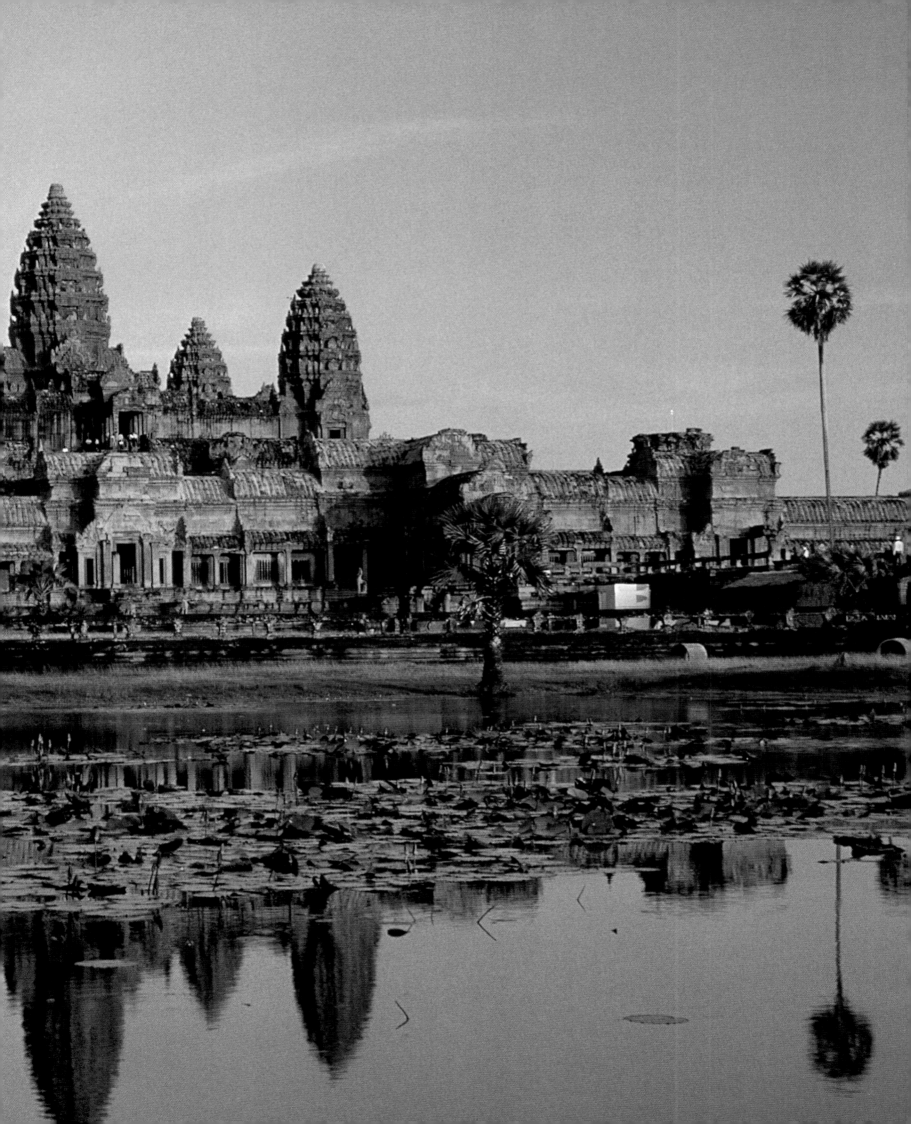

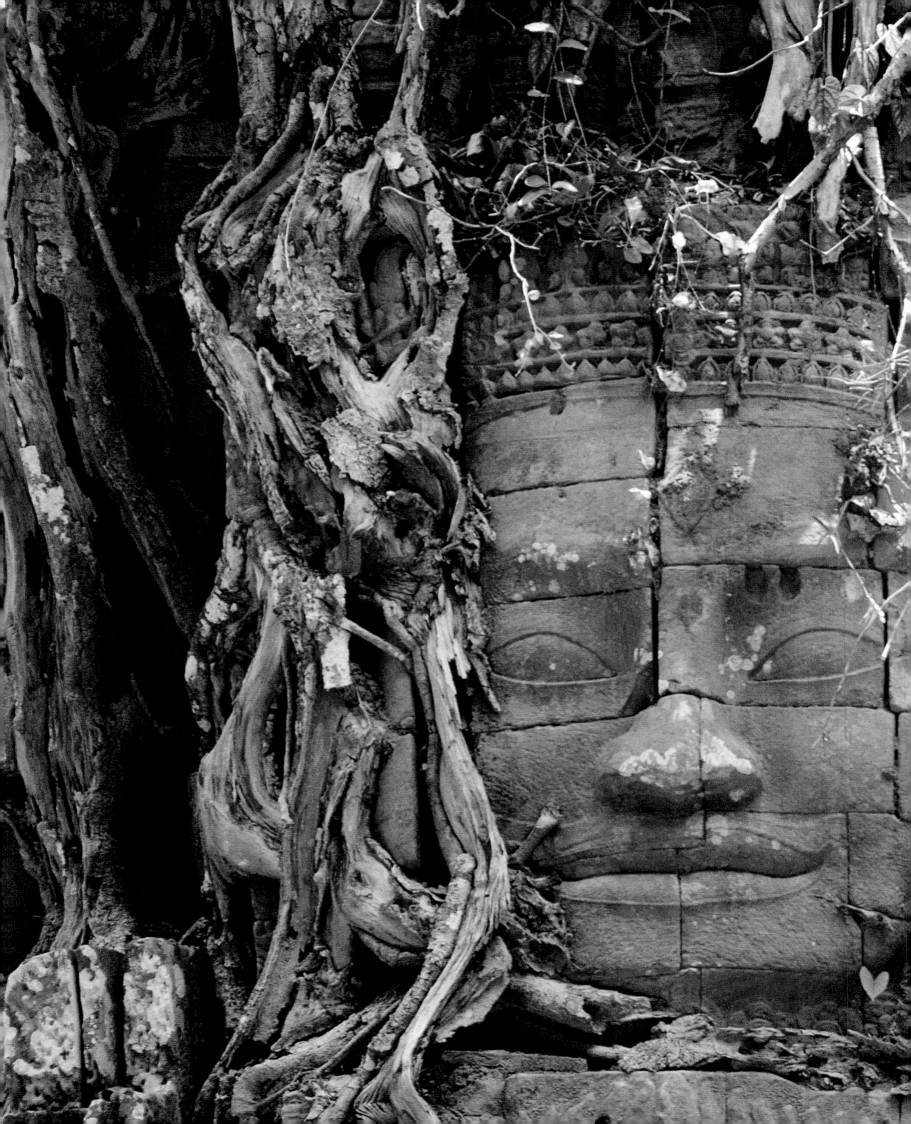

THE TEMPLES AT ANGKOR, CAMBODIA

Preceding pages:

In the twelfth century, King Suryavarman II (1113– 1150) was the enlightened monarch of the vast Khmer empire that then extended across most of the Cambodian peninsula. In the midst of the rain forest he had built a "mountain temple," Angkor Wat, on artificially raised ter- races. But Angkor does not consist solely of this one mon- umental temple with its ringed towers. It had been founded as a capital three centuries earlier, and monarchs carried out building projects into the fourteenth century. Angkor Wat and its countless statues represent classic Khmer art at its most brilliant. But the early thirteenth century saw the construction of Angkor Thom, "Angkor the Great," a host of monuments and temples decorated with bas-reliefs in an enclosure 7 miles (12 kilometers) long.

THE CAMBODIAN JUNGLE

Left:

The Cambodian rain forest is always green; its luxuri- ant vegetation brings to mind the hostile jungle por- trayed in films and cartoon strips, full of mystery and danger. A dense tropical forest where heat and humidity reign, it covers the damp slopes and swampy basins of the countryside, a natural environment of exceptional biodi- versity, even with the steady pace of deforestation. In this unforgiving environment, the fauna, from tigers to count- less snakes, is as rich, diverse, and dangerous as the flora, and human beings have always had to be on their guard against nature. Nonetheless, people managed to create a brilliant civilization here. From beneath the giant ferns, creepers, and proliferating plants of the tropical rain for- est, the now famous and lavish temples of Angkor emerged during the nineteenth century.

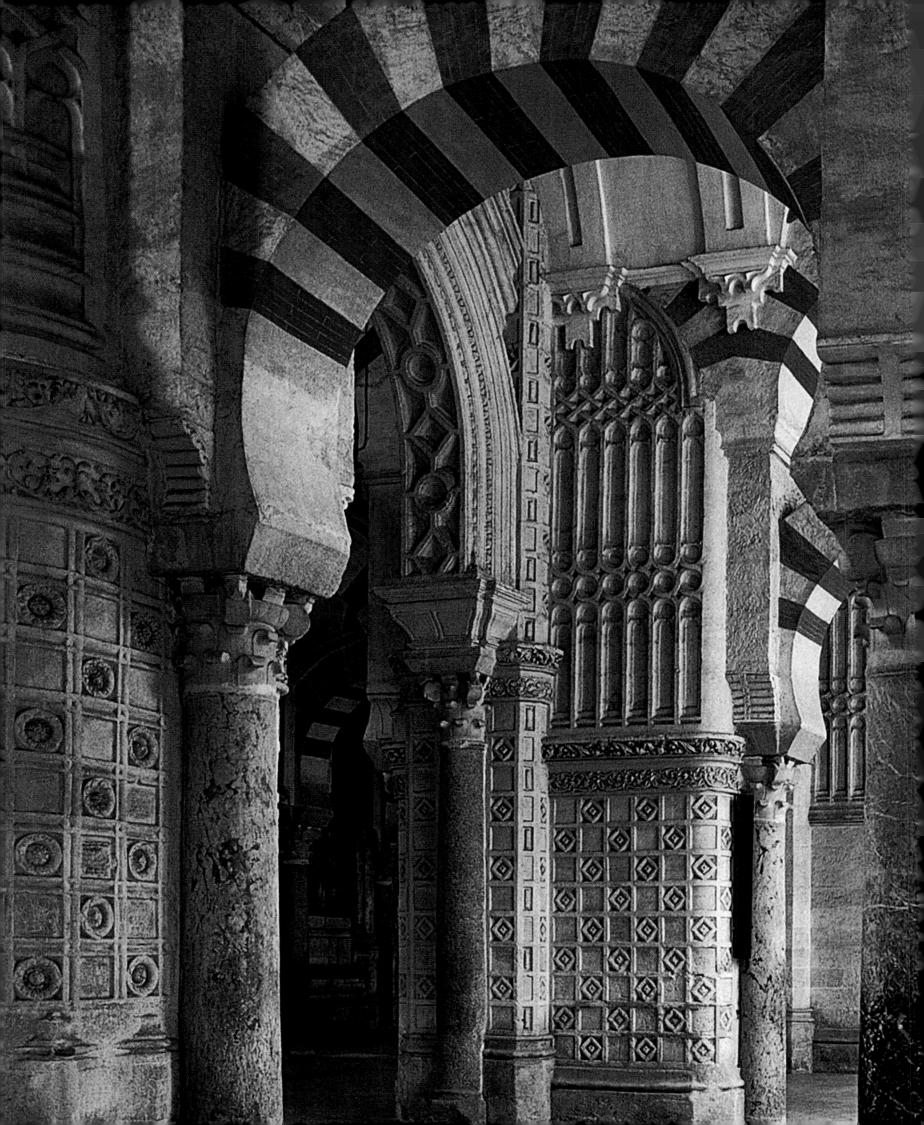

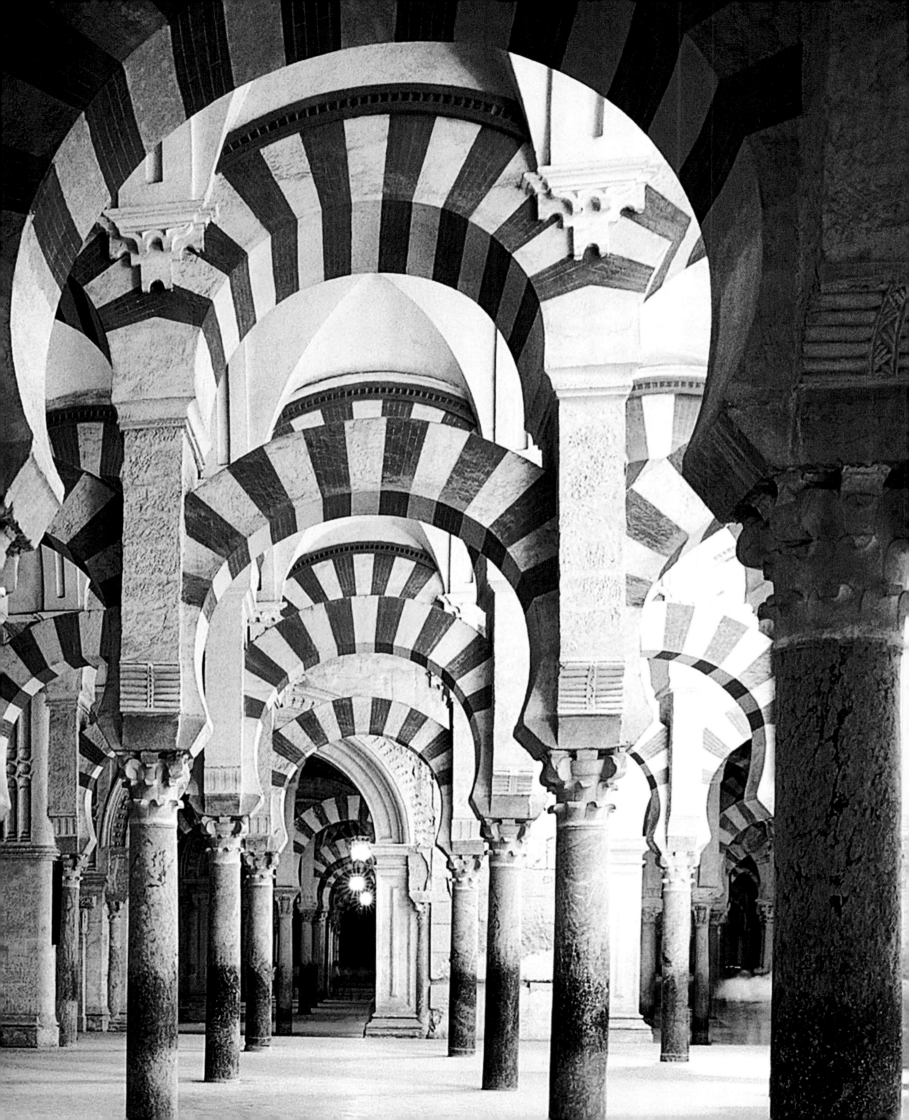

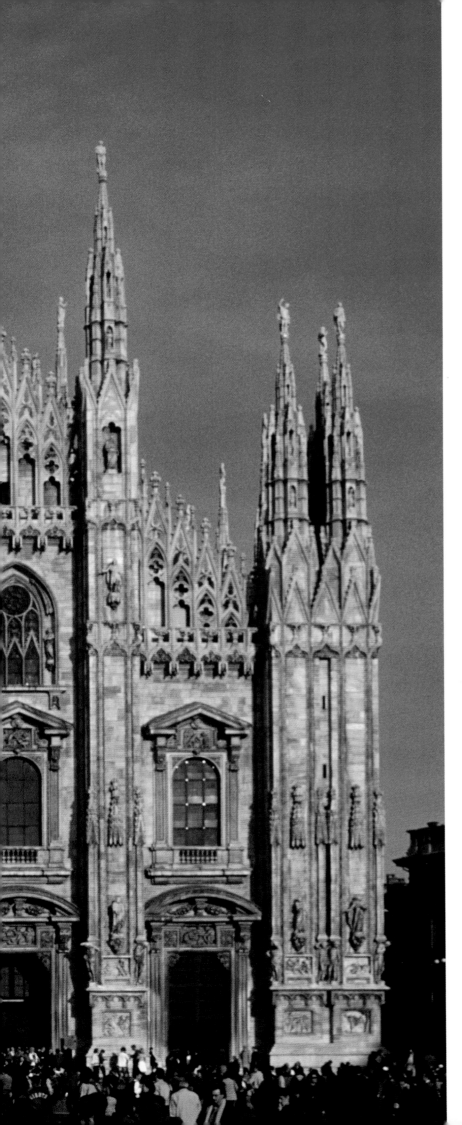

CÓRDOBA MOSQUE, SPAIN

Preceding pages:

From the eighth to the fifteenth century, the Muslim presence in Spain saw the rise of a glittering and tolerant civilization in Andalusia. In 785 in Córdoba, Abd-ar-Rahman I began the construction of a mosque intended to be vast and magnificent. Marble columns from ruined Roman and Visigoth monuments were used to build eleven naves of twelve bays each. Abd-ar-Rahman's successors several times enlarged this "forest of stone," lightened visually by the use of double arches superimposed on brick and white stone, until it was one of the largest mosques in the world, with an area of 75,440 square feet (23,000 square meters). During the sixteenth century the mosque was gutted to raise a cathedral.

MILAN CATHEDRAL, ITALY

Left:

For all its hectic and restless character, the great northern Italian metropolis of Milan is nevertheless a great city of art. At its heart is its cathedral, the Duomo, a masterpiece of Gothic architecture. It is also one of the largest churches in the world and, for the Milanese, it is the obvious landmark in their city's vibrant center. Begun in 1386, construction of the cathedral continued into the sixteenth century; and there were further developments in the nineteenth century, at Napoleon's instigation. Bristling with steeples and pinnacles, adorned with a host of statues, and clad in a luminous white marble that even Milan's pollution cannot tarnish, it is often dubbed the "marble hedgehog." The interior is imposing: almost 492 feet (150 meters) in length and 150 feet (46 meters) high, the capitals of its powerful columns supporting statuary that is larger than life-size. There is a superbly paved floor, and the tombs and effects add to the sense of grandeur conveyed by the architecture.

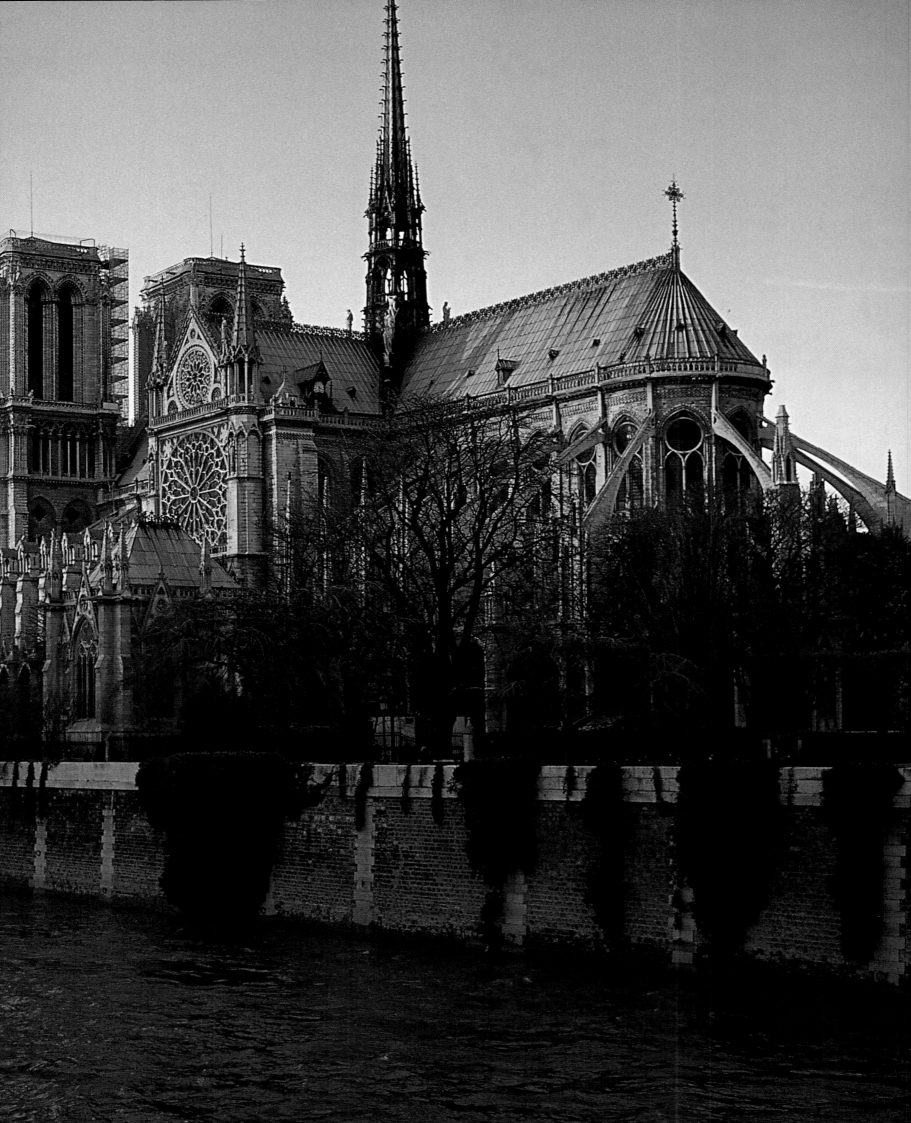

NOTRE-DAME DE PARIS, FRANCE

Preceding pages:

From its island shaped like a ship, the cathedral of Paris overlooks the city as if it were a crow's nest. It speaks of the city's history and its faith; and its spire appears to be the axis from which the entire capital city is laid out. Escorted by its fellow island, the Île Saint-Louis, whose façades look toward it, the Cathedral of Notre-Dame de Paris is a jewel of Gothic art. Planned by Bishop Maurice de Sully in 1160 to replace two older churches, it was finished around 1330. Spoiled by classicism and the French Revolution, Notre-Dame rediscovered its medieval splendor through the restoration work done by architect Eugène Viollet-le-Duc in the nineteenth century. The statuary on its doorways, its stained-glass windows and furniture, no less than its architecture and history—which has shared that of France since the Middle Ages—amply explain the crowds of admirers who flock to see it.

CHARTRES CATHEDRAL, FRANCE

Right:

Two steeples rise up over the city and score the sky above the austere landscape of the plain of Beauce. The cathedral praised by poets seems almost to leap from the wheat fields, with the city at its feet. Reputedly Notre-Dame-sous-Terre, the Black Virgin kept in the cathedral's crypt, is a medieval version of a Gallic fertility goddess. What is certain is that in her honor, after several disastrous fires, those who venerated her built a holy place even greater and lovelier than the last. Of the reconstruction following the fire of 1194 there remain the crypt, the towers, and the western façade. The porches display some splendid Gothic statuary, and the 170 stained-glass windows, which total 8,528 square feet (2,600 square meters) in area, impart a very special colored light to this vast building, which was completed in 1225.

AMIENS CATHEDRAL, FRANCE

Following pages:

The great cathedrals of the Gothic period are collective works; they belong to entire cities and not simply to bishops. Amiens Cathedral is the largest in France, and was raised in record time, between 1220 and 1270. The speed of building is to be explained by the city's wealth, based on the cloth industry, and the commitment of the entire population to its construction. With its ethereally luminous triforium, great length (469 feet, or 143 meters), and impressive height, Amiens Cathedral is an architectural marvel. A whole tribe of stone figures animates its porches, among them the celebrated "Beau Dieu d'Amiens," or "Fair God of Amiens," dispensing reassurance from His serene, peaceful face under the tympanum of the Last Judgment. Each period has left furniture or decoration beneath the cathedral's arches, like the choir screen, with its four thousand characters, constructed during the fifteenth and sixteenth centuries, or the sixteenth-century choir stalls.

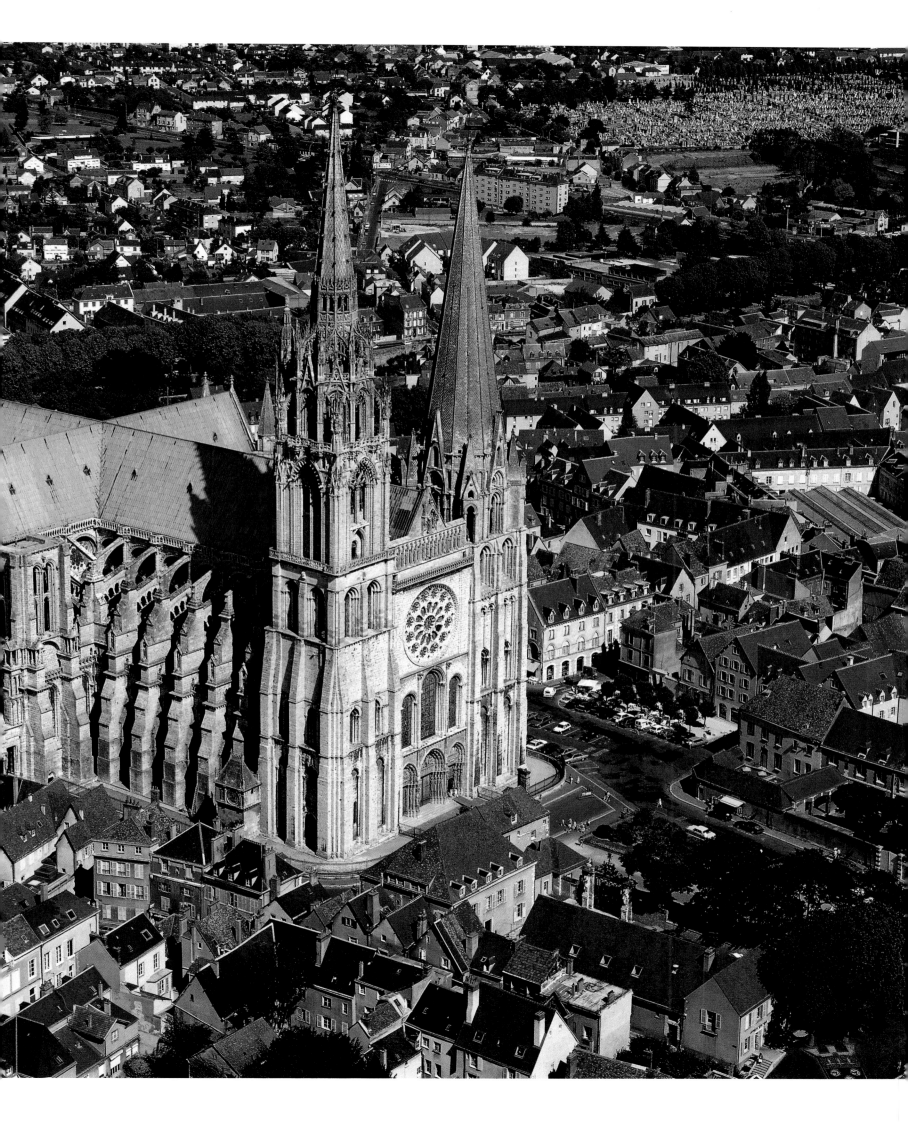

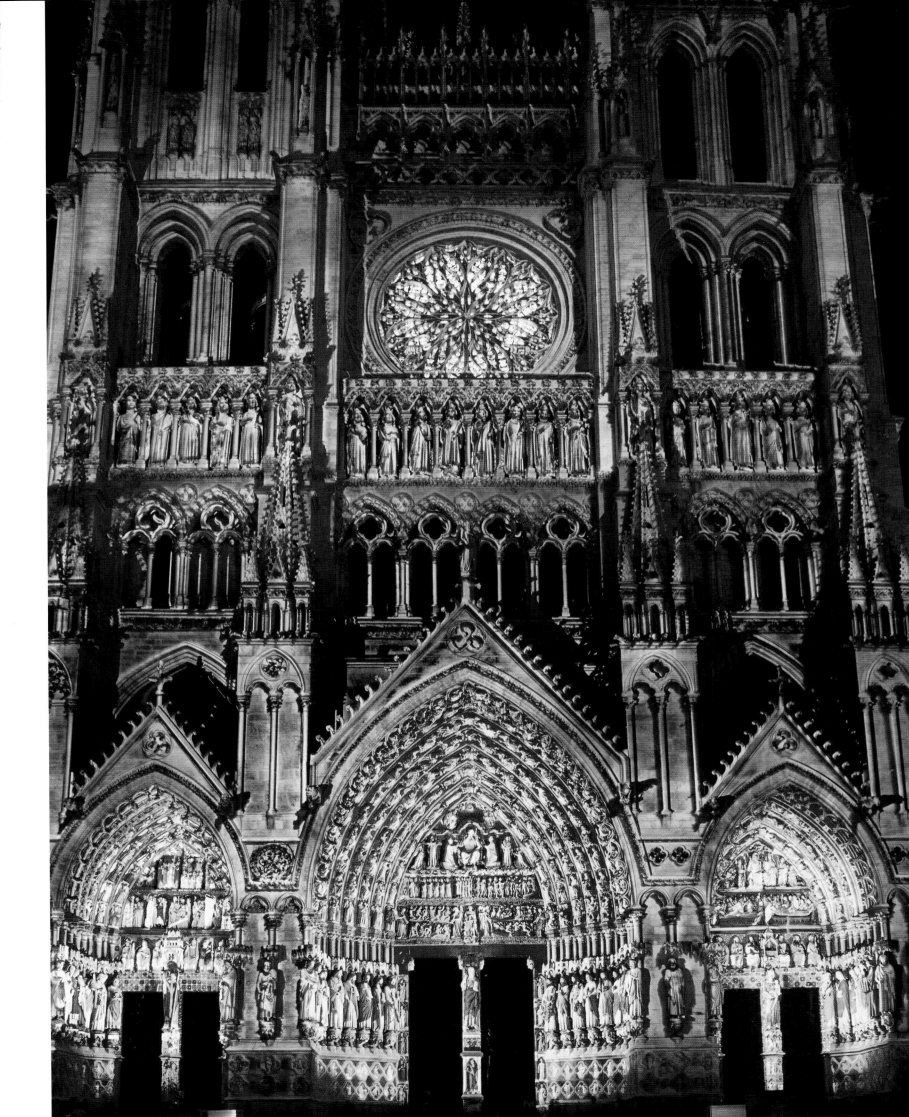

COLOGNE CATHEDRAL, GERMANY

Right:

This historic city has shared in the most glorious, as well as the most tragic, days in German history. Cologne's role in its European heritage is signaled first and foremost by the two high steeples that crown its famous cathedral. This Gothic jewel is only the latest of many sacred buildings erected on the site since the fourth century. It was begun in 1248, but not completed until 1863, in the style of the medieval project. It houses relics said to belong to the Magi. At the cathedral's feet, on either side of the Rhine, the vast city has had a long and illustrious history, from the Roman *Colonia Claudia Ara Agrippinensium* to the European metropolis it is today. A city of passage and trade, a Free Imperial City in 1475, Cologne has been energetic and prosperous throughout its history.

JERUSALEM

Following pages:

The city that is holy to three monotheistic religions continues to search for an elusive peace; yet it is consecrated ground to millions. Everywhere in this city, where the Dome of the Rock glows in the setting sun, there is sacred history. The city was already in existence twenty-one centuries before our common era. But it is the great epic recounted in the Bible that fashioned Jerusalem, and Judaism, Christianity, and Islam have all contributed to the richness of its spiritual and religious heritage. The emblematic golden dome adorns the Dome of the Rock, also known as the Mosque of Omar, one of the most ancient shrines in Islam. Colored marble, ceramics, and mosaics add splendor to the monument, which continues to be used as a mosque. Dating from 691 AD, it is built on the spot where Abraham is reputed to have prepared to sacrifice his son Ishmael; it is also where Muhammad is believed to have been transported in a vision before ascending to Heaven. It is also considered to be the site of Solomon's Temple, which was rebuilt several times, and which lies at the heart of the Jewish faith. The Second Temple was destroyed by the Romans in 70 AD. It was never rebuilt, but, among other relics, part of an impressive Herodian retaining wall that supported the Temple compound still stands, near the Dome of the Rock. Known as the Western Wall, it is the most holy place in Judaism.

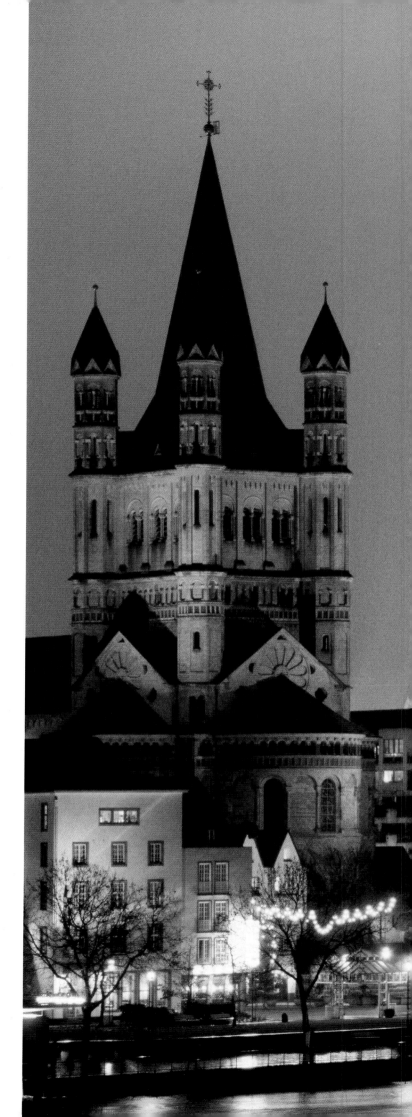

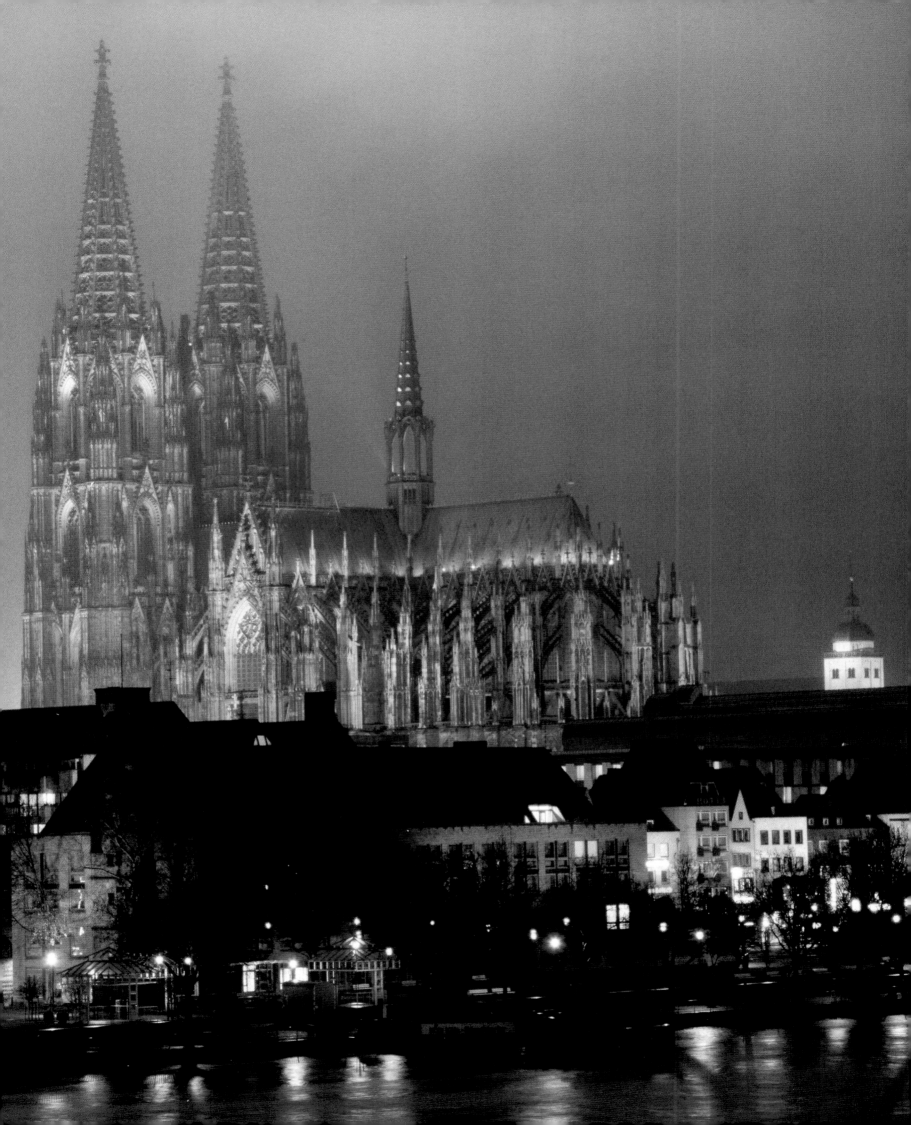

DJENNÉ MOSQUE, MALI

Above:

During the colonial period, caravans with camels and early motorized conveyances turned Djenné into a prosperous way station, just as river transport along the Niger River had already contributed to trade that ceased in the sixteenth century. Djenné was also an Islamic missionary center following the conversion of the local king, probably in the twelfth century. At that time the first mosque was built, although it would have needed constant repair because of erosion from rainfall. Such is the lot of fragile earth architecture, which here is called *banco*. The current edifice, which is the largest built of this material in existence, contains a hall of prayer sustained by ninety columns; it was largely reconstructed in 1909, but on an ancient layout.

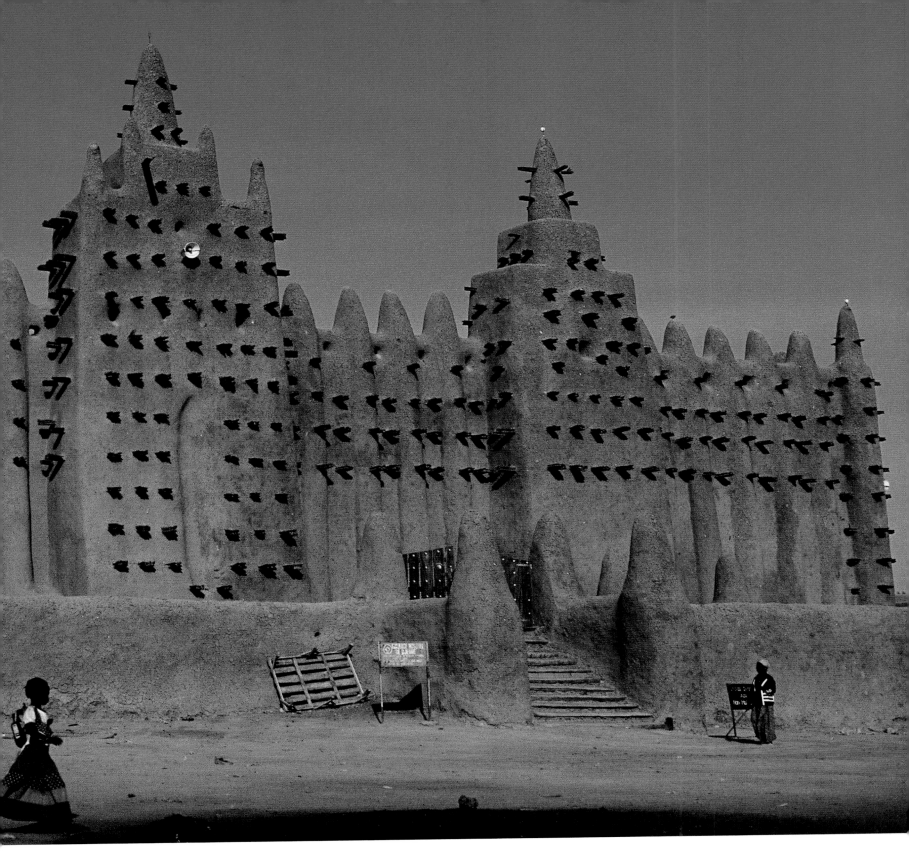

SAINT CATHERINE'S MONASTERY, SINAI, EGYPT

Following pages:

At Sinai were laid important foundations of the three religions of The Book: Judaism, Christianity, and Islam. For eighteen centuries, a small number of men have been praying here, in the shadow of the mountain where Moses received the Ten Commandments and saw the bush that burned without being consumed. In the midst of the Sinai massif, the Monastery of Saint Catherine is one of the oldest in the world; its foundation is thought to date from the third century. Twelve Orthodox monks still live there; in an imposing desert setting, they look after not only a premier religious and cultural site but also some inestimable treasures. The monastery has one of the most important collections of icons in the world; its chapels are adorned with magnificent frescoes, and its liturgical objects are truly precious. The library contains almost as many ancient manuscripts as the Vatican's.

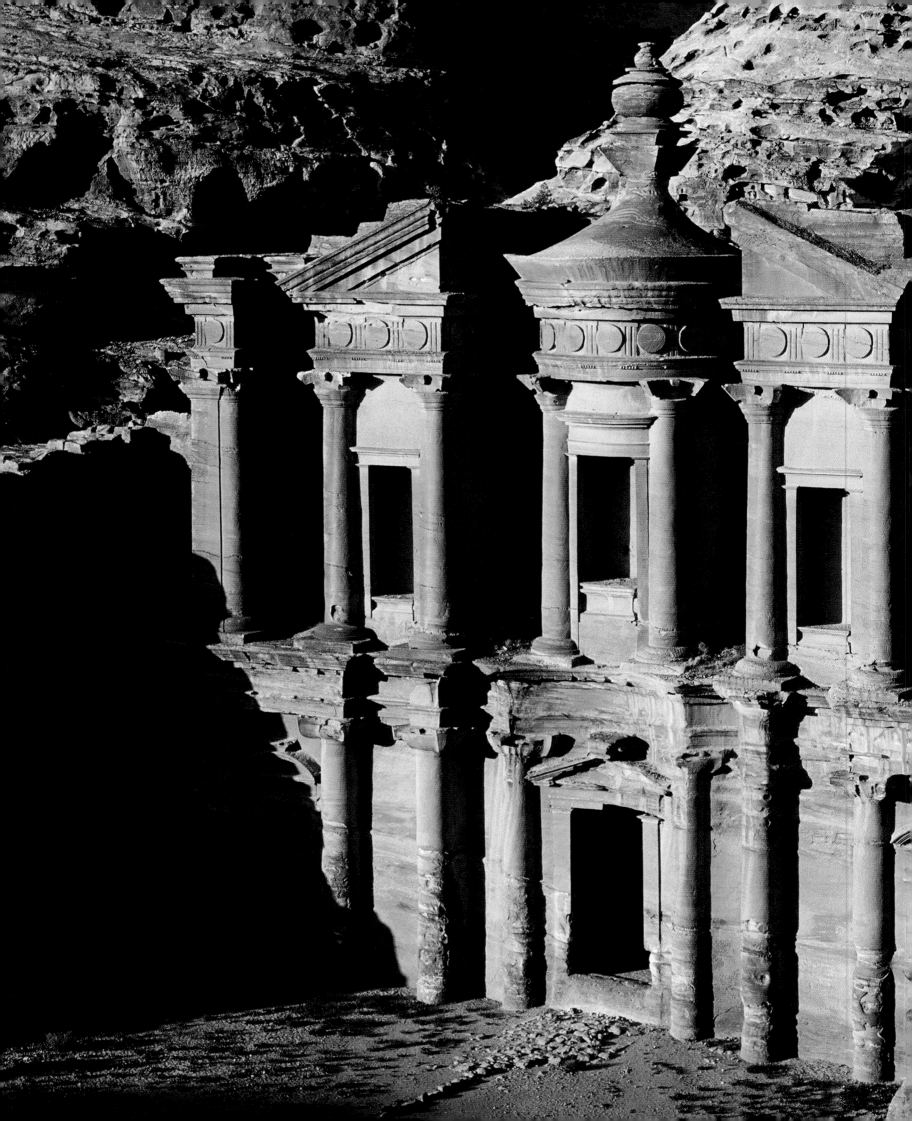

PETRA, JORDAN

Left:

Tucked away in rocky hollows in the desert, in sandstone that is pink, brown, yellow, or in places a grayish blue, Petra is a former city created in the eighth century BC by the Nabataeans. It was an important staging post on the caravan routes between the Red Sea and the Dead Sea. An ingenious system of channels and basins kept the town supplied with water. But the Romans, having seized the place, allowed it to deteriorate, since they preferred to use sea transport. More than six hundred monuments are cut into the rock: just like the houses, they are either built into or dug out from the walls of a round hollow or rocky defiles. Imposing façades that combine classical Hellenic features and Oriental motifs barely emerge from cliffs 328 feet (100 meters) high. These are entrances to royal tombs created in the first century BC; the most celebrated among them, called *Al Khazneh*, or the Treasury, has been popularized by its appearance in film and other media.

LALIBELA, ETHIOPIA

Following pages:

While Westerners were erecting their loveliest Romanesque churches and earliest Gothic masterpieces, in this faraway corner of historically ancient Christian Africa, people dug deep into the rock in the twelfth and thirteenth centuries to create some astonishing holy places. Along the sides of old volcanoes, more than 13,120 feet (4,000 meters) above sea level, an important place of pilgrimage was being established, as it remains today. Eleven monolithic churches make up what was intended to be a New Jerusalem. They were literally carved out of the lava, roughly hewn out first, slowly shaped, then hollowed out to leave only the terrace, walls, and interior supports, so that everything looked just like a church that had been "built." They include decorative frescoes.

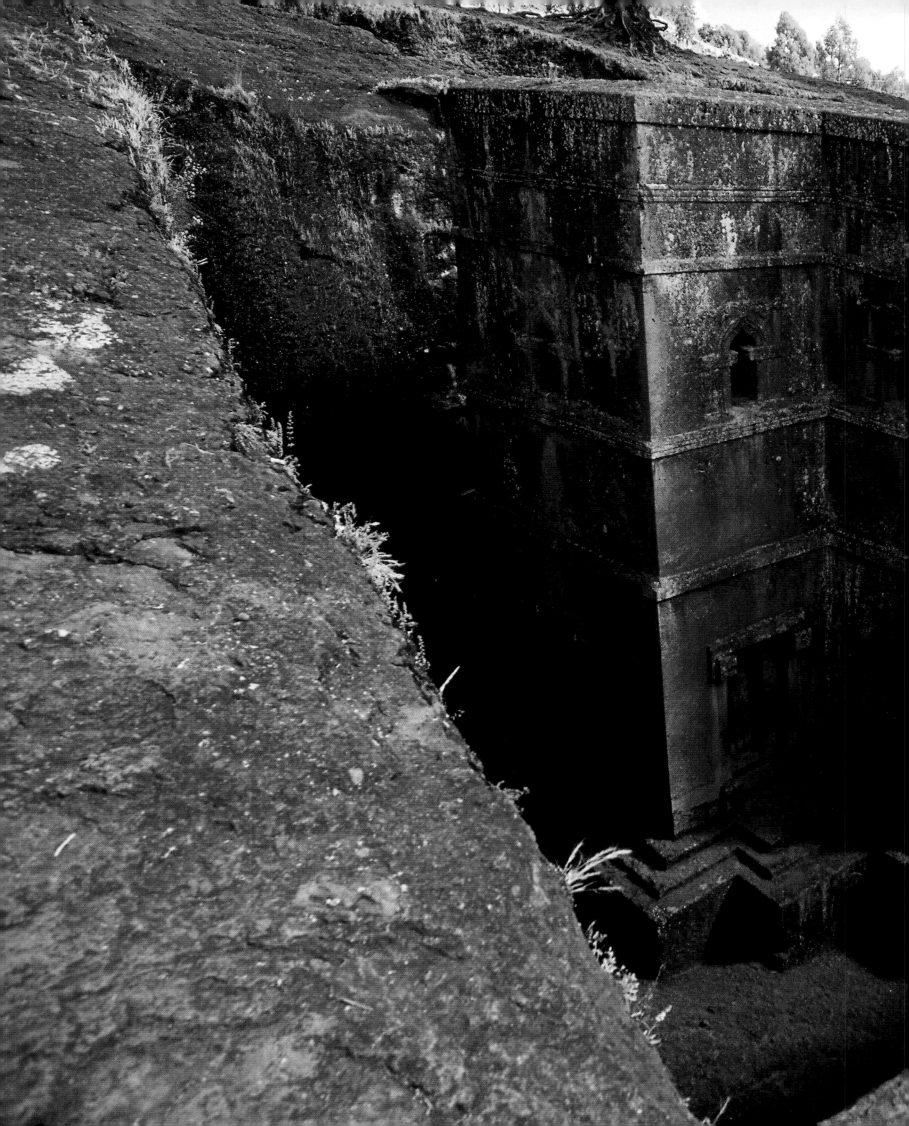

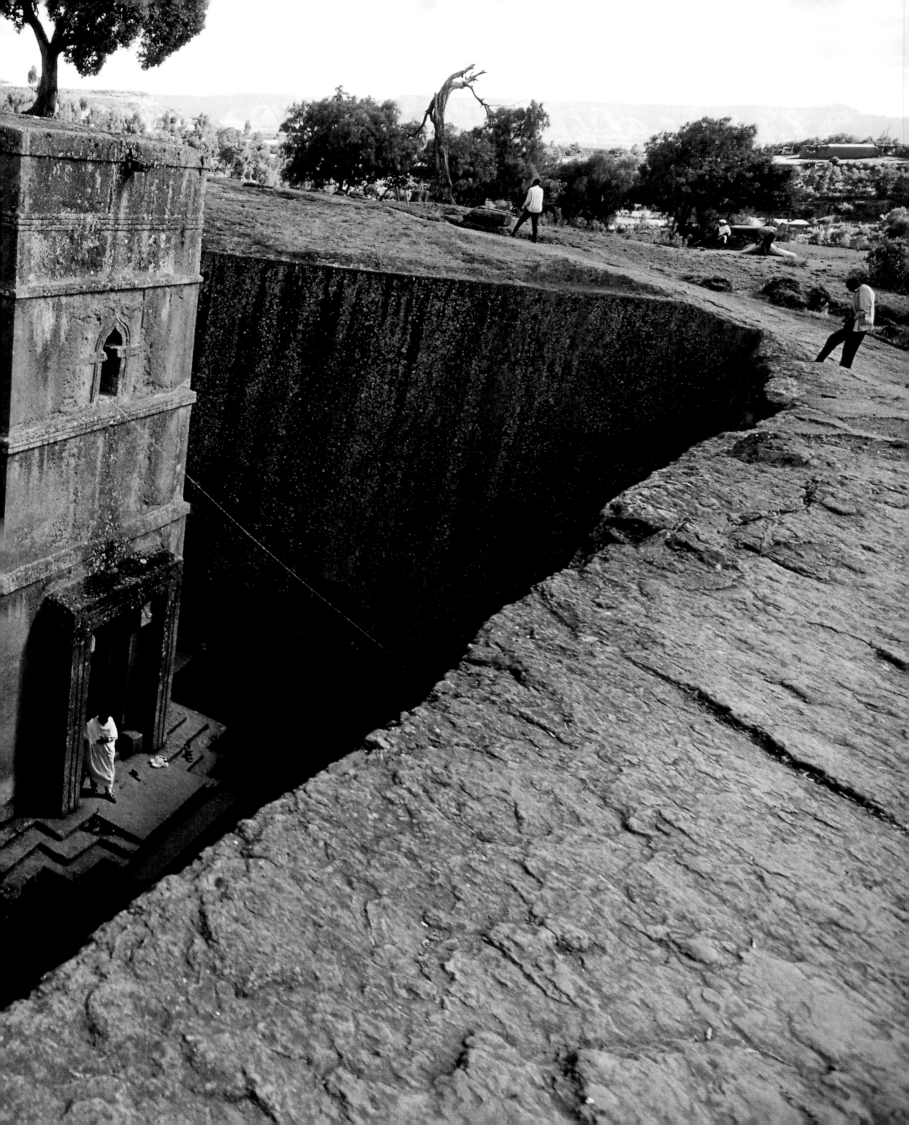

THE CHURCH OF SAINT JOHN
NEPOMUCENE, CZECH REPUBLIC

Right:

In 1252, a Cistercian monastery was founded in a dense forest on the Czech–Moravian border. It remained isolated only for a while, for nearby emerged the township of Zdar nad Sagavou, which became the seat of one of the Great Czech families, the Kinskis. In the eighteenth century, the monastery received the relics of Saint John Nepomucene and was in the ascendancy. Like most of the locality, it was rebuilt, and a pilgrimage church was constructed on Saint Helen's Hill (Zelena Hora) by the architect Santini, a master of the Baroque. Surrounded by low buildings arranged like a crown, the church is conceived on the plan of a five-branched star, referring to the tradition that such a star appeared as the saint met his martyrdom in the waters of the Vltava, the Moldau.

SAN CRISTÓBAL DE LAS CASAS,
MEXICO

Following pages:

Colonial-style houses, Baroque and Rococo churches, and everywhere an essentially Mayan population displaying the products of its craftsmanship: all of Mexico's history is to be found here in the southeast of the country. The town, 7,544 feet (2,300 meters) above sea level, was for a time the capital of the Mexican state of Chiapas. Founded in 1528, it bears the honorable name of the Dominican Bartolomé de Las Casas, who defended the Native Americans during the period of colonization. Everywhere the city is enlivened by bold and varied colors: the red roofs and ocher walls; the retablos and statues in the churches; the traditional costume and fabrics; and the fruits and vegetables in the market stalls.

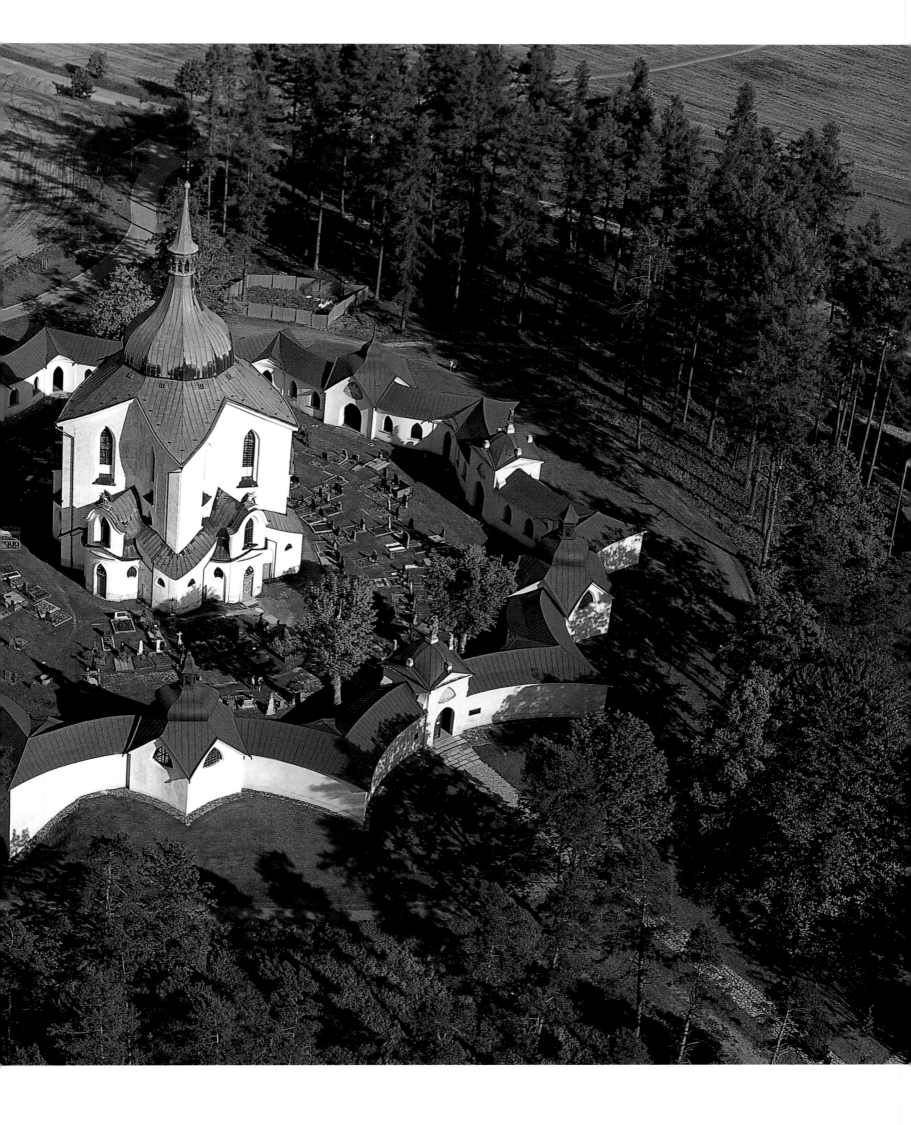

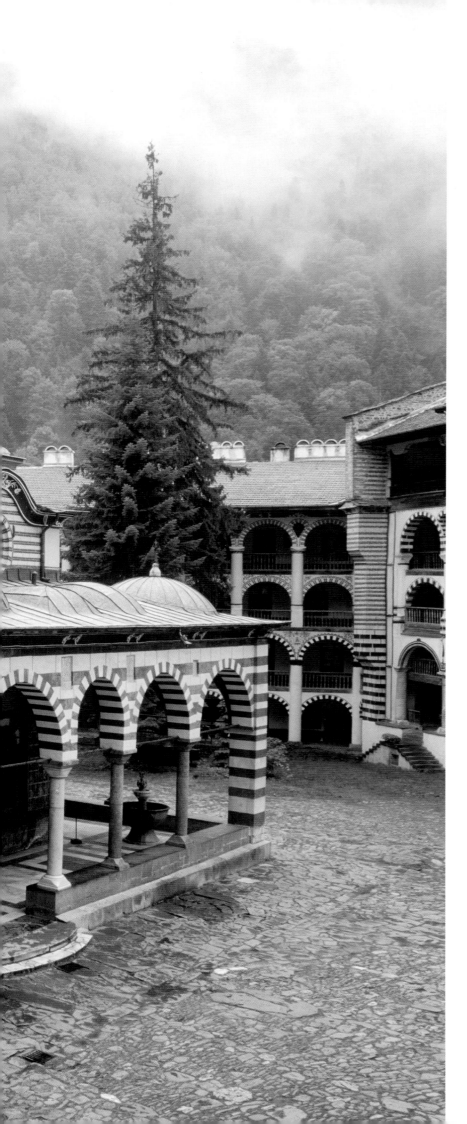

THE CHURCH OF THE NATIVITY, RILA, BULGARIA

Left:

The alternating rows of light and dark stone lend a very particular character to this church at the heart of the vast Rila Monastery some 62 miles (100 kilometers) from Sofia, the Bulgarian capital. Originally a hermitage founded by Ivan Rilski (Saint John of Rila) in the tenth century, this religious establishment was protected by Bulgarian rulers and played an important part in the country's history until the Ottoman invasion of Bulgaria in the fourteenth century. The Orthodox monastery recovered its influential role in maintaining Bulgaria's Slavic identity during the nineteenth century, when most of the buildings, which had suffered destruction by fire, were rebuilt, assimilating a medieval tower. The structures are arranged around the church and open onto an inner courtyard by means of arched galleries or arcades several stories high, as shown here. Within its verdant, mountainous setting, the monastery is a magnificent witness to what is known as the Bulgarian Renaissance.

CLIFF CARVINGS NEAR DAZU, CHINA

Following pages:

On the Baodingshan site in China, 9 miles (15 kilometers) north of the town of Dazu, more than ten thousand Buddhist sculptures were carved into the cliffs during the twelfth and thirteenth centuries. Apart from their religious interest, the depictions of sacred figures are accompanied by scenes of daily life; and, most notably, they have kept most of their original paint work. Some of the representations are quite exceptional. There is a goddess of mercy equipped with 1,007 hands, and a reclining Buddha 98 feet (30 meters) long. Certain carvings combine elements from the Buddhist, Taoist, and Confucian traditions in an essentially Chinese cultural unity. The six segments of the Wheel of the Law represent the six stages of transmigration, and the figures illustrate the virtues leading to paradise. The site's spiritual importance was such that it was spared by the Maoist Red Guards.

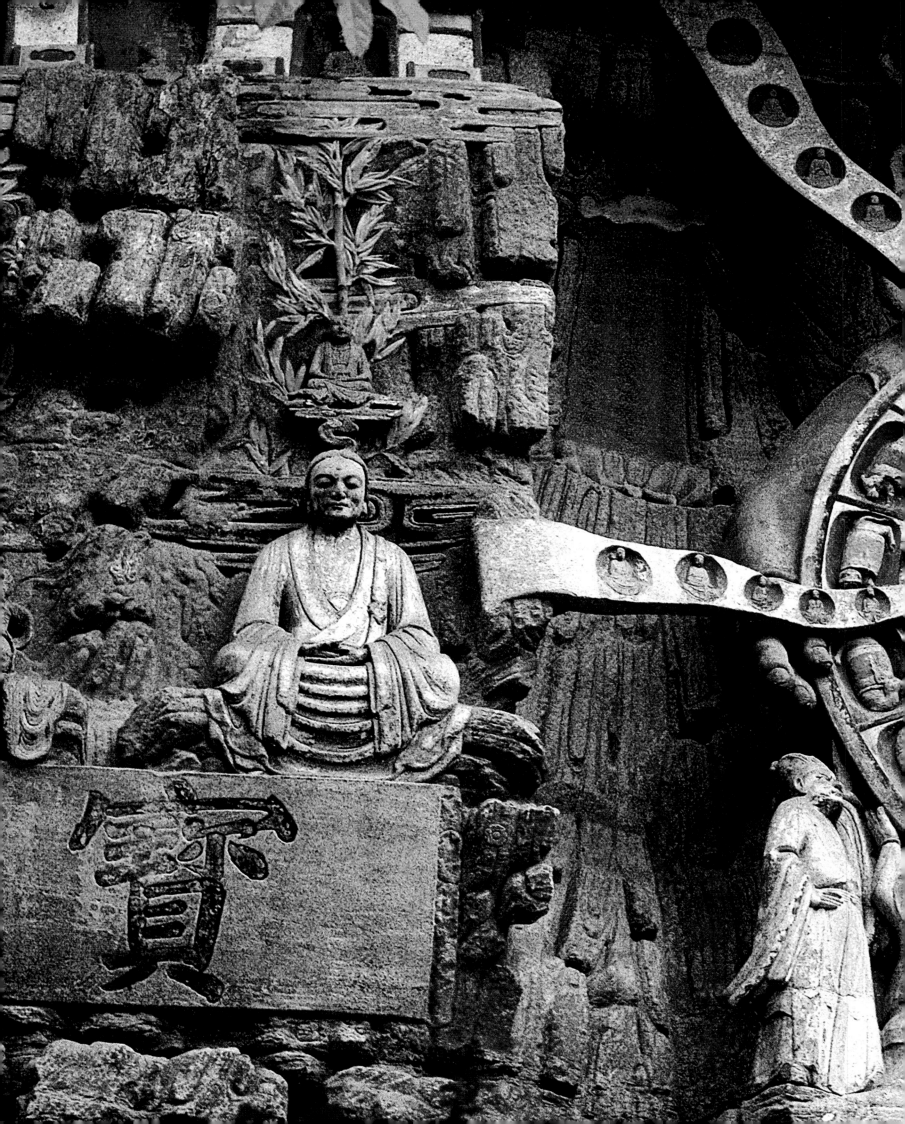

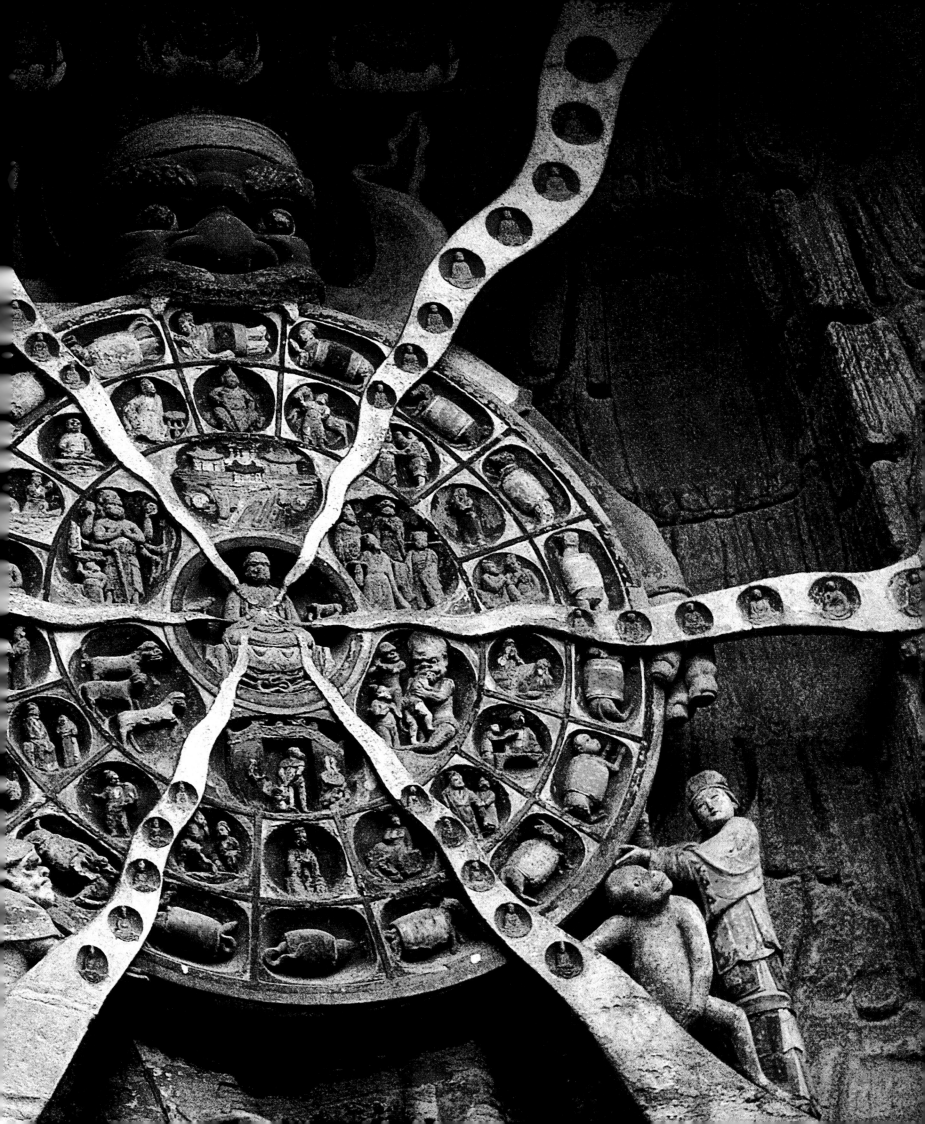

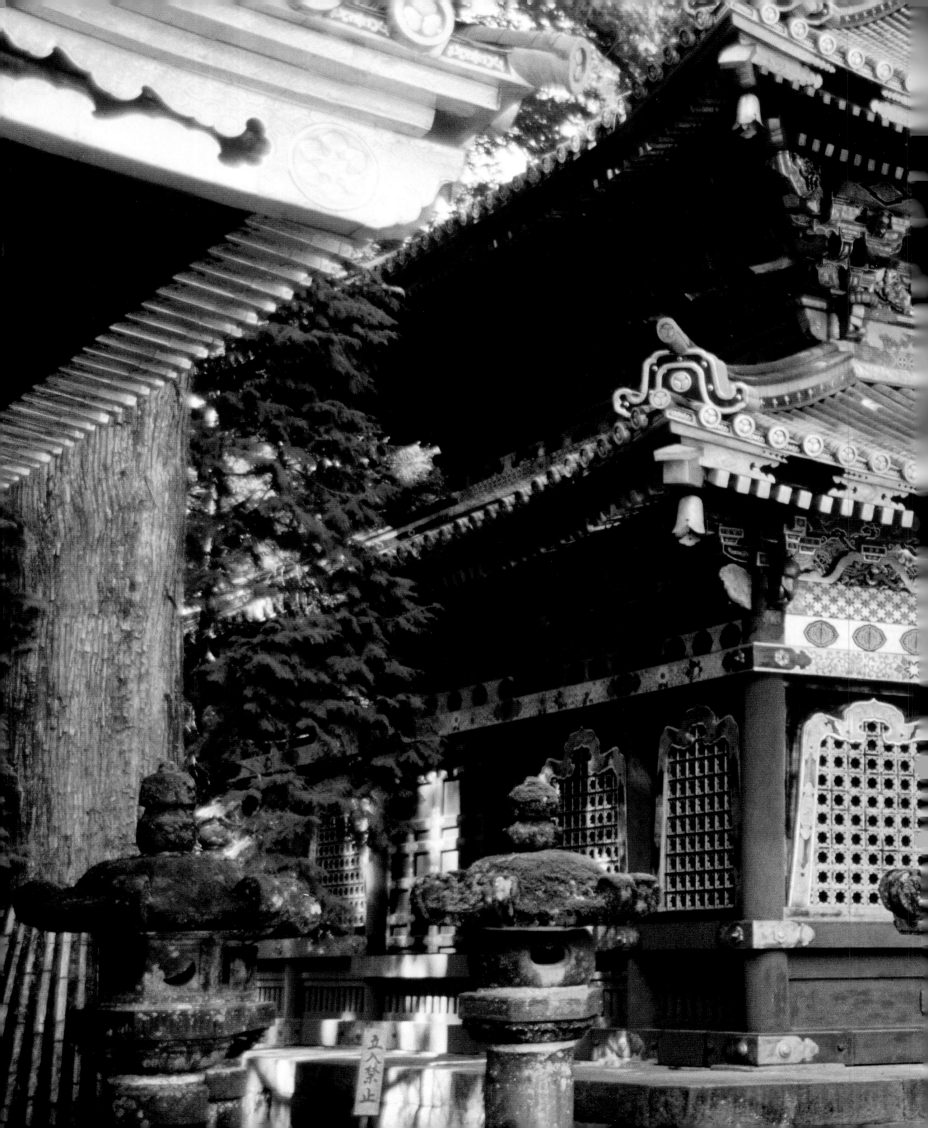

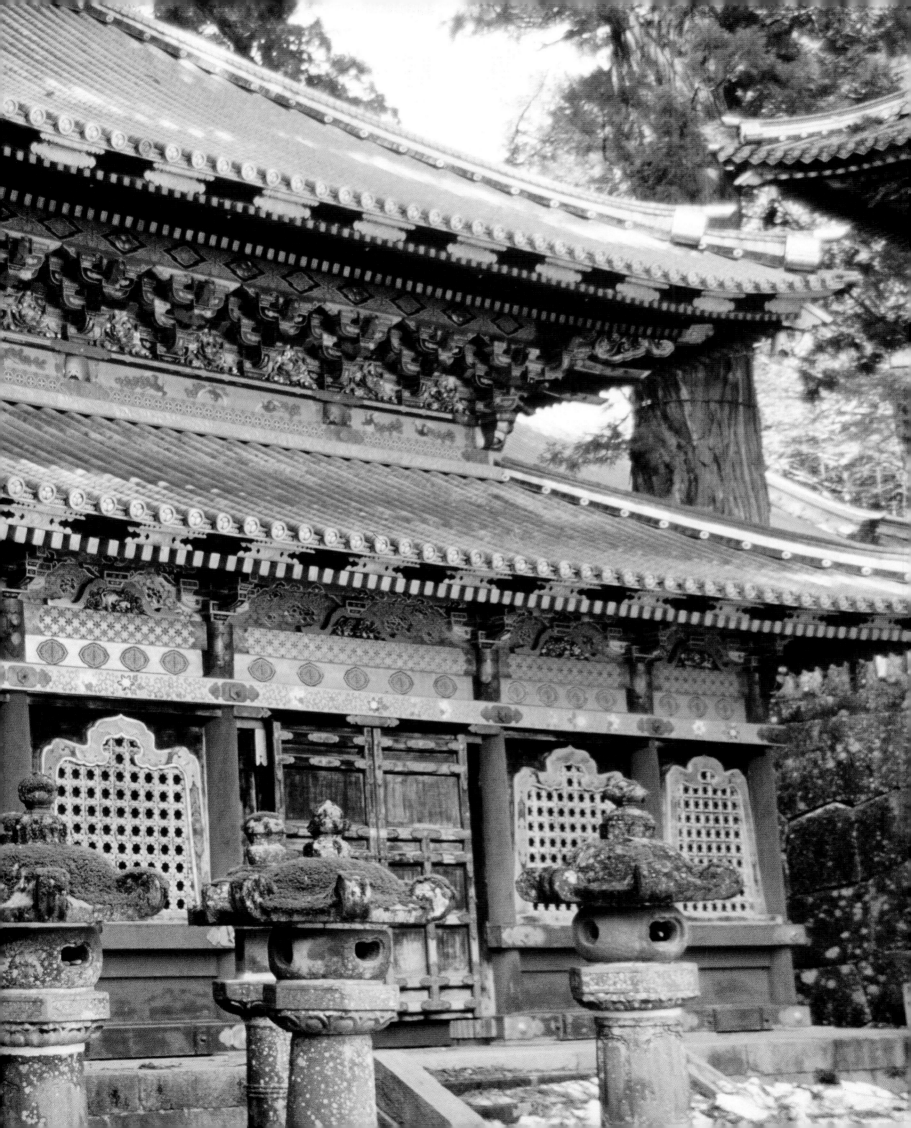

THE SHRINES AND TEMPLES OF
NIKKO, JAPAN

Preceding pages:

In the far north of Japan, beneath the holy mountain of Nikko, more than a hundred religious buildings forming a vast sanctuary are set in superb gardens within a sumptuous natural setting. The site has been religious since the eighth century. People throughout Japan come here to pray, and it is also a destination for tourists from all over the world. Its 988 acres (400 hectares) contain Buddhist temples that, with their reddish walls and black joinery, are typical of the Edo period (about 1600–1868). There are also Shinto shrines built of granite with very ornate walls. In the eighteenth century, Nikko accommodated the Tōshō-gū, the mausoleum, still venerated today, of the founder of the military regime that ruled Japan for more than 250 years.

WOODEN CHURCH, SUZDAL, RUSSIA

Right:

Located near the town of Vladimir, Suzdal lies within Moscow's "Golden Ring" of towns rich in art belonging to "Old Russia." The Russians regard Suzdal as the cradle of their nation: the princes of Suzdal, who became princes of Vladimir and then of Moscow, united "all the Russias" under their sway. Suzdal's fortified walls contain a host of monasteries and churches, including this wooden structure, the Church of the Transfiguration. The various towers and steeples seem to jostle for place on the horizon. Streams run through the town of Suzdal, which appears to have kept its medieval form. But whether dating from the Middle Ages or the seventeenth and eighteenth centuries, the buildings blend together in a marvelous harmony. Here, far away from the challenges facing modern Russia, time really seems to have stood still.

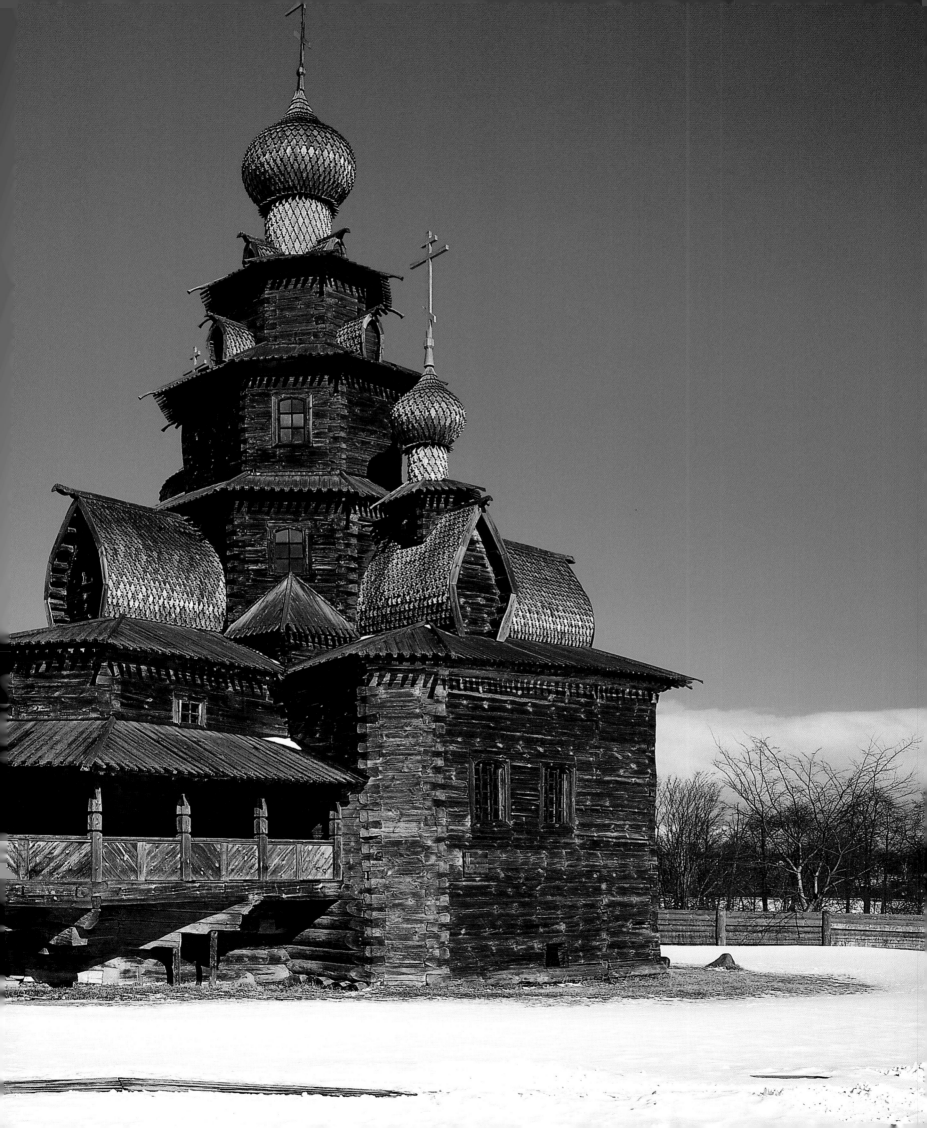

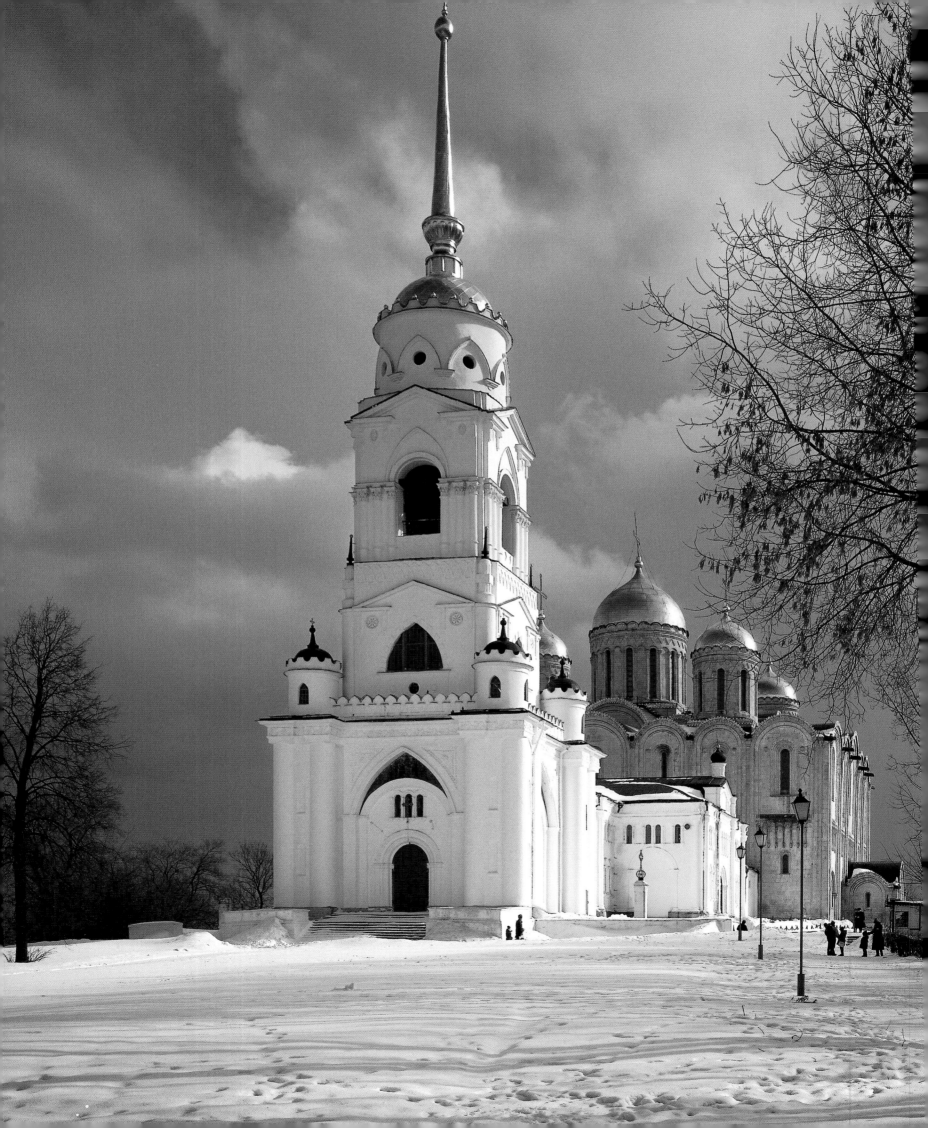

THE CATHEDRAL OF THE DORMITION, VLADIMIR, RUSSIA

Left:

Located 99 miles (160 kilometers) southeast of Moscow, Vladimir is sometimes referred to as "Mother of the Cities of Russia." The city is certainly old, having been founded in 1108 by Vladimir II Monomakh, who gave it his name. His son, Yuri Dolgoruky, who abandoned Kiev to found Moscow, turned the city into the seat of power of the great princes of Russia. At the start of a period of remarkable prosperity, a great many white stone buildings were erected—more than one hundred monumental constructions, including thirty-five churches and five monasteries. Vladimir thus became a virtual capital of Russian Orthodoxy. We can still admire the twelfth-century Golden Gate and Church of Saint Demeter, as well as the imposing Cathedral of the Dormition (1158–85), which contains a superb mural attributed to Andrei Rublev and Daniel Tchiorny as well as an impressive Baroque iconostasis.

BOROBODUR TEMPLE, JAVA, INDONESIA

Following pages:

Located in the center of Java, among the Indonesian island's rice fields and coconut plantations, Borobodur became accessible only in 1965, when its two miles (three and a half kilometers) of carved bas-reliefs detailing the life of the Buddha were revealed. The building is made of black volcanic rock, with a pyramidal mass of five square terraces as its foundation. The truncated-cone top is occupied by three circular platforms bearing seventy-two bell-shaped stupas perforated to let in daylight, each one containing a statue of the Buddha. Finally, at the very top, one enormous stupa crowns the structure. The monument is designed to show the raising of consciousness through the three worlds of desire, appearance, and divinity; this progress is accomplished from east to west, following the course of the sun.

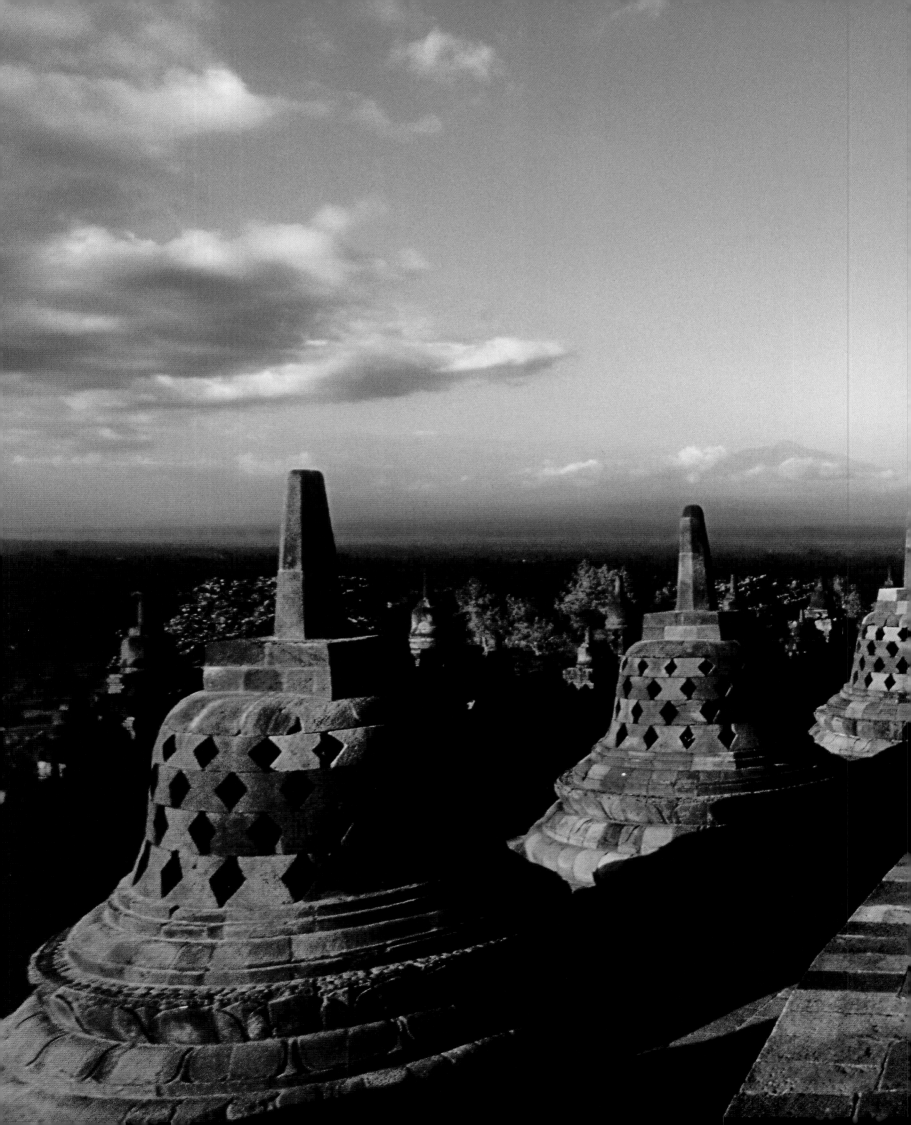

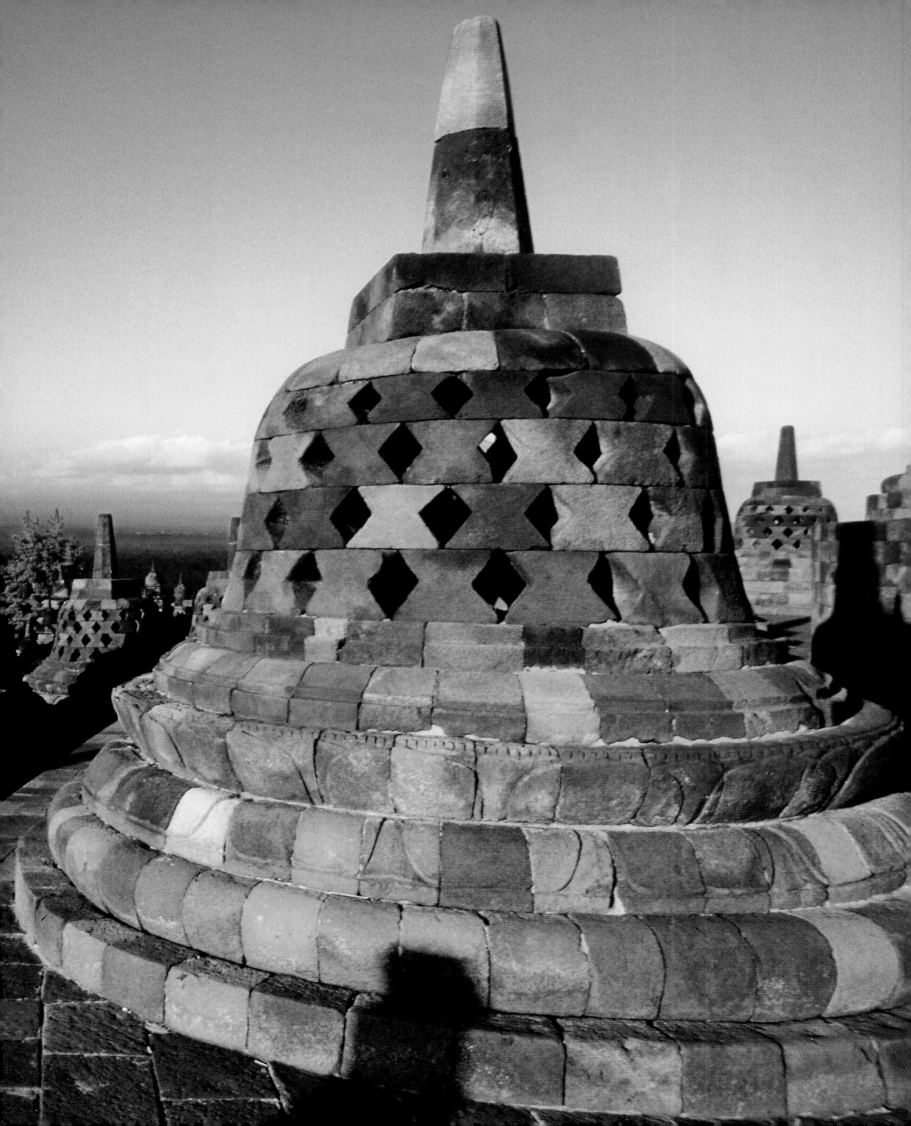

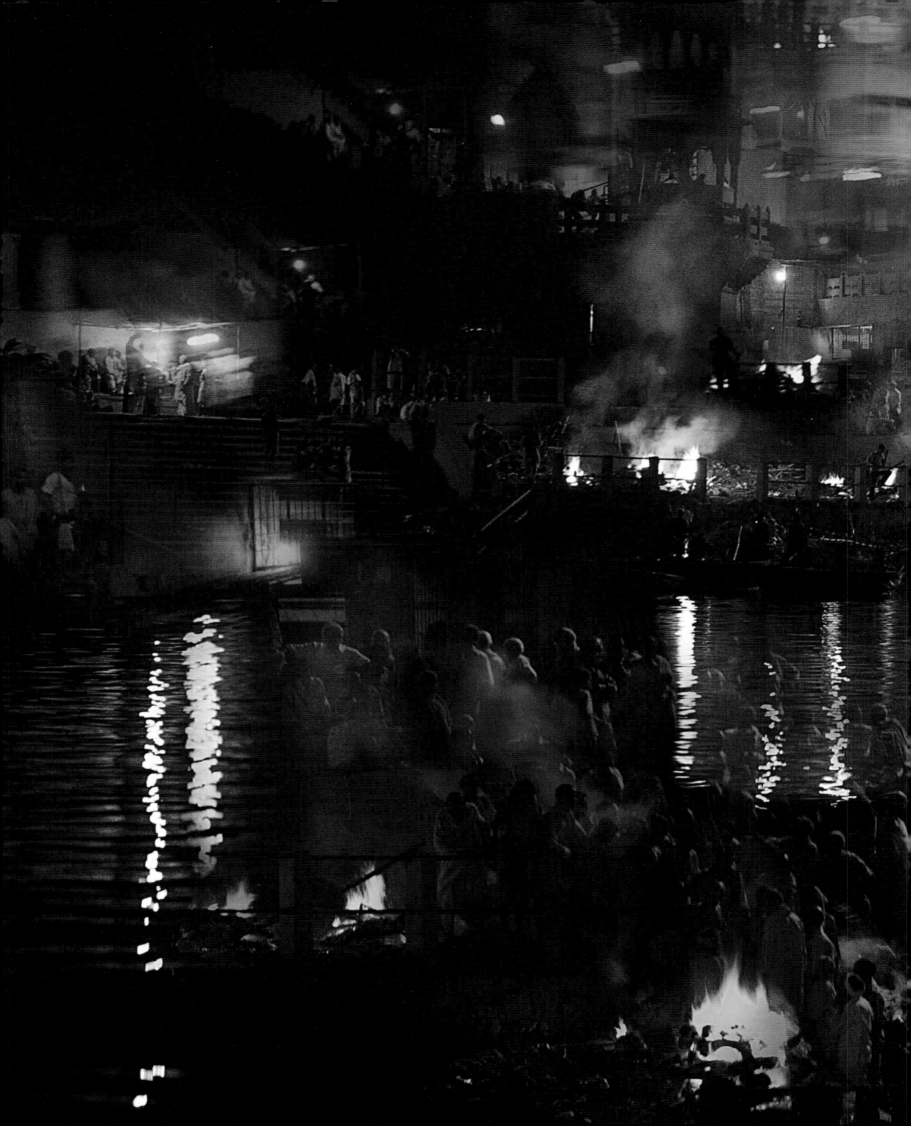

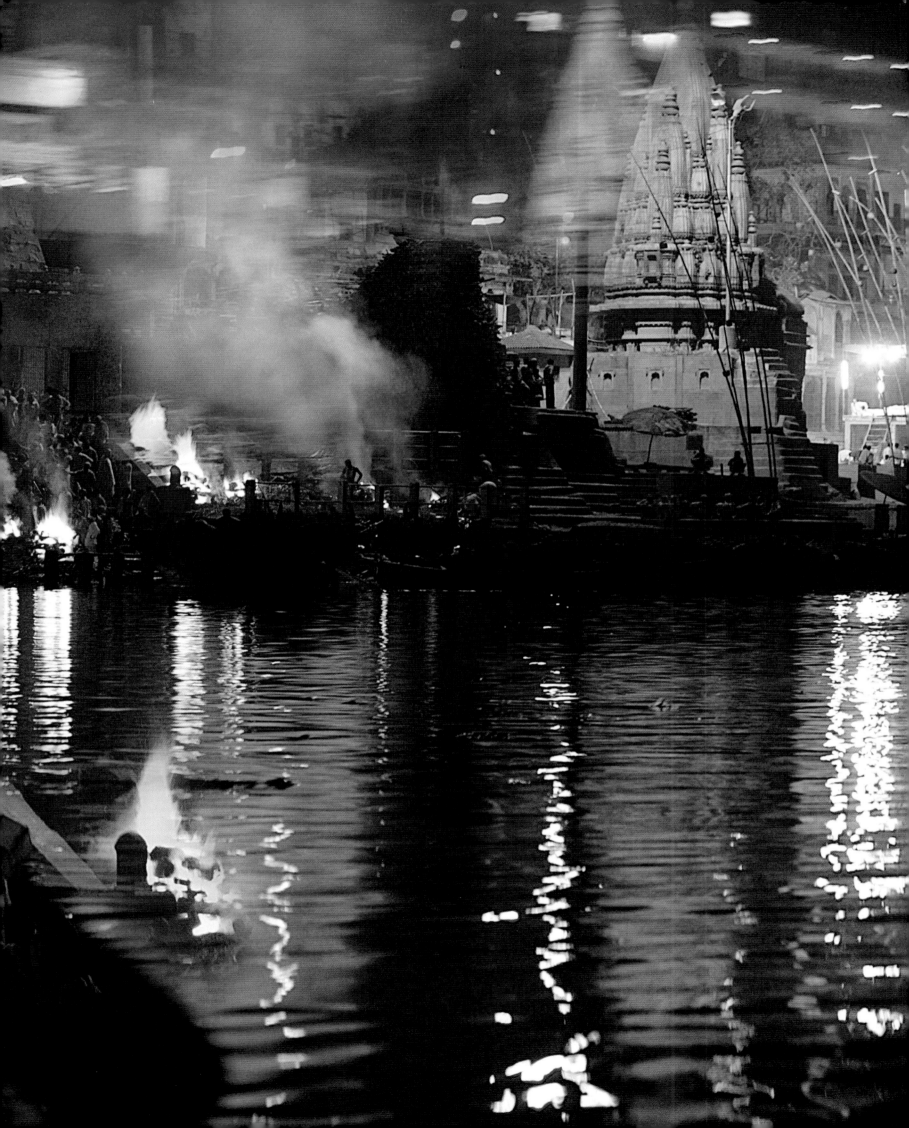

THE BANKS OF THE GANGES AT VARANASI, INDIA

Preceding pages:

Varanasi, also known as Benares, is a sacred and legendary city of life and death. To bathe in the Ganges here represents new life to Hindus, and to be cremated here may ensure the eternal peace of Nirvana. Varanasi, in northeastern India, was probably founded in the seventh century BC; the city is sacred to Shiva. The pilgrims who come here and mix with its 1.5 million inhabitants often gather on the river, where broad flights of steps, known as ghats, have been constructed to face the rising sun. There are more than seventy ghats, where cremations and holy ablutions take place in waters that receive the runoff of more than thirty drains. Above them rise temples and palaces served by an extremely dense network of alleyways; ashrams, or teaching communities, and yoga schools are numerous.

THE STUPA AT BODNATH, NEPAL

Left:

Most often taking the shape of a dome with a truncated pyramid on top, the stupa is a monument that symbolizes the Buddha and commemorates his death; the earliest stupas contained authentic relics of the Buddha. The stupa dome recalls an upturned bowl of offerings; topped with masts carrying sacred flags, it was surrounded by a circular pathway that people followed in a clockwise direction. The stupa's wide dissemination throughout the Buddhist world gave rise to local variations. In Tibet, it was shaped like a bulb and called a chorten. In Southeast Asia, the stupa—as in Borobodur Temple (pages 294–95)—was bell-shaped. The stupa at Bodnath is the largest in Nepal. It is an important place of pilgrimage, located in the vicinity of many monasteries.

THE TAJ MAHAL, INDIA

Right:

The Taj Mahal is not really a palace but a mausoleum, an offering by the Mughal emperor Shah Jahan to his second deceased wife that houses her tomb. The iconic white-marble form of India's most visited monument is dazzling to behold. As visitors approach, they perceive the building's richness, its walls encrusted with jasper, turquoise, coral, rock crystal, malachite, sapphire, lapis-lazuli, cornelian, onyx, and agate. It is said that more than a thousand elephants were needed to transport these precious materials when they began to build the monument in 1631; and that the four minarets are deliberately tilted outward so as not to fall on the dome, and the tomb it harbors, in the event of an earthquake. The design of this masterpiece of Islamic architecture is attributed to a Persian architect.

THE EL GHRIBA SYNAGOGUE, DJERBA, TUNISIA
THE WESTERN WALL, JERUSALEM

Following pages:

Tradition has it that the El Ghriba synagogue on the Tunisian island of Djerba was founded by a group of priests from the Temple in Jerusalem at the time of the first Jewish Diaspora, some five centuries before the Christian era. Now some twenty-six centuries later, a community of one thousand Sephardic Jews still passes through its doors to pray in one of the world's oldest synagogues. It is a place of strong mythic resonance whose importance within historic Judaism, and especially the North African tradition, was highlighted by a terrorist attack in 2002. Surrounded by olive and palm trees, among which grow several Barbary figs, this "antechamber to Jerusalem," rebuilt in the nineteenth century, is a place of pilgrimage, where prayers are said in Hebrew and Aramaic amid a tiled décor of blue and white. Jewish spirituality has always focused on Jerusalem, where a remnant still stands of the foundations of the Second Temple, which was destroyed by the Roman Empire in 70 AD; Solomon is believed to have built the First Temple around 969 BC. Here the Western Wall, sometimes called the Wailing Wall, is the lone survivor of the depredations that have recurred through the centuries; it continues to be a distinguished monument of the Jewish faith and the site of intense devotion and pilgrimage. Between its stones, believers—and other visitors, who have included the late Pope John Paul II—place pieces of paper on which they have written their hopes and prayers.

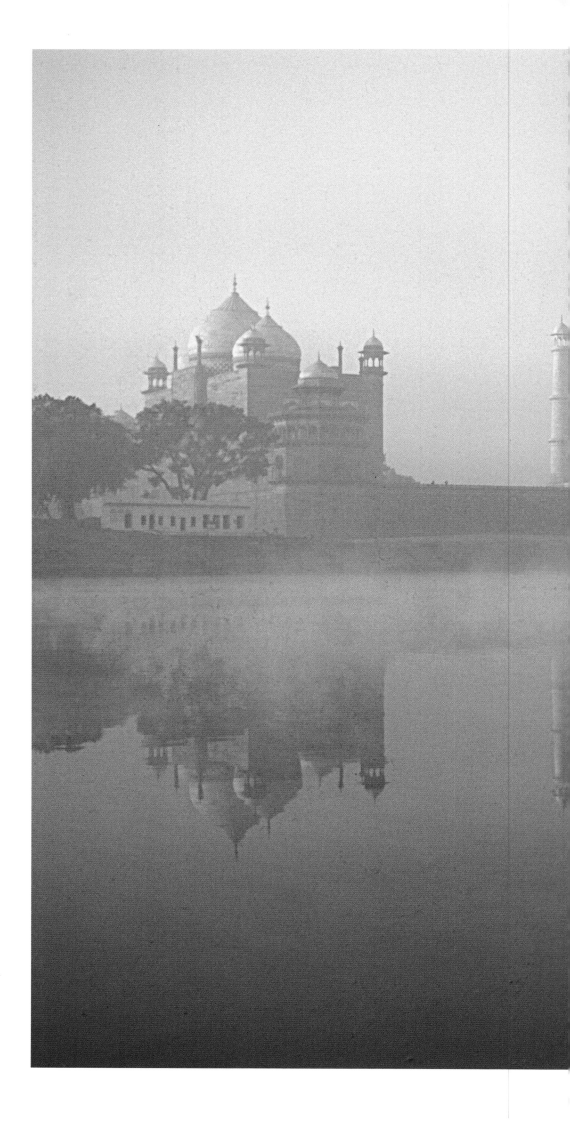

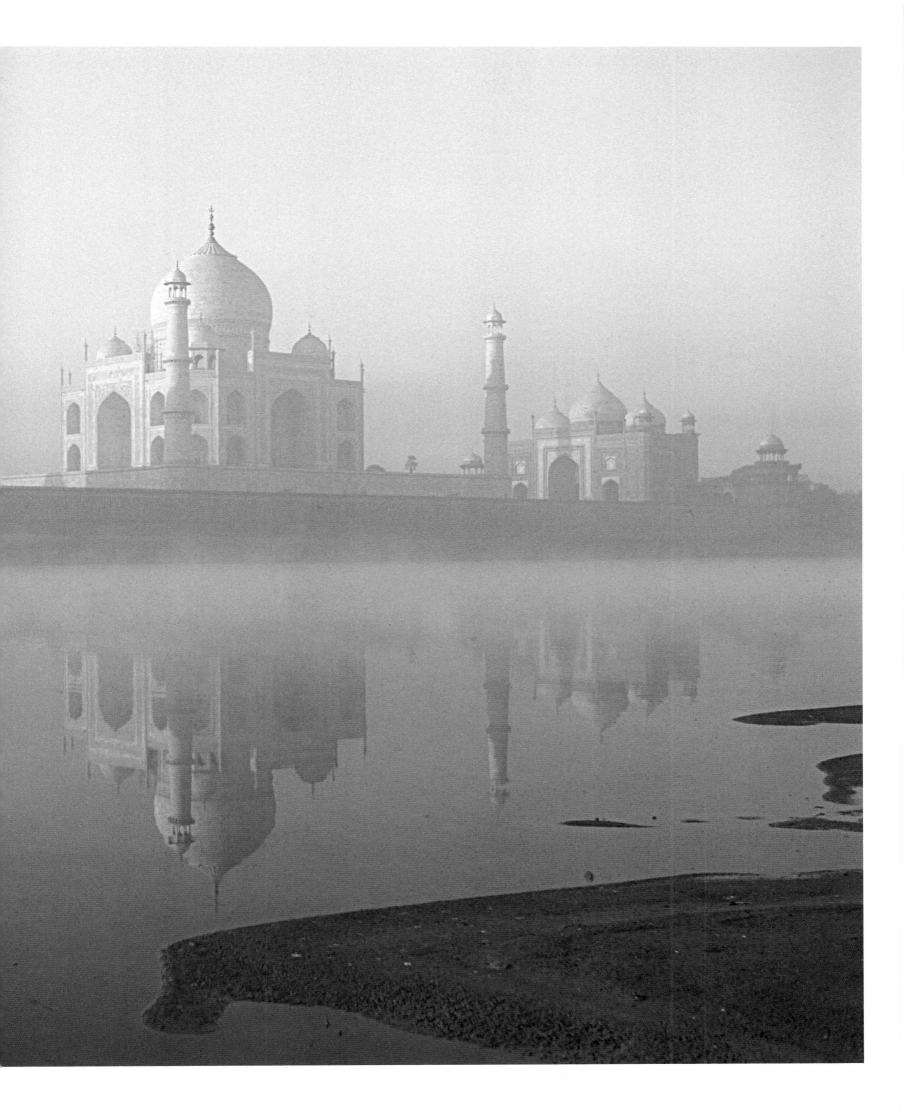

MECCA, SAUDI ARABIA

Right:

It is believed that here, in this desolate corner of the Arabian Desert not far from the Red Sea, a spring gushed forth at the feet of Ishmael, a son of Abraham. In the sixth century AD, Mecca was already home to Bedouin tribes, a trading post on routes to the East, and a religious center. Following his exile in Medina—known as the Hegira, or migration, in 622—Muhammad returned to Mecca in 630. Today the city has more than a million inhabitants. More than 2 million pilgrims gather here every year for the hajj, the largest pilgrimage in Islam, whose rites include circling the Kaaba seven times in prayer; the Kaaba is a cubical structure containing a black stone believed to have been brought by an angel to Abraham. The pilgrimage to Mecca, the place where the archangel Gabriel is believed to have revealed to Muhammad the core of the Islamic religion and of its sacred text, the Qur'an, is one of the five obligatory duties demanded of all believers. Muslims are supposed to undertake this pilgrimage at least once during their lifetimes.

THE BLUE MOSQUE OF
MAZAR-I-SHARIF, AFGHANISTAN

Following pages:

Perhaps the birds of peace are gathering in front of this splendid mosque just as pilgrims gather around the Kaaba at Mecca. Crying as they take to the air, the birds cover the building in an airy white cloak that seems incongruous in this part of northern Afghanistan, bloodstained through years of war. Today restored, the mosque owes its existence to a belief that the Prophet's son-in-law was buried on the site. Riches and prosperity followed, the result of the spice and silk routes that passed through the city. The roads today are controlled by warlords, who use kidnapping and assassination. What value has the beauty of the architecture—its tiered forms, adornments of emerald, azure, and gold—if massacres are perpetrated only a stone's throw away, sometimes in the name of God? Let these images speak for the permanence of hope.

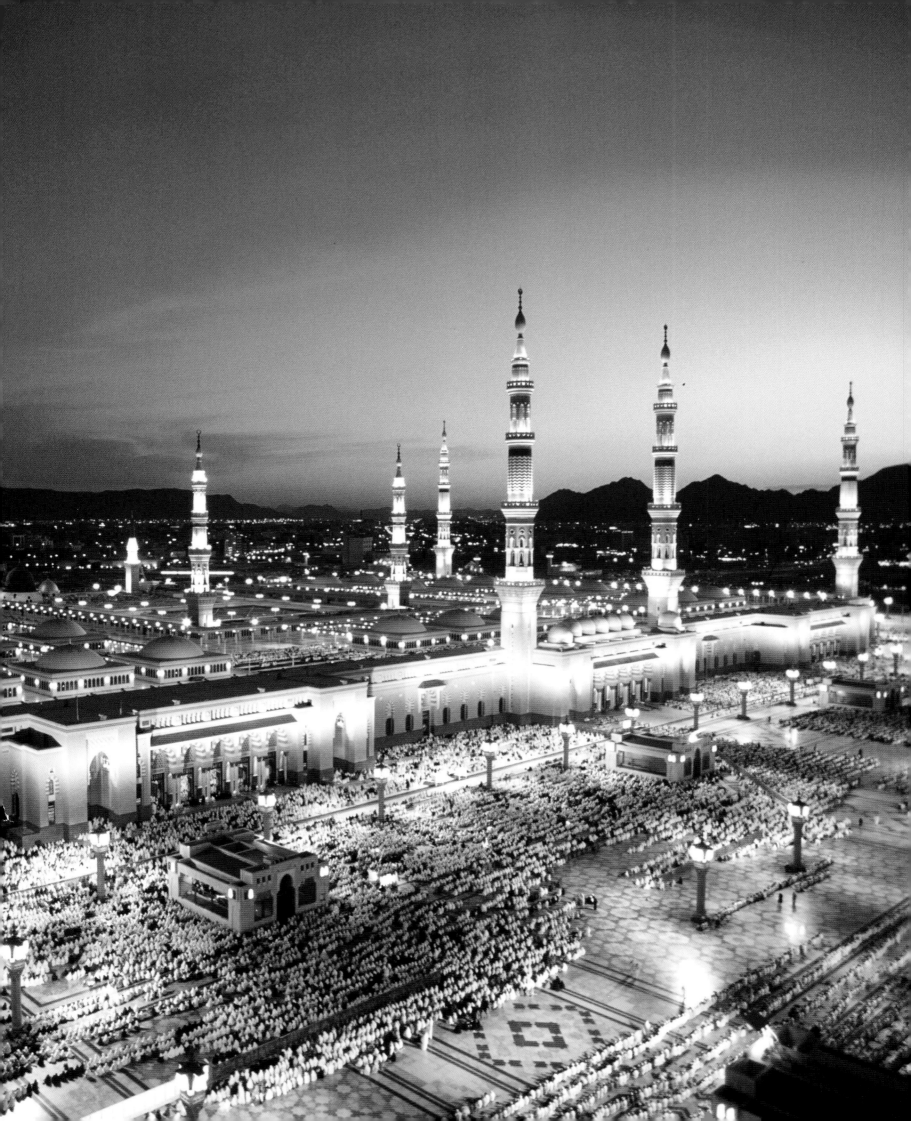

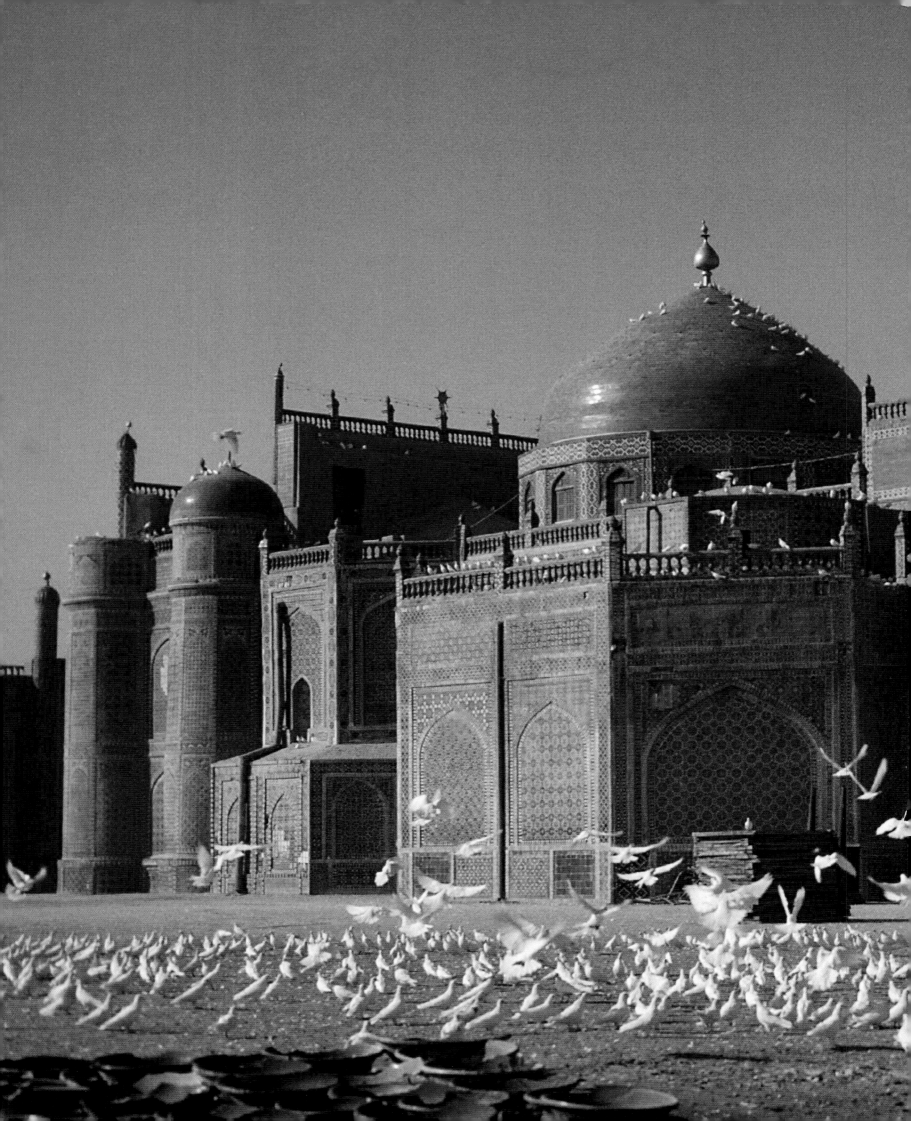

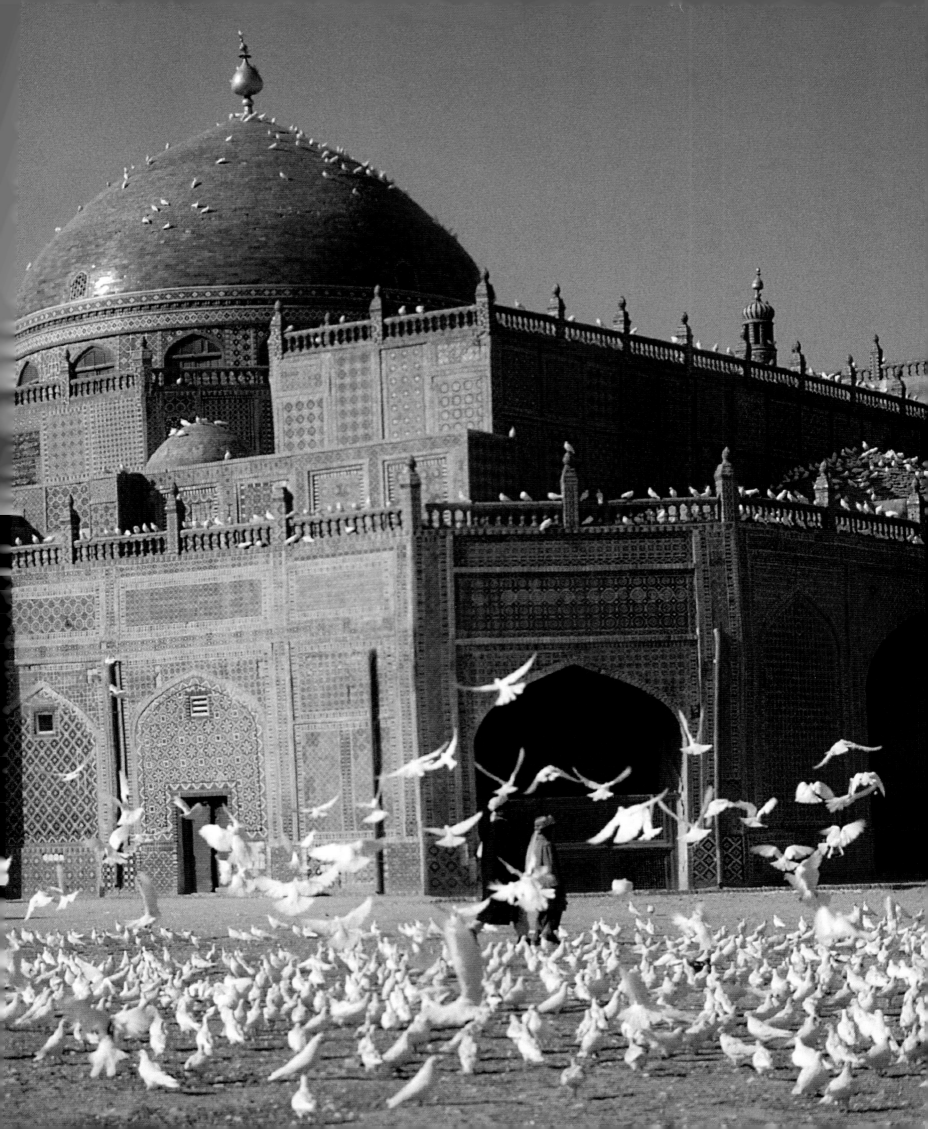

ALPHABETICAL LIST OF WONDERS

PHOTOGRAPHY CREDITS

AGE FOTOSTOCK / Hoa-Qui: 88–89, 176–77

ARTHUS-BERTRAND, YANN / Altitude: 220

BIBAL, FRANÇOIS / Rapho: 190–91

BIBIKOW, WALTER / Age Fotostock / Hoa-Qui: 2–3

BISHOP, RANDA / Imagestate / GHFP: 114, 270–71

BODY, PHILIPPE / Hoa-Qui: 159

BOURSEILLER, PHILIPPE: 40–41, 54–55, 76–77, 82–83, 168–69, 272–73, 278–79, 294–95

BRINGARD, DENIS / Explorer / Hoa-Qui: 52–53

BUSS, WOJTEK / Hoa-Qui: 14–15, 212–13

BUSSELLE, MICHAEL / Getty Images: 258–59

CAHIR, DAVITT / Age Fotostock / Hoa-Qui: 10–11

CASTANEDA, LUIS / Age Fotostock / Hoa-Qui: 252–53

CRACKPHOTOS / Age Fotostock / Hoa-Qui: 4

CHAPMAN, PHIL / NPL / Jacana: 244–45

CHMURA, FRANCK / Imagestate / GHFP: 172–73

DALLET, J.D. / Age Fotostock / Hoa-Qui: 6, 14–15

DUBOIS, JACQUES: 142–43

DURRUTY, VÉRONIQUE / Hoa-Qui: 9

ESCARTIN, DOMINIQUE: 274–75

ESCUDERO, PATRICK / Hoa-Qui: 250–51

EXPLORER / Hoa-Qui: 302

FAILLET / Keystone-France: 200–1

FÖLLMI, OLIVIER: 78–79, 118–19, 130–31, 166–67, 230–31, 298–99

FRAUDREAU, MARTIN / Top: 266

FSG/AGE FOTOSTOCK / Hoa-Qui: 56–57

FUCHS, ARIEL / Hoa-Qui: 214–15

GERSTER, GEORG / Rapho: 248–49

GLEITER, JERI / Getty Images: 124–25

GRANDADAM, SYLVAIN / Hoa-Qui: 36–37

GUICHAOUA, YANN / Hoa-Qui: 100–1, 170–71

HAMBLIN, MARK / Age Fotostock / Hoa-Qui: 75

HELLIER, GAVIN: 228–29, 254–55

IMAGESTATE / GHFP: 104–5, 222–23

JESUS / Age Fotostock / Hoa-Qui: 174–75

JOHNER / Getty Images: 98–99

KOBER, CHRISTIAN / Getty Images: 184–85

KAZUYOSHI, NOMACHI / PPS / Rapho: 304–5

LARREA, JAVIER / Age Fotostock / Hoa-Qui: 206–7

LANGLEY, J. ALEX / Imagestate / GHFP: 236–37

LAWRENCE, BRIAN / Imagestate / GHFP: 96–97, 180–81, 193, 202–3

LAWRENCE, J. / Imagestate / GHFP: 152–53

LAYMA, YANN: 30–31, 80–81, 86–87, 92–93, 120–21, 238–39, 262–63, 286–87

LENARS, CHARLES and JOSETTE: 20–21

LEROUX, JEAN-BAPTISTE / Jacana: 117

LESCOURRET, J.-P. / Explorer / Hoa-Qui: 1, 60–61, 102–3, 122–23, 196–97, 198–99, 208, 209, 218–19, 243, 260–61, 311

LESCOURRET, J.-P. / Explorer / Hachettephotos Illustration: 108–9

MANIN, RICHARD: 232–33

MATTES, R. / Explorer / Hoa-Qui: 44–45, 282–83

MATINA, R. / Age Fotostock / Hoa-Qui: 46–47

MICHAUD, ROLAND and SABRINA / Rapho: 34–35, 154–55, 300–1, 306–7

MONLAÜ, LAURENT / Rapho: 18–19

MORANDI, BRUNO / Getty Images: 276–77

MORANDI, BRUNO / Hoa-Qui: 16–17, 138–39, 204–5

NARAYAN, P. / Age Fotostock / Hoa-Qui: 29, 288–89

NOWITZ, RICHARD T. / Age Fotostock / Hoa-Qui: 134–35

PASQUIER, JEAN ERICK / Rapho: 224–25

PHILIPPE, DANIEL / Air Print: 22–23, 24–25, 48–49, 58–59, 66–67, 68–69, 70–71, 126–27, 128–29, 132–33, 140–41, 144–45, 146–47, 178–79, 182–83, 186–87, 264–65, 280–81, 290–91, 292–93

POELKINKG, FRITZ / Age Fotostock / Hoa-Qui: 72

RAGA, JOSÉ FUSTE / Age Fotostock / Hoa-Qui: 56–57, 160–61, 284–85

RAGA, JOSÉ FUSTE / Explorer: 150–51

RENAUDEAU, MICHEL / Hoa-Qui: 112–13

SAN ROSTRO / Age Fotostock: 216–17

SAMPERS, E. / Explorer: 110–11

SAPPA, CHRISTIAN / Hoa-Qui: 188–89

SAUTEREAU, SERGE / Grandeur Nature: 194–95

SCOTT, DOUG / Age Fotostock / Hoa-Qui: 234–35

SETBOUN, MICHEL: 162–63, 221

SILVESTER, HANS / Rapho: 38–39

SIMANOR, EITAN / Hoa-Qui: 148–49, 240, 303

SIOEN, GÉRARD: 12, 13, 26, 42–43, 50–51, 64–65, 90–91, 156, 164–65, 246–47

SOLTAN, F. / Hoa-Qui: 32–33

STOCKSHOOTER, JOHNNY / Age Fotostock / Hoa-Qui: 94–95

THOMAS, FRED / Hoa-Qui: 267

TREAL / RUIZ / Explorer / Hoa-Qui: 62–63

TRONCY, MICHEL / Hoa-Qui: 84–85

VIDLER, STEVE / Imagestate / GHFP: 226–27

WELSH, KEN / Age Fotostock / Hoa-Qui: 136–37

WERNER, OTTO / Age Fotostock / Hoa-Qui: 268–69

WILBUR, E. GARRET / Getty Images: 256–57

WOLF, ALFRED / Hoa-Qui: 192

WOLF, KLAUS-PETER / Imagestate / GHFP: 210–11

ZIMBARDO, XAVIER: 296–97

Strasbourg Cathedral, France

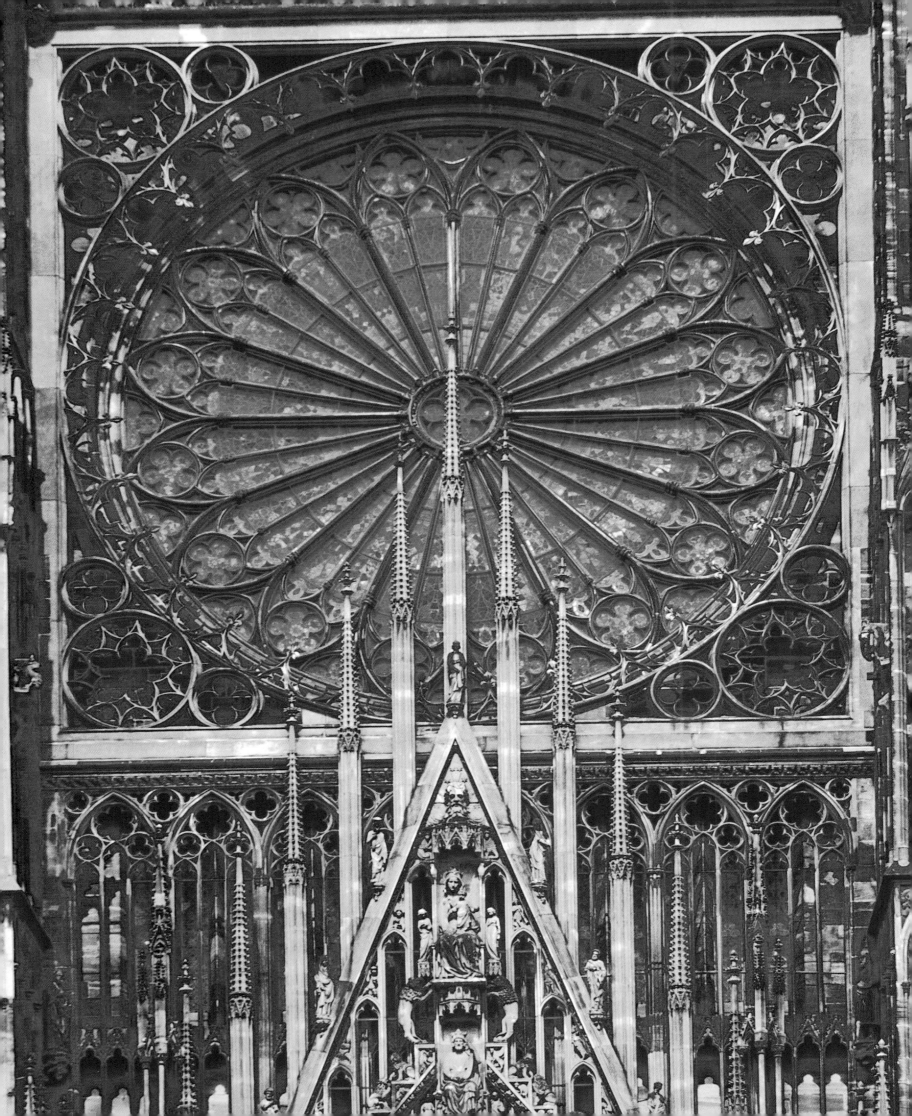